CIVIL IMAGINATION

CIVIL IMAGINATION
A Political Ontology
of Photography

ARIELLA AZOULAY

Translated by
Louise Bethlehem

VERSO
London • New York

This English-language edition first published by Verso 2012
© Verso 2012
Translation © Louise Bethlehem 2012
First published as דמיון אזרחי. אונטולוגיה פוליטית של הצילום
[Civil Imagination: Political Ontology of Photography]
© Resling Publishing, Israel 2010

The author and publisher gratefully acknowledge the permission
granted to reproduce the images in this book. Every effort has
been made to trace copyright holders and obtain their permission
for the use of copyright material. The publisher apologizes
for any omissions and would be grateful if notified of any
corrections that should be incorporated in future editions.

The moral rights of the author have been asserted

1 3 5 7 9 10 8 6 4 2

Verso
UK: 6 Meard Street, London W1F 0EG
US: 20 Jay Street, Suite 1010, Brooklyn, NY 11201
www.versobooks.com

Verso is the imprint of New Left Books

ISBN-13: 978-1-84467-753-5

British Library Cataloguing in Publication Data
A catalogue record for this book is available from the British Library

Library of Congress Cataloging-in-Publication Data
Azoulay, Ariella.
[Dimyon ezrahi. English]
 Civil imagination : a political ontology of photography / Ariella Azoulay;
translated by Louise Bethlehem.
 p. cm.
Includes bibliographical references and index.
ISBN 978-1-84467-753-5
1. Photographic criticism—Israel. 2. Photography—Political aspects—
Israel. 3. Photography—Philosophy. I. Title.
TR187.A98313 2012
770.1—dc23
 2012006239

Typeset in Sabon by Hewer UK Ltd, Edinburgh
Printed in the US by Maple Vail

CONTENTS

LIST OF ILLUSTRATIONS

Cover: Micha Kirshner, preparations for photographing Aisha al-Kurd and her son Yassir, 1988

Introduction

Micha Kirshner, Aisha al-Kurd and her son Yassir, 1988

Chapter 1

Chapter 2

Chapter 3

Chapter 4

Epilogue

Micha Kirshner, Aisha al-Kurd and her son Yassir, 1988

INTRODUCTION

The woman whose portrait appears on the opposite page, Aisha al-Kurd, is the overt and covert interlocutor of this book. I have never met her in person. Yet she has accompanied my thought ever since I first saw her photograph. Aisha and her husband (whose name I do not know), the parents of five children, were held in administrative detention for months by the Israeli authorities in 1988, and their house was demolished. When I first encountered her portrait during the late 1980s, I mistakenly viewed it as an instance of the "aestheticization of suffering": the creative output of photographer Micha Kirshner. At the time, I thought that my analytical position concerning the aestheticization of suffering was a critical one.[1] It was only later that I became aware of the trap inherent in such a stand. This trap—which routinely opposes the aesthetic to the political—already preoccupied me at the time, but it was only gradually that its features, as well as the worldview that it organizes, became clear to me. The present volume will explore the fallacy that beset me then at length, while simultaneously attempting to rethink the category of the "political"—its boundaries and limitations—as well as to clear space for the emergence of a different category—that of the "civil."

My encounters with Aisha al-Kurd over the years, meetings that exist only under the cover of the imagination, reflect changes in my thought concerning photography, concerning the sphere of the political, and concerning citizenship. On the basis of her photograph, and photographs of other individuals, this book seeks to imagine a civil discourse under conditions of regime-made disaster. Under such conditions, citizenship is restricted to a series of privileges that only a portion of the governed population enjoys and, even then, to an unequal degree. The central right pertaining to the privileged segment of the population consists in the right to view disaster—to be its spectator. What is at stake is not the enjoyment

that potentially attaches to the act of spectatorship, but the act itself, which is reserved for the privileged bearers of citizens' rights who are able to observe the disaster from comparative safety, whereas those whom they observe belong to a different category of the governed, that is to say, people who can have disaster inflicted upon them and who can then be viewed subsisting in their state of disaster.

The scandal that attaches to the portrait of Aisha al-Kurd does not reside in the photograph itself, whether in its aesthetic value (its beauty seems to transcend disputes of taste) or in any other of its discrete qualities. The scandal lies in the fact that Aisha al-Kurd's house was, and remains, vulnerable to the violent invasion of Israeli citizens in uniform and also, that it remains permeable to those who observe her suffering— that is to say, privileged citizens who do not see her condition as one of disaster, precisely, or who view it at best as a "disaster contingent on one's point of view."

Aisha al-Kurd's disaster, like that of millions of Palestinians governed by the state of Israel, is a regime-made disaster. A regime-made disaster is brought into being by the regime. In cases like the present one, it comes to define the regime itself and its ability to reproduce itself. The specific regime-made disaster in question is perpetuated without being acknowledged as such by those citizens who live under its reach. This civil malfunction, which does not allow for the disaster that afflicts other segments of the governed to be recognized as disaster, is one of the fundamental conditions for the appearance/disappearance of a regime-made disaster. Much of the violence that brings it into being lacks widespread attributes of violence as we commonly understand it: these acts are neither spontaneous nor are they random, chance outbreaks. On the contrary, they form part of an organized, regulated and motivated system of power that is nourished by the institutions of the democratic state, which in turn is sheltered under their umbrella. My fundamental point of departure in this book consists in the claim that, under the conditions of regime-made disaster, the first step in the evolution of a civil discourse lies in the act of refusing to identify disaster with the population upon whom it is afflicted. It consists in the refusal to see the disaster as a defining feature, precisely, of this population as expressed, for example, in the phrase "Palestinian refugee." A civil discourse is thus one that suspends the point of view of governmental power and the nationalist characteristics that enable it to divide the governed from one another and to set its factions against one another. When disaster is consistently imposed on a part of the whole population of the governed, civil discourse insists on delineating the full field of vision in which the disaster unfolds so as to lay bare the blueprint

of the regime. Civil discourse is not a fiction. It strives to make way for a domain of relations between citizens on the one hand, and subjects denied citizenship by a given regime on the other, on the basis of their partnership in a world that they share as women and men who are ruled. It seeks to isolate potential factors in the real world that might facilitate the coming into being of such relations of partnership, instead of the power of the sovereign that threatens to destroy them.

To achieve this requires an act of imagination.

It has been a little over two hundred years since individuals were called upon to foment an act of imagination in order to see themselves as equal partners in the political framework within which they lived; in order, moreover, to see themselves as *citizens*, male and female. This achievement—the fact of becoming a citizen in practice—sometimes obscures the enormous imaginative leap that was required in order to conceive of subjects as partners in the shaping of the regime who simultaneously possess the right to be protected from it. What is at stake is not the simple exercise of imagining something in one's mind's eye, for example. Rather, I am concerned with the capacity known as "political imagination," that is to say, the ability to imagine a political state of being that deviates significantly from the prevailing state of affairs. In order to imagine himself as a citizen, the eighteenth-century subject had to imagine the possibility of a form of political life not ruled by the monarch, whose sovereign seal no longer would have the power to dispatch human beings to rot to death in suffocating dungeons. In other words, the imaginative ability to sketch out a new reality was bound to the effort to shake off the shackles of a state of perception that accepted the prevailing regime—the monarchy—as an incontestable fact. The beheading of Louis XVI in 1793 has long become symbolic of a form of political imagination that bursts its boundaries.[2] The four years that passed between the storming of the Bastille and the eventual resolve of the people to take leave of the king—on the steps of, and by means of, the guillotine—serve as evidence for the very power of the shackles constraining the imagination.

But, one should ask, is this really a leap of the imagination, a bursting of conceptual boundaries? Might it not be possible that what is presented as the breaking of boundaries actually reinforces them? What, in other words, is political imagination, and is it solely contingent on action in the realm of the political?

Political imagination does not always provide us with the wings we need to soar. Political imagination runs the risk of remaining cramped, limited and circumscribed. It often re-inscribes existing forms, but remains a form of imagination all the same. For the most part, imagination is

neither wild nor cramped, neither breaks boundaries nor works particu-
larly hard to reinforce them. Imagination mostly functions as part of our
structure of consciousness. It is activated routinely, and it forms part of
every communicative act. We do not consciously experience it for what it
is—the activity of the imagination. Imagination enables us to create an
image on the basis of something that is not accessible to the senses. We
call on imagination constantly. Even when objects actually appear before
us, our contemplating gaze encounters not the object in its plenitude but
only one facet of it. It is only the imagination that is capable of creating a
full image, or in Kant's terminology, a "schema" of the object that enables
the coming into being of a synthesis between the particularity of the thing
and its conceptual form.[3] However material the images that we produce in
our mind's eye might be, they remain disembodied and do not enjoy inde-
pendent presence in the world except for that presence which is contingent
upon our imagination. We are not the sole source of our own imaginative
capacities, however. The imagination is always shot through with splin-
ters of images that have their source in the outside world and in other
people. But imagination remains private for as long as we hold it in reserve
in our mind's eye and do not share it with others. In every act of commu-
nication with others, this privacy of the imagination is ruptured and its
products intermingle with other products to take on a form that exceeds
our own private reach. From the moment that these products emerge into
circulation to create friction among one another, sparks of surprise,
astonishment, wonder, shock, consternation, enthusiasm, horror, incom-
prehension or disruption may emerge in the consciousnesses of at least
some of the participants involved in a given interaction, as products of the
imagination. These shows of the imagination are classified as "scientific,"
"political" or "artistic" with reference to the different spheres in which
they operate and in terms of whose criteria they reap praise or disapproval
respectively. Imagination is sometimes termed "wild" or "creative" if
"we" (those who label it as such) see it as opening reality to benevolent
possibilities; whereas it is seen as "perverse" or "pathological" when the
range of possibilities that it generates appears to us to be threatening,
strange or depressing. Most of the time, however, the points of friction
created by the imagination are subsumed within existing economies of
exchange without our even being aware of their imagined status. The state
is a good example of one such category: our frequent recourse to it has
long since occluded the fact that it is the fruit of our imagination—the
product of a common imagining shared with others.[4]
 As I will demonstrate in the chapters below, which deal with the conven-
tional distinction between the political and the aesthetic, the trait of the

"political" when attached to speech, action, creative activity or imagination, is commonly distinguished from its inverse—"not political"—rather than serving to denote specific content in its own right. When the imagination is described as "political," it is usually in order to differentiate it from non-political forms of the imagination. For some, "the political" is a positive attribute. For others, who routinely subscribe to the syntax of sentences like: "One should not mix x with politics," the attribute is threatening. The "political" or the "politicization" of specific issues—typically, the expression of interest in the rights of others or in the righting of injustice—is often perceived in public discourse to be the domain of those who insist on talking about politically contentious issues: a form of expression associated with killjoys. The power of this opposition—political/not-political—is so extensive that all who use it, whether those who seek to uphold it or those who seek to disrupt it, acquiesce in the lines of demarcation that it produces. The repositioning of expressions of concern for the rights of others or concern over forms of injustice as a "political" matter, that is to say, as something that is unworthy of the attention of citizens, is one of the most forceful expressions of the complete transformation of "the civil" into "the political" whose stranglehold this volume seeks to break.

This book suggests that the civil must be separated from the political and defined in its own right as the interest that citizens display in themselves, in others, in their shared forms of coexistence, as well as in the world that they create and nurture. In order to make room for the return of the category of the civil, and for the place of the civil imagination within it, it is necessary to redefine the political imagination.[5] I propose we term "political imagination" that form of imagination that exceeds the grasp of the individual mind—it is a form of imagination that transcends the single individual alone and exists *between* individuals and is shared by them. The political nature of this imagination is not a function of the field of reference in relation to which it is activated—that is to say, does not emanate from its positioning vis-à-vis what is identified as political. Rather its political status stems from the sheer fact that fruits of the imagination are exchanged between people, emerge into existence between them, take on different concrete forms and play a role in the shaping of their lives. Questions such as whether schools, household economies or the market belong within the sphere of the political or whether they exist in the private domain cannot determine the political nature—and meaning—of the political imagination. The description of the imagination as political is an ontological description that presents it as the shared experience of human beings. One can see the political imagination at work in different

historical events. It is evident in situations that have been naturalized as conventional and routine for us: the cutting open of the living human body and its re-suturing without the loss of life; the incarceration of women, each in her highly accessorized kitchen; or the public transmission of portraits of individuals disseminated through the world in a manner not dependent on the presence of these individuals themselves. Although the private imagination of different people plays a role in the evolution of techniques that allow imagination to take material shape in the world, the very ability to imagine innovative states and to make them a natural part of our shared world results from the political imagination and is the product of its shared nature: common to many and frequently tied to the existence of a commons, that is to say—held in and by a public.

The beheading of Louis XVI as it occurred in La Place de la Révolution (formerly La Place de Louis XV and presently La Place de la Concorde) to the sounds of the drumbeats of sixty drummers, under the gaze of thousands of soldiers and before the masses assembled there, is not the fruit of individual imagination. Even if we were to imagine that those responsible for the execution had written precise instructions for its implementation, instructions which resulted with great exactitude in the familiar image of this event as depicted in scores of illustrations, these instructions are not the source of the political imagination that lead to the beheading of Louis XVI. In much the same way, its source is not to be found in the work of any individual politician, physician or philosopher, or in the text of any single pamphlet. The imagination that led to the beheading of the monarch did not germinate in an individual consciousness alone. Nor did it come into being in a single day. On the contrary, this specific imagining circulated among individuals, changing shape and form as it did so. At times it took on the form of the guillotine whose innovation lay in that it reduced the suffering of the executed. At other times, it shifted nervously between alternatives; brought the notion of the general will into being; rested awhile. It concealed itself for a certain period under the cloak of the Committee for Public Safety, but also stirred agents to action under the cover of darkness. It enflamed the masses in the streets; skewered the heads of the aristocracy; suppressed all those who differed from it; constrained the conceptual horizons of its followers, and then again, sometimes liberated them from these constraints in the course of time. It mobilized those of its followers who perceived in it the potential for something still latent and, in short, led speech, gaze and action to places as yet unknown in making the disembodied image real, in transforming the idea of a political space devoid of a monarch—fruit of this very imagination—into reality. By this time, all that was necessary

was the work of a handful of operatives to realize the vision, executors of the imagination.

For the most part, the imagination leaves its imprints on history when it breaks boundaries. The accepted understanding of the term "political imagination" has, in fact, become synonymous with just such a breaking of the boundaries of the imagination. Few among us would, if at all, dare to weave such transformative events together into a narrative of progress when the debris of ruin is visible in every quarter. The rebuke emanating from philosophical texts dating from the eighteenth century onward on the part of thinkers such as Voltaire, Olympe de Gouges, L'Abbé de Raynal, Theodor Adorno, Walter Benjamin or Hannah Arendt, has not prevented the nightmare from taking shape. But it has made it more difficult to write the history of culture without taking the barbarity necessary for its inception into account, to one extent or another. Despite the voices of such critics, however, it is evident that the cumulative weight of discrete historical events has, over the years, rendered them landmarks without which "we" would not have achieved "our" right to political determination. We are encouraged to separate our criticism of these events from the consensus that has come into being concerning their value and importance, thus also forgetting the role that they have played in generating atrocity ever since "the people" achieved their sovereignty. The master narrative that organizes their coherence seduces us into believing that we are citizens—male and female citizens. The beheading of the monarch is paradigmatic of the type of event to which I am referring. Its representation today is not very distant from that which Robespierre devised shortly after the execution: "Louis must die in order for the motherland to live." The elimination of the monarch in 1793 was the precondition for the birth of the political homeland of citizens—the republic—which was supposed to replace and to triumph over the monarchy, itself constructed retroactively as a pre-political space, a special form of natural phenomenon from which liberation must be sought in order to prevent the ultimate war, all against all.

Over time, the need to eliminate the monarch has been replaced with the call to eliminate the son of his son—figured in the guise of terror, fundamentalism (always the fundamentalism of the other), fascism or communism—all of which are depicted as a permanent threat to democratic regimes. If they are allowed to emerge or if they return, we are told, then the democratic order will be terminated. Woe betide all citizens of democracy! It is thus that our political existence is constrained by two alternatives that do not seem to leave us with any choice if we seek to remain within the domain of the political. When the options range between

republicanism and monarchy, between democracy and totalitarianism, between enlightenment and fundamentalism, between capitalism and communism, and between the sovereignty of the state and terror, then the choice between them is self-evident, however much it might be a decision to prefer the lesser of two evils. If this were not in itself sufficient, citizens typically rally around regimes seeking to destroy a supposed threat and are willing to pay the price of sacrificing a portion of the attributes of the democratic regime itself—a sacrifice always presented as justified. The threat that must be eliminated is never external to the regime: it never threatens from without. Rather it is represented as internal to the very foundations of democracy. So it is effectively this internal threat that allows for the preservation of the sovereignty of the regime over the populations subjected to it—a regime that divides between populations marshaling the authority to act on the basis of the consent only of those among the governed who recognize its sovereignty, or who are designated by it as subject to this very sovereignty.

This system of oppositions, formulated at the end of the eighteenth century when the few voices not bound by its logic—that is, neither republican nor monarchist—were eliminated, has not relaxed its grip to this day. It still permeates political thought that finds it difficult to see beyond these two alternatives, where the state of being subject to rule is a constant and obvious component of each. The meaning that has become attached to concepts like "the political" and "politicization," under the patronage of the critical thought that emerged toward the end of the last century, represents an attempt to evade the grasp of these oppositions. For the most part, however, critical thought remains itself caught within two traps that this volume seeks to evade. The first is contingent on what I term below "the political judgment of taste": that formula which determines whether a phenomenon, state or product is political or not, and which ascribes to individuals the power to politicize or to de-politicize all related phenomena, states or products. The second trap is subsumed within the attempt to reformulate the "political" as a certain relation vis-à-vis power, a relation of negotiation, of subversion, of challenge or disruption.

The figure of the citizen that we have inherited from the eighteenth century, the selfsame citizen who supposedly stormed the fortress of the political imagination and thus achieved privileges that generation upon generation before him did not enjoy, is a citizen whose political horizon is blocked by the two-headed creature constructed from the will of the people on the one hand, and from sovereignty on the other. The combination of these two elements created the nation-state as a kind of war-machine, which has once again subjugated citizens by rendering them subjects

compelled to put the priorities of its defense ahead of their own civil needs and concerns. Thus, instead of citizenship limiting the power of the state, preventing its sovereign power from untrammeled frenzy and circumscribing the will of the people so that the latter does not supplant the place of the citizenry of citizens, citizenship has become emaciated and devoid of imagination. It is possible to view citizenship as itself subject to the repressive and dictatorial derivations of the imagination whose language is the only language it is capable of speaking. Once the civil horizon of the citizen is limited by the nation-state, by democratic sovereignty or by the will of the people, the citizen shaped by the French Revolution who retains his contours into the present cannot help but conceive of himself as citizen. This citizen finds it difficult to imagine what it is not to be a citizen or what it is to be a second-class citizen ruled together with him under the category of citizenship. This failure of the imagination is neither coincidental nor does it reflect the shortcomings of one or another specific individual. It is a structural failure that expresses the inversion of the relations between the citizen and power that is a feature of democratic sovereignty—instead of power being subject to citizens, citizens are now subject to power. In their inability to imagine other sections of the governed as citizens, or alternatively, in acquiescing with the fact that other segments of the governed are defined as non-citizens, citizens are ventriloquized by the regime and by its interests, which seem to speak from their throats. Political imagination is insufficient to enable us to imagine the non-citizen or second-class citizen as citizen: civil imagination is also needed. The chapters that follow will proceed to delineate civil imagination in action.

The first section of the book presents a discussion of the political ontology of photography. Here, I treat the photograph as a special event that takes place in two modes: in relation to the camera and in relation to the photograph. The discussion proceeds with reference to two archival exhibitions I curated, "Act of State" and "Constituent Violence." My work on these exhibitions afforded me the opportunity to develop more extensively some of the understanding I first outlined in my previous book, *The Civil Contract of Photography,* and to apply them in practice with respect to the archival corpora. The second section analyzes the judgment of taste commonly expressed in the formula "This is (is not) political." This formula frequently arises in political and critical discussions as well as in the discourses of art and photography. My analysis examines the manner in which this judgment of taste constrains our conception of the political existence of human subjects. I point to the castrating effect of this judgment of taste on the specific domain of photography, which I see as a

privileged site for the generation of a civil discourse. Suspending the judgment ("This is/is not political") enables me to treat the full spectrum of shared human life as political and to formulate a new discourse concerning civil intention as a special form of agency within it. Hannah Arendt accompanies me in my foray into the province of civil existence and I use her thinking to generate new horizons of political thought in which power and sovereignty do not necessarily hold center stage. My use of Arendt facilitates a movement beyond the dictates of the judgment "This is political," although her work is admittedly still bound to this formulation in certain respects.

The third chapter of the book comprises a photo essay that interrogates the question *What is house destruction?* This investigation is based on the assumption that photographs, including those taken by the military, are a valuable source for the generation of a new form of knowledge that I term "civil knowledge." In this turn of the argument, I make claims in favor of what is generally posited as the unreliability of the photograph, that is to say, its partial, false, biased or contingent nature. These designations arise, I contend, because it is impossible to attribute a single sovereign perspective to the photograph, and because what it depicts—its reference—is in at least as much need of specification as is the interpretation that is given to it. This insight brings me to the fourth chapter, where I set out civil uses of the features of photography through staging an implicit contrast between photographs that exist and those never taken. My intention here is to undermine the identification between the indexical function of the photograph and its status as representation. My intervention distinguishes between the event of photography and the photographed event and shows the necessity of addressing a body of photographs that has never come into being with specific reference to the rape of Palestinian women by Jewish soldiers close to the period of the establishment of the state of Israel.

CHAPTER 1

WHAT IS PHOTOGRAPHY?

The Ontological Question

The most frequent response to the above question—What is photography?—is latent in the etymology of its name and recurs from the very inception of photography until the present, or at least until the advent of digital photography. In this etymology, photography is a "notation in light." Writing in light is what transpires when the camera shutter opens and light rays, reflected off that which stands in front of the camera, penetrate the lens and are inscribed upon a certain surface.[1] Henry Fox Talbot, one of the inventors of the technology known as photography, also known by other names such as the "calotype" or the "talbotype" at this time, underscored this characterization of photography in the title of his book, *The Pencil of Nature*, published in 1844.[2] Talbot directed our attention to the question of agency, which distinguishes photography from previous methods of image production. In the place of an individual artists possessed of certain talents and aptitudes, nature now inscribes itself by itself. The term "nature" serves Talbot as a general designation for the referent of the image. Predictably, it gave rise to criticism among those seeking to explicate photography, not because of the use that Talbot made of the word "nature," but because of his elimination of the human agent and his presentation of photography as a medium for the production of images without human intervention.[3] However, Talbot, a photographer whose work features in this book, did not in fact seek to eliminate the human agent.[4] He sought instead to offer an alternative description to the prevailing notion of the omnipotent creator who with the stroke of his brush translates his object of reference into an image possessing a certain impact. Talbot's description moves the emphasis away from the owners of the means of production and points to the potential latent in the capacity of the new technology to deviate from the familiar forms of image

production, which assumed a singular author.[5] His position was, however, misunderstood, as if all that was at stake in his discussion was a technology that seems to act in its own right. His opponents differed from one another yet shared a common motivation: to undermine the assumption that the "pencil" could direct itself. There were those who saw photography as an unreliable medium and the photographer as constantly manipulating reality through the photograph so as to reflect his or her biased point of view. On the other hand, there were others, eager to preserve the photographer's prestige, who insisted that its unique contribution—its artistry—did not result from the technical activation of the apparatus. While the debate raged, a growing number of enthusiasts and technicians of photography continued to make use of photography as photographers, as photographed persons, and as spectators of different fields of knowledge and action. Until the shift occasioned by the development of visual culture as an academic discipline during the last two decades of the twentieth century, however, the contributions of such amateurs were not deemed worthy of investigation, nor of conceptualization as an integral part of the practice of photography.

Talbot's stance, which undermined the status of the author of the photograph, eventually lost its advocates. What was left of this position in a debate that slowly receded was Talbot's emphasis on technology. Certain adherents of Talbot's position investigated the technology in their own right, but they did not present the technology of photography as functioning autonomously, seeing it instead as a form of technology operated by the photographer. The distance between the two opposing forms of objection to Talbot's position diminished until they could no longer be termed oppositional at all. Thus, for approximately 150 years, photography was conceptualized from the perspective of the individual positioned behind the lens—the one who sees the world, shapes it into a photograph of his own creation, and displays it to others. Paradoxically, something of the position that Talbot originally represented, devoid of defenders for a long period of time, emerged in the form of a kind of primitive poetic residue distilled from the arguments of his opponents, as in Roland Barthes' celebrated notion of the "punctum," for instance. Barthes sought to use the notion of the punctum to undermine the centrality of the singular photographer, the uncontested ruler of what Barthes terms the "studium" of the photograph, where the punctum figures as a kind of residue neglected by the photographer.

The emaciation of the ontological perspective latent in the title of Talbot's book and the narrowing of his argument by his opponents, or those who pretended to argue with it so as to make it encompass merely

those aspects of photography that rendered it an autonomous technology, enabled, in turn, the emergence of a no less reductive position—one centering this time around the subject who commands the technology of photography like clay in the hands of the potter. Research into the technology of photography saw the ontology of photography in this light, whereas research into photographic oeuvres and their creators, modeled on the familiar protocols of art or the history of art, took the place of the political question: What characterizes the new relations that emerge between people through the mediation of photography? In both instances, from the moment that photography began to be diffused in the world, it was seen as a discrete technology possessing a clear purpose—the production of images—and it was delineated as a circumscribed technology whose field of action is subjugated to the activating gesture of its users.

These were the conventional boundaries within which it was possible to think about photography until the end of the twentieth century: a technology for the production of images operated by a singular subject—technician, creator or manipulator.[6] Admittedly, the fact that photography deviated from its predecessors was not overlooked: this is precisely what is central to Talbot's position—that which is positioned *in front* of the lens "was there" and is inscribed in and of itself on a surface coated with some kind of chemical. But very few thinkers exploited the radicalism of the insight or dared to think through the tradition of image production in a critical fashion. Among them, we may number Walter Benjamin, who associated photography with forms of mechanical reproduction rather than with drawing and who described the shift entailed in the perceptual system by the advent of photography. Another voice in this trajectory is that of Thierry de Duve whose discussion of the tube of industrial paint surprisingly links painting to the tradition of technology, and sees it from this industrial perspective as the forerunner of photography. But even these dissident thinkers were not fully able to undermine the productive/creative framework that continued to organize thought concerning photography.

It is difficult, perhaps even incorrect, to point to a specific moment or event responsible for overturning the canonical framework of the discourse of photography. But it is easy to point to a series of actions that demonstrate that this framework has recently been ruptured, allowing new questions such as "What is a photograph?" to surface and to elicit answers. Tens of exhibitions, Internet forums, conferences and journals have, over the last twenty years, celebrated photography as a phenomenon of plurality, deterritorialization and decentralization. Photographic archives that

had been collecting dust for years in psychiatric hospitals, prisons, state and municipal institutions, hospitals, interrogation facilities, family collections or police files, unremarked upon by scholars of photography, as well as the notion and institution of the archive itself instantaneously became a privileged object for research and public exhibition.[7] The wealth and variety contained in these collections transformed the canonical discourse on photography, a discourse that had emerged in the shadow of the discourse of art that consecrated sovereign creators and that considered photography from the perspective of its creators alone. In the wake of this shift, the perspective associated with the discourse of art was transformed into merely one possible point of entry into the study of photography, and a particularly limited one at that. It is only fair to point out that the limitations with which I am concerned here characterize a certain type of *discourse about* photography, rather than the practice of photography itself, whose actual activities deviated markedly from the rarefied practice conceptualized and presented as the corpus of photography; just as what was photographed always exceeded the constructs that sought to contain them as the object of reference. The many users of photography, only a small portion of whom operated under the patronage of the canonical discourse on photography, never ceased inventing new forms of being with others through photography. After the shift in photographic interest, some commentators began to address the emergence of such practices, although for the most part their output still tended to remain derivative of the products they investigated, that is to say, bound to the particular photographs accumulated. The photographs themselves continued to set the boundaries of the discussion of photography and allowed for the preservation of the causal connections between the action of photography and the photograph. In other words, photography remained conditional on the existence of the photograph. For my own part, I would like to base myself on the unprecedented wealth of photographs that emerged into view once the boundaries of the discourse on photography had been ruptured, in order to demonstrate that the ontology of photography is, fundamentally, political.

As I have already stated, until the shift of boundaries outlined above, photography was conceptualized as a technology that allowed for the inscription of an image in light, while at the same time, the very technology itself was assumed to remain transparent without leaving its imprint on the final product. The coherence of such a description requires that photography be placed at the service of two masters—the photographer who employs it and the photograph that is the end goal of his activity, while all other traces are eliminated from the final product. When these

traces persisted as visible imprint, nevertheless, their sheer presence was enough to disqualify the photograph or the photographer. Few practitioners in the past sought to foreground such traces, but early examples of such foregrounding do exist. In recent decades, ever since technological mediation began to become visible, it was no longer possible to conceive of the technology as external and separate from the product that produced it. It was now a relatively short path to the recognition that the technology of photography is not just operated by people but that it also operates upon them. The camera was no longer just seen as a tool in the hands of its user, but as an object that creates powerful forms of commotion and communion. The camera generates events other than the photographs anticipated as coming into being through its mediation, and the latter are not necessarily subject to the full control of the agent who holds the camera. The properties and nature of the camera could now suddenly emerge into public view, and it rapidly became apparent that the camera possesses its own character and drives. The camera might, at times, appear to be obedient, but it is also capable of being cunning, seductive, conciliatory, vengeful or friendly. It can be woefully unarmed with information, can magnify the achievements of amateurs, and can destroy the work of

Lemon cameras, negative 4×5 B/W, 5×4 box, perforated black cardboard. Photograph by Aïm Deüelle Lüski. Tel Aviv Museum Collection, 1977

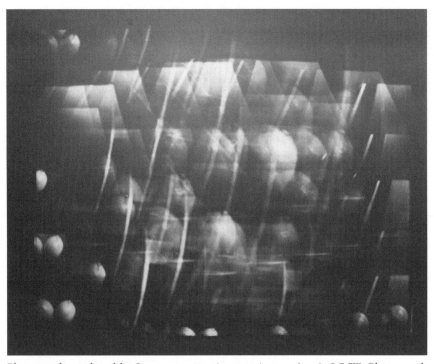

Photograph produced by Lemon camera (concave), negative 4×5 B/W. Photograph by Aïm Deüelle Lüski. Tel Aviv Museum Collection, 1977

master craftsmen. The camera is an opaque tool that does not expose anything of its inner workings. It is difficult for anyone who sees it from the outside in real time to know what it is inscribing, if it is indeed inscribing anything at all. Similarly, it is difficult to establish with any certainty whether the camera is present or absent, whether it is switched on or off, whether it is indeed producing images when it is switched on, whether this is its only effect, or whether its goal might, among other things, consist precisely in hiding its very agency. Does the camera appear to be active when it is actually dormant, or does it create dormancy while actually operating or better still, while being operated? Rather than being considered a device whose presence was totally occluded in favor of its products, which themselves circumscribed the boundaries of the gaze restricting it to the circumference of the frame, the camera—and together with it, the act of photography—now assumed the status of a significant catalyst of events only part of whose impact was contained in the possibility or threat of a writing in light.

The appearance of photography as the object of the gaze made a mockery of the simplistic opposition that had prevailed in the discourse on photography between the device and the subject wielding it, allowing

Photograph produced by Lemon camera (convex), negative 4×5 B/W. Photograph by Aïm Deüelle Lüski. Tel Aviv Museum Collection, 1977

for other possibilities to emerge that have been latent in photography from its inception, such as those intimated in Talbot's own *Pencil of Nature*. The pencil (read "camera") of nature could now be positioned differently—not as a device that wrote itself by itself, nor even as one wielded by the author who used it to produce pictures of other people. Rather, the pencil of nature could be seen as an inscribing machine that transforms the encounter that comes into being around it, through it and by means of its mediation, into a special form of encounter between participants where none of them possesses a sovereign status. In this encounter, in a structured fashion and despite the threat of disruption, the pencil of nature, for the most part, produces a visual protocol immune to the complete domination of any one of the participants in the encounter and to their possible claim for sovereignty. It is precisely this understanding that I would like to extrapolate from Talbot's notion of the "pencil of nature" working *in its own right*. Human subjects, occupying different roles in the event of photography, do play one or another part in it, but the encounter between them is never entirely in the sole control of any one of them: no one is the sole signatory to the event of photography. In seeking thus to revise the notion of photography, it is clear that an

ontological investigation of photography cannot concern itself with the technology of the camera alone. Nor can it be restricted to an investigation of the "final" product created by the camera, that is to say, the photograph. In other words, an ontological description of photography has to suspend the simple syntax of the sentence divided into subject, verb, predicate and adjective—*photographer photographs a photograph with a camera*—which has organized the discussion of photography for so long and which has gravely circumscribed that which is to be deemed relevant to a discussion of photography.

The ontology of photography that I seek to promote is, in fact, a political ontology—an ontology of the many, operating in public, in motion. It is an ontology bound to the manner in which human beings exist—look, talk, act—with one another and *with objects*. At the same time, these subjects appear as the referents of speech, of the gaze and of the actions of others. My intention here is not to lay out an ontology of the political *per se*. It is, rather, to delineate the political ontology of photography. By this I mean an ontology of a certain form of human being-with-others in which the camera or the photograph are implicated. Neither the camera nor the photograph are sufficient to allow us to answer the question, "What is photography," but without describing them as part of the political ontology I am setting forth, it will be difficult for us to reach reasonable conclusions.

The Camera

The camera is a relatively small box designed to produce images from that which is visible through a lens positioned in its front. It goes almost without saying that until the invention of the digital camera equipped with a screen, we were unable fully to perceive evidence of this capacity while the camera was in use, not to mention when it was turned off. At best we could merely invest the camera with such a capacity. When we encounter the camera, it is enough for it to be raised, or to be angled in a certain position in order to signal that it is directed at us or at others. This positioning itself carves up space between the person standing in front of the camera and the one standing behind it. The raised camera poses the threat of observing us, but it also observes us without our necessarily being aware of it. The camera can always respond to the temptation of observing us and of inscribing that which other spectators pass over without photographing or without so much as registering at all. Admittedly, the camera usually serves an individual. But it is increasingly put to use in situations where it no longer stands alone but appears alongside other

cameras, intersects them, acts upon them and is acted upon by them. What is at stake in this context is a physical intersection, if often also an imaginary one, which occurs in real time but may also occur after the fact in cases where we identify places and people in photographs whom we recognize to have been in the same space as ourselves, sometimes even at the same time, together with or alongside still more individuals wielding cameras.

The number of cameras in circulation in the world is growing ceaselessly while the number of people not exposed to their presence is steadily diminishing. Even if the distribution of cameras is not constant from one geographical area to another, and even if there are zones, like disaster zones for instance, where the subjects of disaster are sentenced to be photographed rather than to photograph themselves, the omnipresence of the camera is a growing potential. The increased number of cameras together with their increased potential presence all over enables the camera to operate, as it were, even when it is not physically present, by virtue of the doubt that exists with respect to its overt or covert presence, its capacities for inscription and surveillance. There are no accurate estimates concerning the density of the distribution of cameras in various sites nor concerning their effects when they are trained upon us or, conversely, concerning their influence when they are not in use. But it is easy to surmise that these influences are just as considerable in their effect as is the formal productive capacity of the camera, that is to say, the capacity to produce pictures. One of the most obvious of these effects is the camera's ability to create a commotion in an environment merely by being there—the camera can draw certain happenings to itself as if with a magnet, or even bring them into being, while it can also distance events, disrupt them or prevent them from occurring. The camera has the capacity through its sheer presence to set all of these effects in motion without even taking a single shot. Nor are such influences contingent on the actual pictures produced. We mostly encounter cameras in a state of temporary rest. But even when we see them in action, we seldom have the ability to track the images that they produce, with the exception of the one or two cameras we might own or which might belong to our relatives. In this respect, despite the growth in the diffusion of cameras, most of us do not have the privilege of seeing the images they produce. Conversely, the majority of the many photographs we see every day appear devoid of any connection to the camera that might have photographed them. In most cases, we are not the photographed persons in these photographs and are consequently not perturbed by the possibility of their circulation. But in places where people are irredeemably exposed to the practice of photography, such as disaster zones, the photographs that are not on show are

generally of the people who live in that location. For many such individuals, this is the very essence of photography. The camera is a tool that promises a picture that they will never see. Thus for instance, the woman in the picture who stands outside her home because it has been destroyed is exposed to two cameras at least: one that has produced the image that we observe and another that we can see to be in the possession of the female photographer standing toward the right-hand side of the frame. We can assume that the woman whose house has been destroyed surmises that she and her ruined house have been photographed but she will probably never see the image that results. From her perspective as a participant in the event of photography, the act of photography cannot be summarized in a photograph. Photography might rather consist for her in something like the presence of the camera in front of her, in her face as it were, during the time of her emergency. We, observing her photograph, attest to the fact that a photograph arose from this encounter—here she is in front of us—but there is another camera in front of us as well, whose products we do not see, and which we might perhaps never see, like the woman in the photograph. It is possible that nobody will see them, just as it is possible that the camera wielded by the woman who appears in the frame did not take any shots at all. Her location in a disaster zone notwithstanding, it is not inconceivable that the mere fact of the photographer's presence there is sufficient—even if her camera remains barren of images.

Jerusalem. Photograph by Anne Paq. Activestills.org, 2007

In other words, the event that the camera sets in motion does not necessarily result in a photograph. When it does so, the events unfolding in the wake of the photograph will, for the most part, take place in another location altogether. By virtue of the photographs, or sometimes by virtue of their absence, different people will congregate in their wake than those who met in the immediate vicinity of the camera. Both sets of participants will seek to observe the photograph even as it, or the sheer fact of its existence, ineluctably affects them all.

This being the case, in order to understand the question "What is photography" under the conditions outlined here in brief, I seek to differentiate between the *event of photography* and the *photographed event* that the photographer seeks to capture in his frame (I will elaborate on these terms in greater detail below). Both the camera and the event that it catalyzes are, for the most part, restricted by the skilled gaze of the spectator in order to see the "thing itself," that is to say, that which will become the photographed event. But the rendering marginal of the event of photography, displays of indifference toward it or even the attempt to ignore it altogether, can never obliterate its existence or the traces that this event which occurs between the various partners of the act of photography leaves on the photographed frame, especially when the camera present on site was actually set to work. In other cases where something or someone else stands explicitly in the path of the agent who wields the camera (that is to say, the photographer or someone who has commissioned the photographer), so as to prevent the photographer from framing the shot as he or she desires, it is much easier to use the photograph to decipher the event of photography and to perceive the presence of the camera within the photographed event. Photographs that foreground precisely a "disruption" of this sort have become increasingly common over the course of the last two decades. The traces to which I have been referring, which are not the stated goal of the act of photography, are regulated within the schema of the frame, blunting their presence and allowing the photographed event to be foregrounded as one that has already been concluded. The construction of the event of photography as prior and external to the spectator is not just a technological effect of the type that Aïm Deüelle Lüski terms "the mono-focal camera" in his discussion of photography.[8] Nor is this a necessary effect of such mono-focalism. Rather it is the outcome of a form of discourse whose logic of sovereignty and creativity predispose it to position the photograph as the sole outcome and vanishing point of any discussion of photography.

Biddu checkpoint. Photograph by Miki Kratsman. 2002

Not all the participants in the event of photography play a role within it in the same fashion. Many are not even aware of its existence, not to mention the temporality of its unfolding. Similarly, not all of its participants are able—or are permitted—to view the product that is the outcome of the event, when indeed there is such an outcome. Moreover, those who are permitted to view the final product are not necessarily permitted to use it in the same way. In this context, I would like to make a bold claim, however, and to argue that, in the contemporary era, when the means of photography are in the reach of so many, photography always constitutes a *potential event*, even in cases where the camera is invisible or when it is not present at all. The absence of a camera in the field of vision of those present does not evacuate the possibility of its being there—secreted invisibly in the hands of one of the participants perhaps, or installed permanently as is the case with surveillance cameras. In some cases, it is not even necessary for the camera to be present in order for it to influence people and to organize the relations between them. The event of photography thus contains within itself the potentially penetrating effect of the camera, that is to say, the possibility of our being located with the range of "vision" of a camera that might potentially record a photograph of us. It is a possibility that may well be experienced differently by the various participants as irritating, pleasurable, threatening, invasive, repressive, conciliatory or even reassuring.

The Photograph

The photograph is usually thought of as the final product of an event.[9] In contradistinction to this common assumption, I see the photograph—or the knowledge that a photograph has been produced—as an additional factor in the unfolding of the event of photography (not of the photographed event). The encounter with the photograph continues the event of photography that happened elsewhere. When an interrogator in an interrogation cell tells a detainee that he has a photograph showing the detainee in such or such a situation, the interrogator does not necessarily reveal the photograph to the detainee—if it exists at all. He conducts himself as someone who simply derives his authority from the prior event of photography, which happened elsewhere and which he merely continues. In fact, however, he generates this event in order to put pressure on the prisoner.[10] In such a case, the event of photography can be said to take place in the absence of both camera and photograph. It occurs as the outcome of the interrogator's statement that he possesses a photograph. The fact that the majority of people photographed under such conditions never see photographs of the event of photography in which they participated, on the one hand; and that most spectators, on the other hand, routinely view photographs taken during the course of an event in which they did not participate, creates the conditions under which the mere possibility of the existence of a photograph of us taken without our knowledge might come to affect us with as much potency as if we had encountered the photograph itself. The fact that participants may not observe the photograph in which they played a role does not annul the event of photography nor does it annul the possibility that this event might continue to be played out in another time and place in a manner that is not contingent upon them at all.

The photograph, as I will demonstrate at length in the second chapter of this book, has become institutionalized in discourse through its identification with the photographer, as his or her property, and as the point of origin of the discussion of photography. As a result of this, when the photographer refuses to share a photograph with the public, or when a photograph is not available for other reasons, no discussion of photography is forthcoming. The inaccessibility of the photograph, which might result from the fact that no shots were taken at all, or from the possibility that the holder of the photograph derives pleasure, power or capital from the monopoly that he possesses in relation to it, effectively eliminates the very possibility of discussing the event of photography. This privilege that accrues to the photograph, which has made it a precondition for any discussion of photography, imposes

a form of sovereignty on the event of photography that is essentially foreign that contradict unity and centralization and that deterritorialize various boundaries. This illegitimate sovereignty is based on two principles: the rendering of the photograph into a form of testimony that pertains solely to that which was positioned in front of the lens so as to say *"This* is X," as if it were possible to cut the event generating the photograph into two; and the identification of ownership of the means of production of photography with ownership of the photograph as such, so that its "owner" will be possessed with the sole authority to determine who, what, how, when and if at all the event of photography continues to unfold. Yet it must be stated that even if this sovereign regime threatens to dominate photography, it always remains circumscribed, limited, and temporary.

The reconstruction of the ontology of photography, subject to the new boundaries within which I delineate photography, requires that we suspend patterns of photographic use as they have been institutionalized over the course of the years as constituting the essence of photography. The separation between the ontology of photography and the ontology of the photograph allows us to see the photograph as merely one possible outcome among others of the event of photography, just as we can hold the evidence of other participants in this event to constitute additional sources for its reconstruction. Without the testimony of prisoners photographed during the course of detention, or without the testimony of non-citizens whose photographs are used by the Israeli security services to blackmail them, among other things in order to recruit them as so-called "collaborators," the possibility of reconstructing the event of photography in which they have participated is slender if not non-existent. This is a consequence of the fact that photographs taken during the course of any given event, if they exist at all, are usually held by the security forces and are removed from the grasp of other participants in the event of photography.

The photograph is a platform upon which traces from the encounter between those present in the situation of photography are inscribed, whether the participants are present by choice, through force, knowingly, indifferently, as a result of being overlooked or as a consequence of deceit. Many of these traces are neither planned nor are they the result of an act of will. That which is seen, the referent of the photograph in other words, is never a given but needs to be constituted to precisely the same degree as the interpretations that have become attached to it. Even when these traces express cultural and social hierarchies that organize the power relations between photographer, camera, and photographed person, they never simply echo such relations nor do they necessarily reflect the point of view of the most powerful figure present in the arena at the time the photograph was

captured. This characteristic differentiates the photograph from all other forms of documentation that we know, and renders it a powerful and suggestive source for understanding the political existence of human beings, as well as for investigating their history. But, marvelous as this seems, most historians do not accord the photograph the status of document—something that is very visible in the local context out of which I write. They argue their position strenuously in the volumes they author—they do not see the photograph as a source for historical research. Until recently, the question did not so much as arise among the community of scholars writing about political thought. The photograph is partial, fallacious, random, biased—these are only a few of the appellations that have become attached to photographs and that underpin the renunciation of the act of contemplating them. In contexts where photographs are the subject of more active treatment, in the press, or in historical archives and museums for instance, photographs are displayed or stored as references to the photographed event, there to be retrieved and re-circulated time and time again in accordance with relatively simple but problematic semiotic codes evident in the tagging that is so characteristic of archives: "firing squad" for instance, or "a new residential area." Thus far, scant attention has been devoted to the role of viewing in the event of photography where it is responsible for the always unfinished nature of this event. The position of the spectator is one that any subject can hold at any given moment, whether or not she is photographer or photographed. The overemphasis on the role of the photographer and the lack of weight attributed to that of the spectator are derived from the prevailing but erroneous conceptualization of photography in terms of sealing off a certain instant framed by the photographer who observes it and who witnesses it from the outside, of freezing this instant or sealing it in death before sharing it with those who observe his or her testimony. But a photograph is never the testimony of the photographer alone, and the event of photography, unlike the photographed event, continues to exist despite all other considerations. The preservation of rigid binaries between "inside" and "outside," in terms where that which can be seen is that which was present before the lens at the moment of the capture of a shot that has now been inscribed as a photograph presented in turn to the scrutiny of spectators external to the event, represents a misunderstanding of both photography and of the photograph alike. The event of photography is never over. It can only be suspended, caught in the anticipation of the next encounter that will allow for its actualization: an encounter that might allow a certain spectator to remark on the excess or lack inscribed in the photograph so as to re-articulate every detail including those that some believe to be fixed in place by the glossy emulsion of the photograph.

The Event of Photography

What, then, is photography? Photography is an event. What kind of event is photography? It is clearly not possible to describe it as a kind of interruption of, or deviation from, existing flows, which brings something new into being, as certain theoretical discourses, particularly in France, would see the event. The event of photography is subject to a unique form of temporality—it is made up of an infinite series of encounters. The event of photography has two different modalities of eventness—the first occurs in relation to the camera or in relation to its hypothetical presence while the second occurs in relation to the photograph or in relation to the latter's hypothetical existence. For the most part, these two events unfold in different places at different times such that the continuity between them is not noted nor is the necessity of its reconstruction posed as a problem. The multiplicity of events with which we are concerned as well as the separateness of their unfolding render linear sequentiality between the event surrounding the camera on the one hand, and the event surrounding the photograph on the other, into merely one possible relation between them. The connection between the two is closer to the connection between two constituents of a mathematical equation where one side of the formula cannot resolve the other without establishing the numerical value that will concretize the equivalence between them. We encounter one or another of the constituent events of the event of photography without necessarily encountering them in chronological order. Whatever the case, the moment we attempt to unravel the connection between them, we immediately become aware of the hidden variables in the equation. As is the case with the mathematical formula, it is possible to reconstruct some of these hidden variables based on what is given on one side of the equation, but it is not always interesting, nor the point, to reconstruct the sequence linking the different parts, nor to attempt to unravel a hidden variable. These considerations are not always what is really at stake. Often the reason for a variable's remaining hidden is negligible and circumstantial, or is bound up with amnesia or the seeping away of information. But it can also result from a local or structural shortsightedness, or might derive from a mistaken understanding of the act of photography and the power relations it subsumes. There are circumstances, however, where the oversight is intended, programmatic or malicious—the result of one participant's attempted domination of the event of photography with respect to that which might possibly be considered to be his property but should be considered to belong in some other manner to the public at large. When

one of the participants in the event of photography takes sole control over a variable, he effectively designates himself sovereign by virtue of this very control, given that his actions not only affect the photographic object—as property—but affect all of the people involved in its production.

The event of photography is also unique with respect to the fact that the camera, the photograph, or their hypothetical existence, inscribe a certain inalienable point of view in arenas where people encounter one another—one that cannot be expunged. Such a point of view is very particular: it is other, foreign, opaque, a point of view that nobody can identify with, embody, merge with, or become its ally. This point of view persists in its sustained opacity, threatening to inscribe the event somehow, as well as to exhibit the resultant inscription, including the inscription of that which is irreducible to the individual point of view of any of the participants. What is at stake is not a point of view that can be assimilated to any sovereign or regulating source possessed of omniscience and capable of extending its reach to that which, or those who, threaten its power and unity. On the contrary, this point of view cannot be appropriated. It can be assimilated neither to ownership nor to domination. It evades all forms of sovereignty such that no one can argue that it belongs to him or that she embodies it; just as no one can fully obliterate or erase it completely and for all time and by so doing, impose upon others longstanding relations of repression and domination, or reified contractual relations. Rather such relations have the power to be inscribed in the event of photography as well as in the conditions that organize or prevent free access to the photograph and to the opportunity of "solving" the equation and reconstructing its constituents. With the assistance of the spectator, the point of view under consideration here permits the event of photography to be preserved as one bearing the potential for permanent renewal that undermines any attempt to terminate it or to proclaim that it has reached its end. The notion of a closure is overthrown thanks to the agency of the spectator, and its groundlessness is revealed, while the spectator, for her part, participates in realizing the potential inherent in the act of photography, capable of complete or partial concretization at any given moment, at any instant and on the part of anyone, such that the potential of which I am speaking can never be fully extinguished or fully realized.

The political ontology of photography, as I have interpreted it here, obliges us to rethink the discourse of photography as it has been institutionalized since its inception, and obliges us also to rethink the manner in which it is entrapped in the hegemonic opposition between the aesthetic and the political—one maintained not only by the discourse of art but also by political discourse itself, as we shall see in the discussion that follows.

CHAPTER TWO

RETHINKING THE POLITICAL[1]

The Opposition between "The Political" and "The Aesthetic"

The most frequent use of the two categories, "the political" and "the aesthetic" in contemporary discussions of works of art,[2] sets them in opposition to one another. The category of "the political" is used as the predicate in a common judgment of taste whose most general formulation is: "This work of art is political." The category of "the aesthetic" is not directly formulated but is more often implied as the negation of the political—"This work is not political"—rather than appearing in the explicit formulation—"This work is aesthetic." On the face of it, the latter, positive attribution is meaningless because it is self-evident. But if it is indeed capable of conveying a banal commonplace, then a further question arises to which I shall return later in this discussion: What is the point of the negation?

In cases where the judgment of taste contains markers of excess or lack—"too much" or "too little"—the category of the aesthetic appears explicitly: "This work is too aesthetic." In general, the judgment "political"/"not political" refers to works of art that deal with subjects that are identified as political. Thus for example, "Repose," a work by Ruth Schloss (1974), which depicts a sleeping figure, will not necessarily be the subject of such a judgment of taste, whereas the depiction of a soldier, worker or prisoner, entitled "Soldier," "Worker," "Prisoner," will tend to invite such judgments. But the identification of a work with subjects deemed political is not a necessary condition for their evaluation along these lines. Curators and writers motivated to seek out the political in art will indeed do so even in places where it is not obviously apparent and will insist precisely on the political dimensions of, for instance, the artist's decision to portray a state of "Repose" immediately after the cessation of war.

The categories of "the aesthetic" and "the political" so routinely deployed by most speakers in the discourse of contemporary art serve as the basis for the evaluation and classification of images and for their positioning in different narratives composed of different series of works. The judgments of taste attached to images usually attest to the positive or negative evaluation that a speaker holds vis-à-vis a given work of art and also vis-à-vis one of the categories invoked. When a speaker's preference is for political art, she might criticize a political work for being "not political enough," consigning it to the pole of lack for demonstrating an excess of the aesthetic. Similarly, when the preference is for art that does not yield to political considerations and that treats art itself as its explicit focus, an excess of "the political" will be deemed a defect. These judgments of taste achieve three things:

1. They determine the character of the image under discussion: "aesthetic" or "political."
2. They point to the resultant success or failure of the image.
3. They express the affinity of the speaker of the judgment of taste for work that identifies with one or another side of the opposition.

Walter Benjamin's contribution to the institutionalization and dissemination of the dichotomy between the political and the aesthetic is significant. It is succinctly displayed in one of the most frequently cited of his texts in a statement that concludes his essay on the work of art: "Its [humankind's] self-alienation has reached the point where it can experience its own annihilation as a supreme aesthetic pleasure. *Such is the aestheticizing of politics, as practiced by fascism. Communism replied by politicizing art.*"[3] This piece proposed a complex historicization of the visible world and of its subordination to the senses, all while demonstrating the uses to which fascism puts the visible and its manipulation of the sensory faculties of the modern individual. In its conclusion, Benjamin's essay draws on the simple but magnetic opposition that bestows upon art (or invests art with) a powerful role in the struggle against fascism, in particular, and against oppressive political regimes in general. The aestheticization of the political is held here to be the zenith of "Art for Art's Sake" and of the workings of fascism, while the politicization of art is presented as the task of all those who would oppose fascism. In effect, Benjamin's formula lays out two courses of action—aestheticization and politicization—and sets one against the other. Each strategy is granted the power to turn its object into precisely that from which it seeks to distinguish itself. The two are set up in relation of mutual exclusion: either the aesthetic becomes political or

the political becomes aesthetic. The formula empties the dimension of time from Benjamin's complex line of thought—one that does not easily yield itself to dichotomies nor to the simple revolutionary horizon seemingly ushered in here—leaving his words to make their way alone in the world. Many people have understood this formula as a moral imperative or as a political exhortation, something approaching a clearly defined obligation that the individual must take upon herself or himself in order to halt fascism.[4] Prevailing readings of this particular essay by Benjamin and the routine appeal to the political imperative enfolded in its last paragraph have rendered the term "politicization" to be the task of individuals. The artist, the commentator, the critic and the curator are all measured against the yardstick of the political judgment of taste, which then arbitrates whether or not they have been able to achieve the desired politicization.

With the reorganization of the public sphere at the end of the eighteenth century, new forms of human coexistence began to emerge involving the coexistence of men and women with one another, with works of art and with images in general. The phrase "politicization of art" serves, in this context, to describe the new forms of encounter that people experienced in new locations of art and of power, such as the Palace of the Louvre in Paris or Somerset House in London. The opening of the Louvre to the general public, which from 1740 onward was invited to participate in its salons, created new conditions for the relations between the public, art and power. The meeting of masses of people around works of art, and by virtue of their inspiration, in a space that had formerly been reserved for sovereign power—the Royal Palace—exposed the regime (which would in time come to be known as "*l'ancien régime*") to the gaze of the public to no lesser extent than it was exposed to the representations depicted in the works themselves.[5] It is possible to describe the politicization of art in other European countries toward the end of the eighteenth century in a similar fashion. Holger Hoock, who has conducted work on the British Royal Academy of this time, describes the growing interest of artists in the crown and in government, alongside the flowering of discussions of art on the part of an ever-expanding public. The meeting of this public with art and with power, and to no lesser extent, the public's growing sense of itself constituting a public, sharpened its political and aesthetic abilities and capabilities.[6]

The reverse Benjamin created is a little misleading. It causes us to forget that what is at stake is not a perfect opposition—aestheticization is of the political whereas politicization is of art (and not of the aesthetic).[7] The imperceptible and unsubstantiated passage from "the

aesthetic" to "art" that occurs in the last paragraph of Benjamin's essay is very common in judgments of taste of the kind I have listed. In many cases, this elision serves as a central tool in the practice of art critics. The sheer frequency of the elision has long caused us to forget that the leap it performs is not substantiated. Adding to our amnesia is the fact that what is chiefly at stake in most such judgments of taste is the brute contrast between the political and the aesthetic that casts "the political" as something that an individual can bring about through the act of politicization. The artistic (or the aesthetic—which from the point of view of adherents of the opposition amounts to the same thing) and the political are produced as mutually exclusive poles representing two directions of artistic practice. Benjamin's formula has resulted in numerous books and articles, has motivated scholars to spend years trying to interpret it, and has inspired the work of both artists and curators. The politicization of art appears in Benjamin's formula as one pole in a simple opposition whose other pole is, as we have already stated, the aestheticization of the political. From the time of Benjamin's formulation until the end of the twentieth century, this opposition was understood in such a concise and condensed fashion that no space of action seemed to exist beyond the two positions Benjamin delineated. Any artistic action, or any piece of writing produced in response to it, was seen as a partisan act in a struggle where it was necessary to choose sides, to take up a position, to distinguish this position from others, and in so doing, to reconfirm the power of the opposition and the role that it fulfills. The relation between the different terms of the opposition themselves never emerged as the object of study.[8] If one chose not to resign oneself to the nightmare of the modern world, if one assumed that art was more than the practice of hanging images on the wall, the choice was indeed simple: one had to resist the aestheticization of the political that was itself identified with fascism, and to opt for the politicization of art associated with Marxism. Two decades ago, I quite naturally found myself positioned on the side of the equation that sought the perpetual politicization of art. Even if I still failed at the time to understand that the entire regime governing Israel from 1948 was a dark and oppressive one, and that oppression was not restricted only to actions taking place in the territories occupied in 1967, what I knew about the oppression of Arab inhabitants of Israel on both sides of the Green Line sufficed to induce me to take up the "traditional" position of a criticism from whose vantage point scrutinizing the actions of the regime is the alternative to be preferred and is one that allows for the possibility of creating resistance through art.

It was such a position that guided my first curatorial interventions at the end of the 1980s as well as the writing of my doctorate some years later. In both instances, my chief interest lay in an analysis of the conditions of possibility for "the politicization of art." For someone like me, a citizen of an occupying state whose rule was not achieved through consensual means and whose dominion over a sizeable Palestinian population deprived of political protection was becoming increasingly understood as self-evident, indeed was entrenching itself as the very face of the regime, Benjamin's prescription seemed to be the order of the day. I sought a path that would not compel me to divorce my engagement with art from my resistance to the regime. I drew on Benjamin's straightforward and apposite formula that, as we have stated, was understood first and foremost as oppositional and which positioned those who adhered to it in a dual position of resistance and desire. Resistance involved the dual dynamics of resistance to a regime engaged in the "aestheticization of the political" and resistance to formulations of "art for art's sake," which had abdicated their duty to resist the regime, but it was also coupled with political desire—the desire for the achievement of a different politics through art. This was a politics that was not to be found where it should have been located and had, therefore, to be sought after, revealed, brought to the foreground. But such resistance and such desire both require special expertise: of the kind that knows how to discern the existence of "the political," to delineate and evaluate it, and to a large extent, to bring it into being—that is to say, to engage in politicization. The figure of the critic, who from the eighteenth century onward had become the public arbitrator of art, was transformed over time into the source of an authority who could signpost "the political" as part of her mandate: whether over art, culture or literature.

When, in the eighteenth century, a certain regime persecuted a painter for having produced a certain work, he was persecuted not because the work was defined as political per se, but because of the need to repudiate its contents or to counter the particular political position it espoused. "The political," a category that did not exist then in quite the same way as the object of a judgment of taste, became such an object only with the entrenchment of the opposition between the aesthetic and the political. Over time, the very opposition that had once served as a fruitful point of departure for my thought and a critical tool offering certain advantages increasingly became an obstacle to thinking about the political and the visible. Well before I understood the nature of the obstacle it presented, I was engaged in looking for ways of avoiding the interpretations of Benjamin's opposition then current in the world of art, one that had long since parted company with Benjamin and with the particular context

in which he wrote.[9] These interpretations appeared to me to be narrow and limiting. My position as a stranger in the world of art, and therefore as someone less obligated to conventions held by many of the actors in the field concerning the essential nature of art and of that which was not art, enabled me to forge my own interpretation of the opposition. My foreign status in the art world stemmed first and foremost from the fact that my training was not in art or in art history. This fact had direct implications for the formation of my habitus. Given that my training was not acquired in institutions of art education, I did not absorb the relevant artistic disposition together with its attendant opinions, a disposition usually acquired together with the relevant training in art and one that, in fact, authorizes different players to act in the field. But despite my attempt to maintain distance from many of the accepted assumptions of the field, my practical work as a curator (chiefly in the alternative exhibition space of the Bograshov Gallery between 1989 and 1994), that is to say, my active role as a player in the field of art, necessarily positioned me within the paradigm of art—whose parameters I will delineate below. I found my field of vision restricted, in many ways, to that which the paradigm authorized.[10]

At the core of the Ph.D. dissertation, which I wrote during the first half of the 1990s in parallel with my work as a curator, stood the attempt to reconstruct the process whereby the discourse of art had become enmeshed within museum discourse. I analyzed the reciprocal relations the museum institutionalizes and formalizes between the various players in the field of art, with particular focus on Israeli art of the 1970s.

The title of my dissertation, *TRAining for Art: A Critique of the Museum Economy*, provides some idea of its contents. The museum economy that I described was based on my assumption that the museum trains citizens to see art, and that this training forms part of the instruction in citizenship conducted by the modern state, particularly the nation-state. My use then of a language that was itself foreign to the discourse of art—terms like training, citizenship or economy—was deliberate and stemmed from my explicit motivation: to oppose the dominant art discourse in Israel and to "politicize art" on the basis of the understanding that the politicization of art is not the sole province of artists alone.

The immense power of Benjamin's formula to subsume the totality of activity that goes on in the name of art in such a manner as to relegate each activity necessarily to one or another side of the opposition is precisely the source of that which limits the possibility of thinking outside of the parameters of the opposition, of questioning its validity and of turning it into the focus of research in its own right. The scholars upon whom I drew

during the writing of my dissertation had, after all, based themselves on it and had sought to politicize art from within this very paradigm. It was only when I completed my Ph.D. in 1996 and began to study the rest of Benjamin's oeuvre in the context of a more organized attempt to think about photography, that I began to feel explicit unease regarding the opposition and to seek ways of bypassing it. What appeared to me to be problematic in the first place was the unsubstantiated transition from the differentiation between "the aesthetic" and "the political" to a distinction between "aestheticization" and "politicization" in a manner that renders them equivalent. This equivalence makes the aesthetic and the political into attributes of the image, and makes of aestheticization or politicization a form of action reserved chiefly for those works of art that either strengthen or weaken these attributes of the image.

A Short History of the Judgment of Taste

The conceptualization of the aesthetic and of the political as attributes of the image led to the evolution of a new judgment of taste in the second half of the twentieth century.[11] It was preceded by the emergence of the two judgments of taste whose history I will elaborate here briefly. The first—"This is beautiful"—was formulated by Kant in the late eighteenth century in his *Critique of Judgment*. The work of art exemplified, for Kant, a particular object that could not be subordinated to the general rule (the constitutive judgment) but which forces us to extrapolate the general rule from the particular instance. Kant termed this kind of judgment "reflexive." Taste, supposedly the most individual of our senses, became for Kant that sense modality that a spectator could use to judge the work displayed before her and to share this judgment with other spectators who participate in a community of taste. Thus, even when it seeks to explode the conventions of taste, the judgment of taste still subsists within the boundaries of good taste. Hannah Arendt, for her part, locates the core of Kant's political philosophy in this discussion given that Kant uses it to explore how, through the common sense and imagination, we communicate general rules as derived from a particular instance.[12] According to Arendt, this is the only point in his oeuvre where Kant transcends the treatment of the individual, turning instead to his/her being with others—to the spectator of a work of art as one who in his/her judgment binds him/herself to other spectators in order to pronounce the judgment of taste that proceeds from his/her inclusion in a community of taste. The judgment of taste, claims Arendt, puts on display for us one explicit form of the political—the fact of its being plural.[13]

At the beginning of the twentieth century, the question of "the beauti-
ful" in relation to the work of art was displaced in favor of the question
of "art" in what amounted to a form of speculation, at once epistemologi-
cal and ontological, central to the second judgment of taste. What was
self-evident for Kant—the uniqueness of the work of art—became itself
the object of a judgment of taste in the wake of the famous intervention
by Marcel Duchamp. In his book entitled *In the Name of Art*, Thierry de
Duve analyzes Duchamp's revolutionary gesture toward the ready-made
in terms of a judgment of taste whose essence is "This is art."[14] De Duve
emphasizes the contestation of linear periodization that is implicit in this
second judgment of taste and foregrounds the fact that its pronouncement
actually has the effect of rendering the postmodern prior to the modern,
or of subsuming modernism within it.[15] For my own part, I seek to under-
score precisely the synchronic connection that this judgment of taste
establishes with its inverse—"This is not art." To consider the relation
between them, I argue, is to reveal the extent to which the sociology of
judgment (who may judge, who is precluded from judgment, how does
one judge and so on) and the concrete circumstances in which an object
commands and elicits judgment (an institution, a site, the activities of a
curator or an artist, capital and so on) become part of what is put into
play in the judgment of taste centering on "art." Were it not for the socio-
logical distinctions established as part of the particular circumstances of
commanding the object as art, this new judgment of taste—"this is art"—
would completely obliterate the distinction between the creator of a work
of art and its spectator, placing both on the same plane. The new judg-
ment of taste spawned innumerable new artworks, and in so doing, also
rendered the circumstances of their creation into the object of the same
judgment. The photographs "of" Walker Evans that became the photo-
graphs "of" Sherry Levin (a process that she herself analyzes) offer a good
illustration of this.[16] The second judgment of taste sought to be more
Kantian than Kant, in a certain sense, and to free contemplation from the
world of action in order to reiterate its superiority. Art sought to find
ways to limit its dependence on manual creation, or to render it marginal,
and thus to emphasize the act of selection—"This is art." Duchamp's
ready-made gesture was an early and radical expression of this process
which would take a variety of forms over the course of the twentieth
century. Conceptual art constitutes a later example in its rallying cry to
free art from the creation of objects, reveling in the development of
concepts instead. But we should not lose sight of the fact that this move-
ment toward conceptualization proceeded from the vantage point of the
creator of the work of art who, even when freed from the business of

creating art, was still enmeshed in the world of action—a point to which I shall return below.

The opposite of the assertion "This is art" is therefore "This is not art." It seeks to contradict the positive attribution when other agents bring it into play, using the authoritative inversion "This is not art" to eliminate rival players from the field. Decades before Duchamp and the resultant judgment of taste that is so strongly associated with the inception of modern art, the assertion and its inverse "This is not art" already held pride of place in artistic practice. I am referring to a network of practices extending between various salons where the community of critics (the "jury," so to speak) would pass sentence over what could be admitted into its midst and what it relegated to the salons it repudiated—where artists themselves sought to establish the criteria constituting art. The "official" salons determined what constituted art through a process of negation— whatever was denounced by those responsible as "not art" was expelled from their midst. For those who had undergone exclusion, on the other hand, art came to be constituted through a process of affirmation—such that the claim "This is art" served to contest the authority of those who proceeded through negation. On the face of it, the positive attribution— "This is art"—appeared to be inclusive and expressed the demand of artists to partake in the authority of the spectator who had accrued the power to determine the status of the work of art through means of the assertion alone. But their capability to use the affirmation "This is art" was in fact much more limited, since it was only the artist himself who could issue such a challenge. This second judgment of taste coexisted with the first "This is/is not beautiful" or, in a later formulation, "This is/is not a good work"—one that spectators continued to pronounce alongside artists-as-spectators.

During the inter-war period, a new judgment of taste began to make room for itself alongside the first two. It took the form "This is aesthetic/ political." By the second half of the twentieth century, it had succeeded in establishing itself as the dominant form. This particular judgment of taste, which I term the third judgment of taste, could be pronounced equally by all who loved art. Through its mediation, the spectator, and more significantly the trained spectator, restored her authority as a player in the field of art. In the wake of this new judgment of taste, the determining question is no longer whether the object of judgment is beautiful (as was the case with the first judgment of taste); nor whether it constitutes art (as was the case with the second judgment of taste); but whether the work of art is aesthetic or political. The new judgment of taste takes for granted that what is being weighed in connection with the modern work of art is no

longer solely a matter of art but is also a "political" matter. Taste, which previously judged art, now comes to judge the political and treats these two limbs of the equation as if they were equivalents possessing an equal standing as objects of taste. This simple judgment of taste offers itself effortlessly to the spectator in the face of a huge range of works. When the judgment is adorned with specific attributes describing a given work under discussion it becomes an instance of personal taste that seamlessly meets the attributes of its object. This particular judgment of taste has become so accessible in the encounter with the work of art that questions regarding whether "the political" should be a matter of taste or whether viewing a work of art should be the cause for a judgment of taste are never even contemplated.

The third judgment of taste can be divided into four different types each of which subsumes four different attributions concerning the nature of the object offered up for judgment.[17]

"It is too aesthetic"	"It is not political enough"
"It is not political"	"It is art"
"It is not aesthetic enough"	"It is too political"
"It is political"	"It is not art"

Before investigating the different categories, let me return to the second judgment of taste and to the claim it makes with respect to the authority seen to determine the nature of the object. As I have already stated, the second judgment of taste—"This is art"—became institutionalized in the face of spectators' attempts to "reveal the truth" behind objects termed "works of art" by their creators and institutionalized as such, and thus to issue counter-claims to the effect that "This is not art." This second judgment of taste institutionalized the authority of the artist-actor in the field of art to declare something to be art and to reject external sources of authority seeking to contest the relevance of the attribution and to contradict it by means of the declaration "This is not art." Against this background, the third judgment of taste, which subsumes an attribution concerning the status of the object—"Art/not art" or "Political/not political"—can be interpreted as the attempt of spectators to restore to themselves the authority of which they were deprived by means of the second judgment of taste, to the extent that they now determine whether the object presented before them is really what it purports to be. But the power of the spectators remains circumscribed even when their version of the judgment of taste resonates with the force of the second judgment of taste, "This is art," since what is being weighed up is not the status of the object. The spectator does not render objects into works of art nor does she render works of art into objects—she merely judges them.

The Third Judgment of Taste

Accordingly, the third judgment of taste does not determine the status of the object but places the relation obtaining between the aesthetic and the political under scrutiny, and causes judgment to be passed on the nature of such relations. It should be emphasized that we are not dealing with two elements that share a common status. Rather, what is at stake is the manner in which a work of art hosts the political or gives it expression. The qualifier "too" that affixes itself like a hump to the judgment of taste determines the nature of this relation as something internal to the object of art. Even when variants on the judgment of taste subsume relations that apparently have the work of art as their referent, namely its being "art" or its being "political," what is more properly at stake is a judgment concerning the relation between these two attributions. The political always constitutes one pole of reference, and the aesthetic, another. The qualifier "too" takes up a position between them, pointing simultaneously to excess in relation to the one and lack in relation to the other. To summarize, therefore, the four categories I have just presented can be organized in two pairs whose constituents show great similarity to one another. The assertion "This is too aesthetic" is very similar to the assertion "This is not political enough," while "This is too political" is similar to "This is not aesthetic enough." Each cluster can be described as follows:

1. The first two assertions, centering on variants of the formula "This is aesthetic," are usually voiced by agents who are not interested in the realm of the political. Their use enables the speaker to judge works of art wherein the political dimension is emphasized. Although the speaker may not be terribly interested in the political *per se*, her use of the third judgment of taste renders her a judge of the political. When the political dimension deviates from what seems proper to her, the speaker dissociates herself from it and, at one and the same time, also loses interest in the particular work of art that hosts the political deviation from an implicit (aesthetic) norm.

2. The second two assertions are usually voiced by agents who are interested in the realm of the political. Their use enables the speaker to judge works of art wherein the political is thought not to have attained adequate expression. The speaker in this instance is interested in the political, and she materializes the position that the judgment of taste provides for her—that is, she demonstrates her ability to cast judgment over the political. When the political does

not triumph over the aesthetic dimension of a work of art, the speaker loses interest in it. She loses interest in the political, as it comes to be expressed in the particular work of art, and compounds this loss with loss of interest in the work itself.

For all their differences, the speakers of the various judgments of taste hold a certain concept of the work of art in common such that the work of art is deemed to be the bearer of the political. They also share the assumption that the relations between the political and the aesthetic are subject to standards of appropriateness or decorum.

"Too Much," "Too Little"

Were it the case that the quantifiers "too political/aesthetic" and "not political/aesthetic enough" in fact attested to the spectator's application of a pre-given rule, we would almost certainly perceive the dramatic deviation of the third judgment of taste from the reflexive principle governing its predecessors. We would also no doubt note that the spectator had migrated from the realm of art to another domain altogether—that of science, for instance. The form of the reflexive judgment of taste underpins the paradigm of art. Any deviation from it bears the threat that the transgressor might face expulsion from the paradigm or that its very foundations might be eroded. Were reflexivity absent from the third judgment of taste, it would be a matter for the courtroom or for the scientific journal, with the onus falling on the spectator to provide evidence of the validity of her assertions. Alternatively, were rules for the attribution of political content to exist, we might in fact expect artists to employ them in the manner of instruction manuals, alert to certain principles of decorum between the various constituents in a manner that rules out in advance the prospect of finding a given work to be "too much this" or "too little that." But the satchel of the spectator, like that of the artist, is empty. She is not (nor will she ever be) in possession of a rule that might determine (whether in advance or in retrospect) that a given work of art is excessive or lacking: that it is "too much" or "not enough." Like its predecessors then, the third judgment of taste is the explicit product of artistic practice that positions the work of art as the source of the reflexive formulation of a rule. But, faced with a concrete work of art, and bound to the practice consequent on the third judgment of taste, the spectator represents the work of art to herself in her mind's eye all the while appraising its potential to be realized as an exact distillation of the relation between "the political" and "the aesthetic." She judges it reflexively with respect to this potential and

determines the work to have upheld it or to have failed to uphold it. In other words, despite the fact that the reflexive dynamic is preserved together with the foundational rules of art practice, the third judgment of taste does not consider the visibility of a concrete instance, nor does it try to extrapolate what is at stake in a particular setting; rather, it extracts a formula of similarity from various works of art, having to do precisely with the relation created by the artist between "the aesthetic" and "the political" which, ultimately, itself becomes the substance of the judgment passed. Thus "the aesthetic" and "the political" come to be perceived as attributes conveyed by a work of art, the first as an internal artistic relation and the second as extrinsic to the field of art, where it is the relation obtaining between the two that is under arbitration. The moment that "the aesthetic" becomes a quality or an attribute of a work of art, it is transformed to all intents and purposes into a synonym for form, style or various other categories intrinsic to the artistic field. In a similar manner, "the political" is transformed into a term for the characterization of matters on the political agenda or in the domain of governance that supposedly find their expression in the work of art.

The third judgment of taste renders "the aesthetic" and "the political" into characteristics of a given work of art and determines in advance the role that the spectator or the critic might assume in revealing these characteristics in art. It also authorizes the spectator or the critic to evaluate the artist on the basis of decisions she has taken as the putative source of certain political or aesthetic manifestations in the work. In the discussion that follows, I will ask what is circumscribed and what is foreclosed by virtue of the particular configuration of the third judgment of taste that calls upon the spectator to consider "the political" to be an attribute of the work of art itself.

Beyond the Mutually Exclusive "Either/Or"

At the time of writing my book on Benjamin, my thought remained indebted to these two categories—"the aesthetic" and "the political"— but I was now able to think of them without binding them in the mutually exclusive either/or opposition Benjamin had established. I thus proposed that we see the categories as two distinct axes along which images are transmitted, axes that exist in parallel and constitute two traditions of transmission.[18] The first tradition I characterized as one that sanctifies the work of art as a unique and closed unit that must be preserved outside of the economy of transmission, while the second is a tradition founded principally on the act of transmission as well as on the duty of those

engaged in the preservation of the work of art to continue to maintain conditions adequate to its transmission. From the vantage point of the second tradition, I was able to think of the two traditions as existing in parallel rather than as mutually exclusive, and to analyze the continuum of practices within which the image is transmitted—rather than those existing solely under the authorship of the artist. These practices deviate from artistic practices centered on the artist. Nor does their consideration permit the evacuation of other protagonists from the field, including persons photographed, spectators or critics. In my discussion of Benjamin, the notions of the politicization or aestheticization of the image no longer described the outcome of an action, a stable property of the image affixed to it once and for all by its creator. Instead, they come to constitute part of the economy of exchange which, in one tradition, seeks to stabilize and sanctify the image transmitted and in the other tradition, seeks to alter the image at the time of its transmission.

Discursive Symptoms

Other participants in the act of transmission generally escape the professional gaze of art as centrally enshrined in its governing paradigm. To view a work of art as a visual product is often to move within and beyond the frame, lingering over elements that do not necessarily form part of the artistic intentions that this product is supposed to embody, intentions which drive its aestheticization or politicization. Within the paradigm of art, however, this gaze is compelled time and again to restrict itself to the reconstruction of artistic intentions, often through the mediation of language. On far too many occasions, I have heard far too many people comment that Micha Kirshner's portraits of Aisha al-Kurd or Huda Masud (page 50), for example, "aestheticize the political." This despite the fact that each of these portraits could have served as a rich source of knowledge regarding the women photographed and their life-worlds: women whose presence in the frame is not only answerable to the professional gaze of the spectator who observes them. The judgments of taste expressed time and again on the part of various researchers and curators with respect to images from regions of crisis or catastrophe are disturbing because they are symptoms of a certain discourse. Their effect might be likened to a secret compact entered into unconsciously by people complicit with acts of silencing, distancing or occlusion. They are unsettling for their sheer frequency as well as for their contention that there is nothing to be seen or, alternatively, that what is on view is not worthy of regard. I find no less disturbing the idea that the judgment of taste recruits the abilities and intellectual

capabilities of experts in the visual domain (particularly experts in the field of art) to the service of a kind of work of assessment whose primary purpose is the evaluation of images. Figures for whom the rendering of the visual into the object of a political investigation accords with their own political tendencies and moral sensitivities are very often no exception. The reach of the judgment of taste includes individuals who would explicitly reject any calls to bracket off the political. Under the cover of the third judgment of taste, supposed experts demonstrate their ability to hunt down images that are "too aesthetic" or "too political." They excel at the task to precisely the extent that they deploy their faculties of judgments with respect to images that seem at first glance to resist such classification.

The assertion of the third judgment of taste preserves the Kantian aspiration for a judgment of taste that is universal and unbiased. For Kant, the judgment of taste becomes universal through the mediation of the imagination, since, when confronting a particular work of art, we do not express that which we feel but that which we imagine to be a plausible judgment that might arise on the part of any other spectator who might stand in our place. The person engaged in judgment is expected to use her imagination to overcome her particular interests and to formulate a judgment of taste that might be held in common with others. The judgment of taste is expected to dissociate itself not only from the particular interest of the person engaged in the evaluation but also from any particular interest associated with the artist, gallery or any other protagonist linked to the work, such that the spectator is freed instead to contemplate that which is particular to the object standing before her. But the third judgment of taste cannot be rendered universal and unbiased without something else being sacrificed—in effect, it is forced to bracket the particular characteristics of the visual work in order to allow the work to manifest a particular relation between the aesthetic and the political in an abstract fashion. The third judgment of taste does not index the referent of the image, the narrative the image conveys or the historical dimensions it presents, since all of these must be suspended in order for the judgment of taste to direct itself to the abstract relation between the aesthetic and the political. The evacuation of particular interests enables experts to proclaim in public, without the suspicion of their being partisans, that the work of art standing before them is "too" aesthetic or "too" political and thus, unworthy of regard—consigning it, in effect, to exile beyond the pale of works that might legitimately be contemplated. The relation between the aesthetic and the political serves as a kind of filter ensuring that what can be seen is already an object worthy of inclusion in the field of art. This filter itself is complicit in preserving what I have termed the paradigm of art.

Photography Makes a Difference

In photographs, to a greater extent than in other kinds of images, the evacuation of the signs of the particular from the plane of the visible is not so self-evident. Outside of the rarified field of art, such evacuation cannot in fact constitute an unpremeditated gesture. For the man or woman photographed, it is clearly the case that their image is present at the level of the picture taken. They themselves, or the particular circumstances of their lives, were recorded in the frame under such and such circumstances. Different forms of professional gaze will find distinct sources of interest in what the photograph registers. The professional gaze of art, law, history or medicine will extract a different object from that which is visible and will focus its attention selectively upon it. These are all examples of particular forms of gaze that belong to clearly defined, discrete fields of activity. These gazes are not mutually exclusive. They can exist in parallel and may enrich or contradict one another. But no single one of them is capable of exhausting the field of the visible in its own right. The persons photographed may themselves belong to one of the fields I have outlined, and their involvement in the photograph may or may not stem from the interest they hold with respect to a particular field. But in most cases, the persons photographed are not present in the photo because they belong to a particular field of action. Whether their presence is deliberate or coincidental, their involvement in the photograph is derived from the concrete circumstances under which the photograph was taken, as well as from their potential involvement in what I have termed elsewhere "the citizenry of photography."[19] Their presence creates a certain form of address directed at the spectator. They assume the existence of a spectator who is located in another place and at another time, divorced from the site where the photograph was shot and from whose grounds they look out upon us in the photograph. Although the spectator whom they address is positioned in another time and place, and in certain (changing) historical circumstances, the photograph enables them and others to reach out to the addressee as if to a Kantian spectator, that is to say, a spectator who is capable of transcending her own particular interests and who is capable of judging in universal terms that which is on display. This kind of address, which does not derive from a particular field of knowledge or form of activity, seeks to elicit from the addressee what I will term a "civil gaze" (see discussion below). This gaze cannot itself be reduced to other forms of the gaze.

It is possible to understand the third judgment of taste, centered as we have already seen on the relation between the aesthetic and the political,

as a response to the kind of address that photography creates. The third
judgment of taste is not interested in the question of beauty (the province
of the first judgment of taste) nor in the question of the constitution of art
itself (the second judgment of taste). Rather, it takes the political interest
of a work of art to be self-evident and judges the manner in which it is
treated within a given work. The third judgment of taste directs the trained
spectator to engage her professional gaze in contemplation of a photo-
graph depicting, for instance, a Palestinian girl, framed by soft light, sitting
among the wreckage of what was once her house. In the enclaves of art,
such photographs are generally presented without being framed by essen-
tial information necessary for knowledgeable viewing. At best, a spectator
may exceed her own capacity as a trained spectator of art to the extent
that she is familiar with the Occupation and knows something about the
systematic manner in which the Palestinian homes are demolished in the
Occupied Territories, enabling her to recognize what stands before her as
belonging to the general category of "images of the Occupation." But,
when such a spectator directs her attention to a specific photograph, this
general knowledge in her possession, which also applies to many other
photographs of demolished houses, is insufficient to assist her in expand-
ing her field of vision in relation to the specific photograph at hand. The
photograph thus loses its specificity; loses that which might be argued
precisely from the basis of all that is specific to it, and becomes the mere
illustration of a theme. The spectator's professional gaze may equip her to
distinguish many details linked to the presentation of the image: the posi-
tioning of the figure, background, lighting, the use of color, composition,
cropping, and scale. These may be analyzed and set in relation to other
images with which she is familiar from the realm of the art world. But,
however long or complicated her analysis might be, it will inevitably lack
many details that cannot be accommodated within the conventions of
discussion governing the paradigm of art.

Thus, when confronted with the image of a figure lying on a bench on
the street, swathed from head to toe in plastic (Is it at all possible to
breathe?) and tied with rope to the bench, the spectator is unable to deter-
mine whether the body in question is alive or dead; whether the figure has
the status of citizen or of foreign worker, Palestinian or tourist; whether
the figure has died in a traffic accident and is still to be evacuated or
whether this is someone who has been tortured to death and tied in place
pending further investigation. Yet the professional spectator is not deterred
by the absence of such details in the completion of her survey nor does
their absence hinder her in pronouncing the third judgment of taste, to the
effect that the image is "too aesthetic" or "too political." The photograph

of the Palestinian girl among the ruins of her home, such a spectator might assert, is too aesthetic since the photographer's focus attests to her fascination with the picturesque nature of ruin and poverty. It is entirely plausible that such a commentator would add that the photograph is morally questionable since it uses the figure of the child for the purposes of emotional manipulation. But this moral assertion remains itself questionable if it does not base itself on some minimal familiarity with the circumstances under which the photograph was taken, the reasons for the demolition of the houses in question, or the frequency of the phenomenon in the particular neighborhood shown. These crucial details open a further horizon of questions both with respect to the photograph itself and with respect to other protagonists who might have participated in the particular situation captured by the lens.

The form of the judgment that a spectator might articulate will express the limits of the professional gaze available to players operating in accordance with the paradigm of art. This gaze is circumscribed by certain aspects of the visible, which are themselves held to be the fruits of the artist's intention. The judgment of taste expresses the competence of the spectator in determining the success or failure of the artist in distilling the correct blend of the political and the aesthetic. The professional gaze that allows the spectator to judge the photograph as being "too aesthetic" enters into a direct relationship with the artist, bypassing the persons photographed who are denied a role in the unfolding of this imaginary relationship. The "competent" spectator supposedly knows better than the persons photographed that the manner in which they are present in a photograph is inappropriate. Her position might not change even when their presence states the contrary. They are, after all, merely people in the frame.

It is paradoxical that the speaker who judges a certain image to be aesthetic even when it is possible, indeed urgent, to find it political, severs the image from the political and consigns it to being an aesthetic object. Bound by the paradigm of art, she cannot in fact do otherwise. Her actions are inevitably conditioned because the referent of the judgment of taste—one of the most explicit tools of professional art discourse—is held to be the work of art alone, rather than the totality of relations between people who enable a certain work of art to emerge into the world. Thus "the political," supposedly ushered into the world of art by the third judgment of taste that seeks purchase over the political dimension of the work, does not and cannot exist within the paradigm of art except as the subject or attribute of the work of art itself. The third judgment of taste supposedly foregrounds political interest as something external to art, but, in practice,

it is solely interested in those cases where the political is internal to this domain. Instead of allowing a multiplicity of forms of gaze to converge on the work of art, therefore, the third judgment of taste restricts all variants of the gaze to one sole form: the professional gaze of art. It treats the people who actually appear in the frame as "present absentees" in a manner that assumes that they are solely at the disposition of the professional gaze itself.

Photographed Persons

When one contemplates a photograph from a position outside the paradigm of art, it is difficult to obliterate evidence of the gaze the photographed persons fix on the spectator or the demands they make on her, just as it is difficult to reduce their inclusion in the photograph to the competence—generous, exploitative or violent—of the photographer. When I began to write *The Civil Contract of Photography*, I was no longer an active player in the art world. The constraints my previous involvement had imposed on my own gaze diminished and images increasingly gave themselves over to new types of questions.[20] Why does the person in the photograph direct her gaze at me? Who am I for her? What allows her to assume the existence of a civil spectator? What is the relation between her gaze at the photographer and the manner in which she looks at me? Am I the effect of her having been photographed? What does she expect from me? Why are the relations between us never accounted for within the framework of the discussion of art, or more pointedly, within the framework of the discussion of photography? Why must I attribute everything that I see in the image to the photographer alone? What allows for the relatively easy evacuation of my position and that of the figure photographed from the field of relations that photography opens, while at the same time facilitating a "critical" discussion of the manner in which the photographer treats the person photographed? In what situation was the photograph shot—the same photograph that I now observe outside of the context of its production?[21]

Three Assumptions of the Judgment of Taste

The first assumption of the judgment of taste is that the manner in which the image presents itself to the senses—the aesthetic plane—is identical to the manner in which the image is formed or crafted. When the third judgment of taste asserts that a certain image aestheticizes the suffering of the Palestinians, it implies that this suffering can be expressed in a manner

that does not involve the aesthetic. The judgment of taste thus renders the category "aesthetic" identical to that of "stylization" (or even, to excessive stylization)—a factor whose presence is so strong that it overwhelms the subject of the photograph. The identification of gestures of excessive stylization, and the inclusion of stylization in the category of "the aesthetic," create the illusion that there are images or objects that do not exist within an aesthetic domain and that these are devoid of stylistic components. But various stylistic components are an integral part of objects or images even when their visual form does not derive from reasoned, conscious or deliberate choice. This is also true in cases where an "anti-stylistics" is articulated or in instances of so-called "bad taste" that seek to avoid style at all. Within the context of discussions or polemics concerning images, various speakers may give different weight to the stylistic components attributed to a given set of images, but they cannot eradicate their prior existence. The fact that an image exists within the domain of the aesthetic does not derive from any act of individual choice but results from the manner in which the image presents itself to the senses. Visual or stylistic components exist as part of the aesthetic dimension of images and they can be classified under various categories, or attributed to various forms of taste, schools, movements, periods and places. But they cannot wholly be eradicated, just as they cannot be eradicated from objects and images that are not thought to reside within the domain of art. The fact of a particular image's inclusion within the aesthetic is not subject to the determination of any given artist or critic. The aesthetic configuration associated with a given object or image may be appraised and evaluated in a variety of ways, but it is impossible to negate its existence. The aesthetic exists there as a consequence of the very fact that an object or an image is given to the senses.

The second assumption associated with the judgment of taste asserts that what is seen in a photograph is the result of choices made by the photographer—choices that are primarily stylistic. These choices may be manifest in relation to the cropping of the frame, the positioning of the photographed subjects within it, composition, lighting and the use to which it is put, the choice of colors or the choice of focus—in a double sense. Such evaluations link that which is visible in a photograph to the intentions, vision, planning and talent of the photographer, and relate to the photograph as if it were nothing more than the realization or implementation of these conditions. When the category of "the aesthetic" is hurled, therefore, in denigration of the photographic image—as "too aesthetic"—the photographer's choice of certain stylistic forms is not seen as the expression of a certain preference for one form among a wide

category of additional visual forms but is subordinated to the photographer's determination between the aesthetic and the political. The choice between two or more possibilities that belong to the same plane—that of the "aesthetic"—is, in fact, presented as a differentiation between two distinct and opposing planes—the aesthetic or the political. This elision attests to the nature and boundaries of the category of "the political" when set in opposition to the category of "the aesthetic." Within the framework of this opposition, the political is actually repositioned as an act of style or as a kind of visual idiom that the artist "employs." The conventions current in the field of art at a given time relate to certain styles as deficient or as sub-styles, and therefore as unaesthetic—that is to say, as political, or more accurately, as politically worthy. But the absence or deficiency of a style is in itself a form of style, and deficiencies of style do not evacuate a given image from inclusion within the plane of the aesthetic since the latter arises from the sheer accessibility of an image to the senses.

The third assumption inherent in the judgment of taste is that the aesthetic or the political are attributes of the image itself. This assumption is the inverse of the previous one, which holds that the aesthetic or political dimension of the image merely reflects the decision of the photographer to present it in this form. It follows that the moment that an image is liberated from the hands of the photographer, arbiters of the judgment of taste may deploy it as if it circulated in the world as the bearer of attributes permanently embedded in it, given their assumption that they have the power to discern these attributes while others remain blind to their existence. The spectator or the critic consequently assumes in advance that it is her role to reveal the pre-existing qualities of the image, and to judge the decisions of the photographer as being supposedly responsible for these qualities. The spectator-critic simultaneously denies her own contribution to the creation of the image as "aesthetic" or as "political" within the discourse of art, and ignores her own power to enlarge or restrict the conditions that might enable the image to be enfolded in a continuum of other utterances and to be included within other forms of discourse. The judgment of taste assumes the aesthetic and the political to be attributes of the image and to have resulted from the intention of the artist, even though, as we have already observed, being aesthetic is a necessary component of the being-present of any image, while being political is not a quality that might be attributed to a single person or thing but involves the relations between human beings in the plural—relations that I will treat below.

These three assumptions operate in every judgment of taste that asserts that a certain image whose manifest qualities are political or social, is in

fact "aesthetic" (or "too aesthetic"). The judgment of taste replaces the primary interest of the speaker-spectator in the political considerations the image raises, substituting the unease that the speaker reports in relation to the people in the photograph and their crisis ("the aestheticization of suffering") with an unease regarding the excessive attention the photographer has invested in the appearance of the photograph. The judgment of taste cries: "Scandal!" It points to the photographer's (excessive) concern with visual details in the face of the anguish borne by the photograph, as if it were in the power, say, of a lack of focus or negligent cropping to pay due respect to this anguish or to erase the fact that the catastrophe wreaked upon the photographed subjects were any less scandalous.[22] In the cases under discussion, the beauty emanating from the portraits taken by Kirshner, the skillful use of lighting and the perfect composition that frames the anguish of the photographed subjects, somehow becomes a

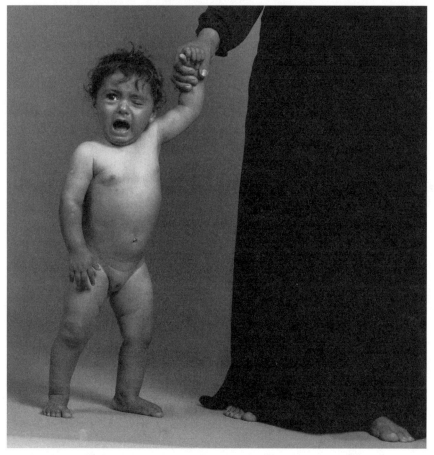

Huda Masud. Photograph by Micha Kirshner. 1988

pretext to expel the people in the photograph from the domain of the visible. A focus on the stylistic devices employed by the photographer, their foregrounding and their identification with political attributes, consign to oblivion that political space the photographer and the persons photographed occupied when they came together in the act of photography.

The speaker of a judgment of taste who asserts that "This image is (too) aesthetic," in fact disregards the violence that her gesture implies for the photographed persons themselves. Her intervention erases the fact that she is their addressee and expels them not merely from her field of vision and from the field of other spectators, but also from a certain political or civil space—the citizenry of photography—within whose borders the photographed subjects fight for their rightful place by means of the photograph and the space of appearance that it opens before them.[23] In order to issue a judgment of taste, the speaker must isolate the work from everything that surrounds it and must suspend the political space in which other spectators variously claim their right to participate, undermine or bring into being the very moment that they encounter others in or through the mediation of the photograph.[24] In other words, the third judgment of taste points to the existence of the work as a special kind of object having a special status—it is an object of judgment of taste. Everything else is distanced from consideration and is presented as extraneous. Paradoxically, in order to make the assertion "This is too aesthetic," the speaker must already be emplaced "within art," and must relinquish the ability to relate to the world that the image intersects as well as to the forms of meeting expressed in the intersection. Were it not for the fact that the third judgment of taste sought to set itself up in judgment over "the political," the form of address emanating from the photographed persons might possibly have succeeded in inciting the spectator of the photograph as a work of art to recognize that the perspective sanctioned by the discourse of art through which the photograph is viewed generates only one form of the gaze within a range of other possibilities.

The judgment of taste is dominant in the paradigm of art. It determines, moreover, the boundaries of this paradigm and the activities it sanctions. It is by virtue of this fact that shaking off the constraints of the judgment of taste, whose object is the relationship between "the aesthetic" and "the political," is equivalent to shaking off the paradigm of art altogether. But before I address an alternative paradigm explicitly, let me first state my objection to the three tacit assumptions submerged in the judgment "This is too aesthetic"—objections that derive from the political ontology I sketched out in the first chapter.

In contradistinction to the assumption that the aesthetic is a quality, and that images devoid of an aesthetic dimension exist, I claim that every image is necessarily contained within the domain of the aesthetic.

In contradistinction to the assumption that it is possible to discuss photography only from the point of view of its product and to attribute to the photographer sole rights over it, I claim that photography is a product resulting from the actions of many agents and that the photograph is only a sample of the relations between people or an effect of the space of relations between them. The existence of such relations cannot be reduced to the status of raw materials for, or mere objects of, the artistic image.

In contradistinction to the assumption that "the political" is an attribute that may characterize one image and may be absent from another, I use the term "political" to describe a space of relations between people who are exposed to one another in public, and I analyze photography, rather than the individual photograph, as one of the manifestations of this space.

Three additional claims will enable me to evade the prevailing practices arising from the third judgment of taste.

The first claim is this: Every image, including images whose contents are explicitly political, also exists in the aesthetic plane. It is necessary to understand the aesthetic dimension of the image as its manner of affecting our senses. Affecting the senses as well as the manner in which the process occurs is devoid of any other end (*telos*) outside itself contrary to other useful tools or devices (such as the seductive garment that beckons "Wear me!" or the computer key that says "Click me!"). The gaze spreads out like a fan becoming a gaze of identification or orientation, which enables us to become familiar with the object as it is, and may incorporate the professional gaze—including the professional gaze of the art lover—which seeks a deeper interrogation of the object it encounters, and which directs questions of an aesthetic order at it. At given periods, certain artistic conventions determine whether a particular artistic form is worthy or unworthy of bearing certain political attributes. The assertion that a certain image is "aesthetic" or "political" is the expression of a convention of representation that restricts the aesthetic dimension of the image to that which we tend to call "the aesthetic" in everyday language, or to the outward "appearance" of the image. As we have already stated, however, the recognition and priority given to certain aesthetic forms and denied others cannot alter the fact that the image always exists within the domain of the aesthetic.

The second claim relates to the photograph. The photograph, certainly any photograph depicting human beings, is not the ultimate concretization of an image the photographer imagined in her mind's eye. It is certainly not the exclusive expression of the emotions she feels regarding

the people whom she has photographed. The photographer engages in a significant series of choices with respect to the event of photography, and these influence the manner in which its final product—the photograph— will appear. Such choices begin with the sheer decision to aim the camera in the direction of a certain event or certain individual, and range through decisions relating to the selection of colors employed or the angle of the shot that will determine the tone of the frame. But even when a photograph is staged in all of its particulars, so that these decisions are highly controlled and highly rigid, the photographer still employs a camera and people are still present in the situation alongside her: they, in fact, stand before her. The co-presence of individuals at the time that the photograph is taken is admittedly usually managed in accordance with the ritual of photography, but it is never totally subordinated to the latter. The space that extends between them, and subsequently the space that extends between them and the spectators of their photograph, is a political space where human beings look at one another, speak and act in a manner that is not solely subordinate to disciplinary constraints, nor to ones of governance. In the face of images of dispossessed Bedouins in the Negev or of Palestinians bereft of all possessions in the caves of Mount Hebron, sentences like "The photographer is not genuinely interested in the people she has photographed," or "We sense that she is infatuated with the textures of dispossession and she is, in fact, exploiting her subjects" relate to photographs as if they were images produced by a lone individual. Such assertions negate the presence of the persons photographed and the relations of reciprocity that exist between them and the photographer. The power of artistic discourse (both in flattening out the presence of various participants in the act of creation so as to render them mere shadows, as well as its attitude toward the artist's gaze or to his touch as bearing the exclusive traces of his presence in the work) is so strong that it sanctions its devotees to look at paintings, not to mention photographs, without knowing anything whatsoever about the woman "with the yellow complexion" (Manet's "Olympia") or about the woman whose son's or daughter's hand has become imbricated in her portrait mere hours before her execution (Kong Sa'aan of South Korea).[25] Artistic discourse (particularly where photographs are concerned) requires enormous power to accrue to it, achieved through long, persistent and ongoing training, in order to negate the presence of the photographed subjects who look out from the photograph as well as to negate the testimony borne by their presence there (a testimony not necessarily linked to the concrete circumstances of production), to the effect that the photograph is never merely the product of the artist's mastery of raw material.

The photograph is the locus of appearance where an encounter between people is registered that is neither closed nor completely defined at the time that the photograph is captured. As I have stated in the first chapter of this book, their encounter may in fact continue to unfold and may be constituted anew through the inclusion of additional people who were not present at the time of the shot—people who now catalyze the second event of photography. This second round of engagement with the photograph is a permanent option for spectators who are personally acquainted with the subjects who have been photographed and who see themselves as their partners in practice, whether voluntarily so or not. From a historical point of view, it is true to say that the photographer did indeed inherit the role of the artist as the author of the image, thus monopolizing ownership of the photograph at the expense of the individuals who came together at the time of its capture, so that the photograph now becomes "his" or "hers" alone. But the space of possible relations between the photographer and the people she photographs is not hereby exhausted. The photographer merely fixes, through her image, a fleeting instant of the encounter in this space. Over and above the aesthetic form of the image, the photograph always preserves traces of the gaze and action of additional protagonists. By virtue of this fact, the photograph becomes a kind of singular point whose reservoir of actions may be reactivated and may return to life in a manner that contradicts those sanctioned within the discourse of art, and which may even contradict the intentions of any of the original players engaged in the event at the moment of its unfolding.

The third claim consists in the following: As already stated, it is not possible to make of "the political" an attribute of the image, not even when the content of a given image engages with explicitly political matters. Being-political, even in its most restricted form, is incompatible with the individual attributes of any given image or any individual person. The state of being political, in Hannah Arendt's terms, exists only insofar as people exist together in public, and it ceases to exist when they part ways. Once the presence of photographed subjects is brought into consideration, it is hard not to see that the space where the image is created, like the space from which it is viewed, is indeed a plural one. Even where a photograph is devoid of people, the surroundings in which it was shot will always consist of surroundings that people created to inhabit; surroundings they crafted and within which they operate.[26] Whereas the space within which people act is, as we have stated, always a political one, the photograph is not political in itself except to the extent that people make it exist among themselves, in plurality, in public.

Two Paradigms

Upon public presentation of these three claims, through which I have sought to demonstrate what is foreclosed by the third judgment of taste based as it is on the apparent opposition between the aesthetic and the political, I have often been asked whether "there might not be something castrating" that eradicates any possibility of distinction in the implications of my argument (or what is taken to be my argument) that "everything is political" or "everything is aesthetic." The very phrasing of the question shows itself to be tied to the paradigm of art with a veritable umbilical cord. It partakes inevitably of the foundational assumption that "the political" and "the aesthetic" are qualities whose presence or absence in certain images is that which enables images to be differentiated from one another and creates the possibility of an adjudication of the achievements of whoever created the respective images. My claim is not, however, that "everything is aesthetic"; rather, I claim that every image is ontologically part of the aesthetic domain (because this is how it is given to our senses). Nor do I claim that "everything is political"; rather, I claim that every image results from the actions of multiple participants who play various roles in its production and dissemination. It is the relations between such participants in the world of action that create a political space. This claim is incompatible with the paradigm of art. It belongs to a different paradigm altogether, which may be termed, at the risk of generalization, the paradigm of visual culture.

What are these two paradigms exactly—that of art and that of visual culture—and what are the relations between them?

I will present the differences between the two paradigms through comparing four basic categories that are common to each: the image, the artist/creator, the referent and the spectator. I will then proceed to analyze the different status of each of these categories within the framework of the two paradigms.

The Image

The discipline of the history of art, as well as the discourse of art itself, both place the work of art at their center as the object of display, criticism and contemplation. The work of art is held to be the source of all activities in the field; that is to say, the artistic object supposedly constitutes the point of departure and point of summation for all discourse and action in the field of art.[27] The resultant closure of discourse and action has two direct consequences:

1. As the particular utterance under consideration, the work of art is supposed always to fulfill the role of first and final utterance in the continuum of utterances within which it partakes. Thus an event (Land Day, commemorating the killing of Palestinian demonstrators protesting a major land confiscation in March 1976) or a person (Yitzhak Rabin) are able to serve as the point of departure for an exhibition only after artistic works have accumulated around them, enabling the curator to extract the relevant series of utterances that will be put on display in the exhibition. Similarly, art criticism is also expected to orient itself toward prior images and to be informed by them, so that a deviation toward a "foreign" image can take place only if it can ultimately be assimilated within the reservoir of existing images already familiar within the field of art. Interpretive deviation will be unacceptable on precisely these grounds.

2. "The political" is narrowed down to a metaphorical claim regarding that which the work of art "does": "The work of art deconstructs the conventional representation of women" or "The photograph disrupts our ability to relate to the state as a sovereign entity." By way of contrast, the speech and concrete actions of participants in the relations of exchange surrounding the image are not taken into consideration except as the means to achieve a single goal: the illumination of the meaning of the work of art and its preservation as the center of gravity of activities in the field. This has the advantage of eliminating a potential threat in advance—namely, the threat that the relations between different individuals who participate in the exchanges to which the artwork is subject will deviate from the hierarchical templates that have come to govern them.

Within the paradigm of visual culture, on the other hand, the image is not the *telos* or sole object of investigation, and the order of utterances under consideration does not have to begin and end with it. The discourse of visual culture is not obligated to precedents in the history of art, nor is it necessary to return to them as points of reference or to respect the links that bind them. For visual culture, the image is the source of special knowledge regarding the conditions of possibility of the gaze, but it is never sufficient in and of itself. Discussion does not end with the image nor is it circumscribed by the image. Rather the image is always the point of departure for a voyage whose route—the route of the utterances ramifying off from the image—is never known in advance. It may be a circuitous one unfolding with unexpected twists, and it may also cross specialized fields of interest where the image in question is actually deployed. In the

discussion of the photograph, for instance, the reconstruction of the situation in which it was produced—a situation whose traces are always present in the image—is essential. But this reconstruction does not have a predetermined role or pre-given place in the eventual series of utterances.

The Artist/Creator

The status attributed to the artist in the discourse of art reinforces the status of the work of art as source. Even in instances where critics recognize the historical-hermeneutic dimensions of the reception of a work of art, the third judgment of taste (like its predecessors) subsumes within itself a form of relating to the image as a finished product created by an artist, as if everything that it is possible to say with reference to the work of art were already latent within it from the moment the artist signed her name to it. The judgment of taste thus determines the status of the work of art in the field of art, while its speaker generally denies the degree to which her engagement in this process is an active one and refers agency back to the artist as someone who has succeeded in, or failed to, make her work become this or that.

Within the paradigm of visual culture, and particularly where photography is concerned, it is not possible to restrict that which is visible in the photograph to the original intentions of the photographer. This is the case even when the photographer exhibits her work in spaces governed by the paradigm of art where she enjoys the privilege of being seen as the sole author responsible for everything present in photographs attributed to her agency alone. The discourse of visual culture insists on making present all the information that can be gleaned from what occurs in the photograph as well as concerning the people who appear in it. The latter invite us, or exhort us, to relate to them, and require that we exchange one form of gaze for another. Reading this appeal sometimes involves relinquishing a contemplative or scholarly gaze in favor of what I will shortly be exploring as a "practical gaze." Most of the time, it is necessary to move from one form of practical gaze to another. The practical gaze takes into consideration the possibility of multiple gazes converging on a photograph—whether that of the spectator or those of other participants. Every gaze renders concrete the extent to which what is seen in a photograph is never a fixed quotient that is instantaneously transmitted. Rather what is visible is the continuing effect of the gaze that contemplates it as well as of its practical context. For visual culture, the image will appear as the seal—forever provisional—of actions or of traces that are available for reconstruction. It will continue to generate new utterances with respect to

the gaze, speech and action. The paradigm of visual culture asks what kind of gaze the spectator will return to Aisha al-Kurd in her photograph that is reproduced on the cover of this book. The spectator's choice of an additional utterance to which she will link this woman's figure—whether this utterance is visual or textual[28]—and whether it is an utterance indebted to La Pietà or one that resonates with the experience of other victims of the Israeli Occupation, will be part of the constitution of her practical gaze. The same will apply to the decision to ignore the event of photography or to reconstruct it and to include the photographed person, as someone who appeals to a potential spectator, in the reconstructed protocol. It is, in fact, the linking of the photograph to other utterances that determines what will become available to the gaze and under which conditions. The gaze is sometimes required to determine the fate of real individuals. Thus, for example, at certain moments, the type of gaze directed at a "wanted person" on the part of the security forces will become complicit in constituting the space wherein his image appears—a kangaroo court or in an open public space. When the security forces mark someone whom they term a "wanted person," often with the help of photographs, they in fact condemn him to death without trial. The distribution of his photograph to soldiers in the field is the beginning of a countdown to death. But when the "wanted person" commissions his own portrait or participates actively in creating it, as in the case of Zakaria Zubeidi who poses before Miki Kratsman's lens, it becomes possible to disrupt the visual field that frames him and the type of gaze that the spectator will direct at his photograph.[29] The active participation of the photographed subject in shaping the space of the photograph, as well as in fashioning his own portrait, enables him to shift the scales of the final outcome.

The Referent

The very use of the term "referent" is itself deviant, jarring and devoid of any standing within the paradigm of modern art. The analysis of the visible within the discourse of art is not bound in the least to the referent of the image. Decisions such as opting to place circumscribed evidence of that which is visible in a painting at the center of the discussion, or to consider its relation to the referent of the image, or to investigate the circumstances that enabled the coming into being of a work of art, are usually half-hearted. The most immediate and most frequent channel for the treatment of the image in art discourse devolves back upon finding precedents for the image in the history of the field. When analysis exceeds

the parameters of art history, it moves within circles of visual association that expand the context of the image in general, rendering any direct and explicit investigation of its referent and the circumstances of its creation superfluous. The identification of visual similarity—"This is like . . ."—is exceedingly common in the discourse of art, both as concerns curatorial practice and as concerns interpretive practice.

Visual culture responds differently. It does not evacuate matters concerning the referent of an image from the discussion, nor does it ignore the manner in which the referent leaves its traces in the photographic frame. It does not preclude consideration of the specificity of the medium or the tools that enabled the production of the image and that simultaneously imposed certain restrictions and constraints upon it. On the contrary, the reconstruction of such factors shapes the manner in which it is possible to speak of the image. Work in the paradigm of visual culture is not the preserve of the researcher alone. Artists, photographers and curators work in the field as well. Donna Ferrato's volume *Living with the Enemy*, photographed in the 1980s, is a journey that began with the post-traumatic contemplation of a photograph that she had shot in the home of a couple named Lisa and Garth for *Playboy* magazine in Japan. Ferrato describes the blindness that descended upon her when faced with the first photograph that she had somehow captured in the series. This is a photograph that depicts a man beating his wife: "When I first saw Garth hit Lisa, I couldn't believe my eyes. Instinctively, I took a picture . . . at home I threw the roll into a drawer and, because I didn't know how to respond to the events of that night, I tried to forget the whole episode. As the months went by, I tried to convince myself it had never happened."[30] Only after the passage of time, when Ferrato was able to overcome her bewilderment and to find words to describe it, was she able to contemplate the photograph once more and to recognize its referent. The image became the first of a series that she shot in jails, apartments, police stations, rehabilitation centers and other locations in the attempt to conduct a systematic investigation into a phenomenon that was then still without recognizable visual templates and that was only just beginning to be named: "Battered Women," or "Domestic Violence." The men and women whom Ferrato photographed are present through their photographs in a space that the photograph opens up to viewing, speech or action. These men and women exist there together with Ferrato. The discourse of visual culture does not privilege them over the photographer in advance, or vice versa. Rather it is interested in reconstructing their being together, in analyzing the event that gave rise to the photograph as well as the role that each protagonist played within it. The photographer

does not enjoy the power of a demiurge that might enable her to render the people she photographs into subjects or objects of a certain kind. Rather photographer and photographed subjects are to be found here together, present in different ways, capable of leaving traces on the basis of which different utterances can be extracted, articulated and connected to one another, or to other kinds of utterance, in a manner that allows them to continue to participate not only in the act of photography, but also in the political space that the photograph elicits, in accordance with the principles by which it operates.

The Spectator

In the context of the paradigm of art, the spectator plays an active role in judging art and in determining the fate of the image in the public discourse in which it takes part alongside all that which it puts on display there. Paradoxically, when a spectator asserts for example that Micha Kirshner's photograph of Aisha al-Kurd, who faces the camera with a baby on her lap, constitutes an "aestheticization of the suffering of the Palestinians," and when she seeks thus to curtail discussion of the image, she denies her own active role in restricting the boundaries of the photograph to the niche of the aesthetic and sees herself as passive in the process of producing that which is actually available for arbitration. She implicitly requires that the image activate her in both the aesthetic and political realms simultaneously, and she might even expect the work of art at certain rare and climactic moments to succeed deus ex machina in changing the world. Such a spectator expects to be aroused by the work of art, moved by it, fascinated by its aesthetic dimension or recruited by its political dimension. Within the paradigm from which she operates, the paradigm of art, the answer to the question of whether or not such rapture will take place is not perceived by the spectator to be dependent on her own agency, but is held to reside in essential characteristics of the work of art itself.

For visual culture, on the other hand, the spectator uses the photograph firstly as the source of information. It is a document, a testimony, a certificate, a means of making a certain situation present for spectators who might belong to a different time or place. The types of use to which the spectator puts the photograph do not allow her to assume the role of someone external to the interpellation of a certain address, someone in thrall to an image that is, itself, eventually emptied of interest. Within the paradigm of visual culture, the spectator is indifferent to the status of the artwork as source, and she is therefore free to link it to other utterances of different orders altogether. Thus the image itself becomes only one

utterance in a chain of utterances and it participates in a space that is inexorably political, if only because the spectator must encounter other spectators there, none of whom has the status of final arbitrator. The mere admission that "the political" is not an essential characteristic of an object, and therefore that the image, the artist and the spectator cannot themselves be political in isolation from one another, can itself motivate the spectator to recognize the existence of a common domain and to ask questions regarding not only what is put on display within it, but also regarding the actors who are authorized to participate in it or who are banished from it; as well as regarding the influence of such permits and interdictions to influence that which is visible to the gaze.

These four differences contribute to the shaping of two distinct paradigms. It is important to emphasize, however, that the two paradigms are not wholly separate given that some of the practices, institutions, forms and concepts that characterize them are common to both. The easily assimilated formula regarding the "tension between the aesthetic and the political," which often serves players in the field of art, might at first glance be applied to the relation between the two paradigms. It is an erroneous description, however, since it reduces the differences operating at the level of the conditions of discourse to differences relating to the products of these discourses. In other words, the ready-made formula locates this tension in the works that are presented for evaluation. I seek to emphasize that the differences between the two paradigms are substantive ones. The first paradigm is connected to the realm of art, as we have already stated, and is perceived as the more senior of the two. The second paradigm is connected to the study of visual culture, which only became institutionalized as an academic field over the course of the last thirty years. But when the development of visual culture is surveyed from a historical point of view, as I shall immediately proceed to do, not solely from the vantage point of its being an academic discipline, then the estimation of its age differs considerably. My suggestion that the inception of visual culture be identified with the invention of photography undermines the automatic privilege bestowed on the discipline of the history of art.[31] It is necessary to emphasize from the outset that visual culture cannot be reduced to photography, just as the differences between the two paradigms—of art and of visual culture respectively—cannot be stabilized through the means of photography. This having been said, photography nevertheless plays a crucial role in the relations between the two paradigms, as I will show. It serves to highlight some of the most crucial differences between them. The two cannot be reduced to a single unified paradigm.

What Is Visual Culture?

The ahistorical approach to visual culture sees it as the continuation and extension of the field of knowledge known as the history of art. According to this approach, visual culture is a mélange of referents, objects or images, present from the dawn of time, given that human beings have always created visual surroundings for themselves. These surroundings are composed of buildings, gardens, crafted urban spaces, useful tools, decorative objects of all kinds, paintings, sculptures, theatrical performances, ceremonies, articles of clothing, manners and customs and so on. In this account, the study of visual culture includes the investigation of architectural works, as well as paintings, sculptures, texts and gestures that have accompanied human endeavor from its inception. The founding assumptions of the ahistorical approach point to the fact that human beings have, from the dawn of history, created objects destined to be seen, to symbolize, to represent, to convey messages or even to give pleasure to their spectators. In addition, the strong visual dimension of these various objects, it is held, eliminates the possibility of reducing their purpose to mere instrumentalism.

This type of ahistorical approach to visual culture is erroneous at its core. Although it might expand the spectrum of objects deemed worthy of investigation, its trajectory remains loyal to the classic research paradigm of the history of art that distinguishes manufacture having an artistic intention, demonstrating talent, informed by style and so on, from manufacture that is devoid of such characteristics. This template assumes the existence of a reservoir of visual objects whose meaning is seen as independent of the conditions that enable them to be viewed and it is indifferent to the historicity of the manner in which they are understood as well as to the means through which it becomes possible to investigate them. In the past, objects and images existed within certain more or less defined and discrete practices, norms, discourses, and institutions: drawing, sculpture, architecture and so on. Scholars researching these fields have divided them and have failed to see them as part of one cultural totality. Visual products have generally been treated as embedded within given practices and traditions of painting, sculpture or architecture. They have been seen, to no lesser extent, as bound to the specific locus of their production, or to that of their use or consumption: namely church or palace, one city or another.

Visual culture is not solely concerned with objects or images. It is interested in all aspects of human existence and seeks to investigate it through

attending to the manner in which it is laid out and organized for the gaze. Visual culture is interested in scopic regimes and in their provision of different frameworks within which human beings act on the world. A retrospective survey, like that offered by visual culture, enables us to become aware of the centrality of the visual dimension of various products and practices that are best investigated on the basis of the assumption that they are objects of the gaze, assumed to partake of and to deviate from the contexts within which they were created, categorized, activated, used, consumed or displayed. Deviation from context is necessary because visual culture comes into being in defiance of foreclosures of context that political or disciplinary boundaries historically imposed on what is permitted to be seen or what is held worthy of being seen; how it is worthy of being seen; what research agendas may be formulated with respect to the visible; how objects of the visible may be reorganized and how it is possible to intervene among them. At the same time, it is necessary to preserve and/or restore a context because visual culture assumes that the objects in relation to which it poses questions are always embedded in a context at least partially different from those which their creators or commentators within various traditional fields of knowledge attribute to them. At the center of visual culture, therefore, stands a new type of practical contemplation of the world, which I shall distinguish both from the contemplative gaze and from two other forms of practical gaze, which I will delineate at length in the discussion below. Unlike the scholarly or contemplative gaze, the various forms of practical gaze are not uncoupled from the fields of practical action in which they are invested, and do not aim to achieve pure contemplation. The practical gaze operates and is operated upon in mundane settings, and is interested in the world that it creates and in whose fashioning it participates.

Visual culture, understood as a field of research centered on the capacity to direct a practical gaze at the world, only became institutionalized fairly recently, that is to say during the 1980s. But the feasibility of its constitution emerged 150 years previously at a period when it became possible to isolate the referent of the gaze from three additional sets of factors:

1. From the concrete place where the referent (object or image) was located, from the event of its creation, and more generally from the determinate context—historical, cultural, practical or institutional—within which it was created.
2. From the cultural context within which the referent was transmitted for use or for viewing (or for viewing while being used).
3. From the value invested in it in this context.

A New Relation to the Visual

What makes this isolation possible? The answer is clear: *The invention of means for the fixing, copying and mobilization* of images, with photography foremost among them, from the 1830s onward. It was at this time that the conditions emerged that enabled establishing a relation to the image outside of the context of its production and consumption. It now became possible for a detached survey of body parts, buildings, objects and events to come into being. Images created within different fields of art or other forms of endeavor could be compared, at different times and across different locations. New visual information influenced by the size of the lens, the speed of the shutter, the mobility of the camera, its proximity to its subjects, its potential for repetition, the involvement of photographed persons in the production of this information, the speed of image production and the capacity to collect information systematically over time—all these factors created a new configuration of the existing gaze.[32] I thus seek to position the invention and dissemination of photography as the moment in which visual culture emerges into view, despite the fact that it would take decades longer to evolve as an intelligible field of research in the framework of a new academic discourse: the study of visual culture.

Photography enables the emergence of a new kind of gaze not only with respect to products produced intentionally as images or as objects of the gaze but also with respect to the way in which people viewed themselves and those around them; with respect to the situations in which they found themselves and within which they acted on the world; with respect to their lifestyles and their surroundings; with respect to the happy occasions that excited them and the catastrophes that befell them. All of the latter emerged as objects of an analytical gaze, one that compared, categorized, organized, interpreted—outside of the rules of classified and hierarchical disciplines associated with discrete fields such as painting or architecture or research in the history of art or anthropology. The new technology of photography was revolutionary to the extent that it created a common and homogeneous platform of use, which people mobilized simultaneously, without advance planning or coordination, in order to transform an unprecedented plethora of objects into images, visual material. From the very moment that depictions of nudes or of landscapes, wigs, bathing ceremonies, details of construction, consumer habits, disasters, postures, work conditions or table manners were enclosed in the photographic frame, they became the object of a

visual interrogation that allowed them to be related to a vast range of objects within the plethora of possible objects that visual culture brought into being.[33] Photography allows for the emergence of a *new relation* toward the visual. It allows us to relate to the image without subordinating it, or the surface appearance that might be extrapolated from various bodies, objects and actions solely to the rules and hierarchies deriving from the practical or symbolic field within which they were created.

In order for this new relation to emerge it was not sufficient for a new technology capable of registering images, rendering them permanent and also detaching them, to come into being. Had this new technology been very expensive or very difficult to use, we can assume that access to images would have remained open solely to a small group of devotees who would soon have created a culture of experts with its own rules of admission and classification, standing and exclusivity, so that photographs would have joined paintings as the province of an entirely discrete cultural field. But a new relation to the visual became possible precisely because the new technology was accessible to masses, at least as spectators. It became rapidly possible to use this technology to create products in a relatively simple format that were portable, amenable to display and dissemination, and relatively economical in terms of time of production and ease of storage.[34] Thanks to the new technology, as well as to its accessibility, the separate existence of the photographic image became possible: an image detached from the situation in which the photograph was created, not to mention from the context in which the material it frames was, in turn, brought into being. By virtue of the new technology and its mass accessibility, it became feasible to detach that which was photographed from the photograph itself, and the photograph from those people who had participated in its production, so that the image could be disseminated far beyond its original place and context to a degree that deviated or threatened to deviate from existing property relations and relations of authority, as well as from established procedures for producing value, interdicts and traditions. In manifesting such qualities, photography created the conditions for the emergence of a new relation toward the visual.

Visual culture is not a form of manufacture. People who produce objects, images and situations do not create visual culture even if objects of visual research are created in the wake of their organization and the reciprocal relations between them. Most people engage with the visual field, in the broad sense of the term, even if they are unaware of this. Their involvement occurs whether they are manufacturing appliances,

decorative objects, works of art, pictures, postcards or posters, and whether they are engaged in the practice of law, medicine, security, politics, education or indeed any other field of endeavor. Most people are unaware of the importance of the visual dimension of their activities or of the fact that they are partners in a scopic regime that determines what is permitted to be seen, who is permitted to see and to put the visible on display and how seeing and display should properly be conducted. We might say that the beginnings of visual culture are to be found in a certain relation to the manner in which things offer themselves up to the visual. This special form of relation does, no doubt, evolve over time into the professional field we know as visual culture, a field that conducts research in much the same way that other fields of research conduct themselves, that is to say on the basis of professional competence, rules, habitus, professional jargon, permits and interdictions, authorities, rules of conduct, means of sacralization and so on. But this field of professional endeavor does not exhaust the relation toward the visual as this developed outside of professional conduct on the part of people who do not necessarily desire to assimilate such a relation to the visual as part of their professional competence, but who experience it nevertheless. Despite the fact that this new orientation toward the visual would eventually result in the establishment of a discrete field of knowledge, I suggest that we think of it beyond these confines, and in relation to other forms of disposition toward the visual. These other dispositions constitute that which I shall term, in the wake of Hannah Arendt, "the practical gaze."

What Is the Practical Gaze?

Human beings have always stood in a certain relationship to the visible. The world surrounding us has an obvious visible dimension, and humans equipped with sight are able to operate in the world largely thanks to the way they see it. The traditional distinction between the life of contemplation (*vita contemplativa*) and the life of action (*vita activa*) allocates a special province to the observing gaze—an absorbed, surprised, astonished gaze; one that tarries aimlessly in the face of a particular landscape or figure but always seeks passage through the veil of the visible to the essence of things. Since the period of Greek antiquity, abstract thought has always been conceived through the metaphorization of this gaze: theory, speculation, scrutiny, things that people understand or imagine in their mind's eye—all attest to this. But it is equally to the point that the relation toward the visible world has also always existed in two

additional forms that do not belong within the world of observation at all, and are in fact closer to the world of action.

The gaze is also an integral part of the world of action. It inheres within instrumental activity that strives to achieve goals, to become more efficient and more sophisticated. Hannah Arendt, who revisited the classic distinction between the life of action and the life of contemplation, distinguishes in her volume *The Human Condition* between three forms and three realms of action. The first, which she terms "labor," comprises activities aiming to supply basic existential needs, to allow for survival and for the reproduction of life. The second, which she terms "work," comprises activities that create products that do not serve basic needs and are not exhausted in immediate consumption: such products include appliances, tools and parts that may serve to create other products and may eventually participate in the creation of a whole world, ordering human life on the planet and allowing humans to render the planet their dwelling place. The third, which she terms "action," is a kind of deed that does not produce anything in the final analysis and does not implement a preexisting plan. Action represents the individual's audacity in daring to create something new in speech, word or action or by means of speech-as-action. Action brings the new into being in public, in plurality, and the agent of this new beginning is exposed in public, to the public. Action always takes place in plurality and is exposed to plural responses; the individual can never predict the outcomes of his action nor control the manner in which it evolves in the world.

It is on the basis of Arendt's distinction between the three categories of the *vita activa* that I seek to characterize the gaze and, in so doing, to contest the evacuation of the gaze from the realm of action and its consignment to the world of contemplation. I suggest that we differentiate between three forms of practical gaze. Its first two forms are very widespread: the first is the gaze that identifies and orients itself and it parallels what Arendt terms "labor." The second is the professional gaze that accompanies certain types of action and guides them, and it parallels what Arendt terms "work." The first gaze is part of the practice of orientation and survival that is based on the mechanism of identifying the visible. Like labor, it constitutes a condition for our very being. The individual observes her surroundings in order to locate herself among them, in order to direct her movements, to identify objects, animals and other people whom she encounters, as well as in order to judge their intentions and appraise the risks or opportunities that are latent in the encounter with them. The second gaze that might be termed a deliberate gaze characterizes professionals (doctors, artists, members of the police, seamstresses, architects,

politicians, educators and so on). It allows the viewer to organize the visible world and to control it by means of knowledge that is accumulated in an evolving and continuing fashion. This professional gaze is not fundamental to survival but to the regulation of certain kinds of action and to the analysis of situations and events, to the processing and ongoing use of data or to the coordination between hand and eye—situations where action is freed from the immediate satisfaction of need and is deployed in the service of higher purposes.

The orienting gaze and the deliberate gaze, which run in parallel with the first two categories of the world of action, have accompanied human existence from the very inception of culture. Until the invention of photography, however, it was difficult to identify a form of gaze that might parallel "action" in the sense that Arendt bestows upon the term. Until this time, the practical gaze was a kind of orienting gaze that served the interests of survival; or it was a professional gaze capable of directing distinct actions that enabled the world to be subjected to human dominion. The third form of the gaze, distinct from the other two, comprised that which was split off from the world of action altogether—the observing gaze, the astonished gaze, the gaze that tarries over its object in order to transcend it and to reveal the truth behind the visible. With the invention of photography, a new relation toward the visible came into being—one which may, admittedly, have existed partially in the past but not in precisely the same fashion or with the same frequency. The fairly simple possibility arose of sharing a certain space with other people and objects without having to be physically present beside them in the same place. This new relation to the visible is in effect a new relation to the visual dimension of existence: it consists in a relation to objects, situations, customs, figures, images or places that had formerly not been deemed worthy of viewing in their own right. It comes into being between people in the plural, in public space where the participant does not hold the stable privilege of remaining merely a viewer. Anyone present in shared space is at one and the same time the spectator of that which she sees and is exposed in her own right to the gaze of others. Such a relation to the visual deviates from the disciplinary gaze, just as it deviates from templates of communication that are known in advance. Its primary characteristics run parallel with action as Arendt defines it: no one has exclusive authorship over her own gaze. The gaze is not a means to an end and does not manufacture any kind of products. Nor is it bound to the rules and conditions that characterize the first two domains of the *vita activa*. Every gaze is always exposed to the gaze of the other and its sense changes in accordance with their reactions.

Visual Culture and Photography

Considered as a field of knowledge that has new objects at its center, visual culture bases itself, as we have already claimed, on a new form of relation to the visual and on different types of visual items that are also partly new. Photography, as a technology of image (re)production, constituted a determinate condition for the evolution of visual culture, although we have already noted that photography as a practice or technology cannot be rendered equivalent to visual culture. The study of visual culture regards photography chiefly as another source of visual images, which are offered for investigation. The users of photography, millions of people across the world, are indifferent to the field of knowledge termed visual culture and are mostly unaware of its existence as an academic discipline. The community that relates to this discrete aspect of images and objects and sees in them the potential for research is an academic or professional community of knowledge. Since the institutionalization of the field as a discipline at whose core is a new relation to the visual, this community has labored to develop and to refine various forms of competence in visual research and has established research tools, bodies of knowledge and institutions of production that produce and circulate knowledge. Membership in this community makes this knowledge accessible to others by means of exhibitions, albums, visual essays, professional literature, visual dictionaries, Internet sites and films. I belong to this community— the community of researchers in visual culture—from the point of view of my professional standing. Were I committed to researching the animal world, I would belong to the community of biologists or zoologists. The community of researchers in visual culture is a restricted one, which like any other professional field has become institutionalized over time so that no small amount of rules of behavior and codes of conduct attach to it. Here it is important to note that this community differs from the community of users of photography that I explored at length in my previous book *The Civil Contract of Photography* as the "citizenry of photography." Anyone who stands in any relation whatsoever to photography has membership in the citizenry of photography—by virtue of the fact that she is a photographer; that she views photographs; comments on or interprets them; displays them to others or is herself photographed. Despite the fact that professional categories tend to divide between amateur and professional photographers, aerial photographers or press photographers, and even between random subjects of photography (someone who happens to find herself in a disaster zone, for instance) and trained subjects (such as

the Isabelle Huppert who collaborated with numerous photographers on the production of "her" image), the community of photography is not organized in accordance with these distinctions. The community of photography is today dispersed throughout the length and breadth of the world. It is a community that has been breached and lacks stable or permanent boundaries. The relations between its "members," moreover, are not based on any shared professional interest in the medium of photography. The interest displayed by members of the community of photography is, in fact, an interest in the referent of photography, but not as the latter appears when interpellated by one or another kind of professional gaze, which bounds and frames it in advance.

Civil Characteristics

In *The Civil Contract of Photography*, I described the characteristics of the citizenry of photography and pointed to a different kind of political space that is associated with it, a space that is not dominated by the pole of sovereignty. It is possible to identify many configurations of control and domination in this political space, and even to reconstruct aspirations to sovereign rule within it. But these are configurations of professional control—artistic, political, scientific or otherwise—whose forms of the gaze, speech and action that they set in motion belong to the second realm of action, in Arendt's terms. They are always circumscribed, temporary, applicable within a limited professional field and destined to be violated and to fail in achieving their desired goals. The preordained failure of the aspiration to sovereign control may be attributed to various factors and may be described in changing terms. The citizens of the citizenry of photography as well as the agency of the camera are that which frustrate any sovereign aspirations. The citizenry of photography constitutes a special laboratory for the study and analysis of political relations. It enables us to see how the forms of gaze, speech and action of citizens mediated through photography are not wholly subordinate to sovereign sanction and often bypass, suspend or evade such sanction. This feature, essential to the third configuration of the practical gaze, is thus identified as existing among the citizenry of photography.

In contrast to the first two configurations of the gaze I described, this form of the gaze is independent of any research or academic interests, instrumental or professional ones. This is a distinctly modern form of the gaze that crystallized as the result of the permanent and ongoing encounter of human beings with photographs whose referents differ from one another and are continuously replaced by others; or ones which subject

the visible to a different play of proportions, sending their spectators to the Land of Lilliput sometimes as dwarves and sometimes as giants, spectators and subject to the gaze of others consistently denied the possibility of even momentarily looking at the world through a classical optical cone. This type of gaze is distinguished by its randomness and superficiality—where the latter term insists on the outward surfaces of things. Most of our encounters with photography are not prolonged beyond the instant of random encounter and exist within the framework of what might be called the gaze of leisure or entertainment. I am not using "leisure" here in the sense of time free of work but in order to characterize more precisely a sort of everyday aimlessness, one that wanders contingently, the effect of a culture of visual plenty. I intend us to reference a gaze that does not seek out anything in particular, is not disturbed by that which it sees and does not seek to achieve anything in particular from deploying the visible. The configuration of this gaze is characterized by a kind of skimming the surface of the visible; an easy passage from picture to picture that does not necessarily stop to decipher—even partially—the content of the visible; an encounter with the external surfaces of things and with their visual dimension. This encounter can rapidly become a sort of lingering or suspension. The act of lingering over the visible can be yoked to the professional interests that characterize the second configuration of the gaze, but nothing makes this subordination inevitable. The contrary is also true. The event of photography that gives rise to this kind of gaze is an event of plurality subject to no sovereign. No one can bring it to a close. No one can wholly isolate it from the conditions of multitude in which it subsists. It has the potential to call to account protagonists who seek to exclude others; to make present protagonists who have been subjected to processes of exclusion; and to put the very strategies of exclusion on display. It is on these grounds that I suggest that this third form of the gaze, one which has evolved out of photography and in close affinity to it, is the equivalent of the notion of action in Arendt. I seek to position it as bearing a civil potential.

Arendt distinguishes action from other activities since it occurs in the space of human plurality. But, in the present era, this characteristic is common to all the realms of the *vita activa* such that it is necessary to define what kind of plurality exists in relation to each one of them. The third form of activity, the one that I have just linked to photography, displays a relation that deviates from any identifying feature, hallmark, form of competence or template achieved within the framework of one or another specific area, field of knowledge or action, interest group, structure of governance or surveillance, or even from the unifying narratives of

a common history or shared cultural horizon. (For the purposes of this discussion, it does not matter whether we are concerned with delineating a national narrative or a coalescence of professional interests.)

Upon entry into the field of vision, the gaze of every one of the participants in the act of photography—whether photographer, photographed person or spectator—encounters the gaze of the others present in the field of vision as objects or as agents seeking to configure it. These other participants are usually expunged from professional discourse. They consequently become transparent. Their presence is conceived of as the effect of someone else. This is analogous to the doctor who does not discern the presence of the radiographer in the slide that he attempts to decipher. Or it is akin to what happens when a spectator at an exhibition relates to the persons photographed there as the effect of the special gaze and talent of the photographer. It is important to emphasize, by way of opposition, that the additional participants who play a role in the act of photography are present even when they do not stand revealed before the gaze of the spectator. They are present as citizens and they demand a civil relation. When they are rendered absent, we can assume that a certain act of expulsion or denial must have been implemented. These violent acts of expulsion have so thoroughly been naturalized within the acquired habitus of the discourse of art that their implementation does not even leave traces in memory. But when the act of viewing exceeds a habitus that seeks to restrict it to gazing on the finished product of the photographer, then the plurality of participants involved in the act of photography (photographer, photographed subjects, spectator) as well as the plurality of elements that seem to have "infiltrated" the frame whether in accordance with the intentions of the photographer, against her intentions, or irrespective of her intentions—all these demand to be taken into account. The expulsion or denial inherent in the conventional templates is what makes possible the restriction of this plurality and its subordination to the logic of the orienting or the professional gaze. The third form of the gaze, not beholden to any professional habitus, enables the spectator to realize the civil potential that the photograph makes possible and to activate a civil gaze that refrains from dominating the visible and that resists the attempts of others who might seek to erase this space of plurality.

Those Who Do Not Have a Stake

The third form of action does not require that the knowledge, skills and competence of interested parties institutionalized in various frameworks be negated. Rather, it seeks a certain dislocation from these frameworks

and from the control they desire to exert over the areas of knowledge associated with them. By means of establishing a new relation to the visible, the third form of action renders present a public, a body politic, a sum total, a citizenry[35] of those who "do not have a stake" other than the stake invested in becoming public.[36] A community of stakeholders is usually *represented* by a certain body or sovereign power. The sum total of citizens cannot, however, be represented. Modern nation-states who bestow a civil status on their subjects presume to manifest and to represent their citizens as if this civil status were the essence of citizenship. But citizenship is the outcome of a hypothetical partnership between individuals that enables them to relate to one another as having equal access to this partnership. Any regime that seeks to subject such partnership to representation inevitably infringes upon it and cannot, therefore, be said to represent it. The foundational principle of partnership between citizens lies in the fact that they are not subject to sovereign power and cannot therefore be represented by it. Such partnership can at most be imagined by the members who participate in it. From the eighteenth century onward, it has been possible to imagine this partnership in different forms, as taking different directions and proceeding through different channels. All such imaginings constitute a form of taking-part in this citizenry and any such partnership presents an opportunity to imagine such a citizenry.

It is on these grounds that I characterize the third configuration of the gaze by means of its affinity to a citizenry and see it as configuring what I term a "civil gaze." This form of the gaze does not precede the other forms of the gaze, nor does it follow them. It is not subsumed within them and is not subordinate to the interests and constraints that guide them. This is not a primordial gaze, which a certain kind of discourse might term "human," as the expression of an innate or instinctive relation that binds humans to one another. Nor does it accompany other configurations as their belated appendix. No professional gaze (of the order of the second configuration) is required here—whether artistic, medical or political—as a precondition for its appearance. The plurality at stake is not human in a raw sense, that is to say, it does not refer to human beings in a primary state before any socialization, but it seeks to encompass a citizenry, a plurality of humans who are partners in concrete communities, having certain forms of knowledge and professional competence, possessed of various interests. No single characterization of this sort can exhaust their plurality, or the plurality of others who simultaneously share the world in its physical and virtual manifestations. Photography is one site where it is possible to discern the traces of this plurality that renders itself present despite, and in opposition to, the intentions of anyone seeking to establish

dominion, even a dominion so seemingly minor as control over the frame of the photograph. The spectator can always deny this plurality, as we have already pointed out, or bypass it in order to decipher the photograph by means of the first two configurations of the gaze. But the authority that the spectator enjoys is valid only within the field of knowledge or activity to which she belongs, and loses its validity in the broader arena of civil existence. Within the citizenry of photography, she cannot impose that which she sees—or does not see—upon others.

The Plurality of the Civil Asserts Itself

In January 2009, at the time of the lethal Israeli attack on Gaza, some twenty photographs shot by an Israeli soldier in Gaza made their way into my inbox. The titles appended to the files described what should be seen in the photographs: "The Orchard That Is No More," "Fighters After a Hectic Night," or "Collective Sleeping Arrangements in Gaza." The letter accompanying these attachments began thus: "We must be proud of our boys ... They are defending the state." It concluded with the recommendation—equally a form of license—to distribute the photographs.[37] The last two photographs in the series, "There Was a Brain," and "Hamas Member Relinquishing Possession of Himself to the Creator," were accompanied by a warning—"These pictures should not be viewed by children." The title of the email, as well as its accompanying text, expressed collective interest and membership in a certain community, the Jewish national community, and positioned itself in resolute opposition to anything not included within it or perceived as belonging to another no less identifiable community—namely the Palestinian national one. The concern for the first community, as well as the abandonment or renunciation of the second, as expressed in the display of photographs, is an effect of the convergence of certain closed forms of national and military discourse within whose framework the first two configurations of the gaze are activated.

It is possible to employ the first configuration of the gaze to identify what is visible in the picture: soldiers sleeping in Gaza (for soldiers must sleep, even in times of war). The picture depicts the tranquility of a domestic residence in the first light of morning, together with the bare walls and brightly patterned blankets that are characteristic of Palestinian houses. Through the mediation of the second configuration of the gaze, embedded within military or national discourse (the national discourse is itself a form of professional discourse), the house in question is perceived to be the house of the enemy. It is a position that must be captured for the

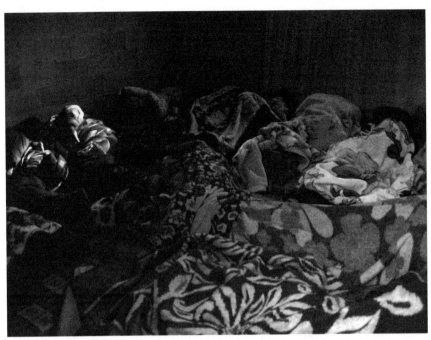

"Collective Sleeping Arrangements in Gaza" [photographer's caption]. Photograph by an Israeli soldier. 2009

purposes of attack or defense. Its inhabitants are perceived as hindrances to this task whereas the soldiers are seen as fulfilling a national mission of defense. But civilians also participate in forms of national or military discourse, as is also the case for any other bounded or discrete form of professional discourse. Their ability to deviate from what is sanctioned by professional discourse and to see that which occurs outside its parameters is largely dependent on the density of the cloth out of which the professional discourse is fashioned; as well as on their place within it and the possibilities it permits them or leaves open to them. The sender of the mail I received fails to deviate from the dictates of the professional discourse and to confront the catastrophe visible in the photographs. It is this fact, clearly, that motivates him to disseminate the mail to its various recipients on the assumption that they, too, are partners in the same discourse: "*We should all be proud.*"[38] All of the addressees in this collective mail were, needless to say, Jewish.

Can these blankets, which probably still retain the fragrance of their Palestinian owners, be reduced here merely to their practical dimensions— as the means to warm enemy soldiers during the cold winter nights of Gaza? Through adopting a different relation to the visual, one that tarries over colored blankets that do not completely cover the limbs of soldiers

poking out from beneath them, we can begin to return the gaze to a consideration of those who are missing from the frame, and to render present once again people expelled from their own homes in favor of the oppressive presence of foreign invaders. The colorful blankets in question will now appear before this gaze as intimate items belonging to the residents of a certain house who became homeless when uniformed soldiers violated their home and curled up in their blankets. The blankets constitute traces of the residents of the home, while the sleep of the soldiers who wrap themselves up within them similarly testifies that the owners have been expelled from their homes. These expulsions enable the Israeli army to create "sterile zones," that is to say, areas free of Palestinians, and to conduct a daily routine during which destruction is wreaked upon the enemy during daylight hours and the soldiers rest securely at night. The civil gaze investigates the context within which the photograph was taken and tries to reconstruct it. It takes cognizance of the fact that in order to allow the soldiers freedom of action during the day and to enable them to rest at night, the entire region had to be evacuated. The photograph does not allow us to reconstruct precise details regarding the size of the "sterile zone." But even in the absence of such information, we can safely assume that not only the inhabitants of this particular house were expelled but all the inhabitants of the region, so that the particular instance serves to shed light on a broader phenomenon.

The spectator who denies this evidence of civil plurality and who remains enclosed within the first two configurations of the gaze remains entrapped within a form of visual disorder that excludes her from the province shared by all-the-citizens (who are not necessarily the citizens of the nation-state) and removes her from the citizenry of photography. Within the context of national communities, this disorder often becomes a form of what I have called "civil malfunction"—a condition so thoroughly naturalized within the logic of the regime that most members of the community do not see it as a malfunction at all.[39] The nation-state should become the object of criticism when its aggression exceeds a certain threshold, as was the case with the last Israeli attack on Gaza. But for the most part, the nation-state, bound in alliance to other nation-states mainly through the mediation of the United Nations, enjoys the mutual reinforcement of other such states and the license they provide to harm those who are not recognized as their citizens.[40]

Civil plurality is one condition, therefore, for the third configuration of the gaze. But it is not sufficient in itself to render the gaze directed at the photograph into what I am calling a civil gaze. Rather a kind of civil intention is required if the plurality of participants in the act of photography—the

photographer, photographed subject, and spectator—is to be recognized, together with the plurality of elements that the photographer has deliberately introduced into the frame, or which have appeared there against or irrespective of her intentions.

The Invention of the Citizenry of Photography

The alternative narrative framework I am proposing is based on the claim that photography came into being at the moment when a named inventor lost the authority to determine the meaning of his invention and so, the question of *who* invented photography also lost its meaning. This was a period of time during which different technologies of reproduction—daguerreotype, calotype, phenotype, crystallograph, to mention only a few[41]—which various inventors placed at the service of the public during the 1830s began to escape the control of inventors, states or other patrons. In other words, "the invention of photography" refers to the creation of a new situation borne of processes of *encounter* where different people in different places succeeded simultaneously in deploying certain black boxes capable of producing images. What is crucial here is not the image but the encounter, not the encounters between scientific protagonists, but between the users of photography and the camera. This encounter, as described in the first chapter, presumes in advance the possibility of future encounters between the photograph it produces and the spectators who will subsequently congregate around it. The invention of photography is not, therefore, the act of any one person nor of a small group of scientists who succeeded in isolating certain chemical principles, synthesizing them and activating them by means of certain optical and mechanical devices. Photography was invented the moment a space emerged wherein a great number of people—from various groups and members of various communities—took hold of the camera and used it to produce images set loose upon the world—without its being possible wholly to control the encounters that would spring into being through and around them.

One cannot pin down these inventors of photography. They do not belong to the familiar circle of stakeholders or people in the know. They are many and different and they are like everybody else. The first efforts to regulate the dissemination of photographic technology through patent laws failed dismally. The patent was totally breached shortly after the technology became relatively simple to use and accessible to all.[42] The first users of photography created, and in so doing institutionalized, new uses of the technology which no one, certainly not the regime, nor that early advocate of photography before and in the service of power—Arago—could have

envisaged. These various new uses created a new collective: not a community of professionals but a new political public comprising men and women whose political relations are not subordinate to the power of a regime whose sovereignty is established with respect of a certain territory. The members of this public used the new technology as photographers, men and women alike, and as persons photographed. The power relations between them were not equal and were mainly, if not exclusively, determined through ownership of the means of representation of the encounter between them. The encounter between them was, however, of an entirely different order from all previous encounters between human beings. This new encounter produced a form of image that differs ontologically from all other images that preceded it. This particular image does indeed bear the traces of the encounter that it represents, but these traces will always contain signs that exceed what the image sought to achieve and which bypass the intention of the person operating the means of representation. These signs have the power to erode—to a greater or lesser extent—the power relations between the photographer and the persons photographed in the photographic situation. In order for these traces to become meaningful, what is required is not only a new kind of encounter between photographers and photographed subjects but also new kinds of spectators. The active presence of the latter begins to exert an influence even before the emergence of the final product—the photograph—and before the concrete encounter between the photograph and its spectator occurs. Spectators predate the moment of photography and are, in fact, taken into consideration in advance by the people photographed—individuals who have come to understand both the form of action in which they participate and the nature of the tool that makes it possible, through actually using photography in their own right.

All the Citizens

It is the existence of spectators of this kind that explains, for instance, the photograph of the palm of Jonathan Walker's hand. In 1845, Jonathan Walker was sentenced by a court in Florida in the United States for trying to smuggle slaves to the north.[43] In addition to a fine and a jail sentence, his hand was branded with the letters SS or "Slave Stealer." Upon his release from prison, Walker turned to the Boston studio of the photographers Albert Sands Southworth and Josiah Johnson Hawes, where his branded hand was photographed. Walker's decision to turn the "mark of Cain" imposed upon him by a state and society that supported slavery into the referent of a photograph that might be viewed by others shows his

understanding, and that of the studio photographers, that photography could be used to contest the verdict. The photograph restored a signifying potential to the pair of letters branded into his flesh so that their official meaning could be subverted: from "Slave Stealer" to "Slave Savior." This was the meaning that indeed became current for many of Walker's contemporaries and for those who succeeded him.[44] Through resorting to the photograph, Walker did not seek to overturn the punishment that had been imposed on him, since it was already inscribed in his very flesh. Instead, the photograph brought about a different form of contestation, relating to the content, meaning and authority of the verdict against him:

1. It undermined the *content* of the verdict whereby the assistance he offered to seven human beings to enable them to live a life of freedom was deemed a crime.
2. It undermined the regime's ability to control the *meaning* of the punishment in what constituted a rebellion against the imprinting of relations of control in human flesh.
3. It undermined the court's jurisdiction over a matter that was the subject of controversy insofar as the regime was concerned. It attempted, moreover, to define anew the boundaries of the *community* authorized to issue verdict.

The encounter between Walker and Southworth and Hawes did not result in their depiction of Walker as a warrior against slavery. But it did produce a photograph directly focused on the palm of his hand, which was without precedent in the history of the medium. The immediacy of the image of the hand conjures up something of the still life—a shell, a hat, a fossil—but unlike such items whose utility is chiefly display, Walker's hand was expected to remain neither still nor silent. Walker inserted the palm of his hand into the public domain, arrogating to it a role in the sphere of speech and action. Upon release from jail, he turned to Southworth and Hawes, precisely because he saw the daguerreotype as having the power to redefine a putative mark of Cain that sought to banish him from the public. He sought to invert the meaning of the mark of Cain through appealing to this very public. His actions teach that he believed certain hypothetical spectators to exist who would respond to the sight of his branded palm. He reasoned that it would be possible to incite them to responsibility in the face of the injustice wreaked upon him and in the face of the continuing injustice of slavery to which the letters branded on his palm testified. Walker did not know these spectators personally, and they remained anonymous from his point of view. He assumed the existence of many

such individuals who, upon evidence of the photograph, and through its
mediation and the mediation of others like it, might coalesce into an
aggregate of citizens. The hypothetical public that Walker sought to reach
was not coextensive with the local community to which he belonged and
from which the mark of Cain was meant to exile him.

We can now return to the claim that what was invented during the mid-
nineteenth century was an imagined public of citizens whose coming into
being is attested to on the basis of numerous photographs and daguerreo-
types similar to that of Walker's hand: images, produced through the
mediation of certain devices and imprinted on portable, lightweight
rectangular surfaces detached from the situation in which they were
created. The citizens of the nation of photography, the members of this
imagined public, were those who employed photography. Their numbers
included individuals indifferent to the citizenship in the nation of photog-
raphy bestowed upon them and others like them who took up a civil
contract invested in them by virtue of the very act of spectatorship that
bound them to other men and women photographed. It was frequently the
case that citizens of the citizenry of photography came to possess such
citizenship despite the fact, or often precisely by virtue of the fact, that
they were denied the status of citizens in their states of residence.

Photography/Art/Museum

Photographs such as the hand of the Slave Savior, Captain Jonathan
Walker, are relatively well known, once taken by master photographers
whose work has been canonized in various stories of photography.[45] This
canon was modeled on the inspiration of the canon of the modern history
of art, and sometimes even cross-referenced the latter. While the discourse
of art did eventually open its gates to photography, the process was a
gradual and a measured one. Regardless of initial hesitation, though, the
discourse of art played a role in the formation of the photographic canon
and resonates through it. Evidence of this dependence is chiefly expressed
through the tendency to isolate a handful of photographers drawn selec-
tively from a much richer and more varied pool whose activities generally
bypass the art world and its sanctioned forms of practice and thought. It
is this handful of photographers who are then accorded the status of
masters. Their photographic oeuvre is presented as the expression of their
unique talent and perspective—and this framework of the sole creator as
something that effectively eliminates the possibility of seeing photography
as the product and effect of an open-ended encounter among various
participants. To survey the exhibitions, catalogues and illustrated volumes

that recount the history of photography until the close of the twentieth century is to acknowledge that the boundaries of the canon were flexible and were often contested. But striking consensus exists concerning that which is held to stand at the center of the canon—the photographs of renowned photographers, however defined.

Photography is readily capable of distribution: the medium employs a relatively uniform platform upon which an image is printed—an image can then be framed, transported and exhibited. This ease of production of image and its transportability partly explains why the discourse of art treats the photograph as a work of art in every respect, save its coming into being in a medium inferior to painting.[46] Not all photographs are equal. Photographs ubiquitous in our everyday life are judged by the discourse of art to be the result of mass-produced commercial patronage, commanded by external interests and uses. The chances of their being included for contemplation or discussion within a canon are very slim indeed. The emergence of a photographic canon depended on the distillation of a tiny corpus of photographs that were the work of photographers held by the discourse of art to possess "artistic" talent over and above the mechanical capacity to click a button on the camera. The measured relegation of a few photographs to the sphere of art ignores, in a way so common in the discourse of art, the circumstances of its production and the involvement of a host of potential participants who might have taken part in its production. Those photographs included in the canon were "chosen" in a manner akin to works of art and were duly sanctified. To attach the name of a particular photographer to a photograph was to begin to immortalize the photographer as an artist-creator. Until the late twentieth century, scant critical or historical discussion was invested in a huge range of photographs that existed outside of the context of art, nor was there much interest in the uses to which they were put. A handful of photographs were canonized, relatively speaking. Although they might number a few thousand, they do not exhaust the plethora of photographs or varieties of photography that we can surmise to exist outside the boundaries of the canon, whose failure to achieve canonicity results in their being ignored over and over again. Achieving a public presence and serving as objects of research are privileges that accrue only to canonized photographs that have been admitted into the province of art in accordance with its principles of selection.[47] The rules and logic of the discourse of art were as foreign to most of the output of photography—newspapers; family albums; photographs posted on drawers and refrigerators; archives; databases of various kinds; military information; exhibits in courts of law or departments of criminal investigation, police stations, hospitals, classrooms and so on—as this output was foreign to the discourse of art.

On the Stage of Photography

Where photography is not considered part of art, which is largely the case outside of its specialized orbit, photographs are subject to a practical gaze and are candidates for circulation and decoding in a manner that does not evacuate the "who" and "what" they depict in favor of a consideration of aesthetics or of the artistic intentions of their creators. Like the theatrical stage, the photograph serves as a kind of arena for putting on display setting, characters, actions and consequences that are not to be considered in isolation but which form part of the plot that the photograph sets in motion. The photographic plot unfolds within the network of relationships existing between people whose presence is necessarily inscribed within its production as well as those people potentially inscribed within it.[48] The primary relation to the image does not erase the referent of the event photographed, staged or acted out. The event, mediated through the gaze of its spectators, becomes a point of departure for the unfolding of other unknown stages of activity. It is impossible to predict who will intervene in the changes wrought through the transmission of the photograph or how its meanings will be articulated and altered. The concrete particulars of the event to which the photograph bears testimony, held generally within the paradigm of art to be a kind of excess that can be sloughed off, distinguish the photograph from other artistic images and bring it into affinity precisely with theater.

Hannah Arendt's comments on theater, "It is the only art whose sole subject is man in his relationship to others,"[49] apply just as accurately to photography, or better still, to the qualities of the photographed image. Arendt's characterization embodies the crucial difference between photographs and other images. The photograph samples a single moment drawn from a concrete sequence in which people encounter one another. This instant is mobilized by the photograph in the service of a temporality that extends beyond the moment. It is coextensive not with the fraction of a second during which the shutter falls, but rather the traces of the instant as a kind of present-absence in the photograph. The photographic sequence is not sealed closed during the fragment of a second when the photograph is actually shot. The coming together of the photographer with the persons photographed always extends beyond the concrete encounter between them. The photograph serves to increase the chances that the encounter will, in fact, endure, migrating to other spaces and circumstances which, at the very least, evade the photographer's ability, or that of the persons photographed, to know them in advance.

Despite the manner in which the modern discourse of art trains spectators to erase the perpetual presence of the men and women photographed from the photographic image, their presence cannot be evacuated. Whoever appears in a photograph or whoever is glimpsed in its frame always stands in a certain set of relations with others. Neither the photographer who is invested with owner-ship rights over the photograph as object, nor the work of art constructed as the center of gravity of the discourse of art, are capable of erasing the photo-graphed persons or any other participants in the event of photography from the civil space in which they are present and whose coming into being they demand from those who observe them. Thanks to their inclusion, this space is always plural. For all that, the photographer may retain rights to the photo-graph as property. As a work of art, any photographic image can in principle come to constitute an independent space of appearance that can only be destroyed through violent means, whether this is concrete violence of the kind over which the state has monopoly or the symbolic violence of the paradigm of art that sanctifies the sovereignty of the artwork, artist and critic. This violence, which threatens to obliterate the presence of the men and women captured in the photograph—participants who should properly be considered equal players in an open game—reduces the various dimensions of participa-tion of the actors in the creation of the image. Such violence is a structural consequence of positioning the image as a work of art subject to judgment.

(Non)Canonical Photography

The growth of scholarly interest in the display and interpretation of photog-raphy outside the perspective of art toward the end of the twentieth century has recently generated prolific outputs, such as anthologies of early writings on photography, or research publications on photography in various profes-sional settings including the psychiatric clinic, the operating theater, the court of law and so on. It has led to the establishment of new professional journals and has motivated curators to mount exhibitions devoted to "amateur" photography, to "blemished" photography, to family snaps, or to the publications of humanitarian and human rights organizations that photograph atrocities.[50] It has generated conferences and has led to the establishment of new programs of study in the academy in disciplines such as international relations, politics, human rights programs, media studies, sociology and anthropology. All these changes have also had an impact on the canon. Whereas previously the canon was the site of struggle among those seeking to preserve its core intact, it has currently lost some of its strength and centrality. The much broader research arenas within which photography now subsists, and the new forms of discussion and display

generated in relation to it, have come to exceed professional or disciplinary discussion of photography of the kind that existed in the past. Part of this research is now grouped under the heading of visual culture, which itself came into being as a reaction against the boundaries and limits of the traditional disciplines, and still other parts proliferate without being subordinated to visual classification, for instance visual aspects of human rights programs that deal with photography.

Adequate historicization of visual culture, a field for whose emergence I claim photography to be a precondition, throws into relief the limitations of treating visual culture solely from an academic perspective and continuing to ignore the practices that have shaped visual culture and the interest in it since the nineteenth century. To historicize visual culture adequately is also to undermine the narrative that presents the history of art as the pertinent field of knowledge for the generation of visual culture in relation to which visual culture stands as a kind of appendix or late variant, possessed nevertheless of loyalty to shared principles. The hegemonic narrative, which accepts the imperialist pretenses of the history of art, presents art as the central channel for visual practice and sees photography as a sub-medium within this. In this account, photography has, since its inception, knocked ceaselessly on the door of art in order to gain admittance into its domain. Within the narrative it offers, the history of photography is indivisible from supposedly key moments when the photograph was admitted into museums of art. Such a narrative erases the infinite richness of photography and the many uses to which it was put outside of the context of art or of the museum. It overlooks the fact that most users of photography display no desire to belong to the field of art, nor do they seek the recognition of its resident experts. When the history of images is recounted from the perspective of the history of the work of art, important differences between visual culture and the paradigm of art are erased.

The adequate historicization of visual culture, which sees itself as responsible to practices and not only to academic disciplines, allows us, I have been suggesting, to reconstruct the two paradigms in question as separate ones and to testify to their parallel existence. It thus becomes possible to outline their major differences, as well as their similarities, and to investigate their points of intersection with other institutions, practices and even concepts. The relations between visual culture and the history of art now shift: they need no longer be restricted to the circumscribed parameters of a disciplinary struggle internal to the history of art, nor are they beholden to the foundational paradigm of art that supposedly hosts the emergent field of photography.

Do Not Pass Zero

The point of departure of John Berger's and Jean Mohr's groundbreaking book *Another Way of Telling* is what they call the discovery that "photographs did not work as we had been taught."[51] In one of the chapters, Mohr presents five of his photographs to ten people and asks them to describe them. The answers, printed below the photos, are presented as possible answers to the photographer's question expressed in the chapter's title: "What did I see?" The photographer has relinquished the position of the knowing subject with regard to his own photos. This position has not been occupied by another knowing subject, such as a critic or a curator, but has rather been offered to "ordinary people" who were chosen randomly. In most cases, what they saw in the photo was not what the photographer saw or intended to include in the final frame. The possibility of seeing this gap and exploring it further is the new way of seeing, the new way of telling what one sees in a photograph, that Berger and Mohr present in their book.

Since the publication of that book in 1982, the same feeling of "discovery" has been expressed in other writings on photography, and in different contexts.[52] Often, these "discoveries" have been linked in one way or another with the way "ordinary" people (i.e., people who are not considered experts in photography) have used photography. These people supposedly possess a certain kind of knowledge regarding the photographed image, helping us to understand that "photographs do not work as we had been taught." The same can be said regarding for example the work of the Israeli artist, Michal Heiman, who conducts "tests" on museum spectators, invited to describe what they see in the photographs presented to them as if they were patients in a clinic.[53] Precedents exist dating from the 1970s, for instance Wendy Ewald's photographic projects, carried out with various communities as an effort to reclaim citizenship through the use of photography;[54] or to take a later intervention, Susan Meiselas's archives for Kurdistan, created in collaboration with the persons photographed or their relatives, all part of a community who lacked the resources to access photographic memory until this archive was created.[55]

The question that I want to raise regarding the recurrence of this "new" way of seeing, is not why this or that writer, photographer, or artist ignores the previous "discovery" regarding the nature of photography; but what are the discursive conditions under which this understanding of photography has been perceived as a discovery whenever it has surfaced over the last thirty years? I do not intend to propose a comprehensive or direct answer to this question, but to describe the conceptual grid, the judgments of taste,

that has contributed enormously to the marginalization of this understanding of photography—this "new way of viewing" which paradoxically is so common among "ordinary people" using photography—within the hegemonic discourse on photography. These judgments, applied frequently to photographs taken in zones of regime-made disaster, usually differ—and sometimes completely prevent—the possible encounter with the photographed people, who through the photograph are co-present with the spectators in the event of viewing the photograph. Often, "non-professional" spectators already display the ability to participate in the encounter without knowing that they have to jettison certain constraints that might have prevented them from taking part in it.

The "new way of viewing" is characterized by the effort to link the photograph to the situation where it was taken. Linking the photograph to the situation and act of taking the photographs does not mean ignoring what John Berger describes as an abyss "between the moment recorded and the present moment of looking at the photograph";[56] on the contrary, it means not giving up on the urgency of restoring and reestablishing as many links as possible between the photograph and the situation in which it was taken. The aim of this effort is to enable us as spectators to reposition ourselves in relation to the disaster we are watching and to let us be engaged with its happening, with its victims, our fellow citizens, and with its lingering effects on its victims and on its perpetrators, as well as on its accomplices—us, the spectators.

The Space of the Museum

History teaches us that the space of the museum did not come into existence as a quintessential artistic space. The space of the museum was heterogeneous, "neither square nor white," used to put various strange, intriguing and astonishing objects on display—objects that have the capacity to teach us about their collectors, inventors and referents, among others. With the fusion of art discourse and museum discourse in the early twentieth century, a distinction emerged between forms of production guided by artistic criteria and subject to judgment on their terms, on the one hand, and forms of production that held these criteria to be irrelevant, on the other.[57] In order to gain entry into the space of the museum of art, an object needed to display qualities of artfulness, surpassing all other dimensions of its manufacture and rendering them minor or irrelevant. Until the 1990s, the reciprocal relations between art and photography were dominated by a single template whereby the paradigm of art, with its attendant rules, was seen as the dominant—indeed the host—paradigm.

When such a perspective is put aside and the confines of the art museum or the paradigm of art ignored, however, it becomes suddenly and abundantly clear that photography has always flourished and that people have always used it in manifold ways. Toward the close of the 1980s, in conjunction with the shift in knowledge production that legitimated post-colonial studies, gender and queer studies, cultural studies, critical studies and visual culture, the legitimacy of photography as an object of research and display was no longer seen as dependent on the patronage of the general field of art and art discourse. The space of the museum, having largely been conquered by art, reverted to its status as a space permitting heterogeneous forms of activity whose gates were open to players who deviated from the rules of art discourse. The latter still continued to defend most of its institutions against the "invasion" of the paradigm of visual culture that sought to use the space of the museum differently, but its resistance is not total. The friction that became apparent between the field of art and the field of visual culture left traces that notably changed some of the rules of the game. The resultant shift allowed for the presence of new and challenging players to seize the space of the museum, however partially. Curators who use the display space as a site for research became increasingly prominent.[58] So too did collaborations between different artists or collectives that work with communities outside of the world of art (whose members are often denied civil rights in the countries in which they reside) in an attempt to deploy the museum in order to rehabilitate, or indeed to create, a common civil space.[59] The collective efforts of such players deviate from the conventional template of the autonomous artist, sole author of the unique artwork whose reception is isolated from the conditions of its production, thus allowing the artist-progenitor to monopolize the contributions of other agents to the production of the work of art.

Artistic autonomy developed into a sovereign principle when the discourse of art coincided with the space of the museum. This principle long rendered the museum into a convenient site for the secular legacy of the notion of singular sovereignty associated with the nation-state. The institution known as the "National Museum of Art," which came to adorn the large cities of modern states, as well as the use of the appellation "national" to describe art created within various states—at the expense of art not produced by the particular ethnic group associated with nationhood—both express the affinity between artistic discourse and national discourse. Photography is fundamentally foreign to this logic. It has, since its inception, successfully resisted attempts to subject it to apparatuses of regulation and control. Attempts to create forms of "Israeli Photography" or "Chinese Photography" along the lines of "Israeli Art" or "Chinese

Art" have failed except under the aegis of the art museum. The uses to which photography has been put have not capitulated to any one form of sovereignty, partly as a result of its diffusion that was based from the outset on deterritorialization, accessibility, inclusion and openness. In other zones of society where photography existed in more rigid environments of professional or other forms of control and surveillance, like prisons, schools or military bases, it was never wholly possible to subordinate photography to their prescriptions, which remained external to it. Institutional and other constraints must thus be seen as temporary and as having limited purchase over photography only to the extent that photography was subject to their territorial dominion.

The Political Judgment of Taste

The judgment of taste is most closely associated with art's field of activity. But this association neglects the important role that the judgment of taste plays in the political realm—or better still, in defining the boundaries of the political. The judgment of taste is one of the chief anchors of the formation of the modern bourgeois public sphere as the latter has emerged since the end of the eighteenth century.[60] Central facets of this sphere that constitute the preconditions for the judgment of taste include: generality ("everyone in principle"), being public (accessibility to the public gaze), and the isolation of spheres of action (political, artistic, economic, literary and so on). The attribution "This is political" is a judgment of taste, and it appears in two forms:

1. *An exclusive form.* The assertion "This is political" takes on a gate-keeping role defending certain spheres of action from the penetration of the political, which is seen as detrimental to their freedom of action and which threatens their activities.
2. *An inclusive form.* The assertion "This is political" takes a different form when issued by feminists or members of non-governmental associations (NGOs) who seek to politicize referents previously held to be foreign to the political and worthy of separation from it.

The assertion "This is political" is not the equivalent of the assertion "This is politics." The latter is not a judgment of taste since it is completely devoid of reflexivity. The referent of "This is politics" is relatively obvious because the attribution recruits a rule that is capable of being activated in order to evaluate a particular instance. Thus the assertion "There should be no politics in the classroom," which relates to the presence of politicians

in schools or to the distribution of political platforms on the school campus, is not the result of a judgment of taste but has the form of a simple assertion converted into an explicit prohibition that may be issued by the relevant authorities in different institutions. But the judgment of taste, on the other hand, is an assertion that anyone can voice in the public sphere, albeit with different degrees of resonance.

Hannah Arendt's lectures on Kant represent the most significant discussion of the political context of the judgment of taste.[61] But Arendt's discussion does not refer to the third judgment of taste in the very act of determining something to be "political" or "not political." It is difficult to imagine that she would have credited this as being a judgment of taste, at all. Nor does she treat the relation between the judgment "This is (is not) political" and its counterpart—"This is (is not) aesthetic," which I have discussed above. Arendt continues to treat the judgment of taste in its Kantian formulation "This is beautiful" and she sees it as central to Kant's political philosophy. No thinker before Kant, Arendt writes, ever treated the faculty of judgment in such a systematic fashion. Earlier thinkers who did broach it tended to regard judgment as "taste" and thus to relegate it to the realm of the aesthetic.[62] Kant's distinction between the moral and the political is based, Arendt claims, on the understanding that the general and the public are central, indeed vital, to the realm of politics. The judgment of taste enables the individual to bind himself publicly to other individuals and to engage, like them, in acts of judgment. Even were an individual secretly to exclude himself from the collective and to engage in deceit, for instance, he would not want deceit to form the substance of the law or of norms. Arendt extracts the general form of judgment from the Kantian judgment of taste and points to it as a model of political "being with others." She shows no interest whatsoever in the Kantian judgment "This is beautiful" in relation to the aesthetic realm. The judgment interests her only insofar as it subsumes a form of political thought.

The Concrete Instance

In some of her writings, Arendt demonstrates the operations of the model of the judgment of taste with respect to concrete instances. Her essays dating from 1959 in the wake of the struggle to integrate black high school pupils in schools in Little Rock, in the context of the struggle over civil rights in the United States of America, illustrate how the judgment of taste might be employed in one concrete instance.[63] The "point of departure" for her "reflections," Arendt attests,[64] "was a picture in the newspapers,

showing a Negro girl on her way home from a newly integrated school; she was persecuted by a mob of white children, protected by a white friend of her father, and her face bore eloquent witness to the obvious fact the she was not precisely happy. The picture showed the situation in a nutshell because those who appeared in it were directly affected by the Federal Court order, the children themselves."[65] The judgment of taste that Arendt extrapolates from this case is not aesthetic and does not relate to the photograph. The photograph served her as a point of departure for a complex reflection on the integration of blacks in American schools without her feeling the need to return to the photograph or to linger over it. What she saw aroused her to thought and the fruit of her thought made its way into the world, where it joined additional utterances disseminated by Arendt and others.[66] Arendt treated the photograph in the manner of a theorist of visual culture. She contemplated the visible, imagined the invisible, and proceeded to articulate between the photograph and other information, be it visual or textual. The photograph that served her as a point of departure shows no evidence of the white children whom Arendt states to have chased the black girl photographed—her description quite naturally integrates utterances from other photographs, and moves between different sources of information so that she is able to reconstruct the act of photography and

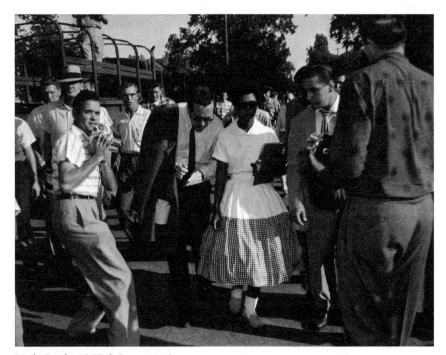

Little Rock, 1857 © Bettmann/CORBIS

to render it concrete in her discussion. Arendt speculates what the central protagonist photographed here, Elizabeth Eckford, might have felt and asks herself "How might I have behaved if I were a black mother?" or "How might I have behaved if I were a white mother?"[67]

The mothers of the children, whether black or white, are not present in the photograph that Arendt contemplated. But their absence did not prevent her from imagining them as participants in creating that which came to be visible in the photograph, that is to say, Elizabeth Eckford's movement through hostile space.[68] Arendt imagines two hypothetical mothers, who represent two opposing positions in the story, in order to attempt to understand what might have guided the actions of each mother respectively among the totality of available laws, without regard for concrete constraints and in accordance with the different forms of crisis each experienced. The answer appeared clear to her: whatever the circumstances, Arendt would not have allowed her daughter to be exposed to political struggle on the school playground, nor to participate in it. She would, moreover, have sought to protect her daughter from the consequences of such struggle outside of the home in general: "For each time we leave the protective four walls of our homes and cross over the threshold into the public world, we enter first, not the political realm of equality but the social sphere."[69] Despite the fact that the law promised Elizabeth Eckford and her friends equality at school, the manner in which this right is exercised, Arendt claimed, cannot be indifferent to the friction generated in social space. The hostility of the whites who refused to allow "blacks" into "their own" school lay in ambush for Eckford and her friends as they traversed public space on the way to school and back home again.[70]

The disparity in the particular instance of Little Rock between the dry language of the law that promises equality and the hostility manifest in social space served Arendt in the formulation of a general law relating to conduct within political and social space: "What equality is to the body politic—its innermost principal—discrimination is to society . . . without discrimination of some sorts, society would simply cease to exist and very important possibilities of free association and group formation would disappear."[71] The restriction of the authority of the state is central here, where the state is conceived in its various institutional guises, and with respect to its ability to intervene in the management of the shared lives of human beings. Just as human beings are allowed to choose with whom they would like to spend their summer holidays, Arendt writes, so too they must be allowed to choose with whom their children spend time in school. In areas subject to state regulation, like education for example, the state must provide equal resources, opportunities, infrastructure and

conditions. But it cannot force certain individuals to spend their time with certain others. At the same time, "Just as the government must ensure that social discrimination never curtails political equality, it must also safeguard the rights of every person to do as he pleases within the four walls of his own home."[72] It is our task as mothers to demand from the state that it fulfills its obligations in permitting both political equality and social differentiation, says Arendt. In voicing this claim, she effectively brings a form of civil partnership into being between the antagonists—white and black mothers. If the state fails at its tasks, however, Arendt goes on to argue, it is our duty as mothers to defend our children when they leave the home and to refrain from making them agents in a political struggle.

It was only in 2005, when Arendt's piece was published alongside the relevant photograph, that its readers were first able to see what Arendt herself saw at the time of writing. When the photograph is put in context alongside other well known photographs documenting the events at Little Rock, the motivations behind Arendt's particular choice become clearer. In the photograph she has selected, Elizabeth Eckford is not alone in her exposure to the abuse of Hazel Bryan at the height of the riots. Arendt has not chosen a photograph reflecting what she is describing as the real dangers to which Eckford was subjected, however accurately portrayed in most photographic records of the event. The photograph that catalyzed her thought depicts Eckford after the danger has passed, accompanied by someone whom Arendt identifies as a "white friend" of Eckford's father. This particular choice of photograph underscores Arendt's claim that an obligation exists to return the pupil and her friends to a space of safety— one to which she becomes a partner by accompanying Elizabeth home with her written gaze. Given precisely this context of accompaniment, Arendt is able to voice her argument against the abandonment of children and the instrumental use to which they are put as a kind of medium for the inscription of the gap between social and political space.

It Is (Not) Political

In a different essay, "Thinking and Moral Considerations," Arendt presents the faculty of judgment as "the most political of man's mental abilities . . ." It is "The faculty of judging particulars (as Kant discovered it), the ability to say, 'this is wrong,' 'this is beautiful,' etc."[73] The assertion, "This is wrong," relates to a particular case and its exercise forms part of the political being-together of human beings. To assert that something is wrong does not represent some kind of rare ability but a skill that is employed on an almost daily basis. We all make such assertions with

great frequency and under a wide range of circumstances. But we seldom do so in a ceremonial guise that might prompt us to recognize that we have issued a judgment. Quotidian judgment calls are crucial to every one of us in all fields of life. The particular form that the judgment takes will change under different circumstances and is open to considerations that sometimes contradict one another and necessitate compromise. In her essay on Little Rock, Arendt does not simply practice the most political of man's mental faculties and attempt to formulate a general rule—"This is wrong"—concerning parental responsibility for children.

Here as elsewhere, Arendt practices a judgment of taste in its third variation and asserts: "This is (not) political." It is important to clarify that the third judgment of taste does not consist in the activation of the political faculty we all possess, which enables us to formulate a rule on the basis of a case for which criteria have not yet been formulated. Rather, the judgment of taste seeks to determine the very boundaries of the political realm itself. It is as if Arendt, after activating a certain civil capacity with reference to school integration in Little Rock that consists in the claim that it is superfluous to expose children to danger in a hostile environment, came somehow to deem this claim deficient without the addition of the political judgment of taste. Arendt uses the formula "It is not political" to counter the claim for equality in the school system issued both by the law and by the black citizens of Little Rock, alike. But her assertion could not go unqualified, and she was eventually forced elsewhere to concede that education belongs within the realm of the political.[74] We can see how the judgment of taste in its third variation has ambushed Arendt and has tempted her to employ it without rendering account for how it has changed since its Kantian inception, indeed without realizing how foreign it is to her political ontology. Arendt is seduced by the judgment of taste into fixing the boundaries of "the political" despite the fact that she herself formulates the political many times in terms of a plurality that counters such closure.

Arendt's neglect of the transition from the Kantian judgment "This is beautiful" or "This is wrong" as employed in various spheres of action to the assertion "This is art" or "This is political"—assertions that purport to define a certain sphere as well as its boundaries—renders her oblivious of the differences between the various of judgments of taste. It is plausible that the third section of *Life of the Mind*, which she never completed but where she intended to deal with the faculty of judgment, would have raised this problematic more explicitly. But given that the faculty of judgment—the referent of the section not written—occupied a central role in Arendt's thought, I feel justified in treating it in excess of its limited appearances in her published works. I will not limit myself only to her

thoughts *about* judgment but will read the traces that her judgments left in her writings in order to reconstruct how she might have seen the practice of engaging with the faculty of judgment.

In Arendt's early works, whether in the face of historical events she explored or while attempting to formulate a theoretical landscape, she issues the general judgment of taste "This is (not) political" on various occasions, without, as we have stated, rendering account for the fact that this is indeed a judgment of taste, nor for what might be specific to it. In a discussion in *The Human Condition*, for instance, devoted centrally to differentiating action from other human activities (work, labor), Arendt identifies action with the political realm. This identification compelled her, as well as most of her commentators, to separate the political from that which it is not, and to repeat the terms of this separation time after time: "This is (not) political." The assertion of the judgment of taste, "This is (not) political," refers to certain configurations of being-together frequently perceived by participants and onlookers alike as political relations. From Arendt's point of view, however, some such configurations actually constituted a diminution, or an emaciated expression, of the political. One famous example of such diminution is Arendt's attitude toward the sites of debate and action that emerged during the French Revolution around such concepts as happiness and suffering, concepts that soon dominated what Arendt would term "the social." Arendt saw the demand to augment happiness and to diminish suffering as a social one, precisely because it was based on a principle external to the political. For Arendt, achieving equality in the distribution of happiness or suffering was neither a possible point of departure for the political, nor its eventual goal. Given such precedents, many of Arendt's commentators came to see the opposition between the social and the political that she established as problematic. They preferred, almost without exception, to give up on the efforts of a rigorous reconstruction of this opposition. Instead they derived the spirit of her intervention from the manner in which Arendt identified the political with freedom and with the emergence of a new beginning, as well as on the basis of her claims regarding the retreat of the political in contemporary circumstances, the precariousness of its being tied to precious and fleeting moments that could only be discerned if one cultivated a special attentiveness to the appearance or disappearance of the political. Like many such commentators, I too paid my dues to such constructions. But I came to realize that there is a price to be paid for making the political into a precious and singular commodity that can only be properly discerned and set to work by the relevant caste of critics in the know, equipped with the tenets of critical theory from the 1970s onward. I gradually came to understand that the supposed "scarcity" of the political is an effect of the (third) judgment of taste.

(The Anxiety Concerning) The Disappearance of the Political

Arendt's neglect of the changes affecting the judgment of taste and its contemporary deployments must be interpreted alongside her efforts to circumscribe a certain form of activity—action—and to identify it solely with a single and distinct domain or sphere of activity.

1. In her discussion of "the political" in her volume *The Human Condition*, Arendt restricts the political to speech and action while excluding gaze from the political space and without relating to the role it plays in the articulation of relations between human beings.
2. In a short discussion of the work of art in the same volume, Arendt reduces the work of art to the status of an object—the product of what she terms "work"—and positions it exclusively within the sphere of art. She assumes the work of art to have a stable referent and to be readily available for judgment as a work of art. She ignores the presence of the work of art in the political space and its role in informing the complex relations that are maintained between human beings through the mediation of the gaze, speech and action.

The act of differentiating the political from its others (regardless of whether the other is held to be "the aesthetic" or "the non-political" in general) that is so central to the judgment of taste is thus related to the common distinction between different spheres of activity. The judgment of taste in general is supposed to allow the adjudication of an unknown situation as well as to provide for the emergence of a rule for the evaluation of that unknown situation. Like its predecessors, the third judgment of taste cannot depend on the deployment of a prior rule. Unlike them, however, it is recruited to the service of an external objective: safeguarding the distinction between different spheres of activity. Claude Lefort summarizes this succinctly in his article on the status of the political in Arendt: "If there is no boundary between the political and that which is not political, then the political itself disappears."[75] Through the mediation of the judgment of taste, the political, in the very basic sense of human coexistence in the plural, becomes something else—the realization of a certain potential contained in human relations that occurs only under certain and rare conditions.

The equivalence that Arendt forges between the political, on the one hand, and freedom, on the other, changes the notion of the political, transforming it from a factual description of the manner of human

existence into the description of an ideal form of such existence. The transformation of space into the space of the political, claims Arendt, occurs when human beings gather together without any ulterior or external purpose other than gathering, such that freedom does not form the goal of the political but constitutes its meaning instead. If we accept the terms of this equivalence then, paradoxically, gatherings imbued with purpose (and how can we evade purpose altogether?) will ironically fall prey to the judgment of taste that states "This is not political."

When thought regarding the political is bound to the judgment of taste, whether toward historical events or toward the present, then the actualization of the political becomes something exceptional and rare. The pursuit of the political ("This is political"), as well as sophisticated forms of its negation ("This is not political"), become ends in themselves. Traces of this pursuit, or of its converse consisting in the impulse to reveal the absence of the political in acts or products that seek the halo of the political, are evident in much critical theory produced since the 1970s.

Variants on the third judgment of taste recognize only one set of links between utterances. In the face of the many challenging spaces of relation between human beings that afford multiple possible junctions of intervention in determining the chain of utterances, the third judgment of taste interpellates individuals to utter a judgment and thus to determine where the boundary will pass between the political and its others. Instead of empowering its user to find the right words, looks, and deeds to add to the utterances of other agents; and instead of facilitating reflexive evaluation in the face of concrete instances; the judgment "This is (not) political" seals the sequence of looks, deeds and actions with the sole choice between "This is political" or "not political."

The Obligation Is Civil

Arendt's exclusive assertion, which alternatively prescribes and proscribes, "This is (not) political," refers at times to a sphere of activity and at other times to a particular form of activity—"action," in her terms. But to consider Arendt's reading of the photograph from Little Rock is to encounter an additional sense of the political. This is an inclusive meaning that relates, in principle, to each and every individual and that obligates him or her irrespective of attitude, class position or role. "The political," in this latter sense, relates to human beings who share the same world and who are mutually obligated toward one another and toward the world they inhabit. (I have already termed this kind of obligation "civil.") We can derive a different understanding of the political from Arendt's criticism of the

mothers of Little Rock, white and black, and of everyone else involved in the events there: the white friends, the black father, the governor, the senators, the representatives of the NAACP and the residents of Little Rock. Arendt castigates them all for their lack of a civil relation: "by abolishing the authority of adults, [they] implicitly den[y] their responsibility for the world into which they have borne their children and refuses the duty of guiding them into it."[76] She ascribes a common obligation to all of them despite the institutional differences between them—whether comprising their different hierarchies of authority, their different roles, the particular interests that characterize and differentiate between them as parents, governors and civil rights activists. This obligation does not only implicate those who act in or from a circumscribed political sphere. Nor is the action it implies something rare that comes into being only in moments of new beginning. This is not a form of obligation or moral responsibility that is conditional on the morality of any given individual, nor does it apply to action occurring within the private domain, in secret or under the cover of darkness. "And in politics, as distinguished from morals, everything depends on *public* conduct."[77] This is a political obligation whose kernel Arendt borrows from Kant—the duty to reconstruct the general rule that someone else might formulate in my place—and she suffuses it with the mutual obligation of humans to safeguard a world that they share. By contrast, each one of the office holders whom Arendt presents in the context of Little Rock engages in calculations regarding various possible courses of action and acts in accordance with the standpoint he or she articulates. Such factors should not be discounted, but they do not suffice to generate an adequate form of human co-existence, nor do they safeguard a world held in common and held in trust for future generations. Alongside the interests, calculations and anxieties drawn from a particular area of doing or from a particular area of knowledge or practical engagement, all of which preserve a certain affinity of humans toward one another or toward forms of cooperative activity, there stands for Arendt an obligation and a responsibility that cannot be restricted to the limited conditions of a particular field of knowledge, to private or group interests, class positions or attitudes.

Although such obligation is irreducible to the sorts of conditions that we have listed, it is not necessarily opposed to other forms of responsibility and obligation, nor does it suggest that they cancel one another out. In order to define the relation between civil obligation and other fields of knowledge and activity, it is fitting to rid ourselves of the distinction between the political and its other, that is to say, to deviate from the third judgment of taste, and to characterize this civil obligation as being one of the three forms in which the political exists.

Political Ontology

The opposition between the political and its other, "not political," to which I have pointed in the context of art and politics alike, prevents us from considering our obligations and responsibilities in an inclusive fashion as pertaining to each and every citizen alike. In her book *On Violence*, Arendt points to the contamination of the political in contemporary life, and comments on the tendency of many people to avoid it, so that politics is no longer an inclusive realm and has become the province of the few. But it is not the contamination of the political alone that has led people to deny the political nature of their being-together. The obverse of this contamination is the sanctity invested in the political through the mediation of the judgment of taste that has rendered the emergence of the political into the epiphany of a select few. Surprisingly enough, Arendt failed to perceive how the sanctity of the political erodes her understanding of political ontology. The judgment of taste, which is responsible for the occlusion of the political and the persistent attempt to differentiate between the political and its other, has served as a kind of dam to hold back a threat that is inherent to the very ontology of the political. For Jens Bartelson, "if politics is boundless by virtue of being bounded by itself, everything human can at least hypothetically be subsumed under this concept . . . if politics potentially encompasses everything, it can itself be but nothing."[78] But Arendt's anxiety is not wholly identical with Bartelson's. The threat she identifies here is not that the political would be rendered null but that it would lose its meaning. "Politics and freedom are identical, and wherever this kind of freedom does not exist, there is no political space in the true sense."[79] For his part, Jacques Rancière, who criticizes Arendt to the effect that she solves the problem of the political in advance through differentiating the private from the public sphere, despite the fact that the emplacement of the boundary between the two is itself political, reserves a certain kind of action as the hallmark of the political. When this is absent, then the political also disappears.[80]

As a result of the identification Arendt creates between the political and freedom, what the judgment of taste arbitrates is sometimes the political, sometimes freedom, and sometimes the-political-as-freedom. Arendt is not concerned with individual freedom, but with a certain individual's determination to generate something new, that is to say, to *act* in a space where others are active too. The identification of the political with freedom, which renders the-political-as-freedom into the object of a judgment of taste, causes Arendt to be oblivious to the very political ontology

that she has formulated. The identification also entails the assertion that we associate so closely with Arendt—that in every place where freedom is violated, it is impossible to speak of the political. Arendt bases the identification of the political with freedom on the differentiation of action from other forms of activity: labor and work. Action is more than simple manufacture and its evolution remains unpredictable. For this reason, it is never possible to know where action will end. Action has an agent but does not have an author. The subject is revealed through action and can in retrospect articulate it in words. Action is never simply subordinated to its end purpose because it is implicated in a network of human relations guided by contradictory interests, desires and intentions. The subject's revelation through action is a risky one because it is never entirely certain who will be revealed. Action necessitates public space as its prerequisite and pursues the value that is inherent within it (fame, civic virtue). Action exists only when the "coming-together of the human" is presupposed. Action always exists in the public sphere between two participants, at least. It is neither concrete nor stable since it does not leave traces, unlike tools or devices. Action generates new beginnings and expresses concern for the world.

These characteristics of action are expressed in different situations in response to various worldly challenges. It is not reasonable to expect them all to coexist in a single instance of action—whose very existence as single and all-encompassing would always already be open to question. But if we assume that such characteristics emerge into view only partially, they can be discerned in a very large number of situations and activities. Thus, for instance, changes in the price of rice, the collapse of the World Bank, racial integration of schools or the demolition of neighborhoods—all instances that would not have been included within Arendt's taxonomy of the political, nor for that matter, would they have been identified with freedom, are clearly themselves capable of generating new beginnings. As much as the evolution of such beginnings can never be fully predicted— because of their entanglement in a network of human relations, contradictory intentions and so on—they are nevertheless the result precisely of human coming-together. The characteristics that Arendt attributes specifically to action, in other words, do not suffice to differentiate it from other interventions to which she does not attribute explicitly political meaning. This failure results from the fact that the characteristics in question are not exclusive to action as opposed to work or labor, but are part of the ontological condition of being-together, which is always already political. Human beings look at one another, speak and act in spaces always populated by others. By virtue of this fact, they can never wholly control the outcome of their actions, nor wholly determine the

outcome of their confrontations with others, or the interventions of others with respect to them.

Whereas Arendt invests action with certain characteristics under conditions of freedom, which may or may not exist in accordance with certain historical circumstances, I claim that these characteristics form no lesser part of the ontology of the political when human beings are subject to repression. When Arendt's conception of the political is released from the judgment of taste that overshadows it, then the resultant ontology may be described in her own words thus: "Politics arises *between* men, and so quite *outside of man . . . politics arises in what lies between men* and is established as relationships."[81] The human being is apolitical in himself or herself. The political comes into being between humans, born of their being together. To speak of the ontology of the political is to assume that it pre-exists the type or nature of action in which human beings engage, or the type of space that comes into being between them. The political cannot be calibrated in accordance with certain measures nor can it be circumscribed. Wherever human beings exist together, their existence is a political existence. If the political exists wherever human beings are to be found together, then the judgment of taste applied to their speech or actions "This is (not) political" has meaning only on condition that it is possible to isolate the speech or actions of any one individual from that of others and to determine that they have not intersected the speech or actions of others. It follows that the speech and action of human beings is always political, even when their activity can be identified as labor or work, and this by virtue of the persistent co-presence of humans in the space that they share, intentionally or not.

My discussion of the life of action (*vita activa*) differs from Arendt's with respect to two additional points. The first relates to the gaze and to its inclusion in the life of action where it forms an inseparable part of instrumental activity, the attainment of goals and ends, and of the kinds of efficiency and sophistication needed to create new beginnings. The second point relates to the relation between the life of action and the various products it generates. Arendt's identification of food, clothing and housing as products of the first domain; of tools, appliances and works of art as products of the second domain; and of political spaces as the products of the third domain; constitutes an integral part of her efforts to stabilize the differences between the various types of human activity. By way of contrast, I seek precisely to emphasize the fact that Arendt's differentiation between the different configurations of activity does not refer to three separate domains, so much as to three dimensions of human activity. Note that human activity, as I have demonstrated with respect to the

camera and the photograph in the first chapter, is not only conducted between human beings but between humans and objects. While humans create objects, it is also true that objects operate upon humans in turn. Rather than distinguishing three distinct domains through the categorization of similar products or activities, every deed and every manufactured object, I argue, shows evidence of the three dimensions whose existence I hold to be at stake. In the discussion that follows, I will demonstrate the civil necessity, in contexts of regime-made disaster, to raise the alarm every time that we discern that human beings have been deprived of the conditions of possibility of realizing these dimensions of action.

In order to reconcile the conception of the political as ontology with the conception of the political as action or as a separate sphere of action, Arendt reduces her description of the inclusiveness of the political to a form of potential whose realization or failure to be realized is subordinate to the determination of the judgment of taste. Political space, she writes, "exists potentially wherever humans encounter one another and the political may be realized in practice at any given moment."

I will propose three changes to Arendt's formulation. Firstly, I reject the assertion that political space exists merely potentially, arguing instead that the political is inherent in every encounter between human beings. Secondly, I reject the assumption that the realization of the potential—becoming political—is a distinct event that should be judged. Thirdly, I propose certain forms of intention and concern for a shared world—the precondition for the existence of political space—as bearing the distinction between the different interventions that human beings perform.

Political space exists wherever human beings encounter one another such that at every moment any individual may choose to realize her civil partnership in the world she shares with others and may manifest concern for this world.

This reformulation will enable me to differentiate between the ontology of the political and the characterization of different types of political intention. In what follows, I will base myself on the distinctions that Arendt reanimated with respect to the three configurations of human activity, but will propose to articulate them as three types of intention that might exist, simultaneously, in every activity.

Three Intentions / Three Dimensions

Wherever human beings exist together with one another, whether in private or in public space, whether in open or closed spaces amenable to, or hidden from, the surveillance of others, their being together constitutes

political existence. This political existence takes different forms character-
ized by varying degrees of freedom and repression. None of these forms is
co-extensive with any single Arendtian realm, nor are such forms restricted
to the private sphere or the public sphere, respectively. Forms of activity
centered on what Arendt terms "work" usually subsume aspects of the
two other configurations, "labor" and "action." The deeds of human
beings, whether they emphasize work, labor or action, have direct or indi-
rect implications for the deeds of others. In most cases, the actions that
people undertake in order to satisfy their needs require that they imagine
the interests of others and that they take such interests into consideration
even when detrimental to their own immediate interests. Similarly, people
must develop certain professional skills in order not to disrupt shared
venues of activity and in order to manifest a certain consideration for the
world. Such a life of action (*vita activa*) is distinguished from the life of
contemplation (*vita contemplativa*), which classical thought associated
with a certain realm of the gaze: theory, speculation, contemplation,
things that people imagine in their minds' eye and so on. The rendering
metaphorical of abstract thought has, since the classical Greek period,
been ramified as surprise, astonishment, a lingering over a figure or a land-
scape with no other purpose than the prolongation of the gaze. Arendt
does not undermine the basis for positing the existence of a separate
sphere of contemplation nor does she thematize the gaze in her discussion
of the life of action.

The gaze, speech and action are three dimensions of political life that
are not manifested in a permanent or uniform form such that they might
be identified with one or another of the realms of the life of action. They
exist in different forms, in parallel, in contradiction, in conflict with or as
complementary to other forms. They can be present simultaneously in two
or three domains, and they are not responsible for upholding the differ-
ences between these domains. What, then, differentiates the different
spheres of the life of action from one another? Any attempt to respond to
this question is necessarily partial and problematic. It restores to the
discussion of the political what Arendt sought to eliminate—interest or
intention—when she identified the political with freedom and distin-
guished the political as constituting a form of non-instrumental action,
devoid of any interests or intentions. The three configurations of the
life of action cannot be thought of as separate realms of action that
never intermingle. They must be considered instead as activities that are
differentiated from one another by virtue of the intention guiding them
without rendering them mutually superfluous. These configurations must
exist in parallel as three types of distinct political concern that are not

equivalent to one another. Each and every one, regardless of its status in the world, exists in relations of mutual responsibility regarding all three dimensions simultaneously:

1. survival, orientation, identification, the satisfaction of needs;
2. edifying a world, an ongoing accumulation of knowledge and its development;
3. concern for the world, civil intention and imagination.

The first form of intention associated with the life of action is expressed by means of activities destined to meet basic survival needs, to enable the reproduction of life, or that which Arendt designates through the generalization "labor." Humans do not conduct such activities solely within the framework of one circumscribed realm; rather, they form an ongoing dimension of quotidian existence. Humans survey their surroundings in order to orient themselves within them, in order to direct their movements, to identify the objects, animals and people whom they meet, to assess their intentions and the risks and opportunities arising from the encounter. They activate a certain form of gaze that I have termed the identifying or orienting gaze, a basic classification of the visible. People exchange signs of orientation in the realm of speech. They name objects, exchange useful information and share their life experience with others by means of speech. Speech is part of the basic practices of orientation and survival. These cannot be achieved solely by a single isolated individual. Someone or something is always present in the field of vision, disrupting or enhancing it. Someone or something has crafted linguistic templates in advance, has generated an economical syntax of sentences or has developed signs that guide humans and orient them in space.

The second form of intention, which parallels what Arendt sees as work, is manifest in activities that produce knowledge or in objects that do not serve immediate needs and are not exhausted through immediate consumption. These allow humans to build a stable, professional and developing world. It is work that is responsible for the production of appliances, tools and components (which may themselves serve in the manufacture of other objects), works of art, buildings and other forms of knowledge. Taken as a whole, these activities contribute to the building of an integrated world, organize human life on the planet and enable humans to achieve dominion over space. Like their predecessors, these activities are not restricted to given places or spaces but constitute a permanent part of the professional endeavors of human beings, whether these are artistic,

political, scholarly or commercial. Such endeavors require prior knowledge to have been attained and to continue to be developed, including forms of professional knowledge that meet accepted standards and allow certain activities to be carried out under surveillance and through controlling the circumstances in which they occur. In the discussion above, I characterized the gaze that accompanies these endeavors as a deliberate gaze associated with professional competence in various contexts. Knowledge accumulated by means of this gaze enables the organization of the visible and its putting to work. The professional gaze exists when a certain activity is freed from the immediate fulfillment of needs and is recruited to a more complex order of goals. Professional speech, which specializes in reporting, documenting, analyzing, validating or evaluating, is associated with this configuration of the life of action. Professional discourse, whether it is medical, artistic, political, or other, has relevant forms of looking, speaking and acting.

The three intentions associated with the life of action, together with the three dimensions that accompany them—looking, speaking and acting—may be categorized and differentiated from one another with reference to templates of behavior, rules and norms. The first intention, which seeks to identify, is used constantly by each and every one of us. The other two intentions (which subsume three dimensions, as I have already pointed out—the gaze, speech and action) require knowledge attained through means of the actions catalyzed by means of the first form of intention. The second form of intention is more selectively engaged, and arises within frameworks of expertise, interest, training, vocation, craft or art. This second intention is accompanied by a specific form of authority that structures it, such as the authority of the artist or the doctor, for instance. Such authority comes into being in the interaction between the professional subject, her work environment and the particular objects associated with it. Non-professional subjects are not required to share the referents of knowledge, action or the gaze. Rather, the professional is obliged to report back concerning the results of the professional intervention in accordance with the disciplinary or institutional frameworks within which it operates.

The third form of intention is associated with forms of looking, speech and action that are not subordinated to disciplinary rules or codes of governance. The third form of intention exists in public, and it is much more difficult to stabilize what is at stake in it just as it is difficult to restrict it or subordinate it to external sources of authority or sovereignty. This is precisely what animates its deployment, which is derived directly from the civil condition.

The Civil Condition

"Men," writes Arendt in *The Human Condition*, "are conditioned beings because everything they come in contact with turns immediately into a condition of their existence."[82] The invention of modern citizenship during the eighteenth century, a condition to which more and more people are exposed globally, has become a dominant condition of human existence. This is why instead of discussing citizenship, *per se*, let me paraphrase Arendt's title and focus on the "Civil Condition," on the conditions of possibility for being a citizen. Over the course of the last 250 years at least, human beings in different locations have thought of themselves as citizens and have debated the essence of citizenship as well as its limitations. Now that so much time has passed, thought concerning citizenship need no longer be bound to the invention of a zero point, a hypothetical moment of inception. It is more productive to see citizenship as an interface that enables humans to create a shared world, one which they will be able to continue to inhabit together in the future, not only because of their actions but because they calculate the effect of their actions on others who share the world. In other words, citizenship is an interface that enables people who inhabit different spheres of existence to share a common world despite marked differences in the conditions of their existence. This interface depends on the recognition that every citizen bears responsibility toward a common world and proceeds on the understanding that if citizens neglect their responsibilities, or incite others to do so, damage will ensue. Under the civil condition, which anticipated globalization and became entwined within it, human beings are dependent on one another to sustain their world in every aspect of their existence. The civil condition was part of the development of a civil discourse, which held the principle of every individual's being ruled like every other individual to be central. Civil intention is a structural consequence of these conditions. Nothing safeguards its existence save for the efforts that people invest in different areas of their lives to protect the conditions of possibility for its appearance. The conditions of possibility for the appearance of civil intention consist in a constant affirmation of the conditions of citizenship and their defense in the face of their takeover or appropriation by any particular group, field or form of governance. The particular functioning of the modern nation-state, however, which has captured the discourse of citizenship and subordinated it to the logic of sovereignty that dictates who among the governed is a citizen, bestowing status and a package of rights and duties on the citizen that are not allocated to other governed individuals, has created fertile conditions—not for civil intention, but for civil malfunction.[83]

Civil Intention

The individual may, through gaze, action, speech or the speech act, dare to bring something new into being in public whether her motivations are professional, civil or derived from the need to survive. When daring is animated by a civil intention, it becomes possible to suspend disciplinary, sectarian or sovereign interests and to oppose the authority of anyone seeking to impose them in the event that they conflict with the common interest of *all the citizens*, or impair the ability of people who do not share any other common interests to coexist in shared space, or that they deprive certain individuals of rights or privileges bestowed upon others on the basis of disciplinary interests or considerations of rule. I term this third form of intention "civil intention" because it is derived from the existence of a heterogeneous collective of individuals who are not empowered to generate the fateful agreement to take the life of a portion of the whole that lies at the heart of the nation-state (a consensus generally achieved through stripping the forsaken population of the protection of an imaginary contract mediated through sovereign power).[84] This heterogeneous collective of individuals is characterized through structural and hypothetical dissent—a refusal to condone the taking or jettisoning of life—as the basic condition for their ability to share a common world. This definition is, in fact, a civil formulation—achieved through inversion—of the classical template of the social contract that pivots on the hypothetical agreement of individuals to be ruled by a sovereign power. Clearly, the sovereign actions of the state are conducted within the second realm of the active life—work—and bear similarity to other forms of professional conduct. Like the latter, they occur in the context of a circumscribed field of activities open to the participation of the relevant authorized professionals. As is the case with other professionals, however, the agents of rule are also citizens numbered among the totality of citizens. When these "professionals" no longer show loyalty to their inclusion in this partnership; when their citizenship is completely absorbed into their professional personae so that they act from the perspective of the second realm of doing alone, other individuals may call upon them to renew their partnership in the collective of all-the-citizens. Civil intention, whether borne by the gaze, speech or action, cannot be circumscribed to a zone designated the "civil" alone, as the monopoly of people deemed to possess professional competence with respect to citizenship. Rather, civil intention should accompany all forms of action routinely conducted by people, whether as professionals, family members or members of a

community. Unlike the goal-directed gaze, the gaze informed by civil intention does not need to be fixated on a referent. The civil gaze, civil speech and civil action do not require discrete times or spaces in order to come into being. Since they can be realized at every given moment, they are not opposed to the other two forms of intention nor do they cancel them out. On the contrary, the civil gaze draws sustenance from the other two forms of the gaze while nevertheless suspending the constraints that characterize these other forms. The referent of the civil gaze, of civil speech or of civil action is neither privileged nor hallowed, neither beautiful nor awe-inspiring, neither complete nor sealed off. The civil gaze may be invested in any object by any individual.

Since photography is produced through the encounter between human beings, it bears the traces of the three forms of intention that I have been discussing. Photography has, since its invention, allowed new referents of the gaze to emerge: not only in the form of pictures, objects or unusual events, but through the documentation of human existence in all of its dimensions, including forms of behavior, objects, situations, customs, gestures, and places not formerly considered worthy of being seen. Photography institutes a new relation to the visible that emerges between the many, in public, such that individuals no longer restrict their seeing to the sanctioned parameters of national, group or professional settings. Considered as an event, photography invites the gaze to wander beyond what the photograph frames, and for individuals to display interest in, responsibility and concern for what they see, in the recognition that each is in turn exposed to a gaze that sees what they cannot or do not want to see.

Civil intention comes under threat from various directions and is prey to various players attempting to control it, to subjugate it to the rules of a certain field, or to subordinate it to their interests. For civil intention to exist, it is necessary to display vigilance in the face of such threats and to resist them when they emerge. In other words, civil intention requires a different kind of work than that required of human beings within their regular fields of action. As a product of the very civil condition, however, civil intention should not be understood as a form of private intention, like ethical intention for example. To relinquish civil intention is to create the conditions for the ascendance of civil malfunction characterized partly by its own inability to recognize the malfunction. Put differently, where there is no civil intention, there is civil malfunction—and nothing stands in the breach.

The Limits of "The Political"

Critical theory, based on the centrality of the project of politicization, has long sought creative means to politicize questions such as poverty, hunger or restrictions on the freedom of movement. Despite differences between prevailing theoretical orientations regarding questions of politicization, they share the impulse to articulate something in a manner held to be political. This consists, firstly, in declaring that something is political and must be included within the boundaries of political discourse rather than being relegated to economic, social or therapeutic discourse, for example, or allowed to languish in silence in the public domain. Discourse arising from critical theory has helped to bring about (or to extend) the distinction between "the political" and "politics"—where the latter is conceived as the inferior province of politicians, lobbyists or stakeholders of various kinds. Critical theory seldom displayed direct interest in politics *per se*: "The political is always an alternative to any police order,"[85] says Rancière. But in many different formulations of "the political," "politics" or governance may be revealed as the implicit objects of desire. Thus, for instance, desire is revealed in the manner in which successful politicization is imagined to arise. Desire emerges during struggles to render instances of violation or exploitation into the catalyst for political intervention at the level of the regime. It is equally present in the yearning to undermine the boundaries set or maintained through politics, or to redefine them through the problematization of governmental power. Rendering such desire visible and following the obvious path to politics might often lead to success in the endeavor of "politicization." Satisfying this desire renders the distinction or the distance between the political and politics superfluous and undermines the efforts critical theory invests in maintaining the political intact on the boundary or at the periphery, where it might better undermine any pretensions of politics to represent the whole. The political project of critical theory displays four major limitations:

1. It constructs boundaries around the political—determines that the political exists here and not there, and may result in indefensible propositions like Arendt's claim that the French revolution was not political or Rancière's assertion that "the USA is indeed a barely political community."[86]
2. It singles the political out as the realm of practices centering on problematization, resistance or contestation, while it does not render account for the fact that such practices characterize human

 co-existence with others more generally and are to be found in other
 domains, politics among them.

3. It signposts the political as the domain of people who do not engage in
 politics. It does not fully render account for the identification of poli-
 tics with certain constituencies, and for the identification of the political
 with others, nor does it account for the relations between them.

4. Its characterization of the political is a formalist one, consisting in a
 relation to a form or rule or regime. It fails to think of human coex-
 istence outside of this perspective.

"Politicization"—which my discussion of Benjamin has shown to rely on
notions of individual agency—was the panacea that critical theory offered
to the ills of the world, aestheticization included. Theory sought to redeem
the world through deploying the critical tool of politicization. Its repre-
sentatives have indeed shown vigilance in pointing to institutions, bodies
and individuals who have abdicated their responsibility toward the world.
But they were animated by what I have termed the political judgment of
taste, which adamantly pronounces when something is political or is not.
The public assertion of the judgment of taste on the part of critical theory
reiterates the understanding, every time that it is uttered, that the political is
infrequent, precious and reserved for the select few—whereas other forms
of interaction are variously seen as not political or are actually denigrated
through being classified "part of politics." The judgment of taste forms part
of the effort to restrict the political to rare moments of epiphany when it
seems to emerge in all its glory. It manufactures the political as a solo
performance, as it were, an event distinguished from an infinite spectrum of
interlocking performances of speech, the gaze, and action produced by the
modern citizen whose ongoing assessments compel them to ceaseless judg-
ments. The worldly influence of such non-ceremonial judgments not
infrequently outweighs that of the judgment of taste that stalks critical
thought as its shadow. The judgment of taste frustrates the development of
a new kind of "positive" thought that might transcend the "negative"
thought based on prevalent categorization of a given reality as political or
not political. It is redolent of covert protest or disappointment when a situ-
ation or an event is felt to be inadequate to the political expectations invested
in it. The mere fact of politicization, however, does not guarantee that an
event or situation will be treated with the appropriate intention.

 In order to determine what might constitute "appropriate intention,"
the civil has to be included within the political. Defining the civil as one
dimension of the political will facilitate the work of understanding its
other dimensions.

The Three Domains of the Life of Action

The attempt to replace the judgment of taste that determines whether a particular form of activity is political or not with the assumption that the political is the various forms of being together—through gaze, speech and action—requires that we redefine the political in positive terms. Its different configurations must be formulated and linked to specific forms of seeing, speaking, and acting. We cannot afford to continue to relegate the political to a place, sphere or region where outcomes are determined or predetermined without anyone's being accountable for them. Thus, instead of perpetuating the impulse toward politicization, I suggest that we consider instead what conditions might allow for civil intention to come into being in any field of existence, at any time, and through the agency of any one of us, male or female.

Instead of investing in pipedreams concerning the future or in apocalyptic visions regarding its form to come, we might do well to begin to re-imagine the spaces of our co-existence with others as possessing three dimensions: experience, professional competences and civil skills. Recognizing that our political life does not exist in isolation but intersects these three domains of the life of action, and that responsibility for any one of them does not cancel out responsibility for any other, will enable us to imagine how it is possible to restore a civil dimension to our decision making under various circumstances—a civil dimension consisting in the exhibition of concern for ourselves that does not preclude concern for the others who share our world or for our shared world itself. The preservation of the distinct nature of each of these domains, as well as of freedom of movement between them is, as I will shortly demonstrate, a precondition for allowing us to retain our purchase over the world (experience); for ensuring that the world surrounding us is not subject to complete instrumentalization (professionalization); and for ensuring that no one is stripped of the ability to negotiate the various domains freely (citizenship). Whereas no individual domain can be relinquished without violating the whole, it is not possible to restrict ourselves merely to the purview of what any single domain might offer us.

The most urgent question confronting us, therefore, is how to clear space for civil intention in the range of actions we perform daily. Concern for a shared world might be thought to be grounds enough for infusing our speech, gaze and action with civil intention on a daily basis. But a misguided identification of this intention as "political," or the misguided understanding that "the political" belongs to its own separate realm, have

respectively enabled citizens to neglect or to forget the civil intention, and to cast off responsibility for the welfare of the world and of those who share it with us.

Instead of opposing the political to its other, as the judgment of taste requires, it is possible to outline a preliminary (albeit insufficient) schema of political life—that is to say, the life of action—along its various dimensions (see table).

The Three Fields of the Life of Action

Type of Intention/ Interest/Concern	Gaze	Speech	Intervention
Survival, orientation	1. Identifying, orienting	Naming, signposting, announcements, messages	Concern for life, provision of basic needs and services
Professionalization, acquiring sophistication, control and representation	2. Professional (artistic, medical or other), object-oriented, sophisticated, cumulative, categorizing, estimating, employs tools	Speech in the name of a professional subject, reporting, documentation, judgments of taste, refutation, confirmation, contracts, negotiation, persuasion, conceptualization	Expertise, management, rule, governmentality, professionalization, authority, organizing a field of phenomena
Civil	3. Suspension of the instrumental gaze, transgression of the given boundaries of the field of vision, problematization of the conditions of the gaze, exercising imagination in areas blocked to the gaze	Suspension of the perspective of governmental power, overcoming the limitations and constraints imposed on speech by the other intentions through imagination and transgression, promising, forgiveness	Concern for shared worlds, accessibility to all, reparation, obligation to all the governed, activation of the shared senses, civil imagining

This schema enables us to avoid the prevalent oppositions that assume that a particular action is too political or not political enough, whereas another is deemed not political at all. It presents the complexity of human action along a number of simultaneous dimensions, while granting that they are irreducible. Although it is tempting to categorize various products as corresponding with certain fixed rubrics in the table—assigning food and clothes to the rubric of labor, and the work of art to the rubric of work, for instance—it is impossible to conceptualize the processes

involved in their production or consumption without conceding that the production and consumption always involve the three types of intention that I have described, and products may themselves catalyze one of the forms of intention. Take, for example, the work of art that Arendt sees as the product of work. The work of art is differentiated from other aesthetic objects through the manner of its operation on our senses and with respect to the type of civil intention embedded in the encounter with it. Contemporary discourse sees the work of art as autotelic, and its singularity as deriving from the opportunity to defamiliarize familiar images and situations. The discourse of art tends to ascribe all effects arising from the work of art to the intention of the artist as unique author of the work of art. Alternatively, it invests agency in the work itself. Thus, for example, instead of an art critic saying that in a certain work one can see a wounded woman, for instance, one can find assertions to the effect that the work of art *deconstructs* the ideal image of the woman as perfect embodiment or the work *problematizes* the representation of the medicalized body and states x or y. This excess, that is to say, speech added to the manner in which the work of art acts on the senses so as to ascribe to it the capacity for argument (one that depends on the existence of a spectator), expresses the professional will to transgress the boundaries of the paradigm of art. But, even when utterances are generated with explicit reference to the political, they continue to unfold within the general framework of the discourse of art: namely, rules are invoked that restrict the discussion to what the work of art generates, consequently rendering the gaze, speech and action metaphorical. While the work of art might, indeed, act upon the spectator or activate her, it argues nothing and seeks neither to persuade, nor to criticize or deconstruct. It is the spectator who must engage in these actions. The image as utterance may well generate a certain interpellation, but the spectator may disregard this interpellation just as readily as she responds to it or agrees to link its utterance further to others.

Photographs and Public Space

Every once in a while, a certain visual utterance is invested with iconic status—the power to capture all of creation—and is deemed to be capable of changing the world, however seldom images actually attain this status. Conversely, many detractors of the visual continue to lament the loss of potency of "weak" images.[87] These seemingly polarized positions share a common attribute—the power they invest in the photograph bypassing the role of the spectator in the work of the gaze: "the success of Lange's

photographs in eliciting aid confirmed a feeling that prevailed during the New Deal: those who saw the afflicted would be moved to assist them . . . when the Depression itself remained largely invisible for several years and a large daily dose of photographs was still a relatively new regimen, the eye and mind, and perhaps the heart, were more receptive."[88] Descriptions of this kind render the spectator superfluous, investing the photograph with magical powers. It is, in fact, spectators who see by virtue of the photograph, who speak on its behalf sanctioned by its mediation and under its sponsorship, and who create the additional links in the ongoing chain of utterances. To revert for a second to Goldberg's claim, above, that the heart or the spirit was more responsive during the New Deal, or to claim alternatively that heart and spirit are more responsive today, is groundless. Without regard for the practical and civil intentions that render the photograph an utterance or a series of utterances, and without regard for these intentions that link them to other utterances over and above the visual concerning the civil space that the photograph makes present, the photograph would remain merely one form of testimony to "the suffering of others," or, if you like, one form of testimony to the fate of those destined for suffering as opposed to the fate of those destined to observe them.

Similar axioms regarding the apparently autonomous agency of the photograph underpin contemporary human rights discourse, as Thomas Keenan has shown in his analysis on "mobilizing shame": "Shame is thought of as a primordial force that articulates or links knowledge with action, a feeling or a sensation brought on not by physical contact."[89] Keenan analyzes the photo opportunities that perpetrators arrogate to themselves in conflict situations, and pauses to analyze the spectacle of a hand gesturing openly to the camera during the looting of Kosovo. The fact that the looter poses openly before the camera erodes assumptions concerning the ethos of shame conventionally held to accompany public exposure. Keenan's analysis of this instance allows him to deconstruct the assumptions of human rights practice whereby the image is invested with agency, on the one hand, and perpetrators are held to avoid exposure in public, on the other hand, for fear of criminalization.

Cases like the one Keenan analyzes are not exceptional, and occur when regimes of chaos prevail—as in Kosovo, for instance. But it is equally possible to identify cases occurring in the margins of democratic regimes where they are generally denounced as worthy of being "uprooted from the source." Note that the looter's gesture puts on display precisely the consensus of all sides—perpetrators, victims and spectators—concerning the referent of the visible, as well as concerning its meaning: looting. The

Kufr Bir'im. By an unknown photographer. 1948. This photograph was given to Nahida Zahra, one of the second generation of the dispossessed of Kufr Bir'im (scanned with the compliments of Meron Farah, another of the dispossessed of Kufr Bir'im).

looters do not attempt to disguise the act of plunder but stage it before the camera as the matter of a certain pride, indifference or apathy vis-à-vis their actions. Looters and spectators nevertheless diverge from one another in the sense they attribute to this same gesture that can also be taken to symbolize the différend between them.[90] But what happens when no such differential arises? In the discussion that follows, I will subject one particular photograph drawn from the hundreds taken in Israel between the years 1948–49 to analysis. Here, too, we will be concerned with a kind of photo opportunity seized by individuals actively engaged in the appropriation of the resources of others. But no différend emerges between perpetrators and spectators with respect to looting, and it is precisely this failure that will be the subject of our discussion.

The image above shows members of a Nahal[91] unit in the Israeli Defense Forces eating together on the balcony of a house in the village of Kufr Bir'im. Members of the Nahal were among the first to denounce the looting of Arab property by soldiers and civilians. But when individual Nahal members were photographed eating on the balcony of a house whose inhabitants had been forcibly removed, or when they looked at this photograph in retrospect, we can assume that they did not see themselves as looters. In their understanding, they had served the state and their deed is an "act of state."[92] In terms of the prevailing climate in Israel between

1948 and 1949, and in the estimation of part of the Jewish inhabitants of the state of Israel to this very day, the photograph depicts not looting but "settlement." Nor is it an exception. Similar photographs adorn local histories of kibbutzim and moshavim (collective settlements), private albums, school textbooks, and innumerable commemorative publications celebrating the Day of Independence over the years. Spectators who identify themselves or their loved ones in these pictures are not in the least unnerved by them.

The appropriation of most of the Arab villages in Palestine that would become Israel and the domination of the Arab minority who were not forcibly removed[93] would not have been possible had mechanisms of socialization not operated within the Jewish population that represented crimes of expulsion and appropriation as part of the "building up of the Land of Israel" and that assimilated them as necessary internal tensions in the establishment of a Jewish democracy constructed on this very basis. The Zionist Youth Movements and the core-groups of the Nahal settler units constituted a kind of laboratory where appropriation could be designated liberation and attendant relations of domination and negligence could be naturalized. The "benevolence" displayed by certain individuals or groups, such as the denunciation of looting on the part of individuals,[94] played an important role in actually legitimating looting conducted "for the state" and on the part of the state—act of state. Thus, for example, when Nahal members took over houses in Kufr Bir'im, they concentrated most of the possessions of the deportees in storehouses on the grounds that they were not engaged in looting. In the context of passionate debates concerning equality and socialism, the primary instance of appropriation that they were party to—the looting of land and houses—was rendered invisible to them, as was the destruction of the lived fabric of Palestinian life. It was simply a matter of course that the upright men and women of the youth movements would live in the houses of the former inhabitants of Kufr Bir'im, while the deportees spent their nights out in the open on the slopes of adjoining hills. No less self-evident became the fact that Nahal members would proceed to cook in the kitchens of deportees exposed through expulsion to lack of adequate food and water. The best of Israel's Jewish youth debated the question of how to build a more just society while the owners of the houses they occupied were cast out of the privileged circle of social justice. It was, after all, not unreasonable for the new settlers to receive the land of the Palestinian deportees after their houses had been demolished, or so they said. Why not continue to expand the kibbutz, the village or the *moshav* built on appropriated land while its owners strove in vain to make the state realize the obligation to return it?

Thus, clad in white shirts and the language of socialism, inconvenient contradictions disappeared. "Let us," proclaimed the guardians of conscience on the left, "guard the possessions of the Palestinian house-holders until they are able to return"—all the while living in their homes. The historical left in Israel, the source of ongoing formulations in this spirit, has been complicit in rendering theft legitimate ever since, a prece-dent adopted enthusiastically by other Jewish population groups.

To expect earthshaking consequences from the public display of a photograph like the one taken at Kufr Bir'im is to assume that the photo-graph depicts something discrete and bounded, existing outside the regime within which it is produced and displayed. It assumes the stability of the referent of the photograph, as well as consensus regarding its meaning. Let us look a little more closely at the photograph taken in Kufr Bir'im. The photograph cannot be assimilated at first glance as an "ordinary" photograph of looting. It can be deciphered, however, as one that permits us to reconstruct the type of regime that renders potential shocking acts of looting unworthy of denunciation. The template of rule that may be reconstructed does not represent the ideal type with which Israeli democ-racy has sought to be identified since its inception; rather, it is the template that actually obtains in practice.[95] The template gives expression to differ-ent principles of separation between the major population groups subject to its rule. In general, one crucial difference determines the most impor-tant forms of discrimination pertaining to population groups with respect to the nature of rule and domination, accessibility to power and the possi-bility of realizing a particular set of rights. From its very foundation, the Israeli regime has been founded on a crucial distinction between governed members of the body politic as opposed to those jettisoned to the abandon of the non-governed—the hundreds of thousands of Arabs expelled from the body politic in order to found the Jewish regime.[96] This constituent violence, the expulsion of more than half the local population, the trans-formation of the landscape in which they conducted their lives and the subordination of the remaining Arab minority to military law for 18 years, has been expunged from official representations of the regime. The traces of such constituent violence are everywhere evident nevertheless, save in the representation of the state as a democracy—a proposition that is ardently defended. This democracy, so we are told, is the best of all regimes and must be defended at all costs.

In the imagination of the democratic state, public space is the arena where citizens voice judgments of taste and determine whether or not something is to be regarded as political, and consequently whether it is relevant to their lives or the lives of others. In practice, public space, one

of the great monuments of modern democracy, is the quintessential space where citizens ratify that fundamental agreement considered hypothetical by the theorists of the social contract—the offering up of their power to the sovereign in return for protection. In this exchange, those who practice politics are exempt from exercising civil intention and are committed (in the best case) to the professional discourse of politics while citizens, on the other hand, are trained to identify their civil intention as "political" so that they remain without a civil foundation for exercising their commitment to other members of the governed.

A photograph of looting, or of other more serious offenses, is not an indictment nor can it initiate changes of regime. The photograph is never a sealed product that expresses the intentions of a single player. The photograph does not make a truth claim nor does it refute other truth claims. Truth is not to be found in the photograph. The photograph merely divulges the traces of truth or of its refutation. Their respective reconstruction depends on the practical gaze of citizens who do not assume that truth is sedimented in the photograph, ready to be revealed, but rather that truth is what is at stake between those who share the space of the photographed image and the world within which such an image has been made possible. Civil concern for the truth is thus concern for the possibilities that enable others to participate actively in the game of truth-claiming.

The practical or civil gaze rejects any conceptualization of the photograph as omnipotent and is opposed to the assumption that the public display of the photograph can bring about change or that the failure to bring about change is the fault of the photograph or photographer. The latter conceptualization stems from the limitations of the institutional frame, which presents the photograph as the work of a single individual—designated the photographer—and the photographed person—designated the victim—as the object of therapeutic or humanitarian intervention. The practical and civil gaze insists that the photograph is the source of heterogeneous knowledge that may enable us to reconstruct the lineaments of the regime as it exists in practice—as the relations between governmental power and the governed population or between citizens and non-citizens—rather than in accordance with the manner in which the regime represents itself. In this account, it now becomes possible to conceive of the photograph as the product of the encounter between citizens, and as the bearer of the limits to the human capacity for engaging in solely individual action in shared space.

Some years ago, one of the members of Kibbutz Biram re-encountered the photograph that I have analyzed above, and became aware of those occluded from it for the first time. The kibbutz member in question

apparently understood that he could not continue to exert ownership over something that wasn't exclusively his own, and he gave the photograph and other similar pictures to the daughter of one of the families expelled from Kufr Bir'im.[97] The restitution of the photograph expresses his recognition that, for all that he and his friends are the ones actually visible in the photograph, what it "inscribes" belongs neither to him nor to his friends. The restitution of the photograph is not the restitution of property—the image never belongs to anyone—rather it makes the photograph visible to the gaze, and accessible to the speech and intervention of the deportees whose loss makes what is inscribed in the photograph possible. The restitution of the photograph is not the rendering of dues for what it inscribed, nor is it a disavowal of what is written there. The opposite is true: the restitution of the photograph represents the first step in an attempt to rehabilitate the civil dimension absent from its earlier uses.

Beyond the Political Judgment of Taste

The discourse of art, like any other professional discourse, imposes limitations on the possibilities of the gaze, speech or action conducted by the spectator. The discourse of art directs us to continue to see the work of art as the source and goal of discourse, and enables the specialist spectator to exercise professional knowledge and to enjoy the fruits of its authority. The growing interest of the discourse of art in atrocities under the patronage of the judgment of taste—"This is (not) political," which has become the dominant syntax for parsing images of atrocities—has buttressed this discourse within itself and has relieved those participating in it from the obligation of developing a civil intention that might supplement the professional one.

A civil intention enables the spectator to exceed the limits of professional discourse and to regard the image, not as source and end in itself, but first and foremost as a platform that bears the traces of others, and thus as a junction that articulates between such traces and the spectator who sees them. This form of looking departs from the form routinely sanctioned by the professional discourse of art and participates in a shared civil space. It is certainly the case that the traces of various participants in creating the work of art can be discerned within it, too, if in weaker form. But their presence in the photograph is incontrovertible, even when the photograph is assimilated to the professional discourse of art, and cannot be erased except through disciplinary or state violence. The men and women photographed in any given image participate in a political space of relations and their presence makes it difficult for the spectator to attribute

that which is visible only to the agency of the photographer. It also becomes impossible for the spectator to position herself as a singular entity standing opposite an equally single artist-creator. The political ontology of photography—the ontology of being-together, of an encounter, whose traces the photograph bears and renders present, invites us to deviate from the professional or artistic discourse within whose frameworks experts engage in authoritarian acts of looking, speaking or intervention. This swerve is not a swerve toward "the political," since both the spectator and the people photographed are always already imbricated in the political. The swerve away from professional discourse is rather a swerve toward the civil. In other words, it is a swerve toward a realm where the presence of others is not foreclosed in advance and their participation, like that of the spectator who foregoes the consolation of the judgment of taste, is a necessary condition for the creation or reinforcement of a civil intention.[98]

The civil intention does not exist in opposition to that of work or labor, and the swerve toward the civil does not involve relinquishing or erasing the others. On the contrary, preserving the distinction between the three is often the last obstacle before the complete instrumentalization of the shared world and its subordination to the professional political gaze of power. At times, the interpellation of the spectator and the photographed person to make room for the civil intention requires the spectator to interrogate the conditions of her existence within the remaining two domains, and to reconstruct them.

Between the Three Forms of Intention

Let me demonstrate my claims with reference to that same photograph of Aisha al-Kurd (see page x). The act of viewing this photograph in the framework of the paradigm of art is organized around the photograph and sees it as the major player in the field of relations between photographed people, camera and spectators. This form of spectatorship prepares the way for the judgment of taste that demands arbitration between "the aesthetic" and "the political." Kirshner's own stylistics and his aesthetic decisions are deeply inscribed in his photographs. The decision to stage the individuals whom he photographs and to put their physical and psychological violation on display in an improvised studio setting is particularly remarkable since the ongoing repression of the Palestinian Uprising by the Israeli army at street level would conceivably have provided a wealth of opportunities for a roving camera to document the vulnerability of Palestinians or the cruelty of the soldiers in real time.

Kirshner's theatrical staging of the individuals he photographs also involves the exaggeration of their poses so as to foreground their violation and to frame it directly using items of clothing, gesture or lighting. These controversial stylistic choices evoked predictable responses. His work soon elicited a chorus of claims regarding the "aestheticization" of the suffering of Palestinians. Although those who voiced it assumed to speak for the persons photographed, they in fact ignored one of the central imprints the latter left on the photograph—their explicit consent to be photographed thus, that is to say, their active participation in the event of photography. Studio photography of the kind that Kirshner conducts requires time, the evolution of forms of understanding between photographer and the people he photographs, cooperation, concentration, attention to detail, the weighing of alternatives, choice, the willingness to be exposed, daring, decisiveness, consultation and negotiation. These attributes are evident in every one of his photographs, rendering his oeuvre into a fascinating documentation of the collaboration between a Jewish Israeli photographer and Palestinians under Occupation where both parties share a common interest in showing spectators what the Israeli army—and in a more general sense, what the Israeli Occupation—inflicts on Palestinians. But none of these factors, which speak of the being-together of the participants to photography—that is to say, their collaboration—are visible to the gaze when the photograph becomes the object of the political judgment of taste and/or when the spectator consents to regarding the referent of the photograph as the work of an individual photographer. Alternatives exist, however. Within the paradigm of visual culture or through the prism of the tripartite schema I suggested above, it becomes possible to develop a reading of the photograph that calibrates between the three intentions that I have described. Such a reading proceeds through:

1. The orienting gaze, which reconstructs basic information regarding the photographed people (Aisha al-Kurd, Kong Sa'aan or Tomoko Uemura) and the conditions of their lives. This gaze seeks out details that will enable their lived conditions to be reconstructed: it identifies them as administrative detainees, as people sentenced to death, as members of subjugated communities, as people whose houses have been destroyed or as individuals who have been deprived of the opportunity to conduct their lives.
2. The professional gaze originating from the discourse of art: composition, lighting, the positioning of the woman photographed, previous allusions to the halo surrounding her, and so on.

3. The civil gaze that employs the fruits of the previous two forms of the gaze while overcoming the limitations that they impose, and exceeding their prescriptions. The civil gaze enables the spectator to use the reconstruction of the situation photographed in order to become aware that the photographer does not stand opposite the figure photographed on his own, nor does the spectator herself confront the photographed figure alone. The spectator also comes to realize that she does not stand outside the regime within whose framework the photographic encounter becomes possible. Civil intention allows the spectator to recognize the presence of those absent from the frame, extending awareness to all those who took part in the production of the visible, and allowing all participants populating the civil space of the photograph to meet on the same plane, even if only momentarily, and to ratify their inclusion within its space. Civil intention requires interpretive effort, the assimilation of facts and work of the imagination, because nothing is given in advance in the photograph.

An aesthetic reading of the photograph, of the manner in which it presents itself to the gaze, does not contradict a civil reading. The aesthetic reading, one of many potential readings of the photograph, enables us to discern what other readings do not reveal and may sometimes even lend a stronger foundation to other forms of reading. The investigative gaze directed at Aisha al-Kurd's black garment, illuminated through a form of lighting that does not flatten it despite its blackness, enables the emergence of a civil gaze—a gaze that sees in the stylized portrayal of the photographed woman traces of her cooperation with the photographer in the building of a set to frame her consummately as La Pietà. Similarly, Kirshner's depiction of the half-naked bodies of Palestinian youth in another of his photographs does not replicate the gesture of the snapshot but is the product of a negotiation between the persons photographed and the photographer concerning the appropriate manner of deploying their images at a given moment in time within a radically deformed public space where the violation of the Palestinian body was not—and still is not—a matter of public interest. The civil gaze is only possible on the grounds of a constant renewal of the necessary conditions of its existence by each and every human being, including the open and unrestricted participation of others. The adoption of a civil intention toward others is insufficient on its own, however. It is also necessary to take cognizance of how the conditions of participation of others in common space has been impaired. Thus, we may call upon an orienting gaze in order to determine the name of the photographed person and so render her a fully constituted participant in

the act of photography—the mother of five violently sundered, along with her husband, from the fabric of their lives through administrative detention, the demolition of their house in the Khan Younis refugee camp (to which their parents have been deported from Palestine forty years previously) and their release without charges five months later.

Unlike the contemplative gaze, the three forms of the practical gaze do not seek to scrutinize that which lies beyond the realm of the visible. The practical gaze seeks to tarry over the visible, to deploy it and to set it to work through making it intersect extra-pictorial information of the kind that other forms of discourse might frame for it. The civil gaze cannot exist within the paradigm of "the suffering *of others*" as if the citizenship of the spectators were insulated from the suffering inflicted on others—in this case Palestinian non-citizens—or as if their suffering were merely to be observed from an external point of reference. The civil gaze does not descend upon the photographed person in isolation but is oriented to all participants in the act of photography: the family friend, the photographer operating on site, the photographer's assistant, the interpreter whose services must be employed in order to conduct the negotiation between photographer and photographed person, the regime that destroyed Aisha al-Kurd's house and left her exposed to the lens, and the soldier who put the demolition order into practice. All the former enable us to derive a picture of the regime within whose parameters the disaster inflicted on Aisha al-Kurd fails actually to emerge as such. The civil spectator will eventually be able to determine that such a disaster is a regime-made disaster.

The movement between the three forms of the gaze is not the preserve of the spectator alone. Her civil gaze is deficient if it does not recognize potential forms of harm capable of being inflicted on the gaze of others and on their right to look, to speak and to act freely while themselves moving between the three modalities of intention.

To Separate and to Bind Together Again

Aisha al-Kurd sits in a black dress on the floor, a child sleeping in her lap. A special kind of light envelops them, causing them to stand out from the background, protecting them from too penetrating a gaze and framing them as one unit—a mother and her child.

In the face of this photograph, we might well ask: Where do we begin? With Aisha's husband who was still in prison at the time of the photograph on charges of belonging to a "hostile organization"? With her house that was demolished by the Israeli army—that too, on the pretext of

"membership in a hostile organization"? With the black dress that Aisha, the woman in the photograph, wraps around her? With the conversation between her and the photographer, which took place through the facilitation of an interpreter? With the photographer's assistant who smoothes down the folds of her dress? With the dark shadow that being a non-citizen casts over the space, contaminating it like a plague that cannot be halted? With other similar images originating in the discourse of art? With the perfect composition of a photograph centering on a figure whose posture frames the left side of the photograph while consummate lighting frames its right side? With the gaze veiled by the woman's eyelids? Alternatively, we might begin with a string of allusions to other newspaper photographs; with the noise of the bulldozer; with the neglect of life under the Occupation; with the sudden and surprising release of the accused from jail without any explanation given; with citizens justifying this as a policy; with her exposure to the photographic team and to the spectators who are latent here; with the umpteenth destruction of Aisha's home, with the feeling of betrayal she experiences; with the feeling of betrayal that I experience. (Even though my experience of betrayal is very different from hers and seemingly incommensurate with it, as time passes and the regime-made disaster whose traces are recorded in this photo still persists, the two seem to approach one another ever more closely and to blend into one another.)

Then again, perhaps it is possible to begin reading the photograph with reference to the four siblings of the baby in the frame whose parents were forced to abandon them in order to serve a jail sentence for resisting the Occupation, or possibly with the baby himself who came into the world between the four walls of a jail and was then ejected, homeless, into a refugee camp. Or with the editor of the magazine who commissioned the photograph then reneged on the commission, refusing to believe his eyes, refusing to acknowledge the blue-and-white Israeli provenance of the injustice that the photograph depicts.

In the final analysis, any reading of the photograph is motivated by at least one of the three intentions that I have described, but giving any one of them priority for whatever reason may eliminate the claims of the others. Although prioritizing one or another intention is often inevitable, when viewing photographs from disaster zones, the spectator must always be ready to assume her civil obligation. She is obliged to reconstruct all three intentions, which constitute the "civil condition," in order to understand the essence of that intention whose negation or violation is inscribed in the photograph, as well as to refute the network of rationalizations intended to legitimate such negation. The civil intention shows concern

for the world and for those who share it with us. The photograph invites the spectator and the woman photographed to meet in a shared civil space where oppression, discrimination, exploitation, robbery and appropriation are not seen as the decree of fate or as a natural law. Alongside her professional skills in analyzing the photograph, the trained spectator is required to activate her civil intention to assist her in deciphering the defective conditions in which the photographed woman finds herself. The civil contract (of photography), between the spectator and the woman photographed, protects her—even if only partially against the takeover of the civil malfunction that structures the regime that she inhabits and that threatens to impair her ability to determine that what is depicted in the photograph is unbearable. Her act of imagination in the face of the woman photographed, as well as in relation to the civil fantasy that binds them, is in effect crucial to preserving the understanding that the photograph depicts the unbearable.

In the following chapter, I will proceed to demonstrate the relevance of the civil contract of photography in relation to landscape photographs as well as in relation to photographs that do not depict human figures, through the unfolding of a visual essay consisting in the presentation of five sequences of photographs.

CHAPTER THREE

THE PHOTOGRAPH AS A
SOURCE OF CIVIL KNOWLEDGE[1]

A Built Environment

What are you doing here, Aisha? I have been looking for you for so long now. Looking here and there, although I should have known in advance where I would find you. The desperation you left in your wake; the fact that you and your family no longer live here—this makes me anxious. Aisha . . . Aisha . . . but why should you answer me? For you have sealed your eyes and your ears, rebuffing unwanted chatter with your silence. Silent in the face of the camera. Just you, your son, and your grief at the house you have lost. You repeat today, again and again, what you first said then: "They have destroyed my house." I am not even sure that you said, "They." I imagine that your words were sparing, that you omitted the agent. So sparing that you did not tell me that they had destroyed your parents' house as well. You thought it obvious—after all, you live in a refugee camp in Khan Younis. You thought it obvious that I should know that all the houses of those who became residents of Khan Yunes were destroyed in 1948.

I am sorry that it is not so, Aisha. I was born in the early 1960s. I heard the phrase "refugee camp" in the manner that Feuerbach must have heard the phrase "cherry tree": part of the lexicon of my native landscape. It took years before I reached any kind of awareness; years before the glue holding the two words together—"refugee camp"—dissolved, releasing a scarcely tangible image of an architect alongside more concrete images of refugees deported from their land and compelled to live in camps. The camps, like the demolition of the houses that preceded them, followed them, and is conducted within their confines, began to seem to me to constitute a form of architecture; to be the fruit of prior planning; to sow ever expanding circles of destruction. I began to perceive the outlines of a

centralized architecture: one that is cold, instrumental, calculated, well managed and focused. I surveyed hundreds of photographs, each bearing the same imprint: not that of a single creator seeking to distinguish himself by virtue of his style or maintaining dialogue with contemporary architectural discourse, but the imprint Aisha might have seen; the imprint of specialist knowledge in various fields—engineering, landscape planning, morphology and so on—guided by goals not immediately transparent to the casual observer.

"Let no man call himself an architect unless he has acquired the proper training," writes Vitruvius in a text that lays the foundations of architecture. To confront the photographs that I will present below is to learn of the existence of a new form of architecture in the Occupied Territories, one that involves skilled professional teams educated in the fields that Vitruvius lays out. But the use to which these professional teams put their training contradicts the principles running through Vitruvius's study— first and foremost, that concern for the community whose welfare architecture is meant to serve. The management of acoustics, part of the army's preparation for house demolition, is deployed to mislead residents of the refugee camps; water is deliberately channeled to flow in a manner detrimental to the needs of the camp's inhabitants, while expert knowledge in the laws of foundations enables houses to be collapsed in upon themselves—to name just a few examples of the flouting of architectural concern. The sovereign does not aspire to the title of architect because he does not see his actions as generating a new spatial reality, nor does he want others to perceive them in this fashion. In the sovereign's account, these acts are "merely" a focused response to the frequent rioting of lawbreaking subjects and form part of the re-imposition of law and order.

Years after the demolition of your parents' house, Aisha, years after the demolition of your own house, the sovereign continues to destroy houses. And the rate of destruction, as far as we can tell from the sources of information available, escalates without cease. The sovereign's interventions change the material foundations of built space. Threatening geometrical shapes replace houses. Deformed polygons rise from the ground in diagonal fractures, the detritus of what were once walls, upright columns, beams and pillars—in a single word: houses. It becomes almost impossible to determine how the space was once used, and particularly to differentiate between outside and inside; between private and public space; or between sealed rooms with roofs and perforated open spaces of invasion. Built space has ceased to be legible. The divisions necessary for a domestic economy have been erased: refuse heaps cannot be told apart from sanitary spaces; storehouses cannot be told apart from human dwellings. The

house no longer functions as a protected and intimate space, set off from the exterior. Nor do the conditions exist that might enable its residents to sustain themselves and to orient themselves in shared public space.

Architecture of Destruction

What built environment is she talking about? And why does she term this "architecture"? Such questions pursued me every time I addressed the exhibition "Architecture of Destruction." Well before I had a clearly formulated explanation for the intuition that led me to coin this phrase, I knew that it would be simply impossible to continue to describe the phenomenon concerned as "house demolition."[2] Under the mantle of the Occupation, the state of Israel has destroyed tens of thousands of houses— and has eradicated the meaning of the phrase "house demolition" in the process. The term "house demolition" has come to appear as a self-evident and structured category, in common use by all: a linguistic phrase that allows a certain reality to be described while obscuring any sense of violence, dissonance or sheer insanity that might attach to it.

While the demolition of a single house can still be parsed as meaningful thanks to its singularity, "house demolitions" is more than just the grammatical plural form. It ushers a new phenomenon into existence that requires innovative forms of analysis. What do we mean by "house demolitions" in the plural? What lurks behind the category of "house demolitions" as an appellation for so many horrors? What is counted as an instance of a "house demolition"? What exactly does the phrase mean? Can its referent even be quantified? Or justified? Can the number of houses that the state of Israel demolished between 1948 and 1949, estimated at about 100,000, possibly justify any end whatsoever? Then again, what does the number "approximately 150,000" really refer to, if we take its putative referent to be the number of houses demolished by Israel from 1967 to the present?[3]

Since the late 1980s, individuals and organizations in Israel and in the Occupied Palestinian Territories have attempted to collect data about house demolitions, updating the statistics every time another house is destroyed: one more, another one, then yet another one, and so on. Resistance to house demolition necessarily entails quantifying the acts of destruction. This cannot be achieved without adding one act of destruction to another, as if these were countable units capable of quantification. Demolition orders, rationales for demolition, documents, classified material, regulations, instructions, misinformation and extensive professional crews tasked with the work of destruction are all seemingly united in one

frame narrative (that of destruction whose rationale the government explains and motivates on the basis of certain evidence) so as to transform the sovereign's actions in Palestinian space into private instances of a single overarching logic.

Statistics concerning house demolition refer to discrete and quantifiable units, that is to say, to houses that have been totally demolished. But what of collateral damage: damage to the neighbor's house not itself singled out for demolition but whose windows and doors were blown out during the demolition of the adjacent building? What of the house whose walls were "only" perforated while the army pursued its "wanted men"? And what of the house bordering on the site of a "targeted killing" that had a huge hole blown through what had once been the children's room? The house that was denied "merely" its former peace and quiet? Or the one whose walls, no matter how thick, could not shield its inhabitants from the horrific noise of the demolition of the neighboring house? What about the houses scattered between and around them, part of the built environment where the owners of the demolished home and their neighbors—whose houses remain intact—continue to live their lives? Although the statistics available do not account for houses that were only partly destroyed, they are as numerous as grains of sand on the beach—which begs the question: What is the point in counting them?[4]

Since 1947, tens of thousands of house-ruins have been sown in the landscape (only some of them figure in the statistics categorized by year and region); photographs of ruins and rubble have been produced and distributed; and various linguistic templates have been fashioned to narrate the destruction ("destruction during warfare," "terrorist nests," "illegal construction," "razing," "military needs," etc.). These are naturally assimilated into the matter-of-fact category, as it were, of "house demolition," as if it this were some routine phenomenon pertaining solely to the private domain of the relevant homeowners, bearing no interest whatsoever for the general public in whose name and for whose sake it is carried out. The statistics are updated every time another house is destroyed, and another and yet another and so on.

Through the reading of a series of photographs taken over the last decade, I will attempt to show not only how certain specific houses came to be destroyed, but also how the Israeli sovereign shapes the character of space under his sovereignty, changing it beyond all recognition. To examine destruction as the intervention of sovereign power in space rather than to treat it from the vantage point of discrete and quantifiable individual actions raises new questions concerning the relation between sovereignty and its subjects, and concerning the relations among various

categories of subjects themselves. The first startling fact that emerges with respect to spatial intervention in Palestine, whether carried out by the sovereign or by subjects, lies in that it fails to emerge from organized negotiation or consensus regarding the nature of shared space. Inevitably, for as long as the sovereign refuses to recognize those governed as his citizens and for as long as they refuse to recognize his sovereignty, such negotiation, of a kind routinely undertaken by democratic regimes, cannot take place in the Occupied Territories. What we have instead is the architecture of destruction by means of which the sovereign seeks to circumscribe a negotiation that never took place. Each justification of a particular instance of house demolition on the part of the sovereign misrepresents an overarching policy of destruction as a private instance of infringement that was met with the relevant response: discrete and focused, bound by law. The victims of house demolition, on the other hand, are presented as law-breakers who leave the sovereign no other paths of action.

A comprehensive picture of house demolitions is still inexistent, and can only be partially assembled from several existing databases. The stability of the category "house demolition" latent in the very phrase itself allows us to assume that it is generated *a posteriori*, whether from the retrospect of the ongoing, daily destruction that the regime holds to be justified and which outrages only the few, or from the retrospect of a more primordial original sin: the constituent destruction that took place during the late 1940s. The government's effort to stabilize the category of destruction and to limit its discussion to one of means, methods and justifications, preserves house demolitions as something that exists only marginally within a properly constituted public sphere where the relation between private and public space is seemingly consensual and uniform for all members of the governed. The current destruction, carried out mainly in the West Bank and Gaza, but also, on a more modest scale within the Green Line, uproots house-by-house, individually, after establishing a special dossier for each instance, properly adorned with warning notices and decrees, evidence and justifications extracted from both local and international law. Much is owed, in fact, to the constituent destruction of 1948 on which the state of Israel was founded, and in whose wake it rehearsed its preoccupation with establishing the abstract laws and ground plans that would come to have territorial purchase, outlining a nationwide project of destruction whose underlying rationale has resulted in the codification of statutes that furnish the more recent destruction, in their turn, with license and inspiration.

The Enterprise of Destruction

The cliché that "all building destroys that which comes before it" sets the two concepts—of building and of destruction—in opposition. But since the inception of the destruction in 1948, destruction has not served as the inverse of building nor has it served merely as preparation for it. Destruction has, in fact, long coexisted with construction, neither contradicting it nor wearing a cloak of invisibility on the part of those carrying it out. Destruction has been an autonomous project from the outset. Since 1947 onward, the Israeli regime has destroyed hundreds of thousands of houses. The creation of a continuum of different practices of destruction carried out over the course of six decades, but equally the difficulty of seeing through this continuum or beyond it, is part of the system responsible for making destruction into a *means*, part of the constituent violence of the regime that came into being here in 1948. This continuity is preserved by means of the ever renewed denial on the part of Jewish citizens of Israel that the regime implements policies of destruction. The lines of continuity between the current phase of destruction and its constituent predecessors are to be sought in the fact that each fashions destruction as a mere vehicle—one tool in an arsenal of means whose significance is determined solely with respect to the ends they serve. On the one hand, there are subjects for whom the possession of a home affords them access to public space and whose homes are immune to demolition, while on the other hand, there are subjects whose homes do not suffice to secure them a place in the public domain and are prone to losing their sanctity as human dwellings, becoming marked for destruction or invasion instead. The dissociation of ends from means, in which the end imposes its teleology on the means from the outside, allows the demolition of houses to be legitimated as a self-explanatory device. When destruction is considered to be a self-evident means available for deployment by the regime, its agents are authorized to sow destruction and to generate forms of knowledge that enable and justify the use of destruction to obtain goals ostensibly not related to it. The Palestinian house loses its sanctity as a home in the process, and can therefore be violated.

The history of this vulnerability to violation reaches back more than sixty years. It can be narrated from the vantage point of the destruction of Palestinian houses, but simultaneously also from the vantage point of the defeat of Jewish voices opposed to the uprooting of Palestinians from their homes. These voices were silenced by the voices of nationalism that overtook the political as well as the military leadership of the pre-1948 Jewish

polity (or *Yishuv*) to render expulsion a fait accompli. The dominant voice representing the Jewish public might have stammered somewhat in its official declarations about the Palestinians but its principal leaders demonstrated considerable practical determination in expelling 750,000 Arabs from the territory of Palestine held under the British Mandate. Over the course of about two years, Jewish soldiers went from village to village and, where necessary, from home to home, uprooting Arabs from their lands and dwellings.

The United Nations Partition Plan of November 29, 1947, was a formative moment in the process of the ruination of Palestine–Eretz Israel.[5] It gave international validity to the efforts of the representatives of the small Jewish Yishuv, acting on their own, to determine the future of an area previously inhabited by an Arab majority that had absorbed Jewish immigrants over the course of several decades. The establishment of a Jewish national home was the professed and explicit goal. In order to realize it, the majority of the Jewish population was recruited and their efforts deployed in the service of a wide range of activities. The ethos of nation-building (*binyan ha'aretz*) infused everything that took place in Palestine during the late 1940s with sense and direction. Hundreds of thousands of acts of destruction were carried out under the disguise of acts of construction. These acts of destruction were represented as a means of achieving the explicit goal of nation-building. This discursive framework subordinated destruction to a higher end and systematically dwarfed its perceived extent for decades to come. What is at stake is effectively a large-scale enterprise of destruction in which thought, talent and resources have been invested, one whose implications go far beyond the instrumental nature ascribed to it by its architects.

The history of the enterprise of destruction, which has shaped and continues to shape the economic, cultural, political, moral, and civil world of the residents of this region, has yet to be written. On occasion, however, fault lines may be observed that enable us to detach destruction from the moralistic frame narrative of justification promulgated by those responsible for it and to analyze it as the object of research.[6] These fault lines enable us to begin to consider destruction as an enterprise in and of itself, to gauge its scope, to reflect upon its depth, and to investigate it beyond the parameters of the national context.[7] Necessary as such dissociation is, it calls for great vigilance lest destruction emerge as one-dimensional—as a delimited activity executed and completed within the boundaries determined by its perpetrators, an activity affecting only the lives of those whose homes were destroyed, as if all that remains now is to write a written transcript of each individual act of destruction as if those

responsible for the destruction were able already to relegate their deeds to a chapter of the past.

Transforming destruction into a *means* expresses the sovereign power not only to render destruction a matter of course, but also to conceal information pertaining to it. In striving to create and stabilize the meaning of destruction on its chosen terms, the sovereign power imposes upon it an intelligibility derived from its own goals and intentions. Tracing destruction independent of the framework of subordination of means to ends promotes not only the realization that destruction does not constitute a means, but also that its meanings can never be entirely in the control of the perpetrator. In other words, no single party to destruction can impose ruin while successfully shaping the traces of this selfsame ruination to fit only its desired narrative. The process of destruction is strung out between those who destroy and those who suffer destruction, between destroyer and destroyee, as it were. To reconsider destruction in this light is to perceive that destruction ruins not only that which it specified in the brief of its architects, but also the very configuration of life allegedly freed of destruction, its agents or victims. Ruination and its concealment are akin to the betrayal of the pact, partnership, and promise that constitute life among and with others.

The enterprise of destruction initiated by the leaders of the Jewish Yishuv in the late 1940s seldom targeted individual houses, although certain exceptions did exist—the focused "salvation" of an ancient synagogue, a Crusader fortress, or of discrete "ordinary" buildings which, although they remained intact after their environment was destroyed, did not suffice to entice the deportees to reclaim them or to serve as a catalyst for their return. The new construction soon came into existence around these isolated buildings, lending them an "antiquated look" devoid of a concrete history. Destruction, more generally, reserved its momentum for the elimination of entire residential environments, whose existence the destroyers—the new masters of the land—could no longer tolerate as they wished the entire land to become Jewish. It is difficult in retrospect to isolate a single cause behind this, whether based on national, political, economic, demographical, spatial, or cultural reasons—or all of these together. The implementation of the demolition program was made possible through the collaboration of the new Jewish citizens of the land—many of whom were overjoyed at the prospect of establishing a state for the Jewish people, and were thus readily recruited in the service of acts of construction that subsumed considerable destruction. Destruction was represented by the Jewish leadership as a means to overcome threats and obstacles on the way to full realization of the ideal of Jewish statehood:

paving safe roads, creating territorial continuity, or absorbing the perse-
cuted Jews of the world. The stated goal of the program, the establishment
of a Jewish state, which could potentially have been achieved through a
variety of methods that do not include destruction, was translated by the
political leadership of the Yishuv (and later by the state) into a destructive
end that also employed very destructive *means*: the establishment of a
state for the Jewish people on the ruins of the society that had lived in the
region at the close of the 1940s.

In many ways, that society was already the outcome of the mixing of
Jews and Arabs, which gave rise to different configurations of co-existence
or "being-together."[8] I use the term "being-together" in its Arendtian
sense. It does not characterize an ideal, but describes instead how people
actually lead their lives among other people and together with them.
Against the backdrop of the configurations of life that existed here until
1947, the enterprise of destruction, which included the ideological
construction of destruction as a means in the service of something other
than destruction, became in fact an end in itself—*destruction of the mixed
society that had evolved here, and the removal of anything that might
enable its resurrection.*

The Jewish military and political leadership used practices of destruc-
tion to strengthen its territorial purchase and to manage the movement of
the local population in space on a differential basis. Alongside the formal
declaration of Partition, public space in mandatory Palestine was increas-
ingly vanquished by a military logic that allowed tens of thousands of
Jewish citizens to be recruited to the idea and project of a generalized
national war. The Arab inhabitants of the area served in the role of
enemies to be contained, appearing to embody the need to create a public
domain free of Arabs. Arab homes were destroyed after their residents
were deported in order to prevent their return in ongoing acts of destruc-
tion subordinated to the goal of an exclusively Jewish public domain. But
the desired goal would not itself have been achieved were it not for the
recruitment of the Jewish inhabitants of the region to the enterprise of
destruction, whether as soldiers or as civilians.[9] To recognize this is to
recognize that practices of destruction express not only the power rela-
tions that exist between sovereign and subjects, but also the power
relations obtaining between subjects of different ethnic backgrounds
which, in the state of Israel, have evolved into polarized and conflicting
ones.

Local space was transformed beyond recognition in the years 1947–49:
whole Palestinian villages and urban neighborhoods were destroyed;
Jewish immigrants were settled in what remained of homes of Palestinians;

new construction covered the traces of destruction, and forests were planted in order to hide the many scars that were its aftermath. To treat all the characteristics of the new three-dimensional spatial forms that came into being is beyond my scope. I will restrict myself instead to the analysis of the spatial boundaries and demarcations that brought about the objectification of new ethnic divisions, primarily between Jews and Palestinians.

As we have already stated, the majority of Palestinians were expelled beyond the new state borders in 1948. This expulsion cost them their social status, transforming them instantaneously into refugees, or in my formulation, into the non-governed of the new regime that came into being. The Palestinians who remained in place and who became an ethnic minority were concentrated in ghettos under military rule, while the Jews who became a majority engaged in the construction of a Jewish national home. In the face of the violent stratification of populations and the radical differences of opportunity open to one population group and closed to the other, the Palestinians can clearly be said to have been deprived of a public domain or the right to participate within it, while the Jews must be regarded as those permitted to conduct themselves freely in this domain. But such a polarization misses the point because it assumes that the public domain can be gauged with reference to a specific segment of the populations constituting it, thus dividing this segment from the others ruled alongside it. This very differentiation between Palestinians and Jews regarding a public space is itself clear evidence of the deformation of the public domain as a result of the substitution of the principle of generality and inclusion with the principle of stratification and exclusion. In other words, from 1947 until today, we have seen the public domain lose its most important attribute—its openness to anyone who is himself or herself positioned in public space. The Occupation of 1967 and the terrible destruction it has sown are commensurate with this pattern and form part of an ongoing enterprise of destruction that proceeds in full swing to this very day.

Israeli Jews routinely move about in arenas of destruction created between 1947 and 1948, but these arenas of destruction rarely proclaim themselves as such given that they have been naturalized by means of categories such as "ruin," "Ottoman architecture," "vernacular building," "Sheikh's tomb," "martyr's forest," and so on. Simultaneously, the same citizens continue to engage with new arenas of destruction that keep on being generated in the Occupied Territories. But these do not speak their names, either, thanks to the regimes of justification and intimidation that derive from the militarization of Israeli society. That destruction

which does not appear to be destruction at all thus never emerges into view in all its nakedness, that is to say, as the expression of a fundamental disagreement between governmental power and governed population over the nature of shared space.

The Walls of the House

The walls of my house are sturdy and protective. I experience them as isolating me from the exterior. Shielded by these walls, I have been able to keep winter storms at bay; have rebuffed "occasional showers"; have held at arm's length the memory of a pathetic figure who sought to breach them like a Trojan horse; have managed to keep at bay the madness of political leaders whose malice is steadily on the rise; the hum of airplanes dropping bombs or the rumble of bulldozers constantly grating their colossal teeth on different building materials just a few dozen kilometers from here. The walls of my house enable me to forget the outside world even when it is intolerable. Despite all the effort I have invested in the painstaking study of house demolitions, I do not fear the imminent collapse of these walls as I leaf through newspaper reports on arenas of destruction. Nor do I fear, as I return to the safety of a home that I share with my family, that my lungs will be filled with dust and I will find myself brushing pieces of plaster off my body, or that I could be photographed as I stand in the rubble next to a pile of objects that was once my home.

The moment I finish writing this description, I feel a rush to delete it without trace, to rewrite it so that it contains an explicit refutation of its reliability. Some form of half-knowledge, half-prophecy grips me every now and then in the face of the circumstances in which houses are destroyed. Today it is "their" homes that are being destroyed; tomorrow it will be "our" homes. But something urges me not to relinquish my opening description, to leave it intact and to give it its due. I am compelled to insist on the reality it depicts and to use it to outline a psycho-political reality that is not private but rather shared by Israeli Jews. The regime to which I am subject, together with others like me, has demolished approximately 200,000 houses since its foundation. And yet there is something about this reality that has enabled me to spend most of my life in denial of the possibility that my house could also be destroyed, save for sporadic moments when I deliberately dwell on this anxiety. I have never truly felt a real threat to the solidity of my home.

What is the source of my confidence that the bulldozer—which never rests for a moment—will leave my neighborhood alone?

. It is easy to dismiss this confidence as marginal to house demolitions: the privilege of someone not directly affected by them. But any analysis of house demolitions that leaves this confidence out of the reckoning is complicit with perpetuating the banality of this form of destruction on the part of a putatively democratic regime. Indifference to it allows destruction to continue to be seen as a routine act that does not warrant the criminalization of the regime that planned and implemented it, nor the prosecution of its various agents along the whole chain of destruction leading from intent to implementation.

In the discussion that follows, I shall try to show that the destruction of about 200,000 houses since the founding of the state of Israel, destruction carried out by the state or by bodies acting on its behalf, is a phenomenon that can only be understood in the context of governance as part of the regime's regulation of the mode of existing-together of *all* those governed by it. Second only to the massive expulsion of about 700,000 Palestinians during a relatively short period of time in the years 1947–49, the demolition of houses is the most extensive and consistent regime-made disaster that has been implemented here, and that continues to be implemented in an ongoing fashion by the regime that came into power in 1948.[10] Since it was founded in the late 1940s, this regime has made of the home an arena for the demarcation of the boundaries of the body politic. These boundaries separate those whose homes are protected—and are deemed worthy of protection—from those who inhabit homes whose walls are exposed, penetrable, vulnerable to violation and demolition.

The Distinction between the Private and the Public Domain

Jewish citizens of Israel confidently inhabit secure domestic space, which plays an enormous role in the manner in which they continue to imagine the worthiness of the regime that rules them—despite its felonious conduct, in practice. This ability is predicated on their experience of a separation between the private and the public domain. But this separation can only be imagined to be real for as long as the regime is perceived as coextensive with a body politic that does not include those whose houses may be violated and for whom this separation is not maintained. Destruction serves as an arena where the lack of agreement between the ruling power and a certain segment of the governed—neither given consideration nor enumerated in the discourse of the regime—can be exposed. In the discussion that follows, I seek to bestow conceptual status on this lack of agreement and to incorporate it into a revised description of the workings of the regime.

It was Hannah Arendt who made the distinction between the private and public domains into a political question, thereby reshaping the boundaries of political philosophy. Inspired by her precedent, I wish to return to the distinction between the private and the public and to combine these usually separate domains so as to analyze the conditions under which the demolition of houses might become the cornerstone of a regime still understood to be democratic, and might come even to be understood as banal within its parameters.[11] I shall not make do with the manner in which Arendt distinguished between these two domains, however. Instead, I propose a renewed conceptualization of their relationship that will enable me to mobilize thought not only to describe the world and to criticize the way it is run, but also to point to new possibilities that might arise. I will harness a form of civil discourse in order to do so, one whose principles I will present later in the discussion.

"No doubt, wherever public life and its law of equality is completely victorious," Arendt wrote in 1949, "wherever a civilization succeeds in eliminating or reducing to minimum the dark background of difference, it will end in complete petrification and be punished, so to speak, for having forgotten that man is only the master, but not the creator of the world."[12] Among the various characteristics that differentiate the two domains in Arendt's oeuvre, I will emphasize one aspect that arises from the citation above. For Arendt, the public domain is characterized by *equality* and the necessity to protect equality, while the private domain is characterized by *difference* and the consequent necessity to protect such difference. Faced with the threat that the logic of one domain might come to dominate the other, Arendt emerged as a prophet of doom to warn against impending catastrophe. The separation of the two domains and the protection of their unique characteristics is a necessity, she claimed, not only to preserve their differentiation but also to protect human beings from man's distorted conception of himself as creator of the world instead of as someone who shares it with others, constraining them and being constrained by them. The horror that is incipient here for Arendt does not arise from the quest for equality in the political domain—the equality of all those governed—but from the desire to impose equality in the private domain, and, sanctioned by the rarefied purity of the latter, to delineate accordingly the boundaries of the body politic and of the appropriate form of "egalitarian" public space that might correspond to it. This accommodation is impossible by definition, even though those in power—who include the bearers of the privilege of citizenship in the modern age—imagine the body politic in which they subsist to be free of difference since the members of this privileged caste belong to the same

race, ethnicity or religion. But the differences among individuals can never be erased by the institution of political equality and remain constant by the virtue of the sheer singularity of each and every individual. Instead of experiencing panic in the face of that which is foreign, Arendt locates horror within the orbit of "sameness": she reviles those who act as if they were the creators of the world and who seek to fashion it in their own image instead of acting in the world together with others who contribute jointly toward shaping it.

Ethnic cleansing is the ultimate solution for the creation of an emaciated world of sameness because it strives for the complete removal of difference and the eradication of all of its traces. In most cases, however, massive ethnic cleansing ends in failure—as manifested in a political lexicon that invents such categories as the displaced, the dispossessed and the refugee. These categories, applicable in the modern era to vast populations the world over whose numbers are constantly on the rise, are the expression of a political language that condones making humans into detritus or transforming them into minority groups as part of the quest of the regime to maintain its propriety by manufacturing an exterior (not always designated in territorial terms) capable of absorbing "those who have been left over." At times, these categories may prove beneficial in that they generate struggles for recognition and restitution; but, in most cases, they mask the political status of those to whom they are attributed. In some cases, the jettisoned are indeed included as members of the governed within the spatial boundaries that they inhabit. In other cases, they belong to the category of the "*non-governed*"—as in the case of refugees exiled from their land by regimes that have forcibly expelled them from the body politic of the governed. My use of the category "governed" (and "non-governed") enables me to reconnect or rematerialize the relationship of those people and the regimes responsible for their status. Furthermore, the use of the category enables me to suspend the distinction that the governing power creates between those segments of the governed whom it recognizes as its own and the others whom it governs without recognizing its responsibility for them, consequently designating them as refugees, as stateless or as displaced persons.

Three Forms of the Relation between the Private and the Public

Although the distinction between the private and the public domains has ignited stormy debate over the past decades concerning the nature of each domain and the relations between them, none of the parties to the debate apparently questions the existence of some kind of distinction between the

two. I propose to see the fundamental relation between the private and the public, assumed as axiomatic in discussions of this kind, as an *empty and necessary* one. The relation is empty because its existence is independent of the forms it takes, but it is necessary at the same time, because we do not know of any forms of human co-existence not based upon distinctions and differentiations that enable humans to assemble and to disband in accordance with various criteria that grant or restrict entry, exit and accessibility. In other words, this basic form describes the relations of binding and separation associated with various realms of activity that come to be reconstituted again and again in different contexts, times and cultures.

The second form of relation through which the distinction between the private and the public is imagined is a specifically historical one and its basic model is familiar from its various historical appearances since the times of Greek antiquity. The condition for partaking in "worldly matters," the prerequisite for entering the public domain, wrote Arendt in her discussion of the Greek world, is home ownership: the possession of a certain spatial emplacement and a private place in the world.[13] In contrast with the first relation—necessary and empty—I propose to call this historical form of relation between the private and public the "*protective conditional.*" As its name suggests, it makes the relations between the two domains conditional: having a place in one domain becomes a precondition for placement and protection in the other—hence the vector of this conditioning, from the private to the public. Modern citizenship as shaped by the French Revolution initially identified the possession of rights in the private domain with the ownership of property, which was regarded as the condition for political participation. It did not take too long, however, for males per se to be invested with the right to participate in political life, and this provision applied even to men who did not own property. It sufficed to be male and to be emplaced within the territorial boundaries of France for one to become a citizen. Thus exerting a claim to place, whether as a property owner or not, became institutionalized over centuries as a condition for moving between the domains of the public and the private. Like its predecessor, the protective conditional presupposes the differentiation between the private and the public, as well as the necessity of keeping them apart so that the conditions of possibility of passage from one to the other might be administered and regulated. As long as this form is preserved, the private domain of those permitted to take part in the public domain is supposed to be protected from incursions originating in the public domain (or at least for conditions of protection to be negotiated), not least of all from the interventions of the sovereign power. The link between this form of conditioning on

the one hand, and the protection of the private domain on the other—a consequence of the differentiating yet binding relation between the domains—is a quintessential principle of the regime and forms part of the hypothetical contract between governing power and the governed concerning the boundaries of governmental power. The stability of the protective conditional, its extent and the manner of its implementation—or lack thereof—with respect to all the governed, including their ability to see that its provisions are properly implemented, often provides better evidence of the nature of the regime than the formal parameters of its constitution, statutes or self-representations.

When a phenomenon like the massive demolition of houses is in question, a case in which the sovereign power treats the private domain of its subjects as it were a theater of military action depriving them of the right to participate in public space, the critical response might consist—somewhat hastily—in enunciating the claim that the first form of relation between the public and the private (one that we have identified as necessary and empty) no longer exists. But if we accept the ontological claim that a certain form of relation between the private and the public domain is always preserved, it becomes necessary to find other means of thinking through the empty and necessary relation in order to render account for a situation in which it no longer seems to obtain. The second form of the relation—the protective conditional—might also seem to be disqualified on the grounds of its being an ideological relation—it formulates the false impression of a stable connection between the two domains but accounts in practice only for the passage of citizens between them, to the exclusion of other sectors of the governed. If, however, we seek to understand the relation between the private and public domains as an attribute of the constitution of the regime, it is necessary to continue to engage with the ideological role of the second relation in allowing a regime to represent itself as legitimate. We must concede in advance, however, that the protective conditional has no implications for the manner in which the relations between the domains are maintained in the case of non-citizens, because it is by no means incompatible with, for instance, the consistent and massive practice of house demolitions, which continue to be depicted as exceptional and corrigible events that might potentially fall away "under different circumstances," instead of seeing this very suspension of the relation to be itself a constitutive component of the regime.

A third form of relation is necessary, then, to account for the way in which ongoing massive destruction shapes the interchange between the private and the public. However, if such a form were to account only for

the condition of the dispossessed, then it too would achieve little more than perpetuating its own complicity in the description of a split reality promulgated by the regime itself, in whose terms citizens exist under the purview of a legitimate regime while non-citizens are implicated in governance—under the conditions of the Occupation, for instance— only temporarily, or until circumstances change, or because there is "no choice." In order to make massive house demolition integral to the discussion of the regime obtaining in Israel, I will delineate this third form of relation, claiming that it combines the first two relations without superseding them, in an attempt to account both for the regime's mode of action and the way in which it is experienced and represented by citizens and governed alike. I propose to name this third form of relation, which reverses the protection afforded by the conditional relation, *the condition of unprotected exposure to power*. It can be identified and its power indexed by observing the state of the dispossessed, of the internally displaced and of the refugees against whom it is directed. Their presence in one political territory or another does not serve as a condition for their entry into public space nor does it entitle them to a place within the body politic. Moreover, and it is herein that the reversal of the protective conditional lies, the absence of this place/ment constitutes a condition permitting the ongoing violation of the dispossessed, and their exposure to violence within the supposedly private space of their domiciles. The inhabited house does not pose a physical or symbolic obstacle in the way of rampantly violent sovereign force. It is perceived instead as a spatial obstacle disrupting the flows of governmental power that does not feel itself to be constrained by the claims of those whom it does not recognize as being included within the orbit of the governed. Unlike the protection offered by the second form of relation between the private and the public, I argue that the third form is neither universal nor consensual. It is seldom formulated as an explicit political project; rather it finds its own circuitous routes of expansion. In this instance, since the displaced and the dispossessed are not perceived to be part of the body politic, what the regime does to them is consequently perceived itself to be external to the regime. The erasure of their being-governed from the representation of the body politic, however, constrains the political imagination of citizens. Under such conditions, civil intention—not mediated in advance by discriminatory claims arising from the differential relation of governmental power to its governed—cannot be put into play. Those segments of the governed designated as displaced persons, as the dispossessed or as refugees, are excluded from the work of civil imagining, something that brings about the undisturbed proliferation

of a distorted political imagination, devoid even of an iota of civil intention. What is at stake in the reversal of the protective conditional is not only the inversion of the direction of the movement between the private and the public, but also of the very possibility of an individual being emplaced in shared space in her own right as a universal condition for participating in the public domain.

The three configurations of the relation between the private and the public domains do not have identical status as descriptive categories nor as categories through which reality can be shaped and changed. I propose to regard the first form of relation—empty and necessary—as a tool of civil imagination that enables one to retrieve and re-inscribe the distinction between the domains as a necessary one: the public, which can be characterized as preserving the aspiration to equality among all members of the governed; and the private, characterized as preserving difference among the various members of the governed. In other words, the ontological claim regarding the necessity of distinguishing between the private and public domains serves as a basis for civil discourse. The demand to rehabilitate the distinction between the private and the public in a manner that is universally applied to all the governed seeks to restrain sovereign power and to institute regime change.

Civil discourse is based on the assumption that although citizens benefit from the empty and necessary form of the relation between the private and public domains, it is flawed to the extent that the non-citizens governed alongside them are denied the same benefits. Civil discourse assumes that the only way to restrain power is to speak from the point of view of *all* the governed. In the face of a reality where a certain portion of the governed are afflicted with the massive destruction of their property, civil discourse cannot assume that the second, protective conditional, is maintained. Instead of disqualifying the protective relation citizens rightly defend and seek to preserve, I propose to reconsider this relation as the correct and necessary form of relation between the two domains. This entails reconsidering the third form of relation, which seemingly pertains only to the state of the displaced and dispossessed, in order to extrapolate from it a general form of relation between the two domains that is pertinent to all the governed. The sheer extent of house demolition, perpetrated by or in the name of citizens who benefit from the protective conditional, renders it impossible to see its suspension as having implications only for the population of victims of house demolition. Rather, such suspension is better considered as a phenomenon that shapes the form of being-together of all the governed.

Why Architecture?

The act of destruction does not constitute architecture. But then again, the mere act of construction is insufficient in itself to characterize architecture. Action alone cannot serve to differentiate a field because any given act might be carried out by different people on different occasions and accrue different meanings from being implemented in a different arena. Nor can the results of action—buildings in the case of architecture—be held sufficient to characterize the field, despite the fact that buildings and styles of building were long held to constitute the basis for thought concerning architecture and for establishing the history of the field. Historically speaking, architecture was considered to fall within the province of art, with the architect being considered as analogous with the artist. In recent decades, however, in the wake of the general revolution of knowledge associated with cultural studies, certain disciplinary boundaries within architecture have begun to be breached, leading to the emergence of theoretical and narrative conceptualization of space based on something more complex than the interrelation between stable, discrete buildings. This development has weakened the isolation of architecture as a closed field of knowledge and has allowed for the public to demand inclusion in the organization, design and management of inhabited space. The notion of the public good has been a component of architectural discourse since Vitruvius but the incorporation of the public in determining what benefits it and how such benefit might be achieved is relatively new.

I propose that we consider one of these recent changes in the field of architecture, to constitute a central part of its definition: the public demand for inclusion in spatial planning. Architecture is a practice that leaves a permanent and enduring imprint on the space that people share. Despite the fact that the architect is the first (*archon*) to intervene in space, and may even play a leading role in the intervention, it is the public that consumes architecture and determines its uses. Architecture is impossible without the active participation of other individuals in space, simply by virtue of the use to which they put the space fashioned by the architect and the manner in which they continue to intervene in the evolution of architectural space. Put succinctly, architecture is intervention in shared space. In contemporary democracies, architectural intervention in shared space cannot be carried out through coercion alone. Regulations; statutes; technical, professional, social and political standards and specifications reduce the dimensions of the violence and coercion attendant on architectural interventions. Through the allocation of responsibility, they enable the

damages resulting from architectural intervention to be limited; for acts of caprice to be restricted; for harm to be prevented; for the safety of buildings and of the environment to be assured; and for the discriminatory allocation of the use and ownership of space to be prevented. Even if the success of such statutes is only partial, they make it impossible for any one person, including the sovereign, to intervene in shared space as if he or she had exclusive ownership of it, and they enable the shared exploitation of space without the frequent need to resort to violence. While some of the procedures, statutes and specifications in question may be worthy of criticism or may be interpreted differently under different conditions, for as long as they regulate relations without creating separate and discriminatory provisions for different populations groups, they safeguard relatively permanent and stable norms of spatial management. In architecture, as is the case with many other fields, the exceptional infringement of the statutes may be cause for the sovereign to act as final arbiter in their implementation, despite the fact that the very existence of rules and regulations is supposed to eliminate the need for sovereign intervention or, alternatively, to prevent the sovereign from imposing power. When the sovereign exploits his privileges against populations of the ruled and infringes these rules and regulations, their status is undermined so that they no longer constitute a stable framework for adjudicating the sovereign's harmful acts or for providing adequate response to disputes among the community of the governed. The sovereign's frequent intervention in space thus becomes a form of architecture in its own right and reflects the type of regime within which it is conducted. Explicit building regulations, as stipulated in law, are not enforced. Rather it becomes necessary to reconstruct the rules and regulations actually obtaining from that which occurs in practice. Such a reconstruction, which I will perform on the basis of my reading of the photographs accompanying this chapter, will enable us to determine the nature of the space under analysis in the case of the Israeli Occupation and the nature of the regime that has fashioned it.

Blocked Horizons

What exactly is the built environment that the sovereign generates through various interventions? The built environment may be characterized first and foremost through its lack of transparency, whether in the stages of planning or implementation, or even as regards the eventual form of building constructed and the uses to which it is put. For as long as its horizon is blocked, the passage through the built environment is restricted and may be prohibited; its legibility is impaired; knowledge concerning it

remains fragmentary; the division between its components is blurred, and its representations are impaired. Those members of the governed deprived of the rights of citizens are not permitted to engage in negotiation concerning the nature, design or management of space. The majority of citizens of the regime responsible for creating this deformed spatial regime know almost nothing about it, and that which they do know is composed mostly of lies. The enclosure of deformed space behind a wall—not only in a figurative sense—contributes significantly to this state of affairs. Over the last decade, it has become increasingly difficult for Israeli Jews to cross the physical separation wall and to learn firsthand what the sovereign perpetuates in their name. When they do so, they risk breaking the law. Signposts warn them on arrival that entry into the Occupied Territories is prohibited. But since the settlers—also Jewish Israeli citizens—are freely permitted access to the Occupied Territories the signposts become just another means of obfuscation impairing the basic transparency that citizens should enjoy with reference to the space that they inhabit. The signposting similarly sows disinformation regarding modes of continuity or discontinuity with practices implemented on either side of the Wall. Policies of divide-and-rule keep the two population groups apart, distancing them from one another, portraying separation as natural and self-evident, and perpetuating it. Divide-and-rule assures that there will be no common coalition of the governed, citizens and non-citizens alike, in order to secure proper management of the space that they have been forced to share subsequent to the Jewish immigration to Palestine at the end of the nineteenth century. The separation of the governed into opposing categories alongside with the division of territory itself enables the disruptive management of built space in the Occupied Territories in violation of the rules and regulations agreed upon by the citizens living on the other, Israeli, side of the Green Line. The process of decision making regarding the built space of non-citizens takes place in secret, insulated from surveillance or criticism—a common feature of despotic rather than democratic regimes. But the policy of divide-and-rule is not without its price for citizens themselves. It plunges them into a state of deformity that prevents them from identifying, let alone acknowledging, the fundamentally compromised and evil nature of statutes imposed on a separate category of the governed whose invisibility seems to render them extraneous to civil life. More often than not, the spatial interventions in question negatively impact the ability of the Palestinian population to conduct their daily lives. They are accompanied by violence, whether carried out at night or in the full light of day. Knowledge concerning such interventions is always hazy: information is manipulated and partial. Interventions

conducted outside the goals ratified in the public domain, or even in flagrant contradiction of them, create long-term damage that cannot be countered by the collective of the governed who subsist in conditions of partial information or no information whatsoever.[14]

Over and above the cruel consequences of the separation wall that have been widely discussed, it is necessary to see the Wall as an apparatus that effectively sabotages the ability of residents living on both sides to orient themselves within the political space that they actually inhabit and in which they are partners. Although the Jews who live on the west side of the Wall enjoy physical control of the territory, their orientation vis-à-vis a political space extending from the Jordan River to the Mediterranean is impaired through the dissemination of partial and distorted facts or contradictory information put out by various sources. They are sabotaged when information that has a direct impact on everyday life is rendered inaccessible, when the rights of contingent or premeditated association between individuals are suspended, or when they are encouraged to build exclusive relations with the members of their spatial enclave alone, to the detriment of their grasp of space and their independent or spontaneous ability to orient themselves within it. The means through which this form of rule is achieved are, at one and the same time, repressive (based on the withholding of information) and productive (based on the supply of information).[15] In order to overcome the fragmentation, opacity, blurring, distancing and amnesia that the Wall sets in motion, special intention and considerable effort must be invested by various independent bodies, researchers or others—all ultimately constrained merely to peer through the chinks in the Wall.[16] The lack of transparency, as I have described it above, is not a local condition or contingent obstacle that might be overcome, but part of the larger picture prevailing on the ground, and reflects the conditions with which private individuals or public groups must engage when they attempt to reckon with this space as the object of contemplation, research and criticism. Under such conditions, photographs taken in Palestine, under various circumstances and for different purposes, provide rare chinks in the Wall through which the nature and extent of the architecture of destruction may be ascertained.

Sovereign Privilege

As we have already stated, the absence of a body of consensual rules and regulations, or the sovereign's deviation from such a body of rules, provides one index of the nature of the regime under discussion. The image of the

sovereign as the founder of cities, who appoints architects and engineers and even invites professionals from abroad in order for them to assist in imprinting the sovereign's image on space, is one stretching back to antiquity. But the history of modern times also attests to this form of sovereign power in that the sovereign is empowered to erect monuments that change the built environment without resorting to organized tenders or to public consensus. In modern France, for instance, this right, reserved for the president of the republic, has a quintessentially architectural context and a specifically royalist connotation: *fait du prince*. In democratic regimes, the sovereign may enjoy certain spatial privileges provided that he employs them in a measured and regulated manner. The monument, for instance, is intended to glorify the president by means of the pleasure and benefit that it grants to all citizens.

Over the almost four and a half decades of its existence, the regime responsible for the Occupation has made extensive use of the privilege reserved for the sovereign under special circumstances (despite the fact that the Israeli sovereign does not recognize the fact of sovereignty over the Occupied Territories and its subjects are not recognized as coming under Israeli jurisdiction). The Israeli regime has made extensive incursions into Palestinian space on three levels: building, regulation of movement, and destruction.[17] These massive forms of intervention exceed the limits of sovereign right or authority, and their extensive implementation is possible, as we have already noted, by virtue of a policy of divide-and-rule separating citizens from non-citizens. Questions of securing the "agreement" of the governed and of their "inclusion" in processes of decision making concerning the space they inhabit have become important categories of public discourse over the last decade, promulgated by Jews on the west side of the Wall and systematically denied to Palestinians who continue to be seen quite naturally as non-citizens, as "stateless," and therefore as lacking the rights of citizens.

Where the three factors of construction, freedom of movement and destruction are concerned, the sovereign intervenes in the lives of the Palestinians under his rule as a foreign despot who aims to deepen his rule and his control of the territory instead of engaging in development on behalf of the local population and improving its standard of living. The sovereign's interventions are implemented by Jewish citizens who participate in these "acts of state" as soldiers and as civilians. Thus, at these three levels of intervention, it is not only the balance of power between the sovereign and the governed that comes into play, but also the power relations between two fractions of the population identified as

occupiers and the occupied and polarized by the Israeli regime as conflict-
ual ones. The use made of the land where Palestinians are condensed, the
routing of traffic in space, land rezoning and the exploitation of natural
resources occur in the framework of polarized relations that fix the
Palestinians as temporary residents in a space whose configuration and
shape are transformed in line with the caprice of the Jewish rule to which
they are subject. Palestinian space has been transformed beyond all
recognition in the process, its stability undermined and many of its
inhabitants made into a new type of internal exile in their native land.
Orchards and orange groves have been uprooted to pave roads serving
the Jewish population. Palestinian homes have been destroyed or appro-
priated so that new Jewish settlements or army bases might be erected.
Familiar routes have been blocked while new roads are forbidden to
Palestinians. The use of public space for civil ends is almost completely
prohibited. Passage through space is constantly monitored while the
houses of Palestinian residents are vulnerable to different forms of inva-
sion. The imposition of power relations in space is not only expressed in
the dispossession of Palestinians and the transfer of their property to
Jewish settlers,[18] but also in the capture of strategic sites and the massive
deployment of forces tasked with the duty of maintaining these polar-
ized power relations.

In the wake of the Oslo Accords, the Occupied Territories were divided
into discrete areas of Israeli versus Palestinian control, but even after their
ratification, the occupying regime did not cease to use the army to ensure
that it had the final say over the management of space and its organiza-
tion, even in areas under Palestinian control. The Israeli regime acts as if
to declare that no wall might serve as a barrier to its passage; while no
Palestinian house might afford its residents sanctuary. The houses of
Palestinians suspected of resisting the regime are a preferred site for the
public display of Israeli might—in an effort at intimidation. In many cases,
it is not the residents of the houses singled out for demolition who are the
suspects, but their family members. Resistance to its power is not the only
pretext serving the sovereign to justify house demolition, however.
Thousands of houses, gardens, orchards and groves have been destroyed
because their emplacement interfered with military maneuvers or because
they prevented a certain Jewish settlement from expanding. In areas that
remain in its sole control, the Israeli authorities invoke legal tools to justify
house demolition. The procedure is a relatively simple one, based on the
consistent denial of construction permits for newly erected buildings—a
devious strategy that makes Palestinian structures illegal and marks them
out for future demolition.

Photographed Architecture

Only a handful of photographs document the approximately 1,000 buildings Israel demolished in 1967 in Imwas, Beit Nuba and Yalu. I have not been able to obtain even a single photograph of over 10,000 construction units destroyed in refugee camps in Gaza during the early 1970s. Nor did the 125,000 houses destroyed between 1948 and the 1960s leave much photographic evidence behind them—most were captured years after the destruction so that the detritus already resembles ancient ruins. Many of the photographs of the first intifada show destruction in retrospect—but the bulldozers are already absent from the frame. The second intifada presents a different state of affairs, however. Photographs taken since the outbreak of the second intifada show the actual processes of destruction at various stages of house demolition. Since such a profusion of photographs exist it is tempting at first to see them as "more of the same." Wreckage, wreckage, more wreckage. But prolonged contemplation enables the identification and categorization of characteristic patterns of destruction, the identification of various forms of machinery used, as well as patterns of damage to residents and the environment. The complex picture that emerges into view is different from that which the regime proposes. In the military or legal terminology associated with the occupying regime, different kinds of demolition are differentiated from one another on the basis of the military rationale that supposedly justifies them, including illegal construction, membership in a terrorist organization, or operational considerations. But the type of classification I propose here is based on the connection between the type of intervention performed and the architectural stamp it leaves on the landscape. This initial reclassification enables us to direct the gaze away from victims of this regime, used as the pretext or justification for the acts of destruction, and to focus on the language of the occupier in an effort to analyze the toolbox at his disposal for spatial intervention. This toolbox, readily available for use and highly sophisticated, affords the sovereign spatial privilege: maintaining the momentum of construction activities for Jewish citizens and transforming the spaces of Palestinian residence by means of the architecture of destruction. The typology I propose shows the extent of destruction to be far from capricious, random or local. Rather, destruction is deployed in a systematic and regulated fashion throughout the Occupied Territories and is everywhere violently imposed on the Palestinian population. The photographs collected here also show how junior deputies of the Israeli sovereign

operate to neutralize and contain Palestinian resistance. But they also record the massive military force the sovereign is compelled to employ. This military force combines combat strategies with competence and expertise in the fields of construction and engineering. Military force is predominantly, if not exclusively, deployed to impact upon shifting local targets. Its impact cumulatively changes the face of the landscape with immediate effect. In its onslaught upon the built environment, the Israeli regime appears totally indifferent to the long-term effects of its interventions in space. The same is true regarding the architectural component of the regulation of traffic and freedom of movement that serves the divide-and-rule policies of the regime. It is the unique spatial syntax that can be identified here which I will use the three different photographic sequences presented below to elucidate.

Damage to Spatial Orders

These spatial interventions that manifest the sovereign's excessive privilege with such frequency are the source of immediate harm to Palestinians.[19] Calibrating this harm does not just involve a simple extrapolation of the damage incurred during "house demolition" or in the erection of a "barrier" for those directly affected by such interventions. All violations occurring in public space have implications for the manner in which the population as a whole uses it, rather than solely targeting those whose bodies, property, or mental well being are directly affected or who are forced to suffer delay and loss of time at the hands of the authorities. Interventions in public space take on a number of dominant forms:

1. Spectacles of power, usually of limited duration, involving the instantaneous production of disaster (destruction).
2. The enduring presence of the effects of damage (the texture of destruction).
3. The creation of architectural "sentences" whose syntax is composed of different modular units developed in the service of the military management of populations (subjection or domination).

These three configurations of intervention are imposed on the Palestinians to their detriment and preserve the power relations between them and Jewish citizens as relations of subjection. It is not sufficient to bestow the status of non-citizens on the Palestinians in order to deny them participation in the shaping of the space they inhabit. Rather, apparatuses of

subjection must be put into operation at all times and in all places in order to ensure their domination as passive subjects.

For all that the photographs to which we shall shortly turn show the indelible imprint of sovereign power in space, they afford only a partial reconstruction of such apparatuses. The sovereign, who does not recognize the Palestinians as his subjects, appears within the spaces of Palestinian life and disappears from them at will, retaining the exclusive capacity to wreak catastrophe upon the Palestinians—who, in turn, do not recognize Israeli sovereignty. The conditions of urgency and catastrophe the Israeli sovereign creates paralyze the Palestinian subjects even once the agents of sovereign power have exited from a certain zone. The sovereign still retains the ability to control the movement of Palestinians, to monitor them, to restrict their activities to the provision of basic needs and to paralyze their agency. These interventions undermine the fundamental principle of shared public space: the fact of its being open to passage, free of violence, and shared by all in accordance with regulated consensus. The Palestinians are denied freedom of movement, their movement is hampered and is violently regulated by spatial and other means, the Israeli sovereign's spatial interventions seek to isolate the Palestinians from one another and to prevent public gatherings or the conduct of a reasonable public life.

On the Verge of Disaster

Under conditions that undermine the very principles of a shared public space, the disaster inflicted by the occupying forces at various sites actually catalyzes the most common sanctioned form of public gathering available to the Palestinians. The imposition of a disaster usually produces massive public gatherings at the time of its occurrence. The ongoing presence of the detritus of disaster evident everywhere in the Occupied Territories serves for its part as the equivalent of the public forum, or *agora*, within the texture of disaster. In a manner typical of sovereign power, the sovereign assumes that he is able to control the manner in which spectators will view the acts of horror that he instigates, the messages they bear and their public reception. The occupier is convinced that his lessons can be "seared into" the consciousness of the occupied— or, as one Israeli army officer put it, "We sent an unequivocal message to the population, the essence of which is that all those involved in terrorism—they and their next of kin—will pay a heavy price."[20] The sovereign's attempt to control the meaning attached to space and the uses to which it is put cannot change the very ontology of the political, however, as that

which is constituted *between people*. This is clearly evident from the accompanying photographs. Even where spatial interventions lethally harm the agency of individuals and violate their shared horizons, their shared response to the disaster imposed on them as well as the forms of congregation that arise from the measures imposed to restrict their movement create zones (in shared space) that are not completely subject to the sovereign's intentions, goals and plans.

As part of a policy of punishment and control, the sovereign does not take responsibility for the damage inflicted on Palestinian public space, nor engage with its consequences. The disasters inflicted are justified in a manner that allows the sovereign to be absolved of responsibility toward victims who are dispossessed and rendered homeless overnight. The sovereign's refusal to accept responsibility for clearing wreckage, rehabilitating space and providing financial reparation leaves enduring scars on the spatial fabric, and forces the Palestinians to bear the brunt of spatial violation alone. Paradoxically, this also provides an opportunity to revive a space of coming-together.

Palestinians are typically kept at a distance from the site of a demolition while it is in progress in order to prevent violent resistance. When permitted to return, they find it impossible to turn back the clock. Vertical, three-dimensional buildings become horizontal textures of ruin after the bulldozers complete their work. Movement along roads suspended during the demolition is resumed, but in accordance with the new textures of destruction now making up the spatial fabric: piles of debris become impromptu public squares. Various Palestinian and international aid organizations like the Red Cross or UNRWA process historical refugees or the new kinds of refugees that Israel is intent on creating in the present. The inhabitants themselves attempt to deal with the new conditions they face despite the severe restrictions that the Israeli army imposes on their freedom of action and of movement on the ground.

The Acting Together of Non-Citizens

The disaster zone that the sovereign evacuates and abandons serves to bring into being a form of acting together on the part of the inhabitants of the Occupied Territories that is usually forbidden on other occasions. I will use the accompanying photographs to reconstruct traces of such activities on the part of Palestinian non-citizens at disaster zones. I will present these activities, which are usually the subject of the sovereign's destructive agency at other times, with reference to the three realms of the life of action:

1. Palestinian men and women gather together and supply the means to provide for the basic and immediate needs of the victims.

2. Palestinians attempt to find professional remedy for the ongoing damages that remain in place for months or even years after Israeli interventions. The ongoing presence of destruction creates a "world" in Hannah Arendt's sense. Its products come to constitute an environment where that which is temporary becomes permanent and the textures of destruction provide an intimate and highly familiar environment for the Palestinian population.

3. These new configurations create new possibilities, including Palestinian efforts to reclaim public space, for however limited duration, as an open space of movement and freedom.

Contemplation of photographs from disaster zones shows that the gatherings they set in motion are multifaceted and do not only consist in meeting only the immediate survival needs of victims or offering them assistance. Every site of disaster potentially becomes a public forum where Palestinians meet around a common referent of the gaze, while their very coming-together actually determines the extent and constitution of this referent. Thus, for example, more than one of the Palestinians who contemplate the enormous crater that was Sami al-Shaer's home (see page 166) seems astonished at the proportions of the devastation. Their shared contemplation of the crater, and, needless to say, the things they say about it, form a link between the crater and the rest of the city. The faces of the spectators are closed off, distant. At times, it seems they betray contempt or hatred for those who force them to operate in a public space fundamentally configured as one of disaster. With endless patience, acknowledging the limited powers of the occupier and holding onto the knowledge that the Occupation can never wholly erase public space and deny them their shared political existence, they contemplate the spectacles of disaster and refute the arrogance of a sovereign who believes that such spectacles can convey unequivocal lessons in domination. It is difficult to determine whether they are astonished at the sheer force of human destruction or at the sight of the stupidity of the occupier. The means that the occupying power invests in practices of blocking and separation, which seek, among other things, to restrict the expansion of disaster to one side of the spatial divide, and thus to isolate the other side and protect it from potential disaster, speak to the difficulty of actually achieving hermetic separation and full control of the disaster. The Palestinian contemplation of destruction, through the physical gaze, is not limited to reckoning with the urgency created by an immediate

instance of disaster. Investigating the scope of the gaze creates wider perspectives for recognizing the disaster as a form of ongoing domination rather than as a discrete temporal event. As the occupier destroys more and more, rendering space itself a continuum of disaster, blockage and separation, so too his power becomes more entrenched and harder to undo, reverse or dismantle. The gaze in public, of the public, is stratified and mutual. The occupied subjects, sentenced to contemplate destruction, also look back at the other members of the governed, the occupiers who gaze at them from afar, shrugging off their active role in sowing destruction. It is, paradoxically, disaster itself that allows the occupied subjects to recognize the arrogance of the occupier who presumes to control the boundaries of disaster. The subjects of the Occupation refute the sovereign's efforts to make it attach to their bodies alone, and signal the sovereign's imbrications in it even as the occupier seeks to impose a violent logic of separation.

The five sequences of photographs collected here enable me to reconstruct the internal grammar of the spatial acts of state associated with the Occupation.[21] This visual-spatial essay constitutes a stubborn attempt to observe Palestinian space "alongside" Palestinian men and women who are forced to live in a sealed-off enclave, using this shared perspective to undermine the separation wall and the illusion of spatial division and mutual isolation it generates. The ease with which the decision was taken to establish a separation wall points to the fundamental principle of the regime, that is to say the separation between citizens and noncitizens. It underscores the civil malfunction of citizens of the state of Israel who do not recognize the criminality of the regime's decision to construct a separation wall in the heart of the territory under its control. Needless to say, comparable violent acts of internal separation and territorial appropriation would not have been tolerated by Israeli citizens within the Green Line. This forces the conclusion, I claim, that any separation that exists in practice depends on the prior division of the world into that which may be tolerated or even justified, and that which can be neither tolerated nor justified. Under the illusion of physical separation, the occupying regime constantly erodes that which is deemed intolerable. It erodes, in the process, the separation between two regimes of justification. The Occupation invests considerable effort in stemming the spread of destruction and restricting it to "one side" alone. The landscapes depicted in the accompanying photographs are, in the main, the preserve of the victims. The sovereign exerts power on his own citizens too so that intolerable scenes might appear palatable in the guise of disaster—this he achieves through various modes of separation. Acts of

destruction that are seen as horrible crimes on the east side of the wall are thought to constitute a respectable commitment to self-defense on its west side. But it is precisely here that the structural weakness of the Occupation is manifested and its blind spots revealed. The efforts that the sovereign invests in destroying the Palestinian built landscape and in the ruination of Palestinian public space become a kind of virus. The deformation of public space imposed on Palestinian non-citizens migrates to the other, Israeli, side of the division. There can be no question that on the Palestinian side, directly affected by the disaster, the public sphere is extremely limited and restrictively monitored, and disasters are imposed one after another. But, on the Israeli side, the side of those responsible for creating and managing the disaster, the public sphere is increasingly contaminated through camouflaging the disaster and rendering it a "disaster from a point of view" in a manner that denies its relevance to those responsible for it. The regime must ceaselessly recruit its citizens to inflict and to legitimate disaster.

The accompanying photographs show the multiple damage inflicted by the Israeli regime on Palestinian private, as well as public, space. An overt Israeli military presence rules over and manages public space, restricting or neutralizing the freedom of action of Palestinian residents. Private space is fragile, and open to incursion and penetration. Those who inhabit Palestinian private space have to make do, in the best case, with the satisfaction of their immediate needs and are liable to become homeless at any point. The sovereign displays his might and power through public acts of destruction, destroying the boundaries of the Palestinian home and invading its intimacy. The interior of the home, usually the province of family members and relatives, is exposed to the public gaze and its sanctity trampled beneath the ruins, abandoned to all comers. The private interior is mercilessly turned inside out, and public space is managed in a highly centralized fashion, devoid of the characteristics usually attaching to open space.

After studying hundreds of photographs, I have isolated sequences that present typical configurations of destruction. These photographs, accompanied by architectural figures produced by the architect Meira Kowalski, point to archetypes of destruction and serve as a legend for interpreting addition spatial interventions on the part of the occupying regime. The repeated appearance of these configurations in scores of additional photographs enables us to understand how different patterns and tools of destruction, which first arose in response to local stimuli and which were barely tolerable at the time of their emergence, have become ready means for repeated use, requiring for their ongoing implementation merely

technical efficiency and the hasty training of additional soldiers. The various techniques of house demolition honed during the course of the El Aqsa intifada approach an assembly line of operational efficiency directed at the destruction of tens of thousands of buildings each year. A fundamental condition of this "operational efficiency" is to detach the process from nonoperational considerations that might delay and encumber it. Such detachment enables the regional commander to decree and implement demolition without waiting for the confirmation of his superiors and even to skip the early warning phase that allows the owners to appeal to the courts for an injunction or interim order. The house destined for destruction is singled out by the General Security Forces. The seemingly "motivated" selection supplies an answer in advance to the question of why this particular house is being demolished and renders superfluous the larger questions of why houses are demolished in general. It is enough for the residents of the house, and sometime the house itself, to be presented as dangerous. The order to blow up the house is accepted as inevitable by the soldiers who implement it. Thus is the question of the legitimacy of the destruction of a Palestinian home rendered irrelevant and the necessity of blowing up a particular house is accepted automatically. In effect, this has become an unquestioned norm.

Archetypes of Destruction

Evacuation and Controlled Collapse within Building Perimeter

Most of the apartments in this building were deserted well before it was demolished. Situated not far from the Qatif Colony block (*Gush Qatif*), it was an easy target for shooting and shelling, making the life of its residents unbearable. According to the Israeli army, Palestinian fighters took cover in its deserted apartments—sufficient cause to mark it for destruction. The act of demolition was probably documented by one of the soldiers in the demolition team. These photographs, produced by the army, are not generally accessible to the public, but serve instead those who implement the demolitions, allowing them to learn from previous experience and to improve the efficiency and sophistication of the assembly line of demolition.

The extensive technological and operational know-how that the Israeli Defense Forces have accumulated as a result of the monitoring of house demolitions in real time has enabled them to simplify the process of destruction and to break it up into modular phases, so that just a handful of soldiers are able to carry out a house demolition in a very short space

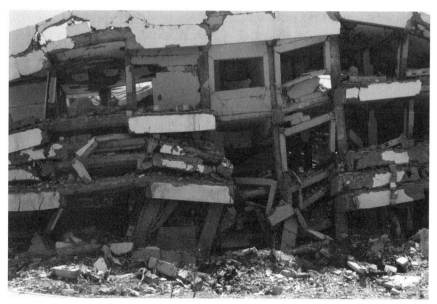

Rafah. Photograph by Miki Kratsman. 2005

of time. The simplification of the demolition process allows soldiers to operate without relying on engineers or the crack-unit members who have been especially trained for such missions. The procedure is clear and explicit, and combat soldiers are trained in the operation of the relevant equipment. The team implementing the demolition arrives in several armored personnel carriers that invade civilian space, surrounding the building destined for destruction. After breaking in the door, the first group of soldiers enters and begins to isolate beams and foundations. With a nail gun, one of the soldiers "hammers" size-10 nails into the center of each of the beams and supporting columns. A second group of soldiers carries explosive charges into the building (each containing about ten kilograms of high explosive) and hangs them on the nails, while other soldiers chain the explosives to each other with a detonator connected to a wireless operation system. The soldiers retreat a few hundred meters away and count down until the blast is heard. It lasts several seconds and makes the entire area tremble.

I viewed a video of this kind of "construction of destruction" produced by the army as a promotional device to attract teenagers to join elite units whose prestige derives entirely from the blowing up of Palestinian houses.

The horror I felt at the noise of the explosions and the sight of the building collapsing (a horror not confined to the aftermath of viewing the promotional film), is negligible compared with that of someone who sees her home destroyed before her eyes. Hanging the explosives on beams and support walls causes ceilings to collapse, so that the entire building implodes in upon itself as if built from rubber. The degree of professionalism of the demolition team is judged depending on how successful it has been in containing the damage within certain marked perimeters. The successful implementation of an operation is the source of pride for the team and those who have deployed it. From their perspective, the absence of unnecessary damage is a measure of their consideration. Their consciences thus pacified, the authorities can continue to see the destruction of the apartment building as justified.

In some cases, the army sends in bulldozers the next day to finish up the job, grinding the building to dust. In others, as can be seen in this photograph, it leaves the destruction half-finished, indifferent to the fact that the precarious structure constitutes a safety hazard in its own right. Once the Israelis unilaterally "withdrew" their (permanent) presence from Gaza, complete darkness has fallen over the city of Rafah. For an Israeli citizen, what little information it is still possible to glean about the city today is mediated almost exclusively through the Israeli Security Forces who continue to operate there under the cloak of invisibility.

The Targeted Destruction of Housing Units in an Inhabited Residential Building

At the center of the photograph stands a five-story apartment building. Two of its stories have been totally ruined, and another two partially damaged. The "targeted" blast spared the first story. The building shows evidence of perforation from ongoing exchanges of fire in the area, but these are not considered assaults nor included in the statistics of house demolitions. Were statistics pertaining to house demolitions based on photographs of the interiors of buildings damaged in this manner (revealing the extent of the internal damage), the data would probably have to be adjusted to include such apartments in the tallies of house demolition. Advanced technologies of targeted destruction enable the army to carry out "controlled demolition," which ruins "only" the apartments of those it suspects of terrorism. The fact that the rest of the building's residents are forced to live in a ruined, mangled building is irrelevant to military logic. The sovereign uses his junior and senior delegates to continue to justify his actions. In the few instances when such violations are challenged in the

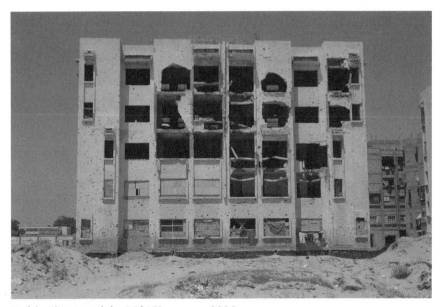

Rafah. Photograph by Miki Kratsman. 2005

courts, legal precedents are invoked enabling the sovereign to claim to have acted with maximum accuracy so as to prevent harm to "innocent" populations. This operational discourse remains coherent because the security forces have the exclusive authority to determine who are guilty and who are innocent. The security forces announce their possession of evidence that remains largely

confidential, implementing their decrees under the rationale of military considerations, leaving no room to appeal the sentence. (If appeal were possible, it would in any case probably be deferred.) An Amnesty International 2004 report challenged the Israeli army's claims that Palestinians used the houses it demolished for shooting or to launch assaults, and questioned their being "partly deserted," "empty," or "uninhabited."

Outer walls made of bare, un-plastered cement in the Occupied Territories cannot attest to a building's being uninhabited, as is plainly visible, for example, from the state of the two bare buildings visible behind the damaged building in the foreground of the photograph. The constant threat that looms over Palestinian construction as well as the ongoing economic depression help explain why Palestinians often dwell in

"unfinished" buildings, devoid of outer layers of plaster, from whose roofs iron rods still protrude so that construction work might be resumed as soon as resources become available again. The specter of future destruction haunts them constantly, scarring the present and shaping the norms of spatial organization, dwelling, and movement in both private and public space. The holes blasted in these classical housing "boxes" are a constant, tangible reminder that any Palestinian, regardless of his deeds, faces the likelihood of being evicted and seeing his house destroyed.

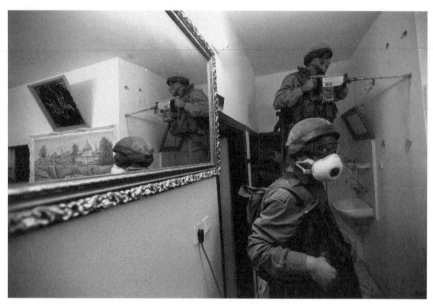

Tulkarm Refugee Camp. Photograph by Nir Kafri. 2002

The Targeted Destruction of Housing Units in an Inhabited Residential Building: Interior View of Preparations for Demolition

The soldiers surprise the residents, appearing at night at the house marked for demolition. They have about six hours, until sunrise, to make the building uninhabitable and then return to their base. In their pioneering days of "Wall and Watchtower" settlement during the 1930s, Jewish settlers new to Palestine would erect an entire environment within a few hours, between midnight and dawn, unilaterally creating facts on the ground in the face of the British Mandate and the local Palestinian population alike. The demolition of homes of suspected terrorists now takes place like an inverted projection of the historical "Wall and Watchtower"

operations. The soldiers leave behind dispossessed families whose belong-ings are also usually turned to dust. The demolition itself is not an arbitrary act, but the result of a complex preparation that involves planning, tools, means, edicts, justifications, and precautionary measures.

The army arrived at midnight at the home of Sirhan Sirhan, a Palestinian suspected of murdering five Israelis at Kibbutz Metzer. The demolition operation lasted ten minutes or so. This was also the time allotted the residents to salvage some of their belongings. Needless to say, the residents were unable to salvage all their valuables in such a short space of time. The operation was rigorously planned, including inviting a photojournalist—whose photograph we are now viewing—to document the proceedings as part of the publicity that the army sought to attach to the operation. At least another two video cameras were employed to document the interior of the home in a systematic fashion. Sirhan's father was asked to look at the camera and to confirm that this was indeed the home of Sirhan Sirhan. The photograph shows two of the soldiers concealing dynamite "fingers" in the house's inner walls without damaging its beams and foundations. Precise engineering planning and the calculated use of explosives enabled the army to focus the demolition on one specific apartment in an apartment building, "sparing" the neigh-bors: "Up until now, we didn't touch Sirhan's apartment because it was located on the third floor of a building and it was feared that if we blew it up, the other floors underneath and the houses nearby would be damaged. We decided to carry out a controlled, microscopic implosion, the purpose of which is to cause the ceiling of that particular floor alone to collapse inward without harming any innocent bystanders."[22] The commander's emphasis on a microscopic "focus" resembles the army's discourse concerning targeted assassinations. Such concern deflects attention away from the brute act of demolition, offering precision as a decoy. This rationale ignores the fact that a field tribunal effectively passes unilateral sentence on the house, determining the scope of destruc-tion in the process. Thus, for example, after the army "surgically" targeted and assassinated Sirhan Sirhan himself, it proceeded to demol-ish his parents' house "precisely," without damaging neighboring houses. The blast took place as planned, and the damage was inflicted "only" on the family's dwelling. The relevant commander confirmed by radio that "the relevant floor is no longer usable, while the rest of the building is intact"—and the forces of destruction withdrew.

The Bulldozer—Erasure through Slow Attrition

The building visible in the photograph below no longer exists. It disappeared from the face of the earth when the bulldozer and associated demolition equipment completed their task some hours after the photograph was taken. The use of bulldozers is usually reserved for the demolition of illegal construction. The residents of the house, as well as their neighbors, are expected to perceive the bulldozer as the agent of law enforcement.

The building is slowly and methodically made to crumble. Destruction begins at the building's right angles and outer walls. Once the outer shell is removed and the volume of the separate apartments is reduced to various strata of floors and ceilings, the bulldozers continue to gnaw away like children savoring each layer of a chocolate-coated wafer. The duration of the work varies according to the height of the building and the number of rooms on each floor. Normally, no more than a day is required to turn the building into a heap of rubble and another few hours are all it takes to pulverize the remains beyond all redemption.

The Heap

If the army has obtained a demolition order, demolition can be carried out in broad daylight. The order pertains to the building alone, not to its contents. Since the demolition

Sur Baher. Photograph by Keren Manor. Activestills.org, 2007

Wadi Qaddum, East Jerusalem. Photographed Keren Manor. Activestills.org, March 2007

order applies only to the building, its execution necessarily includes evacuation. Large contingents of "security forces" are employed to evacuate the family who reside in the house marked for demolition and to keep them away from the site, ensuring that they will be unable to barricade themselves inside or sabotage the demolition. The bulldozers usually commence their work only after the residents and their belongings have been removed. The inhabitants usually evacuate themselves, and the security forces make sure they are kept away while army employees, clearly identifiable in their orange-colored vests, remove belongings. These are packed by alien—sometimes very crude—hands: mattresses, beds, chairs, a refrigerator, a baking oven, a wash basin, cushions, a table, and games are all heaped next to the building soon to be demolished, absorbing layers of dust that will be etched into them for an eternity of shame, a reminder of having been salvaged courtesy of the occupier intent on "considerately" sparing the owners unnecessary suffering.

The Spectators

The residents are removed from the site but remain within the range of vision. Can the spectacle of demolition be accomplished without spectators? Like eyes riveted to a flame, they are attracted to the scene of horror, seeking a platform or peephole that will allow them to witness the ongoing destruction of their houses to the tune of the death march of the bulldozers.

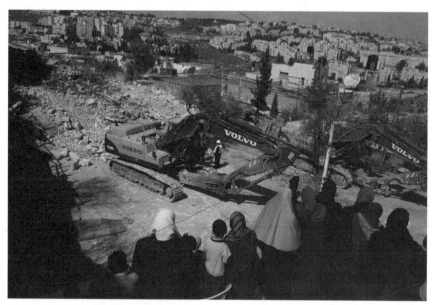

Sur Baher, East Jerusalem. Photograph by Keren Manor. Activestills.org, 2007

 Neighbors join the vigil, perhaps rehearsing their own turn in the near future. Some observers remain in place throughout the entire demolition process, while others emerge every time the house changes its material state. Once the rubble has been nearly flattened and evenly covers the ground, they appear to assemble for a last farewell.

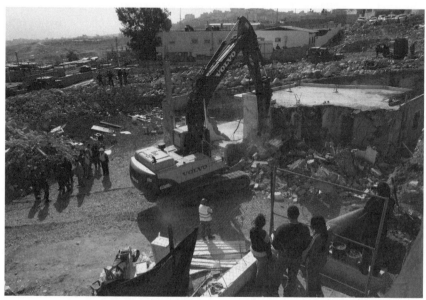

Al-Tur, East Jerusalem. Photograph by Tess Scheflan. Activestills.org, 2007

Surrounding the Building

A huge contingent of policemen and soldiers is posted at several points around a building destined for demolition. Their job is to safeguard the demolition from potential resistance on the part of the evacuees. The absence of resistance, one must assume, does not represent consent but fear of the awesome power of the machine of destruction that has technology, the law, and an infinite number of deputies at its disposal.

The Tent

International aid organizations set to work immediately after the demolition has been completed. The division of labor is achieved through a sort of silent consensus: the state of Israel destroys; the international community compensates and rehabilitates, helping to prop up the Occupation in the process. The frequency of house demolitions over the years has led to the institutionalization of processes of coordination and cooperation. These processes are sometimes denied— "We do not tell them what to do"—and sometimes emphasized—"The operational directive itself contains humanitarian provisions."[23] The efficient collaboration between the agents of destruction and the donors of humanitarian aid delays the pronouncement of a disaster zone in the Occupied Territories. It effectively sentences the Palestinians

Al-Tur, East Jerusalem. Photograph by Oren Ziv, January 2007. Activestills.org, 2007

to life on the threshold of disaster. The question of how the state of Israel might behave were thousands of homeless Palestinians left to wander the streets of Palestine remains open. The sight of Palestinians deported from their homes and crowding into the tents provided by humanitarian organizations scarcely dents the civil consciousness of Israelis.

The location of the tent provided by the Red Cross marks the outer circumference of the rubble. The tent is too small to contain valuables and belongings, so these are all piled up in front of it, objects accumulated over the years. In the small yard created in front of the tent sit the evacuees, bracing themselves for the hours to come.

Crater, Disappearance, Congregation

Late at night, several days before the residents of the Brazil Camp in the Gaza Strip were photographed standing on the rim of the crater pictured here, many of them rushed to open their windows when they heard the familiar chilling roar of a fighter plane, seeking to minimize the damage from the blast that would soon rock their dwellings.[24]

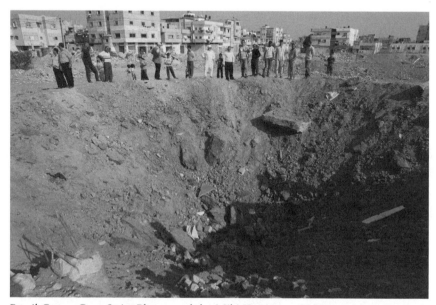

Brazil Camp, Gaza Strip. Photograph by Miki Kratsman. 2007

They know what follows when an F-16 penetrates the camp's skies: their bodies and possessions having refuted time and again the Israeli army's pretensions of sophistication and precision. With the paltry means at their disposal, they try to protect themselves from the horror and to minimize the range of injuries as far as possible. Daem al-Az Hamad, a fourteen-year-old girl living about three hundred meters from the spot where the bomb fell, turning the house that had stood there previously into a crater, was killed by a beam that collapsed on her parents' home. The state refused to take responsibility for her fate, while the army repeated empty slogans about the precision of an operation that affected "only" Sami al-Shaer's house. This house was targeted because the army thought its yard concealed a tunnel for smuggling arms. The spectators (over twenty people) standing at the rim of the enormous crater (about thirty meters in diameter, seven meters in depth) gaze at various focal points of destruction (most of the exterior walls along the Philadelphi Road adjacent to the camp are perforated like sieves by now). They embody the gap between the laundered, quasi-legal language the army uses to justify its actions and the brute spectacle of this space in which destruction looks anything but focused. The pure human violence exercised here capable of swallowing an entire house almost without trace, fascinates the audience. The amazement of the spectators prevents the house from vanishing entirely. They cling stubbornly to the house: a wake of memory. None of the spectators is safe from the specter of a destruction that might recur and surprise them at any time.

The sight of spectators gathering together around a crater is one of the few forms of congregation in public space that the occupying regime seems not merely to tolerate but even to encourage, fuelling the spectacle again and again through its acts of destruction.

Tunnel One Meter Above the Ground

The hole in the wall frames Mrs. Rajab as she moves to and fro in her home whose interior is visible through it (see p. 169). The photograph, taken some time after soldiers ruptured the wall of her house, suggests that she has already grown accustomed to it. The hole was violently breached one night in September 2009, taking her whole family by surprise. First came the hammering and the slight blast, then dogs barking and strangers moving around—Hebrew-speaking Israeli soldiers. The soldiers send dogs into the "tunnels" they bore through houses, letting them absorb the blows and gunfire anticipated in response to their passage. This hole in Mrs. Rajab's home brings her into unfamiliar

contiguity with her next-door neighbors. It is one of a series of several dozen holes breached by Israeli combatants as they pursued a man targeted as a potential suicide bomber. The holes blasted through the Rajab, Namruti, and Taha family homes enabled the soldiers to make their way unseen through the crowded camp in a relatively straight line. The walls were not held to constitute an obstacle to their passage. Nor was any respect accorded to the privacy of families living inside the devastated houses. Moving through walls is a novel tactic of war developed by the Israeli army during the second intifada. In some respect, these new forms of warfare represent the inverse of the methods developed by the army in the early 1970s to crush resistance among refugee-camp dwellers. The two kinds of warfare differ greatly, but they share a significant common denominator—the Palestinian home is no obstacle to the army's movement. The inversion of spatial relations achieved by the new theory of warfare, eradicating distinctions between open and closed, solid and air, mobile and static, seems to resonate with various postmodern theories.[25] In fact, this type of warfare, like the theories that inspired it, is the outcome of a postmodern situation that threatens at this time to eradicate the distinction between the practices of power and the theories that address them.[26] In the early 1970s, the army looked for ways to clear broad swathes inside the dense texture of the camp, through which it would move undisturbed, visible to all, obtaining deterrence and control of the space, razing whole building blocks in the process.[27] Now the army seeks rapid contact with targeted individuals drawn from the civilian population and aims for minimal friction with the surrounding environment during its incursions into Palestinian territory.

Razing and Road Clearance

The D9 bulldozer moves forward, devastating any "obstacle" in its path. It acts relatively quickly to "clear the area" of anything the army has designated as a target. A cast-iron blade installed in the front of the vehicle pushes aside everything in its way, piling up soil and stone, and uprooting obstacles, while a ripper in the rear cracks open hard objects and material. Side blades resembling sharp fingernails installed on some bulldozers enable them to apply concentrated force to small objects. The bulldozer is immensely powerful. Its custom-made protective armor turns it into a terrifying tool capable of inflicting enormous damage and violation without its operator even sensing the extent of its destructive swathe. Over the course of the twelve days of "Operation Rainbow" during May 2004, army D9 bulldozers demolished

183 houses in Rafah, partially damaging dozens of other buildings. They razed miles of paved road, and devastated electricity, water, and sanitation infrastructures. Specially installed cameras recorded the destruction.

If the army were to allow the public to scrutinize even a single one of the photographs taken by those cameras, it would be possible to learn a great deal concerning its perspective and the type of visual material it seeks to collate so as to refine its methods of destruction further. Exposing those photographs might also reveal the identity of the photographer who took the photograph we are currently viewing, and might expand our knowledge about the army's mind-set concerning photography.

I discovered this photograph on Wikipedia.[28]

The security logic and the Zionist ideology that I readily identified in the various entries I examined, all connected to various machines of destruc-

tion employed by the Israeli army, leaves no doubt that it invests human resources in disseminating its worldview, language and repertoire of images in virtual space. It should be assumed, therefore, that this particular photograph was "approved for publication" by the Israeli army, which maintains a vested interest in our viewing and using it without even having to secure copyright permission.

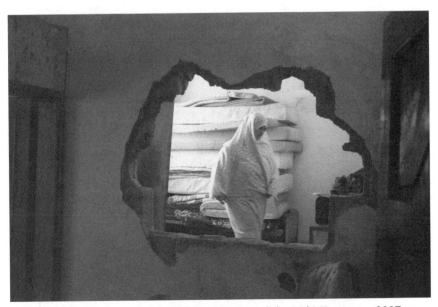

Ein Beit al-Ma' Refugee Camp, Nablus. Photograph by Miki Kratsman. 2007

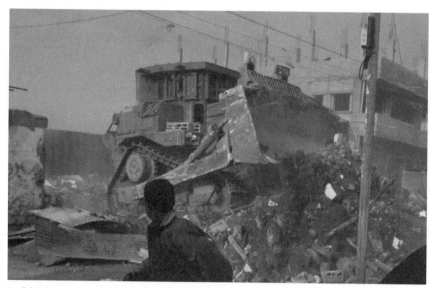

Rafah. By a military photographer. 2004

What is it about this illustration of the D9 that makes it particularly suit-able for publicity purposes—or at least motivates the army not to prevent its publication? What exactly is the link between the act of photography that produced the photograph and the action it describes: home demolition? The most obvious answer lies on the performative level: through the dissemina-tion of the photograph, the Israeli state declares that home demolition is not a contemptible act, but a justified response to "terror" that takes place in broad daylight, in full view of the camera. But this is not all that is at stake. The photograph, like the act of destruction it depicts, is not only meant for the eyes of the home community that will inevitably legitimate it. It is also intended for the eyes of the community being deterred and terrified. Home demolition, in the words of the deputy to the state attorney, advocate Shai Nitzan, is "intended, among other reasons, to deter potential terrorists, as it has been proven that the family is a central factor in Palestinian society."[29] The photograph selected by the army, which shows a Palestinian boy at its center—he, too, a "potential terrorist" like every other Palestinian boy, according to the self-same operational logic—is supposed to serve as a deter-rent inhibiting people whose family is important to them. The boy looking at the might of the Israeli army is supposed to internalize a military logic that selects targets of destruction on the basis of various criteria, and to acknowledge its rationale. The result of such internalization, the army implies, will be that he relinquishes his resistance to the Occupation; his civil aspirations (being governed like others); and his nationalist hopes (enjoying

self-determination or at least participation in the regime to which he is subject). But the army cannot control the way in which a young boy, forced to escape the jaws of this terrifying tool that wreaks destruction everywhere, will appear to spectators. The boy is familiar with these scenes of devastation—he has probably seen too many already and he still seems unwilling to acquiesce in their logic or to recognize their implementation as embodying justice. He flees the powerful D9 in terror, but seems unable to tear his gaze away from the colorful shreds of houses mangled in the dirt.

Destruction of Infrastructure and Life Fabric

The photograph depicts one segment of a larger compound that was destroyed. The operation combined aerial bombardment with ground operations carried out by the Engineering Corps. The contingency plan to demolish this particular government building in Jenin was prepared long before the order was issued. Many such contingency plans exist. Soldiers practice them, anticipating the right moment for their execution. The soldiers charged with carrying out the demolition in Jenin waited at an "assembly area" for as long as it remained unclear whether the plan would be carried out. Then the World Trade Center came down. The army identified a "window of opportunity" while the attention of the world was riveted on the horror in Manhattan. In the words of one of the soldiers of the Engineering Corps: "As soon as the second plane hit the second tower, we got the okay to go ahead. The army always does this when there is something special on the world scene. So, for example, when Princess Diana was killed and world attention suddenly went elsewhere, they [the army] gave us the 'go ahead.' There are a thousand and one controversial contingency plans waiting implementation. This way no one even notices."

Indeed, destruction of the three-wing al-Muqata'a compound, as well as the inner yard where its residents used to grow vegetables; the destruction of the neighboring mosque; and the killing of nineteen Palestinians in the aerial bombing, raised not a murmur in the local and international media. This photograph was taken accidentally by a journalist who happened to be in Jenin about a month later. He first heard of the destruction from Palestinians: "There was a garden here and a decorative fish pond. For years, we received Israeli officers here royally [under the coordination arrangements between Israeli and Palestinian security forces in the days of the Oslo Accords]. This is how they reciprocated."

Why was a ground operation necessary in addition to the air strike used to demolish al-Muqata'a? Aerial bombardment, however accurate, can

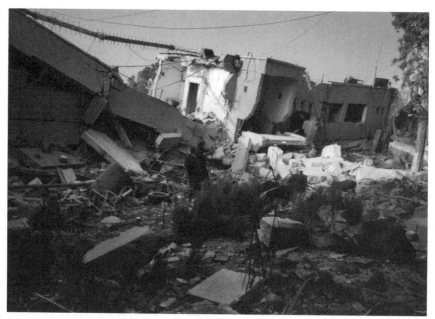

Al-Muqata'a, Jenin. Photograph by Joseph Algazy. 2001

never obtain the level of precision desired by the army. When the Israelis withdrew from Jenin under the Oslo Accords and handed the building over to the Palestinians, they concealed an electronic surveillance device within it. It was necessary for the Engineering Corps crew to see to its destruction, so that it would not suddenly emerge into visibility in the rubble and precipitate a diplomatic incident that would reveal the extent of Israeli penetration into Palestinian life.

Following the bombardment, the various wings of the building became unusable. The fact that their destruction was never fully completed has rendered the building an ongoing safety hazard and an additional monument to devastation.

Textures of Destruction

The spectacle of destruction is, as we have already stated, the first stage in mangling space so that it bears the seal of sovereign power. Every spectacle leaves a tactile imprint all its own. Some buildings are so thoroughly shattered into small pieces that nothing can be imagined to cohere ever again. Sometimes the destruction is deliberately left incomplete to ensure that a particular structure can no longer serve its role, despite the preservation of its exterior form. Even if the larger detritus is evacuated, a crumbling

building will continue to generate dangerous or merely mundane refuse even when uninhabited. Like something sealed in vacuum packaging, the contents begin to decay the moment it is opened. It is sometimes sufficient merely for foreign forces to penetrate the house in order for its seal to decay. In more radical cases, the internal composition of materials is undermined: the interior generates dust and toxins. The blows inflicted on the house loosen its grip on the earth, so that it sloughs off everything that is not tied down. The detritus of what was once a life breaks through the ruins. Their devastated remains constitute a danger to the public even as they undermine the emotional stability of the former residents.

The contemplation of photographs depicting whole buildings reduced to textures of rubble does not easily yield answers as to why the architects of destruction chose to end their "work" at one stage rather than another. The cessation of interventions at various stages leaves different textures of destruction. They appear devoid of logic, save the intention of preventing former residents from re-inhabiting them. Whatever the case, the different textures do nothing to mitigate the deliberate disruption that these "public squares" impose on the fabric of Palestinian life, including slowing down various kinds of exchanges and the disruption of the flow of life in open space. On routine days, days when no episodes of eruptive violence[30] are recorded in the protocols of the Occupation, the occupying forces concentrate their efforts on the management of various roadblocks and checkpoints on major arteries between regions. The occupying forces generally ignore the ruins they have created, oblivious of their potential to become "living public squares." With the departure of the sovereign, many of them become twilight zones. But here and there Palestinian men and women continue to gather around them, using them in ways unanticipated by their makers—in ways, moreover, that run counter to the intentions of the agents of destruction.

Al-Faradis, Hebron region. Photograph by Yotam Ronen. Activestills.org, 2008

The site where the house once stood is covered with masonry shards, like an expensive vase that has been smashed to smithereens. Its visible surface surely hides still further additional layers of shards and detritus.

Hebron. Photograph by Anne Paq. Activestills.org, 2003

As in some delicate filigree, building blocks have been removed from the metal rods, and the house now resembles a transparent hothouse. Here and there, concrete beams hang from the ceiling, as if someone had tried to regulate the entry of light.

Anata, East Jerusalem. Photograph by Keren Manor. Activestills.org, 2006

Clothes torn out of the closet add some color to the monochromatic stone mosaic. Does the child on the neighboring hill whose gaze lingers on the geometry flowing out of what once was a house, identify familiar shapes? When he grows up, and is invited to testify before some future Truth and Reconciliation Commission, will he be able to organize these chaotic impressions into a more organized form?

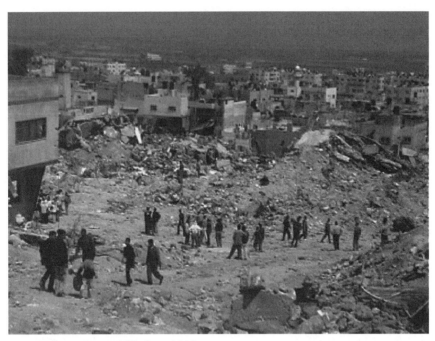

Jenin Refugee Camp, B'Tselem. 2002

The massive destruction of about five hundred houses after Operation Defensive Shield, most of them in the Hawashin neighborhood, created vast "plazas" inside the camp's dense fabric. The rubble layer covering them created a potholed texture that hampered movement in the camp but served as the pretext for local gatherings to be constituted. New hills consisting of the remains of pulverized houses also emerged from the wreckage, contributing to the camp's altered topography and the new organization of life within it.

Al-Walaja Village. Photograph by Keren Manor. Activestills.org, 2007

The sovereign's privilege, which granted building permits to the houses of the settlement of Gilo visible in the background, is also that which deprived this Palestinian house in the village of a-Walaja from continued existence under the protection of the law.

The road from al-Ram to Ramallah, Yotam Ronen. Activestills.org

At times, the stones of various ruins are elegantly compressed into a heap bearing no resemblance to the house from which it was formed. The bare ground surrounding the heap reinforces the illusion that these are, perhaps, stones meant for masonry or construction.

Al-Issawiya, East Jerusalem. Photograph by Keren Manor. Activestills.org

Several days later, as the site of a demolished house loses its aura, passersby throw empty bottles or refuse bags into the empty space, where they blend in with the rubble.

Types of Blockage

The management of "types of blockage" and "the architecture of separation," focuses on processes and interventions responsible for the creation of a space of disorientation whose legibility and intelligibility are impaired. This disorientation makes gibberish of maps and renders cartography into detective work. Most, if not all, such interventions slow down Palestinian traffic, sometimes paralyzing it entirely. The movement of Palestinians, restricted in any event, is measured and regulated by means of "architectural" components like concrete cubes, parts of walls, barbed-wire fences, plastic barriers and so on. The photographs I have chosen feature patterns of blockage that share the common denominator of preventing Palestinians from reaching a destination that is nevertheless clearly visible in front of them. They show how that which is close by, in the range of vision and formerly within arm's reach, is rendered inaccessible.

A common form of architectural syntax is discernible at checkpoints and various other obstructions that rely on the familiar, quintessential logic of obstruction. This series of photographs depicts how Palestinians are distanced from their homes, positioned on their threshold and prevented from entering them.

Hebron. Activestills.org, 2007

Blocking openings

The matching stones inlaid in the windows are the visual seal of the confiscation of the house, wrenched out of the possession of the Palestinian family who formerly lived in it.

Luban al-Sharqiya, north of Ramallah. Photograph by Dafna Kaplan. 2003

Confiscation of Property and Closure for Military Use

Under the trappings of a military outpost—the Israeli flag, barbed-wire fencing and camouflage netting—is a Palestinian home. The army declared its need to occupy this site. The family living here was removed indefinitely. For as long as it is "decorated" thus, the family who once lived here may view this building from afar, may dream about it—or lose their minds.

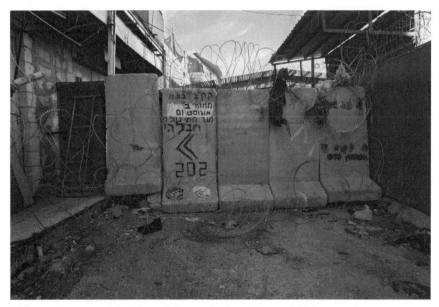

Hebron. Photograph by Keren Manor. Activestills.org, 2007

Temporary-Permanent Road Closure

Concrete modules stretch across the street between two houses. Behind them, Jews reside in houses previously inhabited by Palestinians. In front of them dwell Palestinians whose city—over half of it—is blocked to them, and their movement restricted in the remaining parts. In addition to these walls that obstruct movement through the streets, Hebron also contains sixteen manned checkpoints.

Beit Hanoun, B'Tselem. 2004–5

Rendering a Bridge Unusable

A direct hit to the middle of the bridge disabled it. The army suspected that launchers of Qassam rockets used the bridge in order to transport rockets, and consequently justified blocking any Palestinian movement between Gaza and Beit Hanoun on these grounds.

Jayyous. Photograph by Miki Kratsman. 2002

Transparent Gates in a Fortified Wall

In places where the separation wall has driven a wedge between Palestinians and their fields, schools, and workplaces, gates have been erected for the local population, open three times a day. Eighty-seven such gates are scattered along the length of the wall. Every gate is the site of a new queue, a tool for stealing time.

Between Qalqilya and Tulkarm, B'Tselem. 2003

Coils of Barbed Wire

Where the topography provides a "natural" gap in the separation wall, the army makes do with barbed wire.

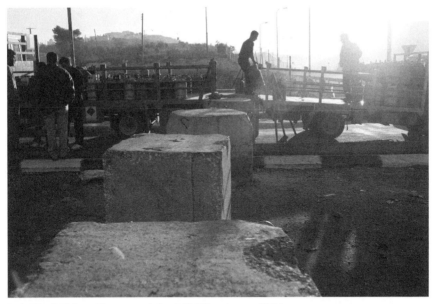

Beit Ur al-Tahta. Photograph by Miki Kratsman. 2001

Blocking Moving Vehicles

Before erecting the separation wall, the army used concrete blocks such as the one in the photograph to impose separation between Jews and Palestinians. After the erection of the Wall, the blocks remained on hand to create "local separations." Hundreds of separation lines formed out of these concrete blocks now criss-cross the West Bank, preventing the passage of vehicles.

The food shortages caused by the blockages the army has imposed since the beginning of the El-Aqsa intifada have been partially remedied by maneuvering within the blockages to create what the army calls a "back-to-back" compound for the transport of goods. This military patent, conducted under close and invasive surveillance, allows the movement of basic foodstuffs in and out of enclaves. Two trucks move between the concrete cubes: one full of produce; the other empty and waiting to be loaded. These back-to-back arrangements have not solved the problem of food shortages; rather they seem to perpetuate them. Some Palestinians have therefore improvised "back-to-back" arrangements of their own, without the army's permission.

Beit Ur al-Tahta. Photograph by Miki Kratsman. 2001

Blockage to the Power of Two

All attempts at improvisation are read by the occupier as provocations. The army does not rescind its monopoly, even in the "back-to-back" domain. The army obstructed the Palestinian improvisation visible here. The abundant rubble produced by house demolitions was recycled and used to cover the concrete blocks and fill the spaces between them that previously enabled the transfer of goods from one side to the other. For as long as the army denies that every blockage imposed on human beings, every restriction to their freedom of movement, will be met with resistance and with the attempt to bypass such restrictions, it will no doubt continue to refine its techniques of separation. The Palestinians will, in their turn, find new ways of bypassing them.

Architecture of Separation

The types of blockage evident in the configurations I have presented above exist in a field of vision that remains mostly visible to the Palestinians. The blockages are intended chiefly to restrict their freedom

of movement in a certain territory. In the sequence that now unfolds, blockage becomes fully-fledged separation with the intent of imposing complete division between areas designated for Jews and ones designated for Palestinians. In addition to the discriminatory divisions that allow Jewish access to certain spaces while restricting Palestinian access, the blockage creates a split in the field of vision shared by two populations that are subject to the same regime. The separation managed by one side for its own benefit is presented to its beneficiaries as a banal form of division into two units, thus dissimulating the violation, theft, aggression and coercion imposed on the victims. In this split field of vision, the gaze of Jewish subjects and of Palestinian subjects are intended never again to intersect.

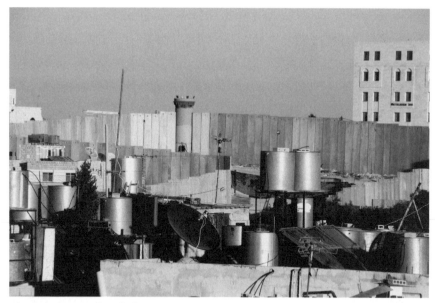

The winding path of the separation wall around Rachel's Tomb, Bethlehem. Photograph by Anne Paq. Activestills.org, 2006

A view from the Aida refugee camp. The illegibility of space along this segment of the separation wall betrays its absurdity in a nutshell. The separation wall does not delineate a border between two entities that have gone their separate ways, but is a new formation contingent on the governing power's need to control the Palestinian population through separation. The sovereign pursues his self-image as wholly distinct from those who live in the West Bank and Gaza, although the means and efforts invested in maintaining separation impose unceasing friction with them.

B'Tselem, year unknown

Heavy boulders block passage on the road leading to the Teko'a settlement. The separation between Jewish and Palestinian vehicles takes place on the approach roads leading here. Chances that Palestinian traffic will even access this fork are effectively nil. It thus becomes possible to save on human resources and to let a boulder do the work instead.

Kharbata. Photograph by Miki Kratsman. 2005

The world goes on its merry way. The high road for Jews; the low road for Arabs.

Near Anata, East Jerusalem. Photograph by Yotam Ronen. Activestills.org, 2007

Separate roads. Right for Palestinians, left for Jews.

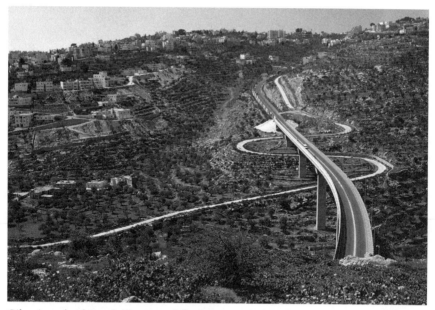

Gilo, Apartheid Road. Photograph by Ian Sternthal. 2005

The dream of separation seeks here to overcome a certain excess in the visual field that enables the spectator to see, simultaneously, two spaces that are intended never again to meet.

Architecture of Fear/The Language of Subjugation

This sequence of photographs to which we shall now turn trains the gaze on various blockages in order to reconstruct the spatial language and stylistics that the Israeli regime implements in order to regulate Palestinian movement. It shows how this language of subjugation ensures that the Palestinians, whose freedom of movement is restricted in advance, will be unable to unite as a group—a force inevitably more threatening than the power of a single individual—but will stand, or move, in single file one behind another. When Palestinians are constrained to move in single file, it suffices to deploy only a small group of soldiers to monitor their motion and there is no threat that the soldier at the point of face-to-face contact will have to deal with more than one person at a time.

These photographs are the source of rich knowledge, concerning traffic and technology, demography and management, topography and domination. Architectonic icons showing the "temporary" components of the new architecture accompany this sequence and the one on the architecture of blockage, like a legend on a map. They represent part of the arsenal of portable and temporary components at the disposal of the sovereign's minor deputies. They compose a kit that can be deployed in a relatively short space of time at any given point in space, thus impinging on, restricting and blocking the movement of people, goods and vehicles. These components, so deeply familiar, are imprinted on the somatic consciousness of Jewish Israelis as mechanisms of defense whereas for Palestinians, they are links in the chain of domination.

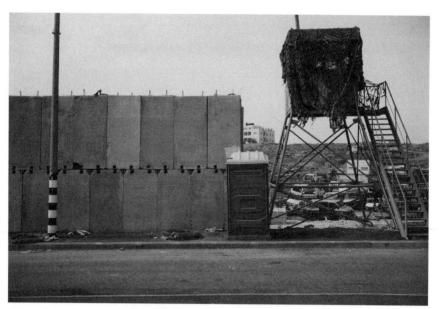

Route 443. Photograph by Miki Kratsman. 2006

The arrangement in a straight line—like objects in a showcase—of the various items seen in the photograph differentiates them from the scraps thrown at random into the plot directly behind them. Beyond this formal difference—random piling versus orderly arrangement—their presence at the roadside might seem odd to strangers from countries where civil space has not been corrupted by occupation or apartheid. In this local space, however, such signs—a watchtower, camouflage netting, a field latrine, concrete segments "sewn" to each other to form a wall, chicken-wire fencing—and their unexplained combination, are a familiar sight to both Israelis and Palestinians. Even when each of these items separately does not voice its "intrinsic" meaning, and even when the logic of their syntax is hardly decipherable, they produce general utterances such as "The army is here" or "There are Palestinians nearby." The relative intelligibility of these phrases for passersby results from the presence of such utterances in many different places and from their naturalization as an intrinsic part of the landscape. Their familiarity enables them to reappear later in different contexts without their standing out as odd or their being taken for what they are in fact—tools of harassment.

Beyond the abstract meaning of such architectural phrases, whose local yet reiterated familiarity suffices to naturalize them, they contain concrete and immediate meanings for the people who experience them closely on an everyday basis and whose movement they shape. Israelis—especially soldiers and settlers—see them as means of protection from Palestinians, and they soon learn to operate them effectively and to expand their range of use. Soldiers and settlers perceive Palestinians as a form of human raw material that must be processed using these tools. The Palestinians, especially those who have not given up their basic right to move through space but who are subjected to the apparatus of blockage, recognize each of its components and know how to decipher the nuances of their syntax. Most of them develop such hermeneutic skills in order to lighten—however slightly—the toll that such components of blockage inflict. Some Palestinians hone the relevant syntax in order to resist—violently or nonviolently—the blunt obstruction of their freedom of movement in public spaces that these tools impose.

The bluntness of such tools is part and parcel of a comprehensive logic of the regime of occupation, intended to repeat to the Palestinians the fact of their subjugation at any given moment through edict, deed, and sign. This bluntness seeks additional purchase—over the interpretive plane, for instance—regulating how Palestinians decipher the various signs. Thus, for example, the army persists in the display of watchtowers such as the one in the photograph, portraying them as elements of supervision even though the second intifada yielded a crop of hundreds of reinforced pillbox posts, making the watchtowers less and less necessary. Most of the older watchtowers have been covered with camouflage netting and a decoy guard dummy of the type used for target practice has been placed inside. Several times a day, soldiers scale the post with "provisions" so that it will not occur to the Palestinians that the tower is empty and that they have been left unsupervised for a given amount of time. The soldiers who so assiduously feed their dummies are convinced that the Palestinians really believe that the tower is manned. But the Palestinians just smile.

The accompanying picture shows a segment of an entire compound surrounding a barrier. If the frame were wider, one could see a checkpoint located further to the right. The purpose of the checkpoint—filtering or even denying entry to Jerusalem to Palestinians from villages such as Kharbata or Beit Liqya—is achieved more effectively when the road leading to it is already lined with policing signs that make the rules and their authors clear to Palestinians.

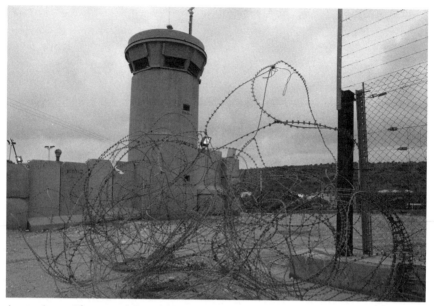

Azzun Atma. Photograph by Miki Kratsman. 2006

A barrier is usually associated with an entire compound sprawling around it: some of it visible, the rest invisible; some of it permanent, other parts temporary. Photographs documenting checkpoints and barriers usually present only a segment of the entire spatial compound, which consists of the total spatial distribution of a military force and which changes according to specific geographic-topographical conditions and updated intelligence on the movement of Palestinians in the area. Normally, however, every such segment embodies the principle of the whole: organizing space in a way that ensures Israeli control and sovereignty and Palestinian subjugation and obedience. The fear that such power relations will be disrupted and that the Palestinians might move out of their assigned places accounts for the expanding architecture of fear that creates compounds of spatial control.

A small, but typical section of this architecture is seen in the photograph above. A violent uprising of Palestinians—present and past, individual and collective—against the rules of the game imposed upon them usually translates into upgrading the level of protection of the security forces and the further proliferation of devices that aim to subjugate the Palestinians and to restrict their movement ever more tightly.

The concern for the soldiers' safety—metonymically perceived as the concern for the Jewish citizens of the state—has been constructed over the course of many years as an objective above and beyond any discussion or debate. Any deployment of forces on the ground is subject to this yardstick. The stalled lives of hundreds of thousands of Palestinians are taken into consideration only within a secondary discourse that deals with reducing the negative effects of the Israeli presence out of concern for the soldiers' security. Thus, after the army callously spreads its forces inside the civil life space of the Palestinians, it initiates various "humanitarian" actions in order to minimize to a certain extent the damages it inflicts upon them and to show some consideration for their lives. But humanitarian concern is shown within the invariable assumption that when Jewish lives are to be protected, the lives of Palestinians are dispensable.

The Palestinian rejection of such assumptions is perceived as a direct threat to the soldiers. The soldiers, sensing the threat to their lives from the moment they step inside the Occupied Territories, wish to protect themselves and remove this threat. In order to protect the soldiers and to give them a sense of security, the army constantly improves the inner syntax of the blockage compounds. Instead of exposed watchtowers, it installs reinforced concrete spires with narrow observation slits at the top, enabling monitoring through remote control. Instead of bare ground on the way to the checkpoint, the army deploys barbed-wire spirals. Instead of dirt or paving, the army lines the road or path with tin sheets that make a noise when anything or anyone moves upon them. Instead of erecting fences scaled to human proportions, two- and three-story-high fences are erected when necessary. Instead of wire fences, the army installs modular concrete walls. Instead of permitting an uncontrolled stream of people to flow between any two points, the army slows down movement by narrowing passages.

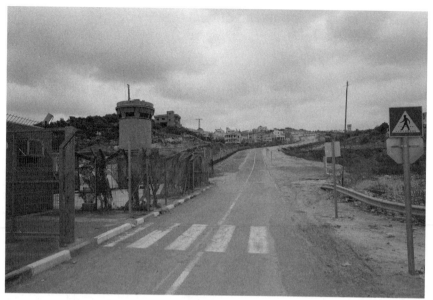

Azzun Atma. Photograph by Miki Kratsman. 2006

For Israelis, such tools as shown in the photographs embody the "no choice" assumption. Not only is the landscape in these photos familiar, it even gives most Israelis a sense of security: shreds of camouflage netting, various metals, shades of khaki, shooting slits, field glasses. These tools aim to quench the visceral fear that afflicts Israelis when they drive on roads paved on Palestinian soil, roads that whisper to them that someone might be lying in wait around the next curve, ready to strike. Instead they comfort themselves with the knowledge that someone is probably sitting in that army trailer, watching over the road; someone is leaning out the top of the tower with his gun drawn, ready to snipe at anyone who would wish them harm. Sometimes the tools on which they rely inconvenience them, as when they happen to get stuck in a line of waiting cars, for example, stalled as a result of a mobile checkpoint that the army is "forced" to place on a road that Palestinians were not even supposed to use. But they realize there is "no choice." They understand that the wall and the pillbox posts now form an integral part of the landscape they must inhabit, day in, day out. This plight seems minimal to them, compared with the benefit attributed to these tools. Their resultant suffering is, in any case, immeasurably less than that of the Palestinians.

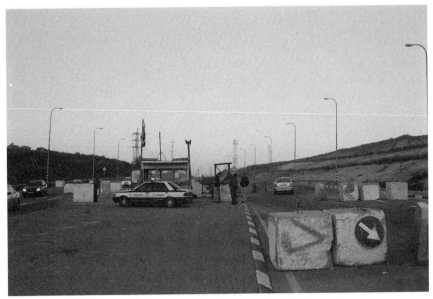

Maccabim checkpoint. Photograph by Miki Kratsman. 2001

Most of the time, Israelis who—daily—cross checkpoints of the type placed along the apartheid Route 443, do not even think about them. The concrete cubes placed in three half lines across the road require them to slow down and slalom for a short distance, after which they accelerate back to their normal driving speed. Palestinians are not supposed to use this route—although the prohibition is not anchored in any writ of law.[31] From the dominant Israeli point of view, those living in the villages should find themselves some source of livelihood that does not necessitate travel by car. It is meaningless to the Jews that before the road was widened (on lands confiscated from Palestinians) and traffic restricted to Jews alone, it used to form a central artery used by Palestinians to move between the southern Ramallah region and villages lying to its southwest. The routine conduct associated with this checkpoint, and others like it, appears to suggest that there is no cause for alarm—thanks to the hundreds of checkpoints and barriers dispersed throughout the entire West Bank. The minimal barriers deployed here merely prove the effectiveness of the blockage points deployed elsewhere, all part of a single continuum. Similarly, the police presence at such checkpoints is merely intended as a final precaution to prevent the entry of Palestinians who have dared to use

the road in spite of the expensive deterrents placed in their path. It is enough to claim that they have infringed one or another of the edicts of the traffic code to prevent their entry. The Israeli flag stuck on top of the guard shack embodies perhaps more than anything else the Israeli sovereign's preferred method of showing his mastery.

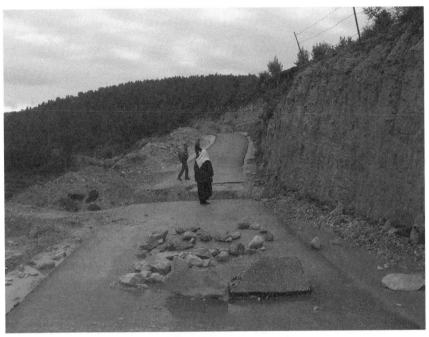

Unidentified location. Suha Zaid, B'Tselem, 2004

Digging a ditch across a road restricted for Palestinian use ensures that they will be prevented from accessing the roads serving Jews on a daily basis, as in the Maccabim or Atarot areas. A wide and relatively deep ditch is cut through the road, not only controlling access but ensuring that the lives of Palestinians will proceed very slowly, with many disruptions, and not much time will be left for matters beyond the basic concerns of livelihood and daily survival. The army does not make do just with digging a ditch, however. Like devoted gardeners tending their plants, the soldiers regularly frequent these barriers to make sure that the Palestinians have not "sabotaged" the obstacles they have just "constructed." Keeping Jewish traffic along the roads and checkpoints free of disruption achieves two of the regime's goals: firstly, separating the Jews from the Palestinians, and secondly, manifesting presence, "being there" in order to secure and maintain partition. These obstructed roads are not included in the tally of the 734 kilometers of apartheid roads the Palestinians are not permitted to use at all.

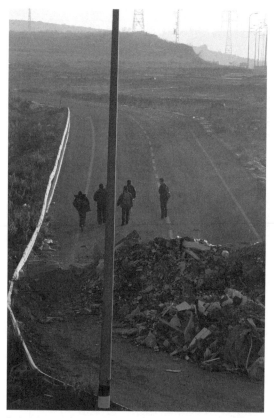

Beit Liqya. Photograph by Miki Kratsman. 2001

Some of these barriers have an ecological rationale. The army recycles the debris that it produces when it demolishes houses. This pile is one of 208 heaps of rubble placed at the entrance to villages or as barriers on roads and one of 486 blockage points of various types scattered at different points in the West Bank in addition to the 100 permanent checkpoints and numerous "mobile" checkpoints regarding which no precise data exist. The explicit purpose of such barriers is the prevention of vehicular traffic. But when debris is dispersed across the entire road, pedestrian movement is blocked, as well. Only people young enough to climb these artificial hills can cross them. Behind one another, in single file, they create a virtual path of sorts to the left of the barrier, each in turn deepening the footsteps of his predecessors. They, the non-citizens who do not suffer from the

"civil malfunction" that characterizes the fully fledged citizens of Israel, know that the discrepancy between their fate and the free movement enjoyed by those traveling the road to their right will assure that this regime will not reign forever.

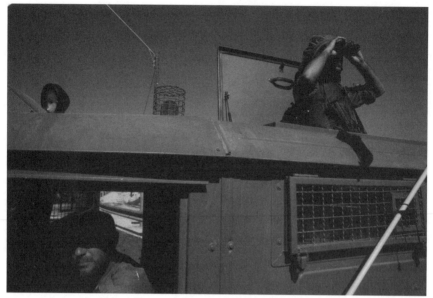

Flying checkpoint, Trans-Samaria Highway. Photograph by Miki Kratsman. 2001

The Trans-Samaria Highway (Highway 5) stretches from northern Tel Aviv in the west to the Ariel colony and Samaria (the northern West Bank) in the east. The eastern part of this road was paved in the 1990s on Palestinian lands, mostly for the use of Jews. The founding fantasy involved the dream of total control in a sterile zone, but the presence of Palestinians necessarily disrupts the relative calm in which the Jewish population rides these roads as their very own and requires the erection of "flying checkpoints"—fleeting and short-lived. A platoon commander who served for two years at the checkpoints says: "You get out there and identify areas where Palestinians travel the roads, and you put up an flying checkpoint." The flying checkpoint has evolved over the years. It is modular, mobile and can be used at any time—all that is needed are two iron rods with a red-and-white stripe in the middle, two spikes on a rope, spike strips on the asphalt, a STOP sign, and a SLOW sign.

The soldiers serving in the West Bank and Gaza are required to maintain such a kit in their vehicles when they go out on patrol. Its availability enables the soldiers to carry out the "full" or "partial blockage" of Palestinians' lives—with instant effect. Here is the commander's testimony once again: "Erecting a flying checkpoint is a mission, by all means . . . It

could be the result of an intelligence alert, or because we haven't been in a certain area for quite a while and need to be seen everywhere. And then we say 'Let's put up a checkpoint between this village and that hamlet.' It usually happens at unexpected times . . . A checkpoint has to be a surprise . . . The bad guys need to know we're always around. We expect the [Palestinians] to go to the village and tell the others: 'The army is everywhere.' " The army must seem present everywhere in order to keep the Palestinians from rebelling in practice. But the necessity simultaneously reflects the invincible fear of possible rebellion. The Palestinians have managed to etch onto the soldiers' consciousness the fact that they can always potentially surprise them, emerge into visibility, and engage in resistance. Resistance, before constituting an action that deploys violence, is first and foremost a political capacity, the power of citizens to act freely and in concert with others—even and especially where the state accords them the status of non-citizens. Only their extermination can deprive them of this power. But Israel stops short of genocide, exterminating only individuals in its targeted killings. The fear persists: Whoever has not been targeted and killed is inevitably the source of potential future violence.

The soldiers in the photograph, protected behind their bulletproof vests, armored vehicles, helmets, and goggles, try to retain the element of surprise on their side and on the side of their buddies who are actually deploying the kit and erecting the flying checkpoint. Since the Jews and Palestinians do not agree on the rules of the game obtaining here, the battle of this flying checkpoint will be decided on a sporadic basis. Either there will be conformity or there will be violence.

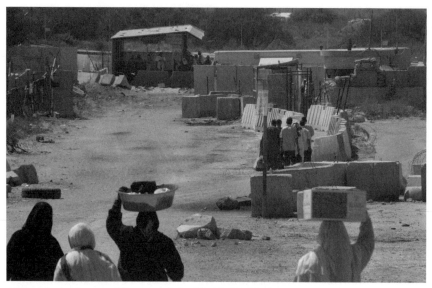

Al-Tufah checkpoint, Photograph by Nir Kafri. 2003

The components of this checkpoint—concrete cubes, sandbags, plastic barriers, tin sheets, and barbed-wire spirals—are no different from those used at other checkpoints. But its syntax, a random patchwork that has extended haphazardly over time, is gradually disappearing. It is being replaced by a lean, tight, sterile syntax of modern installation designed to provide a prefabricated answer to problems that previously found local, improvised solutions. The new installations remove some of the visual "disturbances" evident in the present photograph: The Palestinians are required to walk amid potholes, and the path sown with sharp rock shards is a dangerous tripping ground. The route is not clearly marked nor bounded by fences that might protect the soldiers against a potential Palestinian outburst, and the relations between the heart of the checkpoint and its periphery are no longer clearly differentiated. In spite of its disorder and the improvisation that is evident in attempts to connect its various components, this patchwork checkpoint still preserves one of the army's guiding principles in administering the movement of Palestinians: narrowing movement into a single file of individuals kept as far from one another as possible. In current military lingo, this is called "laning." It not only assures control over the actions of those waiting in line, but prevents the area of the checkpoint from becoming an agora, a public space where the many assemble to constitute a power that—together—determines the conditions of its own existence.

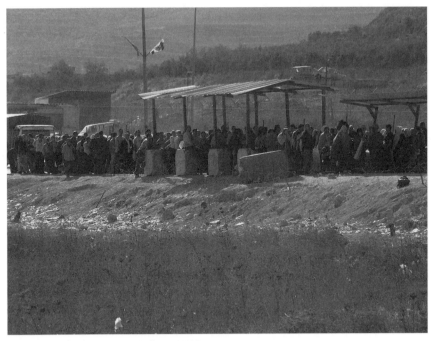

Huwwara checkpoint. B'Tselem, 2003

The longer it takes to check the individuals at the head of the waiting line, the longer it grows, stretching far beyond the end of the shed that the army provides. But as the line at this checkpoint grows longer, the dangers it produces increase. The army thus relays pressure to other places and produces a general slowing down of the system. Every now and then, the soldiers use a concussion grenade to straighten up the line—it is, after all, a "no choice" situation, they claim. For the most part, when the width and length of the line is under control, one soldier suffices to discipline it, forcing back into single file anyone who dares to step out of place.

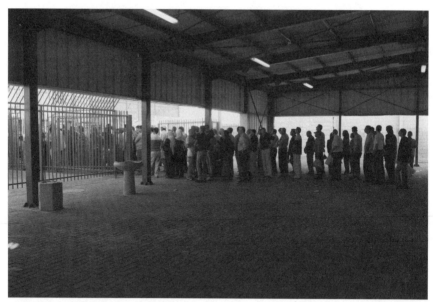

Qalandiya checkpoint. Photograph by Yotam Ronen. Activestills.org, 2007

There can be no doubt these new installations are more photogenic—the waiting hall is spacious, the ceiling high, the shed has ample room for everyone, the ground is paved, the colors are not depressing, there are taps for the thirsty and an ashtray for the smokers. Everything indicates that the quality of life of those having to pass the checkpoints has been taken into consideration.

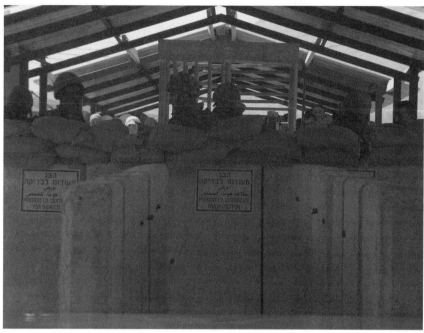

Beit Furik checkpoint. B'Tselem, 2004.

Alongside the new and relatively spacious installations, which only a very small percentage of the Palestinian population enjoy, a new species of installation has been developed, containing nearly everything necessary for operation, but without wasting a single centimeter of air or ground space. The width of the turnstile bars has been reduced from 80 to 60 centimeters, and the ceiling has been planned to be precisely high enough so that no one will be injured by it, but also to ensure that no one might be fooled into thinking that the sky is the limit. Even slits for daylight have been preplanned so that the crowding will not become unbearable.

Huwwara checkpoint. Dorit Hershkowitz, 2006

The necessary minimalism does not omit gender considerations: A narrow cubicle is ready and waiting for the invasive body search of women, requiring privacy.

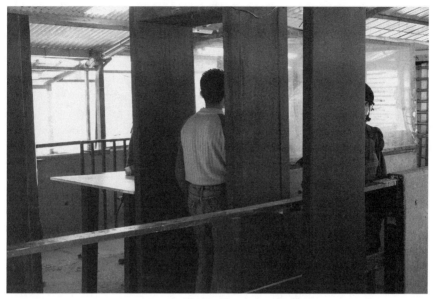

Huwwara checkpoint. Photograph by Miki Kratsman. 2007

The ongoing enforcement of the policy of slowing down traffic in the Occupied Territories is supposed to reduce pressure at the checkpoints. Different tools "lane" the Palestinians into long waiting lines in order for them to reach the new metal detectors in an orderly, restrained manner. Sometimes it works, as on the day this photograph was taken.

Watchtower at the entrance to Hebron. Photograph by Anne Paq. Activestills.org, January 2006

In order for this sophisticated pillbox post to be effective and to enable remote control, numerous ground troops are needed to go on doing the "dirty work." The only way to make this work cleaner is to slow down the Palestinians altogether and prevent their access to public space. The army may distribute food directly to their homes in order to ensure calm and to reassure the soldiers who, fearful, hide behind protected shooting slits.

The Erez Crossing into Israel. Photograph by Nir Kafri. 2007

The door opens, and a lone Palestinian enters the cell. Another door closes behind him. He receives a laconic instruction to raise his hands, the check is carried out, the front door opens, and the Palestinian can now leave this place to his successor. The actual body-check is not time consuming, but to get to the head of the line might consume about half a workday. Should one file a complaint for lost working hours? For invasion of privacy? Discrimination? Complain to whom? In any event, the installation is scarcely in use today. No one enters or leaves Gaza. Except, that is, for the forces of destruction and the rescue services that follow in their wake.

Grains of Hope[32]

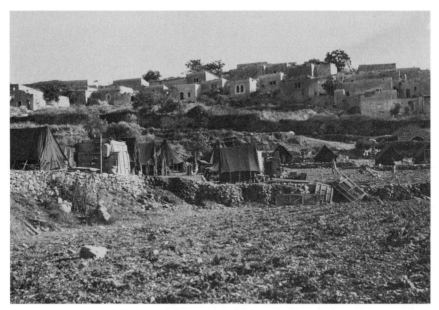

Suhmata. Photograph by Zoltan Kluger. Government Press Office, June 1, 1949

Some of the houses of the village of Suhmata are visible at the crest of the hill. Its approximately 1,200 residents were expelled in 1948, leaving behind 200 houses, a mosque, a church, modern olive presses, schools, two pools, a flour mill and a cemetery. Jewish immigrants from North Africa were settled in the village shortly after the expulsion of the Palestinians, and were housed at the foot of the hill in a tent village erected specially for them. Within a year, all the houses in the village had been destroyed. In their place, the state of Israel built new houses for the immigrants. The name of the village was erased and the new settlements bore new names: Tzuriel and Hosen. Today, the majority of the Palestinian villagers and their descendants live in refugee camps outside of the borders of Israel. Some of them still retain the expertise they invested in the construction of the distinctive houses of the village that were destroyed: stone houses with granite walls and wooden roofs covered with a layer of plaster that had to be replaced each year. The village, which might have been deemed a site worthy of conservation in other contexts, can no longer even be identified let alone restored.[33] Not, that is, in accordance with the conservation practices popular in Israel that apply conservation techniques solely to existing buildings. But it is still not too late to adopt the

conservation practices common in Japan where conservation does not necessarily take a particular building as its object, so much as the building techniques used to construct it. In order to keep conservation practices alive, the Japanese periodically destroy existing buildings so as to enable artisans to refresh their skills and thus to preserve building techniques passed down from generation to generation. Some of the villagers of Suhmata are still alive, as we have noted, and some live as internal displaced persons in Israel. It is still not too late to save their expertise and to learn from their hands and their mouths the skills necessary to construct a village on the hills surrounding Suhmata that would give expression to these distinctive building techniques. This settlement would serve them, their descendants, and others, no longer able to live out their lives in contemporary Israel without making reparation for the crimes their parents committed.

CHAPTER FOUR

CIVIL USES OF PHOTOGRAPHY[1]

The properties of photography identified in Chapter 1 of this volume will now enable me to isolate four civil uses to which it might be put. In the discussion that follows, I will analyze a number of photographs to show how the act of viewing a photograph prolongs the event of photography and enables renewed discussion of that which might be figured in the frame—so that something buried in the photograph or by means of the photograph might emerge.

The Photograph as a Visual Document in which Excess and Lack Are Inscribed

It is usually the photographer who determines the way the photographed event will be cut into the photographic frame. As is well known, state mechanisms are frequently able to restrict the photographer's field of vision, significantly influencing what enters the frame—a fact conspicuous in zones of disaster or catastrophe. Cropping the frame is a decisive factor in determining what is visible in the photograph, but contrary to the status we usually accord it, framing itself does not have the last word or occupy a sovereign position with respect to the visible. Whatever judgments it imposes can always be contested. That which is inscribed in a photograph does not merely result from setting a clear boundary between the interior and exterior of the frame. The "interior" itself is not constituted exclusively by the photographer, and that which is inscribed in it always exceeds the intentions of the photographer or any other agent seeking to impose its sovereignty on the field of vision regarding what is actually included. The photograph, then, is never solely the realization of the preconceived plan or a vision of a single author, but is rather the outcome of an encounter. This encounter involves four protagonists at least—a camera, whoever stands behind the lens, whoever faces the lens, and whoever might become a spectator viewing the product of the encounter.

Mainstream discussions of photography, as I claimed in Chapter 1, tend to attribute that which is visible in the photograph to only one of the participants involved in the production of the image. This is the consequence of discursive conventions—in the discourse of art and, eventually, that of photography as well. Authorship of the photograph is attributed to whoever framed the image. When this axiom of rule is suspended, however, what is inscribed in the frame no longer appears as derivative of the photographer's point of view, nor as its projection or implementation. Rather it can be seen to result from the encounter between the four protagonists, each of whom might take on a different form. Even if one of the protagonists—usually the photographer—enjoys a privileged position of power and is responsible for setting the boundaries of the photograph, the photographer alone does not determine what will be inscribed in the frame or reconstructed from it with respect to the photographed event. The photographic image produced in an encounter, then, invariably contains *more* and *less* than that which anybody intends to inscribe within it; more and less than that which one of the parties to the encounter at the moment of photography is capable of framing. What is inscribed in the photograph at the moment of the encounter depends on the agency of all parties to it and on their ability to intervene in the frame or to restrict it. The photograph maintains its position of excess and lack regarding each of the protagonists, but excess and lack are not evenly distributed among the participants in the photographic encounter and cannot be subordinated to the point of view of any single participant.

Let us consider an example of excess and lack with reference to a concrete instance. The photograph on the following page was filed in the archive under the laconic caption "Afula. Arab civilians harvesting a field, Haganah members standing guard over them." Based on the evidence of the landscape depicted in the photograph as well as the presence of the many Palestinians here, it is more likely that the photograph was taken in one of the Arab villages in the vicinity, Zir'in or al-Lajjun, rather than in the Hebrew town of Afula, established on the site of the village of al-Fula after the eviction of its inhabitants in 1925. This is not a classical snapshot but rather a deliberate instance of framing, a studied allusion to art history that clearly evokes Jean-François Millet's *The Gleaners* (1857). One cannot with any certainty determine whether the photographer who took it was summoned to the spot or came at his own initiative, whether as a wanted guest or not. It is possible to state, however, that the photograph itself is the result of certain negotiations between the photographer and the soldiers present, empowered to regulate the distance he was supposed to keep in order not to get too close to the object of photography, and in order not to infringe the boundaries of the

field of vision determined for him in advance. The framing consequent on his emplacement is misleading: it makes the spectator acquiesce, even if only momentarily, that what is visible accords with the verdict of the official caption—"Arab civilians harvesting a field." Were the photographer to have approached any closer, it would have been possible to record not merely the silhouettes of the men at work but also the object of their intervention—the spot toward which they are all leaning. However, in spite of the relative distance from which the photograph was taken, the details inscribed in it suffice to refute the pastoral description of a grain harvest attributed to it. The armed soldiers overseeing the work of the Arabs protect their mouths and noses from some powerful stench using strips of white cloth. It is not heaps of harvested crops that are visible at the perimeter of the circle they form: the field they are supposedly harvesting is not cultivated but barren. The Arab figures gather around a pit. At least two of them hold hoes: they are digging a pit. The pit they dig is not shallow—some stand in it, knee-deep. *Alongside this excess* of details that contradict the official caption of the archive, the photograph suffers from a substantial *lack* of information concerning the photographed event. When the official caption is juxtaposed against the details I have described, one realizes clearly that this lack of information is no coincidence but was meant to prevent that which is inscribed in the photograph—the burial of something inside a pit—from emerging into plain view, and to help bury this sight behind a bucolic caption.

Afula. Photograph by Fred Chesnik. IDF and Defense Archive, 1948

The photograph under discussion was exhibited as part of the exhibition, "Constituent Violence." During the course of my work on the exhibition, I had hoped that I, or one of the historians I consulted, would be able to link the photograph to a specific event and location. The first options for investigation were massacres that had taken place in the area. Although I gradually accumulated fact after fact concerning the photograph, it was not possible to link it with any certainty to a specific event, time or place. I almost gave up intentions of exhibiting it, fearing to render a specific disaster into an abstract and generalized image—a mere illustration—and thus to reinforce the prevalent tendency of de-historicizing visual evidence of the Palestinian catastrophe. However, through the numerous verbal testimonies of Palestinian men and women referring to other places but matching that which is seen in the photograph in every detail, testimonies describing how they had been assembled by soldiers at gunpoint and ordered to bury the dead, with the stench of bodies heavy in the air, I was able to restore the missing dimension of specificity to the photograph. Not the specificity of an event that took place at a specific time and place, but the specificity of a procedure practiced repeatedly during this period. The photograph revealed itself as a rare concrete instance of this procedure. The extent to which the various testimonies matched what I had managed to reconstruct on the basis of the specific pattern of excess and lack configured in this photograph made it clear to me that even if I could not determine the singular event, the photograph nevertheless testifies to precise circumstances of a procedure typical of the 1940s where Palestinians were called upon to bury Palestinians. The difficulty of determining the time and place of this specific occurrence derives from the very nature of this procedure.

The Photograph Is Not a Representation

Much has been written about the indexical nature of the photograph. Roland Barthes gave voice to its most popular formulation: *"this was there."* The *"this"* Barthes refers to is supposedly abstract enough to include whatever might have "been there" in his formulation, and to reference its inscription in the frame regardless of its specific nature, character, type or gender. The interpretation of this phrase, however, has always been inspired by the claim *"this is X"* latent within it. *"This is X"* already constitutes a form of naming of the *"this"* that *"was there."* When *"this is X"* is linked to *"this was there,"* a representation is distilled from the photographed event and is grounded in the photograph itself. Thus, in many archives, photographs are filed under categories including "refugees," "torture," or

"expulsion" in a way that turns the photograph into a representation of phenomena or situations such as "refugees," "torture," or "expulsion." The representation annuls the excess and lack that were inscribed in the photograph, subordinating it to one, supposedly factual, point of view, thus enabling the photographs to determine that *"this is a table"* or *"this is a refugee."* The identification between *"this was there"* and *"this is X"* can be thought of as a kind of paper clip, a sort of temporary office accessory used at the desk to attach things, but also to allow them to be detached time and again, at any given moment. When the paper clip, so to speak, solidifies into a representation, anything temporary or contingent is eliminated so the photograph is reified under one stable representation that has become attached to it, and it continues to make its way in the world as such. When photographs of refugees from one village are used for the cover of a book dealing with expulsion from another village, for instance, we have a good example of this process: the *"this was there"* is submerged under a different claim: *"These are refugees."*[2] In other cases, the *"this was there"* is not attached to the claim *"this is X"* but serves to justify the creation of X. Thus, a photograph taken during an expulsion may be included in a volume about the "building of the Land of Israel" under the caption "The terrible price of war."[3] The abstract and general form of the caption not only takes this toll of warfare for granted, it does not even specify which war—the one waged prior to the founding of the state, or a later war?

The link between *"this was there"* and *"this is X"* renders the photograph a re-presentation of a person, event or deed that has already taken place—so we are able to clearly designate the categories of "refugee," for instance, or "infiltrator," which the photograph presents and represents, as it were. This verbal representation forces the photograph, produced in a situation of encounter, to conform to a highly reduced template of polarized relations such as inside/outside, photographer/photographed person, spectator/subject of observation. Critical discourse on photography is not oblivious to this polarization, but adopts the identification of the representation with the essence of photography without problematizing it. Once we suspend this identification, however, it becomes possible to discern other relations that rival this one, and which it seeks to obliterate. That is to say, viewing photography as a non-deterministic encounter between human beings not circumscribed by the photograph allows us to reinstitute photography as an open encounter in which others may participate. Deploying the photograph for purposes of representation has become one of the most prevalent uses of photography in the political regime to which we are subject, itself grounded on polar relations of inside/outside, citizen/non-citizen, governed/not-governed.[4]

Any use to which a photograph is put, representation included, not only constructs and regulates "the seen," but also the relations obtaining amongst those who share a common world, and from whose encounter images are produced, and thus, too, their access to photographs. The struggle between the different modes of using a photograph is not a struggle over the visible, over the "truth" as if the latter were ever simply given in the photograph, but a struggle over the mode of being with others—a struggle motivated by concern for the truth reformulated as concern for the possibilities open to other participants to partake in the game of truth.

Al-Ramla. Photograph by Beno Rothenberg. Israel State Archive, 1948

The ontology of photography that I presented in Chapter 1 allows us to transcend the question "What is the 'seen' of the photograph" in favor of the question concerning the encounter that produced an image and around which it revolves. In support of this claim, let us take the photograph of al-Ramla (above), dating from 1948. The archive classifies the photograph under the caption "Refugees escorted by Haganah soldiers." The claim contained in the caption—"these are refugees"—refers to the group of men who are being marched down the middle of the road. The identification created by the photographer (or those who subsequently dealt with the photograph) between those photographed and the abstract figure of the refugee as it is expressed in the caption, does not attest to what is seen in the photograph but rather to the manner in which the photographed

persons were perceived by the photographer, or those who succeeded him, irrespective of the specificity of the photographed event.

When the Palestinian men visible here were led along the streets of the occupied city, it is true to say that the category "refugee," which designates a kind of superfluity created by the nation-state when it distinguishes between various kinds of governed (or even non-governed) persons, was available for the classification, processing and photographing of human beings.[5] Its availability, however, or the fact that someone already existed who intended to impose the category upon the group of men in the center of the picture, does not suffice to render this a reality. The photograph does not put abstract concepts such as "refugee," "stateless person," "citizen" or "non-citizen" on display. Rather these are conceptualized within the parameters of political thought or through an act of rule that seeks to stabilize the legal and political status of the governed—including the stabilization of the very concepts that enable such rule to be achieved and differences between the governed to become intelligible. The visual characteristics of the figures in the frame may be classified and identified: people bearing bundles or holding IDs, and so on. But this does not suffice to stabilize these characteristics as essential components of their identity, nor does this reduce the photographed persons to the compilation of figures having certain attributes or exemplifying certain categories. In order for this identification to take place, it is necessary to erase the singular event of photography and to strip the photograph of the heterogeneity of information inscribed within so as to isolate within it a figure who might serve as the stable signified of a political category such as "refugee."

Instead, I claim, attending to the event of photography inscribed in the photograph disrupts the attribution of a stable political category to the photographed person, which makes his being a "refugee," for instance, self-evident. Although the photograph is itself frequently conceptualized in terms of death and loss, it does not seal the event of photography. It is, of course, always possible that a spectator might well treat the photograph as sealed and take for granted that human beings can be rendered into refugees—identifying this propensity as a feature of a certain population. This perspective, usually privileged by institutions of power or those controlling resources, constitutes an act of law-preserving violence, since it acknowledges the authority of the sovereign power to separate people into categories, denying certain people rights that are readily given to others by means of the constituent violence of the regime under which they live. The ontological properties of photography enable one to rebel against the paradigm of sovereign spectatorship, and to undermine that which constituent violence renders self-evident. The civil use of photography invites the

spectator to undermine the self-evident status of the act of dispossession. The information inscribed within the photograph does not stabilize through its own devices into the signified of categories such as "refugees" that are attached to certain people, and does not concede that "being-a-refugee" is one of their essential characteristics.

Back to the photograph from al-Ramla (see page 224). The men being "led" through the streets by Jewish soldiers, like the Palestinian woman walking down the sidewalk on the right, *are not* refugees. A violent intervention, whose initial phase we are viewing, eventually culminated in rendering most of them into refugees. The state of being a refugee already hovers over them as an option, in potential. At the moment the photograph was captured, however, as in the hours and months succeeding it, anyone who came into contact with these people one way or another either contributed toward the realization of this option, or to its repudiation. As spectators forced to acknowledge that these men and women were indeed rendered refugees, it is important to remember that state is not a trait of the people it afflicts but is, rather, a status imposed upon them by those who expelled them from their homes. In the photograph itself, we see a group of young Palestinian men surrounded by armed soldiers who, pointing their weapons, escort them to a place that is not depicted. The homogeneity of the group walking down the middle of the road, comprising young, healthy men exclusively, enables us to deduce that some form of processing has been implemented. These young men have been taken out of their homes and separated from the general population. Additional photographs taken on the same day indicate that the men in question were eventually held in temporary enclosures improvised at the roadside, where they spent a relatively short time, before being transferred to POW camps, or deported and rendered refugees. On the right of the frame, a Palestinian woman can be seen walking along the sidewalk, without the escort of soldiers with weapons drawn. She will, herself, inevitably be expelled a little while hence, and will also become a refugee. But for the moment, her presence serves as additional evidence that the rendering of Palestinians into refugees did not come about on its own accord. Nor was it the consequence of wartime. Rather it represents the outcome of a policy adopted by the regime whose implementation endured over time and required that fairly extensive resources be deployed. The first phase of the expulsion focused on men. Once the men had been processed, it was the turn of the women. If anything, the photograph depicts, first and foremost, a category of men who have been separated from their women.

The Photographed Event / The Event of Photography

The photograph, as we have already observed, is the usual point of departure for the discussion of photography. The indexical gesture pointing that "This is X" or "This is Y" usually guides the encounter with the photograph, like a paper clip attaching itself to that which was there. This gesture, leading the spectator directly to the photographed event, regards the camera as a means to achieve a goal—capturing a certain event in a frame—and privileges the camera over the event of photography. In cases where the camera gets in the way of the agent using it—the photographer or his patron—not permitting her to frame the photographed content as she desired, it becomes easier to achieve the separation of the event of photography from the photograph and to perceive the presence of the camera as a means to an end or as an obstruction. Both the camera and the event it generates are usually filtered out by the skilled gaze that reduces the visible to the "thing itself." However, even if the event of photography is occluded, ignored or treated with indifference, it is still impossible to wholly erase the traces that the interaction between the partners to the act of photography leave in the photographed frame. These traces, usually tangential to the goal of the act of the photographer, are regulated by means of the theoretical model of the frame that dulls their presence, foregrounding the photographed event, instead, as having occurred in the past and as stable in the meaning it has accrued. Constructing the event of photography as prior to, and external to, the spectator is not just the effect of the instrumentation that Deüelle Lüski has termed the single-focus camera. Rather any discourse that makes the photograph the point of departure and vanishing point of the discussion of photography makes a decisive contribution to bringing about a non-civil orientation. This focus on the photograph also lies in ambush for the critical theorist of photography as is clear, for instance, from the title of Susan Sontag's *Regarding the Pain of Others*, which positions the gaze as external to the event of photography.

In most of the photographs I have surveyed recording the expulsion of Palestinians from their lands, homes, and status between 1947 and 1948, the photographer keeps his distance from the objects of photography. In the photographer Miki Kratsman's opinion, this distance expresses fear on the part of the Jewish photographer (see the following page).[6] I believe that this explanation is insufficient in view of the overall situations documented by Jewish photographers. I propose that we see the distance maintained by Jewish photographers as a strategy to adopt a point of view that enables them to render the *photographed event* external to their own

inclusion in the larger event of photography in which they participate. In the accompanying photograph, from Qalansuwa, traces might be discerned of the event the camera precipitated, but the photographer apparently waited for the moment that the event of photography became marginal to

Qalansuwa. Photograph by David Eldan. Government Press Office. May 10, 1949

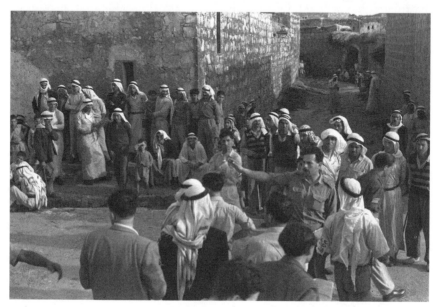

Qalansuwa. Photograph by David Eldan. Government Press Office. May 10, 1949

the "thing itself," the scene he wished to record—an encounter between the local residents and the military administration at the time when military rule was imposed upon them. In the second photograph, we see how the arm on the bottom left acts to distance the photographer from the site photographed, as Kratsman observed. For my part, I read the very same gesture differently, to claim that the photographer is seeking precisely to overcome his distancing, attempting to move beyond the distancing arm and to render it nearly invisible in the photograph.

None of the photographs I surveyed showed the repertoire of gestures that foreground the event of photography par excellence, such as the tactic familiar from the 1980s onward where the photographed person shows his or her catastrophe to the camera. During the 1940s, the figure of the photographer was not usually perceived as an addressee for expressions of distress or resentment. It is possible to assume, however, that at least some of the hundreds of thousands of Palestinians who had been dispossessed of their lives did not yet acquiesce in their obliteration as political subjects or their being made into "refugees," and that they attempted to show the camera what had been done to them, seeking recognition for the injustice or help in stopping the disaster. It was only after I surveyed hundreds of photographs of the Palestinian catastrophe, or *Nakba*, that the absence of this gesture suddenly became salient. In most cases, the photographer seems to have waited for the conclusion of the event of photography so as to avoid the encounter as an active participant in the event of photography with any of those whom disaster had struck. None of the hundreds of pictures taken by Jewish photographers of the period depicts the Palestinians who appear in the photograph explicitly as plaintiffs. The presence of Palestinians as plaintiffs would disrupt the rationale offered for their absence; that is to say, that the events depicted were not conflictual or that they had, in any event, been consummated without their victims rejecting the consequences of the constituent violence involved.

My assumption concerning deliberate abstinence from participation in the event of photography is based on three photographs. The first was taken on the square leading to the sacred compound of al-Haram al-Sharif (page 230). Although the photographed person does not face the camera squarely in the frame, it is clear from the absence of other people here that he is showing the camera the damage done to the compound. The photographer who took the pictures did not withdraw at the sight of the photographed person's gesture, nor did he wait for the moment after the cessation of events in order to photograph the "thing itself." Rather he photographed the actual performative gesture. Similarly, the additional photographs repeat the gesture of pointing deployed by the photographed

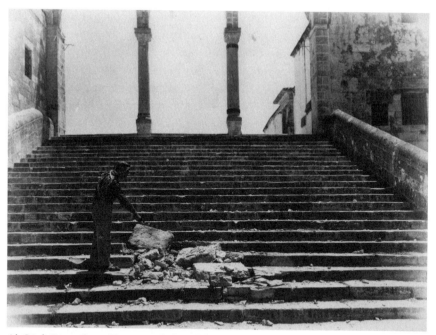

Al-Quds/Jerusalem. Photograph by Ali Zaarour, with the kind permission of Zaki Zaarour. 1948

persons. In both these images photographed at the same place, it is not the raised hand that points to the damage incurred but the circle of people gathered around a corpse covered with a blanket on the ground. In one of the photographs, the body is covered. In the other, it has been unveiled so that it becomes possible to see the signs of the violence inflicted upon it. All three photographs were taken by a Palestinian photographer, Ali Zaarour. It is impossible to tell whether similar photographs taken by Jewish photographers actually exist, but access to them has been denied us. It is possible that photographic archives are also subject to the strategies of occlusion and misclassification that various historians have documented with respect to written sources. The fact that the convention of complaint, in circulation since the 1980s, is absent from the photographs does not, however, mean that they do not voice complaint. Nor should we assume that the damaged party is the only agent who is authorized to complain, or that the photographer is the sole agent who might facilitate its expression.

The civil spectator can retrieve the grounds for complaint from a photograph in which the photographed person does not embody the figure of the plaintiff and thus become, herself, a plaintiff. Such civil viewing constitutes both resistance to the constituent violence that turned the photographed persons into refugees, and to the potential of law-preserving violence preserved

in the way the photograph is presented. Every time a spectator faces a photograph of constituent violence and sees that which is photographed as a fait accompli, an event that is finished, an event to which the spectator is an outsider—the spectator exercises law-preserving violence. In other words, even if the photographer *abstained* from capturing the plaintiff or the archive *prevented* the plaintiff from emerging from the photographs, certain options remain open. Instead of taking the usual critical position and indicting them, the spectator can participate in the event of photography employing the civil faculty that contests the distancing of the plaintiff at the moment of photography, and the spectator's own distancing at the moment of viewing.[7]

Instead of speaking of the omnipresence of photographs, it is time to think *about* and *through* the omnipresence of the event of photography, independent of the accessibility or availability of photographs. Civil viewing cannot acquiesce in the partial field of vision created by those in whose power it is to make photographs inaccessible—whether it is an interrogator employed in the service of the state security, the state archives, Claude Lanzmann who declared that had he found photographs from the gas chambers, he would have destroyed them, or even Barack Obama who decided to prevent the display of photographs from interrogation and torture chambers. In the age of the omnipresence of photography, the answer to violent sovereign acts of regulating the field of vision cannot be restricted to the demand to publicize confidential photographs—thereby sanctifying them. The compilation of verbal testimonies of those interrogated under the threat of photography and while they are being photographed is decisive in constituting the field of vision anew and disrupting the authority of anyone who claims a sovereign position in its regard. Efforts made by various agents, usually state establishments, to control the content and accessibility of photographs, seek to obtain sovereignty over the event of photography and over the interpretive framework of its consequences. Yet the very conditions of photography as an encounter undermine the feasibility of such sovereignty.

The Need to Discuss Photographs Not Taken

After having said all this, the time has come to discuss photographs that were never taken. Not photographs that have been lost, but photographs never captured. I will begin with a citation:

On August 25, two Military Police investigators, Second Lieutenants Zelig Kingsbuch and Haim Kazis, arrived at the outpost [of Nirim in the western Negev], along with Dr. Eliahu Fakbaum, a gynecologist. They hoped that the physician would be able to examine the girl's body, but

when they opened the grave they found that the body was already in a state of decomposition, the skull coming apart and fluid leaking from the brain. The physician was unable to determine the cause of death or whether the girl had been raped.[8]

Had a press photographer been on the scene, we would surely have been able to see a man—probably the gynecologist or his assistant—positioned beneath the diagonal line formed by the angle of the trenches, leaning toward a small, elongated trench, about the length of a twelve-year-old girl's body, filling the center of the frame. The man would be holding a black camera to his eyes, blocking his face from view. In the background, left, we would be able to see the lower bodies of two soldiers, standing by. We would also be able to see what they did: the shocking sight of a smashed skull and the remains of a brain oozing out of it.

But possession of such an imaginary photograph taken by a press photographer is insufficient to reconstruct what actually took place or what we might see in the photograph. We would need not only other visual and textual material, we would also have to practice *civil imagination* in order to reconstruct what went on at the moment the photograph was taken—to understand the relation between the *event of photography* and the *photographed event*, between the exposure of the girl's dead body and her being made into a corpse. Additional material would be needed to establish what it is that we might see, and to make it speak. We would

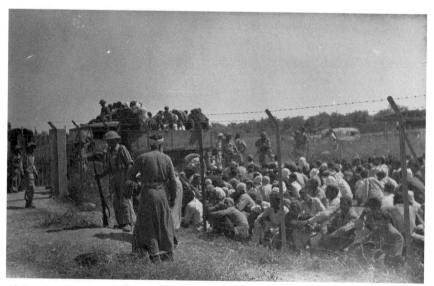

Al-Ramla. Photograph by Beno Rothenberg. Israel State Archive, 1948

need to insist on seeing through the accumulated pathological signs, through the distortion of the child's body and its becoming bone and mucous tissue mixed with sand. We would need to see a child precious to her mother and father, a child who had cried to high heaven when she was raped dozens of times over the course of a whole week, a child who, in the moments in between, had tried against all odds to complain to the officer who seemed to her in charge, begging him in vain to be left alone. But I possess neither the photograph taken by the press photographer nor that of the forensic investigation. Nor do I have any proof that the event was even photographed, that a photographer or camera were present.

Why then discuss photography *in the absence of the photograph*?

As I finished structuring the exhibition *Constituent Violence 1947–1950* and writing the first draft of the relatively long captions for each photograph, I found myself with over two hundred photographs—none of which documents the rape of Palestinian women in spite of dozens of references to rape, all laconic, in books and articles dealing with the period[9]. I found no traces of rape in the photographic corpus. In light of my argument in *The Civil Contract of Photography* regarding the continuous absence of rape from a visual repertoire of horrors, I looked for a way to address rape within the context of *Constituent Violence,* at least on a textual level.[10] Going through all the photographs again and again, the only place where I felt I could connect the meager available information on rape having occurred at a certain site with a specific picture was in the photograph from al-Ramla (see page 232).[11] My initial interest in this photograph (and in some others taken at al-Ramla and elsewhere) stemmed from the clear traces visible in it of procedures used to select certain individuals from within the general population and separate them into groups. One could thus refute the longstanding myths regarding the supposedly unsystematic expulsion and dispossession of the Palestinian population, which is presented as having occurred without there being a policy for its implementation. But while mention of rape in the context of this picture seemed apt, I had very little to say about it other than what I gleaned from the meager material available concerning cases of rape in al-Ramla. According to the testimony, cases of rape occurred after Palestinian men had been segregated from the women and assembled in detention facilities at the roadside. This seemed sufficient cause to return to the photograph and to what was known about rape in this context.

Repeated encounters with the photographs I had collected for the exhibition and with the references to rape that I had found soon enough inspired me to speculate about photographs that had not been taken, or ones which had been made inaccessible. The photographs I envisioned in

my mental reconstruction resembled none of the familiar rape scenes in fiction films—no dark alleys or back rooms where the crime itself could be voyeuristically observed. Nothing that I saw in photographs of the period, or read in texts, could lead there. After all, civil imagination is not cinematic or literary imagination. Civil imagination is a tool for reading the possible within the concrete. Every additional documented detail allowed me to imagine more. It remained for me now to extend my usual procedure for reading photographs through the faculty of civil imagination to photographs that had not been taken. Photographs, including ones not taken or unavailable for scrutiny, gather all the participants in the event of photography on a single plane without allowing the perspective of any single participant to be privileged.

Let me now return to the photograph *not taken* at the Nirim outpost with which we began this discussion. The soldiers still stand there around the pit that remains partly open. As soon as the photographer packed his equipment, they closed the pit again. The same soldiers exposed the pit before the photographer even arrived to take his pictures. But what the hell are they doing there? They are, after all, the very same agents who raped, abused and committed murder. Now, when the affair is finally under investigation, it is they who determine the field of vision open to the physician-turned-coroner; they who expose and conceal the central piece of evidence shown to him, and which—because of the limitations of his profession as a specialist in gynecology rather than forensic medicine—he is incapable of investigating.

If a photograph was indeed taken at the site of the crime, it is unavailable. If it was taken on behalf of the powers that be, it is possible that it is lying in storage somewhere—censored. If it was taken by whoever really wished to investigate this or another case—some representative of an external authority—then it was surely confiscated. With the constitution of the state, any photograph not sanctioned by the authorities has been unwelcome. The general syntax of the injunction in force during the period reads as follows: "Speaking of the film confiscated from the camera of an American doctor who visited Majdal Krum, I explained to observers our position regarding the prohibition of carrying and using cameras on the ground, especially at the front."[12]

In the revised version of *The Birth of the Palestinian Refugee Problem*, Benny Morris argued that several dozen acts of rape were perpetrated during the period between 1947 and 1948, but also estimated that this number is but the tip of the iceberg.[13] Ilan Pappé, for his part, in *The Ethnic Cleansing of Palestine*, devoted a three-page sub-chapter to the issue of rape, also describing several dozen cases and emphasizing the necessity of

conducting focused research into the issue. This data is based mainly on details mentioned in *texts* accessible for research. Relying *strictly on documents*, certainly on *documents released by the regime*, makes it all the more unlikely that its point of view will be transcended. The point of view of the regime emerges clearly from the various mentions of rape and may be summed up according to the official doctrine that treats rape as isolated cases rather than an extensive phenomenon, stressing its marginality within the conduct of solders committed to an ethos of "the purity of arms," and declaring the intention to punish perpetrators where rape indeed occurred.[14]

Reports of rape in internal memoranda, as well as their condemnation by the authorities, were often voiced in the same breath as the condemnation of looting: "The bitter issue of robbery and rape in the occupied cities has come up: soldiers of all battalions have committed robbery and theft."[15] Instead of criticizing and refuting this association, I wish to regard it with all seriousness and to apply the insight gained from one phenomenon to the other. I have yet to meet photographed documentation of the type of looting which, according to the regime, merited condemnation. Such looting is lawless and shocking, easily dismissed as violent, vulgar, spontaneous, inconsiderate and inappropriate. Its limit is that of *constituent violence*, of looting that has become the law and wishes to distinguish itself from unlawful looting in spite of their similarity. Dozens of photographs in the exhibition *Constituent Violence* helped me reconstruct the ways through which the new regime sought to draw the line between the condemned practice of looting and the act of looting that was not even recognized as such. In an analogous fashion, I sought to reconstruct the type of rape proposed for condemnation in order to draw the boundary line of its form of constituent violence that occludes the acts of rape about which no one speaks and which no one, consequently, condemns. The particular acts of rape that allow condemnation to be voiced have left no photographic traces. I have not found—nor am in all probability likely to find—photographic evidence of such acts. They are positioned as taking place beyond the reach of any law: the cruel and shocking rape may be attributed to outlaws or those who violate the "purity of arms." Alternatively, it may be aestheticized and expropriated from the mundane economy of violence: "She was bathed, her hair was cropped, she was violated and slain . . ."[16] When I understood how looting and rape had been linked to one another in the language of the new regime that came to power during the period in question, I initially assumed that reconstructing hegemonic condemnations of rape would allow me to delineate the limits of constituent violence, and to fathom the similarity and differences between one and another form of rape. But whereas in reconstructing

sanctioned looting I found the archive replete with photographic evidence, the context of rape still had me groping in the dark.

Back then to the act of rape with which I began—one duly condemned and even exposed in court. For several days, twenty-two soldiers and their commander raped a twelve-year-old Bedouin girl in the Nirim outpost, and then murdered her. In 2003, *Haaretz* daily newspaper published an extensive investigation of the rape. In this account, the rape was depicted as "one of the ugliest and most appalling episodes in the history of the Israel Defense Forces."[17] I do not wish to detract from the horror, but I do wish to emphasize that this claim is groundless: to the best of my knowledge the writer of the article could not have compared it to any other rape crimes since this is the sole instance in which specific details are known, over and above a general narrative template that confirms that there have indeed been other instances. Were we to read a detailed investigation of many of the other incidents of rape, the general outlines of which are enough to shock us deeply, it is highly likely that the rape, abuse and murder in Nirim outpost would have had to compete with other shocking accounts for the title of the "most horrendous affair." The device of rating the shock value of an act of rape forms part of the rhetoric of its condemnation and helps render it exceptional. But despite a lack of specific details, we know of several dozen documented cases, cases held in fact to constitute the mere "tip of the iceberg," and these require discussion outside of the discourse of condemnation. Through the device of imagining, time and again, photographs that *were not* taken of such cases, I began to realize that most of them share a common frame narrative that is linked to the facilitation of rape, or more explicitly, that creates the conditions in which it was possible for Palestinian women to be raped and abandoned during the period in question.

The frame narrative can be extrapolated from the case of Nirim, for instance, where it occurs in two variants. There is no need to decide between them, for their outcome is *precisely the same*: In the most general formulation, Jewish combatants, all men, encounter Arabs, and their first act is to separate the women from the men. In the first version of the frame narrative, we learn that "platoon commander Moshe ordered the soldiers to seize the Arabs [two men and a girl] and search them. The soldiers found nothing. Officer Moshe then ordered the soldiers to bring the girl into the vehicle. Her shouts and screams were to no avail. Once she was inside the vehicle the soldiers scared off the two Arabs by shooting in the air." In the second version, that of the platoon commander, he recounts that: "I encountered Arabs in the territory under my command. One of them was armed. I killed the armed Arab on the spot and took his weapon. I took

the Arab female captive. On the first night, the soldiers abused her, and the next day I saw fit to remove her from the world."[18]

A similar pattern emerges from most of the rape accounts I have encountered concerning the years 1947–48: whether of encounters on the individual level or with entire populations of villages or towns. The pattern displayed is unlike rape in a mixed civil environment where a rapist ambushes a woman alone out of doors; rather, we see the patterning of rape under conditions of military occupation. Armed men, members of a group with group characteristics par excellence—in this case national ones—distance the men of the other national group designated as the enemy. This pattern was repeated in Akka, al-Lydd, Safsaf, Tantura, Qaqun, Hunin, Jaffa, al-Ramla—the list goes on and on.

I return, then, to the initial photograph from al-Ramla (see page 224). A laconic, partial account of several of the rape cases that were perpetrated there was held by the cabinet.[19] How can this be linked to the photographic record? By expanding my analysis of the photograph, it becomes possible to see it not merely as the segregation of Palestinian men identified as being "of military age"—as an act of manifest triumph—nor is it merely the first phase of expulsion as a multi-phase method. What we see in this photograph is the *backstage of a crime scene: the crime of rape.*[20]

The photograph is capable of making us recognize the separation it inscribes while concealing the violent intercourse taking place simultaneously elsewhere. This photograph is, I claim, far more important for understanding the phenomenon of rape during the period in question than the photograph of a certain crime scene might be, where say the specific rape of a particular woman actually took place, since the rape cases at hand *are not* private cases. Rather, the photograph contains lessons for us concerning the general conditions created by the emergency military government for the abandonment and rape of Palestinian women. Testimonies collected by Fatma Kassem from women who were in the town at the time document the women's terror of the armed combatants present throughout the town, and the measures women took to defend themselves from rape.[21]

Imagine a town that has just been occupied, where only women, very elderly men and children have remained, after armed combatants have filled its streets and have arrested all the younger men whose physical prowess symbolizes potential resistance to the new rule imposed on the town. Imagine these women left on their own. Imagine their plight, exposed to Jewish combatants who treat anything they find as their own—who demand to be served food, drink, sex. These demands, documented in history books, reports, memoranda, and court rulings where they are represented as distilling the horrors or excesses of war, should not be

understood as marginal or contingent. They are a structural part of emergency rule based on population selection and the segregation of populations on the basis of criteria of age, nationality and gender.

But this is not all. In an interview, Benny Morris draws our attention to another common characteristic of rape incidents during the period: "In a large proportion of the cases, the event [rape] ended with murder."[22] Morris did not go into details, nor did his interviewer press him. In my own turn, I assimilated the statement without further speculation for a long time. But eventually, it occurred to me to ask why most cases of rape ended in murder. One answer, as shocking as it was obvious, suggested itself: had rape *not* ended in murder, at least some of the cases of rape would have eventuated in the birth of "mongrel" children. The murder of the rape victim, then, not only does away with the principal witness, but also with the consequences of the act of rape. Just as in the case of the rape of the Sabine women upon which Rome was founded, the emergence of the consequences of rape could generate precisely that mixed regime that the war machine was dedicated to preventing.

Nevertheless, burying the principal witness and doing away with the results of the deed are not in themselves sufficient to wholly occlude rape as a "non-topic" or one which cannot be fully excavated, given that the keys to its investigation lie in the hands of the rape victims themselves. Pioneering women researchers including Susan Slyomovics, Laleh Khalili, Isabelle Humphries and Fatma Kassem have indeed tried to extend the boundaries of the archive as a framework for the discussion of rape.[23] Their studies included interviews with women alongside citations of archival materials that served historians such as Benny Morris, Ilan Pappé or Yoav Gelber, whose own mentions of rape were mostly laconic. While conducting my own research, I had hoped that returning to the original archival documents they had used would provide further detail. To my surprise, not only could I not discover any more details, I was actually prevented from accessing some of the documents that previous researchers had seen. Thus, for example, the section on rape in the Haganah archive, to which Morris refers in his description of the rape at Hunin—"That summer, four women were raped and murdered by IDF soldiers"—was censored recently after being opened to the public.[24]

Over the period 1947–50, censoring documents was not held by the regime to be a sufficient response. Actual initiatives were taken to destroy evidence, blur facts, deny access to crime scenes, silence testimonies, distance witnesses and delegitimize them. All this was necessary prior to the imposition of military government (over the Palestinian population that was not uprooted), while foreign eyes of the UN or International Red

Cross representatives were still able to demand the investigation of horrors that had not escaped their sight.[25] Here, for example, is a case reported by Yoav Gelber that occurred in Majdal Krum, an account by Brigade No. 9 of the Northern Command about completing the efforts to remove evidence prior to a UN investigation: "The village may now be visited and nothing will be found that might incriminate us."[26]

Distancing Palestinian men and women as witnesses is not particular to a specific case but rather constitutes a structural device, part of a system, a component of the horror that took place in Palestine during those years. It enabled a monstrous regime-made disaster to be established and to be perpetuated under the cloak of a vocabulary of building and resurrection, vision and morality, liberation and redemption, wholly capturing the hearts of the Jewish inhabitants of this land who propagate themselves in a crime zone whose features have intentionally been blurred. Much has already been written about the military government imposed on the Palestinian citizens of the Israeli state during 1948–66, but not enough has been written about it as a mechanism for destroying testimonies and preventing the production of historical knowledge. Traces of this emerge for instance when various agents complain about the need to institute military government in order to silence the victims who dared to complain: "This state of affairs enabled the Arabs to behave improperly while giving testimony to UN observers."[27] Testimonies of Palestinian men and women began to be collected in an orderly fashion only several decades later, after years of being terrorized into silence. By this time, their testimonies already appeared one-sided par excellence, an inverse mirror image of the Israeli testimonies. They could not easily be rendered compatible with the sanctioned hegemonic narrative shaped and orchestrated by the Israeli state and narrated by Jewish Israelis. Nor were they sufficient to contest the constituent violence that separated Jews, those responsible for the Palestinian disaster, from Arabs, those struck by disaster—thus consigning their catastrophe to the category of a catastrophe "from their point of view."

At the margins of this campaign to destroy the testimony of Palestinian men and women, I would like to point out another, discursive procedure, directly linked to the rape issue and replicating the silence that was constructed around it. Essentially, this strategy attributes the silence surrounding the rape of Palestinian women by Jews to the mental and cultural difficulty of speaking about rape ascribed to Palestinians. Such claims have been made by numerous researchers, Jews and Palestinians alike. Thus, for example, Benny Morris writes of rape that it is: "a crime viewed with particular horror in Arab and Muslim societies."[28] The argument recurs in many variations, and is even frequently appended to appeals

of Palestinian women to UN observers to report what had been done to them.[29] The repetition ad nauseam of the claim of their silence does not attest to the true state of affairs, but rather to the successful attempts to enshroud the rape of Palestinian women in silence. It is time now to refute the silence of the rape victims but also to examine the contribution of historians to the efforts of the ruling regime in this regard. It is time to inquire, for instance, on what basis Benny Morris, who possesses a historian's expertise in reading the official archive and considers the archive to be a sufficient source for the reconstruction of history as the result of the deeds and intentions of historical actors, should be able to make pronouncements concerning the codes of behavior of Muslim or Arab society? I would not be so strident in my disagreement with Morris were it not for the fact that his particular brand of positivist history has become authoritative for the period, and were such pronouncements not assimilated in his positivist texts to constitute a prism through which subsequent researchers continue to view history.

This claim concerning the difficulty Palestinian men and women experience in testifying about rape, once removed, makes way for an altogether different picture. Palestinian men and women, whether the victims themselves or witnesses, spoke about the acts of rape, protested them, took action to halt this plague, reported incidents of rape to various bodies, formulated public statements and asked to testify and to be heard. Here, in brief, are three examples: A Palestinian woman in al-Faluja reported to UN observers that she had been raped. They then cabled this to Ralph Bunche. The Israeli liaison officers were appalled and did everything in their power to dismiss the testimony and present the Palestinian witness as unreliable.[30] The second instance is cited from a memorandum presented by the Jaffa Emergency Committee to the UN via the International Red Cross office: "Serious offenses have been perpetrated against several women in the presence of their spouses or brothers, including the rape of a twelve-year-old girl, and an additional case of abuse of an even younger girl. Armed soldiers forage nightly the residences of respectable families . . ."[31] The third example is cited from a letter by the legal adviser to the government, addressing the minister of justice, about the rape of a Palestinian by four policemen. The letter clearly indicates that the Palestinian complained that she was raped and furthermore claimed to retain evidence from the rape scene in the form of a fountain pen she had taken out of the pocket of one of the policemen.[32] After their expulsion, from the beginning of their residence in the refugee camps, Palestinians spoke about rape as one of the different forms of traumatic experience they had gone through.[33]

In conclusion, I wish to return one last time to that photograph from al-Ramla and to read an added dimension into it: one that will finally extricate it from the possibility of relegating it to an example of "regarding the suffering of others." This time I wish to look not at the Palestinians as the victims, par excellence, of separation and segregation but also at the Jewish combatants standing guard over them. Like those whom they have separated from their wives, they too are separated from the women they are supposed to defend. This separation—of Jewish women from Jewish men—is the fundamental separation of the Israeli regime, the condition for all other separations. Even if the occasional woman did penetrate the ranks of Jewish fighters, they did not significantly affect the regime of segregation. Those who separated Palestinian men from Palestinian women, who had violent intercourse with Palestinian women while Palestinian men sat by the roadside, are the very same people who constructed a regime of separations. This separation of Jewish women and men was made without resorting to violence, and thus never turned into a project of this regime, an object of its law-preserving violence. It was its own self-evident given, enabling and conditioning the subsequent actions of the regime. The separation between men and women in Israel is that which has maintained the regime from its very inception, perpetuating it into the present as a regime of military emergency, a form of male rule that "provides protection and security" of the kind that only men can provide. The project to which this regime has devoted itself—national separation—is the same project that necessitated the kind of protection and security it knows how to provide.

The answer given by this regime is, then, the answer to a problem it had created. The problem it created, like the chain of solutions it has never ceased to offer—is *our* own catastrophe, the regime-made disaster that affects us all, men and women, Jews and Arabs who live in Israel–Palestine. Under a regime of separation, no one can avoid catastrophe. It is futile to search for lost testimonies or testimonies that may be retrieved only from those who can no longer testify. A mixed reading of the testimonies that already exist of the years of the establishment of the state of Israel that disregards divisions of age, gender and nationality which contribute to replicating the regime would be sufficient cause to make us realize that a regime-made disaster took place in the area in 1948, destroying all other possibilities of life. The civil use of the attributes of photography forms part of the effort to read the past from a vantage point other than that of the regime—the regime of disaster—and to describe it in terms of a vocabulary that contests the rhetoric of the regime. This is the attempt to contest the claims of the regime through the evocation of a civil language that it consistently fails to recognize.[34]

EPILOGUE

THE RIGHT NOT TO BE A PERPETRATOR

Regime-made disaster is prone to occur when one population group is ruled over a long period of time in a different and distinct manner from other ruled groups, as I have stated throughout this book. In the case of disaster zones, the dividing line between the two ruled populations and their respective exposure to that disaster for which the regime is responsible—a line that usually differentiates the population of citizens from another population consisting of flawed citizens or non-citizens—assumes two additional features. The first has to do with photography, and takes the form of a division between those who are constantly exposed to being photographed and those who are not; and the second relates to space, and takes the form of a division between those who can retreat to a private space of their own and set a boundary to the incursions of the regime, and those who cannot.

The Borderless Photography Studio

The spatial organization of the land between the Mediterranean Sea and the Jordan River, whose traces can be read in many photographs produced from this area, is an expression of what I have termed "regime-made disaster"—disaster generated and orchestrated by a political system in which one part of the population is mobilized to see the disaster of the other part as a non-disaster. Since they were first conquered, and increasingly over the past two decades, the Occupied Territories have become an extended borderless photography studio whose reach may be extended at any given moment to more and more areas, including private homes. This studio without borders is not a private space over which the photographers operating within it have ownership and the power or authority to delimit it and differentiate it from that which lies outside. Nor is it a

public space in which everyone can participate in the same manner.[1] Photographers might, for instance, rush to photograph a house in situations where they accompany a detachment of combat soldiers, outstrip such detachments, or follow in their wake. Alternatively, they may enter a home at the behest of the Palestinians living there, or at the invitation of the commanding officer in charge of the incursion, or contrary to his orders.

This studio without borders therefore spans the length and breadth of the Occupied Territories, extending between private spaces that have become public and public spaces that have become private. Its divisions are not erected and dismantled in accordance with orderly and well-known distinctions between private and public space or ownership, and with the consent of the *owners* of private space or the *users* of public space, but according to needs of the regime, which include the military operations imposed on the residents, all of which inflict shifting rules on the management of space.

Most of the time the Palestinians stumble upon this studio, frequently located in their very own home, as extras. Even when they resist the passivity foisted on them, and become active agents, they are revealed to be unprotected governed people, because they cannot retreat to a private space and remain there safely, and they are not free to go out into public space and participate in it like all other fully constituted citizens.

Well into the present, the Palestinians remain the main object of human rights discourse in the area. The growing presence over the years of human rights organizations in the Occupied Territories is testament to this fact. These organizations have evinced a growing interest in photography in their practice, and they now possess the largest integrated archive of human rights violations in the land between the sea and the river, given that photographs attesting to such violations are scattered or kept under various separate categories in other archives. The photographs in their possession are natural candidates for any discussion that seeks to ascertain the place of photography in human rights discourse and in the practices it entails.[2] However, a critical discussion of the question of photography and human rights cannot be limited by the institutional boundaries that the organizations set in regard both to photographs and to the very concept of human rights itself. The assertion that a human rights violation is whatever the human rights organizations portray as a violation is a tautology that should be resisted.[3] It is one of the main reasons why photographs that testify to what I term "regime-made disaster" have been perceived in recent decades as photographs of human rights violations.[4]

Human Rights Violation

Presenting the violation of human rights *in itself* is a reduction of the disaster to the way in which it is registered on the part of its victims. The identification of an instance of violation as a human rights violation does not depend on the violators, and is easily disconnected from the complex deployment responsible for it. This equation of the violation with the violated positions violation as demarcated and delimited to a certain location, for example, the body, where its explicit signs may be found. The violated, who are primarily the subjects photographed, appear in these photographs as carriers of a violation of a clear-cut category of human rights. But the *regime* rather than the *policy* responsible for the violation, together with the rest of the governed population, citizens for the most part, who support this regime directly or indirectly, and who perceive the violation of a particular governed population as self-evident, remain outside the framework of legibility that the organization fashions. In other words, the photographed event becomes an object of debate only after it has been abstracted and placed under a legal category, while the photographer and the act of photography—the event photography as distinguished from the photographed event—are left outside the discussion.

Breaking out of this circular relationship requires that we treat photographs taken in a disaster zone as the basis for reconstructing the photographic situation, whose boundaries never correspond to the frame of the photograph.[5] Using photographs differently allows us to imagine a *new*—or renewed—human rights discourse, which besides the traditional assistance to a population designated as violated, stands also to benefit the citizens ruled alongside the violated population.[6] This new form of intervention would help the privileged citizens to identify and acknowledge the inherent flaw in their citizenship, a flaw that makes them accomplices to the crimes of a regime that does everything in its power to keep from appearing to be criminal.

To view photographs solely from the perspective that recognizes only those who were directly violated as potential objects of human rights discourse is limited. A renewed look at the same photographs allows us to read not individual portraits of this or that person framed under the category of human rights violations, but rather traces of a discriminatory regime alongside the fundamental features of a regime-made disaster.

When we are presented with a particular governed population that suffers systematically from a loss of rights, photographs enable us to

reconstruct the existence and involvement of another population that is protected from such a loss.

As I have already stated, the imprint of the regime is evident, first and foremost, in circumstances where a given population is regularly susceptible to being photographed, usually not at its own initiative. But it is no less evident in the manner whereby the population of citizens is conscripted, often without its knowledge, to perceive the discriminatory regime to which it is subject as an egalitarian regime. The supposed access to egalitarian rights applies to the population of citizens, but is violated on a structural basis when examined in relation to the population of the governed as a whole. Thus, as a result of a blatant policy of withholding civil information, the citizens of the regime do not see the photographed subjects as part of the body politic, which is made up of governed persons who share the same regime to which all are subject. Instead it sees them as "Palestinians"—i.e., as "occupied" or "stateless" persons who have forfeited one of the four historical basic human rights: the right to *resist oppression*. Hence the Palestinians appear as harbingers of their fate— objects for intervention by a human rights discourse that focuses on the tip of the iceberg that is the violation, and disconnects it from the context of the larger operations of the regime.

Human rights discourse should be redesigned to focus on the regime and to analyze photographs from zones permanently prone to disaster as the documents of regime-made disaster. Redesigning the perspective of this discourse will let us see the very recruitment of citizens—taking part in the creation of those regime-made disasters of which a particular governed population is the main victim—as another type of human rights violation.

A Call for Assistance

Budding signs in this direction can already be seen in Israel in an organization like "Breaking the Silence," whose members, former soldiers (in other words, citizens who were drafted for army service as adolescents straight out of high school) became disillusioned with the actions they had perpetrated, and now wish to break the silence around them, which conceals their criminality.[7]

At the time when the following photograph was taken, those holding the camera—who were still soldiers—used it to manufacture souvenirs for themselves. In time, when they looked at the photographs, they came to realize what they had committed, what they had witnessed, and in what they had participated. The following testimony was elicited from one of their members:

Refugee camp near Ramallah. Photograph by soldiers, members of Breaking the Silence, 2002

We were sweeping a certain village at the time of the FIFA World Cup, and had to go into one of the houses. Now, you've got an awesome platoon leader, he's also an Argentina fan, he also wants to see the game, so you tell him: "Listen, bro . . . what difference does it make . . . this house or that house, it's the same thing, but this one has a TV, bro." So we went into the house with the television, just like that we cleared a family out of the house so we could watch the Argentina-Nigeria game.

(From testimonies collected by Breaking the Silence)

The invasion of the soldiers in the picture into a Palestinian home, and the expulsion of its inhabitants, was not an unprecedented or exceptional act. This was not the first time that the invaders, as well as those whose home they invaded, had participated, whether actively or indirectly, in the flimsiness of the walls of Palestinian houses in the face of Israeli might.

By sharing the photograph with others, the soldiers were able to recognize the contours of, as well as to show, the crime in which they were complicit. The way the soldiers reframe photos taken during their military service under the title "Breaking the Silence" should be read as a first step toward rehabilitating their civil competence and regaining the right denied to them by the regime, namely "the right not to be a perpetrator." I suggest

that we read their actions as a call for assistance addressed to the human rights community. Without in any manner detracting from the enormity of the atrocities inflicted on the victims, i.e., the Palestinians, and without creating any symmetry between perpetrators and victims, we need to acknowledge that the soldiers are seeking recognition as victims too, victims of their own regime and their own government.

The photographs, taken as part of their becoming-perpetrators, contributed to the awakening of their consciousness and made them understand the "acts of state" they had performed to be crimes.

That this awakening is a belated one is not due to a personal blindness or defect but results from the fact that the soldiers were impaired as citizens by their own regime: their military service has been both the effect of a civil malfunction orchestrated by the regime and an instrument in its reproduction. Without the soldiers' knowing or understanding it, their right to enjoy full, unimpaired citizenship has been violated. The discourse of human rights should include this kind of violation—the making of a citizen into a perpetrator—within its frame and as part of its mission.

To protect human rights means also to protect the right of the citizens NOT to be perpetrators and not to assist perpetrators of crimes. The case of Breaking the Silence plainly shows that this includes the right of citizens to criminalize the regime that has made them criminals.

NOTES

Introduction

1 For another later critique of this position, see for example Mark Reinhardt, Holly Edwards, Erina Duganne, eds., *Beautiful Suffering: Photography and the Traffic in Pain,* Chicago: University of Chicago Press, 2007.

2 See for example Susan Dunn, *The Deaths of Louis XVI: Regicide and the French Political Imagination,* Princeton University Press, 2008, or Michael Walzer, *Regicide and Revolution: Speeches at the Trial of Louis XVI,* New York: Columbia University Press, 1993.

3 "Hence," writes Arendt, "metaphysics, the discipline that treats of what lies beyond physical reality and still, in a mysterious way, is given to the mind as the nonappearance in the appearances, becomes ontology, the science of Being." Hannah Arendt, *Lectures on Kant's Political Philosophy,* Chicago: University of Chicago Press, 1982.

4 For a discussion of the manner in which we imagine the state, see Adi Ophir, "State," *Mafte'akh,* no. 1e, Summer 2010.

5 My work on the three archival exhibitions that I curated in recent years ("Act of State," "The Architecture of Destruction" and "Constituent Violence") required an enormous effort of the imagination on my part. I found myself confronting photographs about which little was known. But what was represented in them was neither strange nor opaque. On the contrary, familiar and easily recognizable elements constantly appeared in them. Through the activity of the imagination, these elements were transformed into the source of provocative new knowledge at times, or served in other cases as the mere thread of a possible trajectory, sometimes powerful enough to open the gates of the past. In the introduction to my book *Act of State,* I still termed this imagination "political imagination." It was only with time that I understood the necessity of differentiating between two uses, political imagination versus civil imagination. For more on the role of civil imagination in this exhibition, see Adi Sorek, review of *Act of State: A Photographed History of the Occupation 1967–2007,* by Ariella Azoulay, *Umbr(a): A Journal of the Unconscious,* 2009.

Chapter 1

1 The discourse on photography that has flowered over the last two decades has produced many texts on the technological, optical and chemical technologies that characterized the various "inventions" of photography on the part of people like Daguerre and Nièpce, Talbot and Bayard. Despite the importance of these differences, I have bracketed them off in order to discuss the broader common denominator that obtains between them: writing in light. For the specific characteristics of each of the inventors, see Michel Frizot, *A New History of Photography*, Köln: Könemann, 1998.

2 I am not concerned here with the totality of Talbot's oeuvre nor with the innovation his invention introduced based on the difference between negative and positive, and on the creation of a temporal gap between the moment of the writing in light of a given image and the moment of its appearance. For the "latent" image of Talbot see Larry J. Schaaf, *In Focus: William Fox Talbot: Photographs from the J. Paul Getty Museum*, Los Angeles: Getty Publications, 2002; and Frizot, *A New History of Photography*. For the conception of Talbot's image as the antithesis of witness, see Vered Maimon, "Displaced 'Origins': William Henry Fox Talbot's *The Pencil of Nature*," *History of Photography*, vol. 32, no. 4, December 2008; and William Henry Fox Talbot, *The Pencil of Nature*, London: Longman, Brown, Green and Longmans, 1977. Although his formulation—"the pencil of nature"—was not the only one of its kind, possibly because it was compact and precise, it endured where others have been forgotten. The first decade of photography gave rise to articles with titles that are similar to Talbot's notion of "automatic writing": "A Mirror That Preserves All Its Traces" by Janin, or "The Photographic Device Is an Artist" by Théophile Gautier. Their writings have been compiled in a collection by André Rouillé, *La photographie en France: Textes et controverses, une anthologie 1816–1871*, Paris: Macula, 1989.

3 Criticism ranges from scorn for the photographic image along the lines of Baudelaire who termed it a "trivial image" and the camera "the handmaiden of the sciences and arts" (1859), to the print workers' petition against photography on the grounds that it threatened their livelihood. See Rouillé, *La photographie en France*.

4 For the various verbs that he would use to describe his invention—for instance, "to deliver," "to copy," "to inscribe," "to catalyze," "to imprint"—see Geoffrey Batchen, *Burning with Desire*, Cambridge, MA: MIT Press, 1999, 68.

5 Or as reconstructed historically by Batchen, in relation to Nicholaas Henneman, who was responsible for the prints included in *The Pencil of Nature*: "As many as nine people might have worked on any one print, a collective labor completely subsumed under the name of 'Talbot' in *The Pencil*." Geoffrey Batchen, *"Pencil Revisited"*, *Source: The Photographic Review*, no. 67, Summer 2011.

6 Photographers have been vilified since the invention of the technology. The photographer, by virtue of his craft, has been seen as a robber of portraits, as manipulative, as a master of lies and deceit, as someone who capitalizes on the suffering of others, and so on. Baudelaire's negative portrayal of the photographer is well known, but he is not the sole representative of this tradition of vilification that continues unabated. For its inception see Rouillé, *La Photographie en France*. For later expressions of this trajectory, consider the title of the special edition of the magazine *Camera Obscura* published by the

Camera Obscura School of Photography and the supplement of the Hebrew-language newspaper *Ha'ir*, edited by Adam Baruch, and entitled "Photography Is the Biggest Con-Job of Them All: Creator of Realities, Director of Memory, Promoter of Manipulation" (April 25, 1997).

7 See for instance the following works: Georges Didi-Huberman, *Invention de l'hystérie: Charcot et l'iconographie photographique de la Salpêtrière*, Paris: Macula, 1995; Denis Bernard and André Gunthert, *L'instant rêvé: Albert Londe*, Nîmes: Jaqueline Chambon, 1993; Sandra S. Phillips, Mark Haworth-Booth, and Carol Squiers, eds., *Police Pictures: The Photograph as Evidence*, San Francisco: Chronicle Books, 1997; Okwui Enwezor, *Archive Fever: Uses of the Document in Contemporary Art*, London: Steidl, 2009.

8 For the mono-focal camera, see Aïm Deüelle Lüski, "Fragments of Horizontal Thinking," *Plastika*, no. 3, 1999 (in Hebrew).

9 Digital photography and the possibilities that emerge through its processing emphasize precisely the extent to which the photograph is not sealed. But the discussion that has followed the advent of digital photography has concentrated mainly on practices of changing what is inscribed in the frame, without reference to what took place at the moment of photography. I am not party to the resistance that this discussion creates between analogue and digital photography nor to the lack of distinction between technological potential on the one hand, and its uses on the other. But this topic is the subject of an investigation in its own right and since it will distract us from the issue at hand, I will not dwell on it here. For more on digital photography, see Fred Ritchin, *After Photography*, New York: W. W. Norton, 2010.

10 See chapters 8 and 9 of Ariella Azoulay, *The Civil Contract of Photography*, New York: Zone Books, 2008.

Chapter 2

1 This chapter is a reformulation of a number of lectures given in the framework of the Annual Workshop in Visual Culture, in the Cultural Studies and Hermeneutics Program, Bar-Ilan University (2007–2008); in the second Lexical Conference in Political Philosophy, The Minerva Center, Tel Aviv University (2008); and in the annual conference of the Association of Historians, Tel Aviv University (2007). For an early version of part of it see Ariella Azoulay, "Getting Rid of the Distinction between the Aesthetic and the Political," *Theory, Culture & Society*, vol. 27, no. 7/8, 2011.

2 Excluding literature or music, which fall outside the scope of the present discussion.

3 Various versions of this essay were written in the face of the horrors emerging in Europe during the latter half of the 1930s. Quoted from the last version written in 1939. Walter Benjamin, *Selected Writings, Volume 3: 1935–1938*, Cambridge, MA: Harvard University Press, 2002, 270.

4 This accounts for the frequency of the question "Is there a political art?" that emerges in various locations from the mid-twentieth century onward. The question takes different forms but is commonly accompanied by an answer stating that political art does or does not exist in a particular place at a particular time. Here is one random such response offered by Vilencia in reaction to the violent closure of an exhibition of young artists in Pristina: "It is possible

to say that artistic practice functioned effectively as a political front in the nineties, today political–critical art no longer exists."

5 For the migration of political concepts to works of art, see Francis Haskell, "Art and the Language of Politics," *Journal of European Studies*, vol. 4, no. 3, September 1974, 218.

6 See Holger Hoock, *The King's Artists: The Royal Academy of Arts and the Politics of British Culture 1760–1840*, Oxford: Oxford University Press, 2005.

7 See Susan Buck-Morss, "Aesthetics and Anaesthetics: Walter Benjamin's Artwork Essay Reconsidered," *October*, vol. 62., Autumn, 1992.

8 Many theorists have criticized the "aesthetic" position from a Marxist point of view, notably Fredric Jameson, *The Political Unconscious*, Ithaca, NY: Cornell University Press, 1982; or Terry Eagleton, *The Ideology of the Aesthetic*, Oxford: Blackwell, 1991; or from a feminist point of view, for example Robin May Schott, *Cognition and Eros: A Critique of the Kantian Paradigm*, University Park, PA: Pennsylvania State University Press, 1993. For the discourse of photography specifically, see Martha Rosler, *Decoys and Disruptions: Selected Writings, 1975–2001*, Cambridge, MA: MIT Press, 2006.

9 Two recent books differ from the tradition that was developed in the wake of Walter Benjamin's formula. Both address the "aesthetic" and present a significant critique of the tendency of art to become "political." See Boris Groys, *Art Power*, Cambridge, MA: MIT Press, 2008; and Jacques Rancière, *The Emancipated Spectator*, London: Verso Books, 2009.

10 Take, for instance, the ethnic or national borders circumscribing the field of art. I can reconstruct two distinct turning points in my becoming aware of these restrictions. The first occurred as a result of an interview that I conducted with the Palestinian-Israeli artist Abdel Tamam in 1996, published in the newspaper *Ha'ir* and then in a book (Ariella Azoulay, *How Does It Look to You?*, Tel Aviv: Babel Publishers, 2000 [in Hebrew]). It struck me that despite his being an artist in Israel, his drawings "are not part of the canon of Israeli art and are not even included in its margins. The massacre in Kfar Kasem is not a landmark that is relevant for any of the chronological axes used to narrate the history of local art." The second turning point was a text that I wrote for a lecture on Roee Rosen's "Justine Frank" project. Rosen invented the figure of the female Jewish artist and novelist Justine Frank whose important artistic work was said to have been produced in the 1930s. Rosen produced a considerable artistic corpus on "her" behalf, composed of paintings, drawings and a novel. He also wrote her biography. "In a certain sense," I claimed in that lecture, "Justine Frank enables us to relive the fantasy of that normalcy despite the radicalism of her being and her art and in fact by virtue of both—now Israeli art has an eccentric figure, pornographic writing and Jewish drawings of the human body. In other words, Justine Frank's deviation from the norm serves as a way of rehabilitating normalcy, and between two seemingly opposed forms of the normal, there is nevertheless one common denominator: Jewishness, even eccentric Jewishness, serves as a basis for the fortification of the art community." One symptom of this emerges from the answer of the Palestinian caricaturist Said Nehari, also invented by Rosen, who appeared in a television program on Justine Frank. When asked like other participants to attest to knowledge or ignorance of Frank's work—he replied in the negative and in surprise. In fact, his presence signifies the boundaries of a secret that excluded him from the "secret"

altogether, outside of the charmed circle of those in the know. This was in contradistinction to Jewish Israelis (including myself) who, in response to Rosen's work, expressed their belonging to a community one way or another through simulating knowledge of Frank. See Ariella Azoulay, "Ecclesia and Synagoga," presented at the conference "Footsteps, Folds and Cracks: Kinds of Continua in Israeli Literature," organized by Rachel Albeck-Gidron and Roman Katsman at Bar-Ilan University, January 7–9, 2002.

11 This brief history does not wholly coincide with the development of a similar judgment of taste in literature (which remains outside of my brief) where the third judgment of taste evolved as early as the late nineteenth century.

12 In a series of lectures on Kant, Arendt claimed that Kant did not write political philosophy, although if there were to be a point from which his political philosophy might be extrapolated, it would be *The Critique of Judgment*. See Hannah Arendt, *Lectures on Kant's Political Philosophy*, Chicago: University of Chicago Press, 1982. In her work on Arendt, Julia Kristeva emphasizes the role of judgment in Arendt's political philosophy and claims that this discrete faculty "attests to the immediate belonging of every human being to the community of human beings." Julia Kristeva, *Le génie féminin: Hannah Arendt*, Paris: Fayard, 1999.

13 See Ariella Azoulay, "Outside the Political Philosophy Tradition, and Still inside Tradition: Two Traditions of Political Philosophy," *Constellations*, vol. 18, no. 1, March 2011, 91–105.

14 Thierry de Duve formulates the revolution that Duchamp generated in art in terms of a judgment of taste and analyzes its relation to the Kantian judgment. See Thierry de Duve, *Au nom de l'art*, Paris: Minuit, 1989. See also Gideon Ofrat, who seeks to deal with the new status of the work of art, in *The Definition of Art*, Tel Aviv: Hakibbutz Hameuchad, 1976.

15 De Duve formulates the paradox with which Jean-François Lyotard also engaged ("A work cannot be modern unless it was first of all post-modern") and argues that "in order for a work of art to be identified with modernity, it has first of all to innovate, to be dissociated from its times in everything that concerns the conventional taste of the period. Picasso was post-modern in 1907, but he became modern in 1930." Duve, *Au nom de l'art*, 67.

16 They can be seen at AfterWalkerEvans.com.

17 Each typical instance can generate a multiplicity of particular instances, such as "too propagandistic," "spoon feeds," "too formulaic," "too pretty," "too stylized," or "too frank."

18 For the notion of transmission in this context, see Ariella Azoulay, *Once Upon a Time: Photography Following Walter Benjamin*, Ramat Gan: Bar-Ilan University Press, 2006 (in Hebrew).

19 See the Chapter 2 of Ariella Azoulay, *The Civil Contract of Photography*, New York: Zone Books, 2008.

20 A series of interviews I conducted during the mid-1990s with various professionals—a pilot, a scuba diver, an architect, a combat soldier, a politician and others—enabled me to listen more attentively for evidence of other forms of professional gazes and to the discourses within which they are formed and expressed. See Azoulay, *How Does It Look to You?*.

21 Despite the fact that the field of visual culture came into being in opposition to the discourse of art, most scholarly research in the field passes over the very

254 Notes to pages 50–64

question of their oppositional relations in favor of creating new areas of research and of broadening the tools and areas of questioning formerly blocked within the field of art. See for instance the anthology *Visual Culture* (Jessica Evans and Stuart Hall, eds., London: Sage, 1999), which brings together texts from a variety of fields (on the part of authors such as Freud, Althusser, Barthes, Foucault, Homi Bhabha, Laura Mulvey, and others), and which broaches questions concerning visual culture that were not formerly possible in the field of art. For an articulation of the new problematic of visual culture, see Nicholas Mirzoeff, *An Introduction to Visual Culture*, London: Routledge, 2000; and Irit Rogoff, *Terra Infirma*, London: Routledge, 2000.

22 In her preface to the screenplay of *Hiroshima Mon Amour*, Marguerite Duras writes that it is not the discussion of Hiroshima in a hotel bedroom that is scandalous, but "Hiroshima itself." Marguerite Duras, *Hiroshima Mon Amour*, New York: Grove, 1994, 12.

23 For the "space of appearance" see Hannah Arendt, *The Human Condition*, Chicago: University of Chicago Press, 1958.

24 On the particularity of the moment of looking, see John Berger and Jean Mohr, *Another Way of Telling*, New York: Pantheon, 1982.

25 For discussion of this series of photographs from South Korea, including the photograph to which I am referring, see Lindsay French, "Exhibiting Terror," in *Truth Claims: Representation and Human Rights*, ed. Mark Bradley and Patrice Petro, New Brunswick: Rutgers University Press, 2002.

26 For a discussion of the landscape and images of the landscape, see W. J. T. Mitchell, "Holy Landscape: Israel, Palestine, and the American Wilderness," *Critical Inquiry* vol. 26, no. 2, Winter, 2000, 193–223.

27 For further elaboration, see the last chapter of my book: Ariella Azoulay, *TRAining for Art*, Tel Aviv: Hakibbutz Hameuchad, 1999 (in Hebrew).

28 I take it as self-evident that different types of utterances can be chained alongside one another—visual utterances, textual utterances or spatial ones. For further discussion see Azoulay, *TRAining for Art*.

29 For more on the photograph of "wanted persons" see Ariella Azoulay, "The Execution Portrait," in *Picturing Atrocity: Photography in Crisis*, ed. Geoffrey Batchen, Mick Gidley, Nancy K. Miller and Jay Prosser, London: Reaktion Books, 2011.

30 Donna Ferrato, *Living with the Enemy*, New York: Aperture, 1991, 144.

31 Vanessa Schwartz and Jeannene Przyblyski reconstruct the emergence of visual culture from within the general cultural and technological context of the nineteenth century. See Vanessa R. Schwartz and Jeannene M. Przyblyski, eds., *The Nineteenth-Century Visual Culture Reader*, New York: Routledge, 2004.

32 Thus, for example, photographs of catastrophes such as fires or earthquakes that occurred in a specific place were distributed elsewhere in order to raise money for survivors. Certain body parts became the object of focused interrogation, such as the photograph of the legs of the Duchess of Castiglione created in conjunction with the photographer Pierre-Louis Pierson. Parts of certain buildings became independent images, like the photographs of Philip Henry Delamotte that depicted part of the structure of Crystal Palace as an eyeball ("View through Circular Truss, Crystal Palace," 1853–54). Group identities were constructed by means of group portraits, like that of laborers on a construction site whose portrait enabled them to observe themselves through a

mediating gaze (see for instance the workers of the Trocadéro in the late 30s. The labor of workers was placed under surveillance without their knowledge on a daily basis by a photographer who charted their progress, as was the case with the Trocadéro construction site in Paris). Private and intimate images were transmitted in rapid succession while others of their kind found a public and were displayed as calling cards, as was the case with the calling cards of Prince Lobkowitz created by André-Adolphe-Eugène Disdéri.

33 In his essay on the work of art in the age of mechanical reproduction, Benjamin speaks of the change wrought by photography but does not explicitly conceptualize this change within a distinct discourse of visual culture. André Malraux, a few years later, also pointed to this potential inherent in photography, without, however, problematizing the boundaries of the discourse of art, when he coined the phrase "museum without walls." See André Malraux, *Le musée imaginaire*, Paris: Gallimard, 1996.

34 This trend was reinforced in successive waves. The most recent of them is the digital camera and the Internet, which have created new uses of the photographic image and opened new options for political partnership that I will not discuss in this context.

35 Here I am avoiding the word "community," which presupposes a common history or narrative, and instead speaking of a certain public as the totality of people whose interactions do not require a common identity.

36 My description of the relations between individuals who aggregate is similar to Jean-Luc Nancy's description of them as an "inoperative community" (Jean-Luc Nancy, *The Inoperative Community*, Minnesota: University of Minnesota Press, 1991). My emphasis is not only on the absence of common purpose but on the lack of agreement between individuals as a crucial principle. In this matter, see Ariella Azoulay, "The Absent Philosopher-Prince," *Radical Philosophy*, no. 158, November/December 2009.

37 The email was signed by the director of a large company who also represents a large European company. His full personal details appeared in bold at the bottom of the text.

38 For an earlier version of my analysis of these photographs, see my essay, "Asleep in a Sterile Zone," at aperture.org/humanrights.

39 For the notion of the "civil malfunction," see Ariella Azoulay, *From Palestine to Israel: A Photographic Record of Destruction and State Formation, 1947–1950*, London: Pluto Press, 2011.

40 For the seizure of the nation by the state, see Hannah Arendt, *Origins of Totalitarianism*, LaVergne, TN: Benediction Books, 2009; and Judith Butler and Gayatri Chakravorty Spivak, *Who Sings the Nation-State?*, London: Seagull, 2007.

41 For a brief historicization of these inventions, see Alan Trachtenberg, ed., *Classic Essays on Photography*, Stony Creek, CT: Leete's Island Books, 1989, 3.

42 During the first few years after the patenting of the daguerreotype, suits were filed by the patent holder in England, Richard Beard, against operators who had not paid for use of the patent. For further discussion of the legal suits Beard filed, see R. Derek Wood, "The Daguerreotype in England: Some Primary Material Relating to Beard's Lawsuits," *History of Photography*, vol. 3, no. 4, October 1979, 305–9.

43 See Jonathan Walker, *The Branded Hand: Trial and Imprisonment of Jonathan Walker*, New York: Arno Press, 1969.

44 See for instance the evidence of a song composed upon the publication of Walker's hand, "Notes on a Photograph."

45 See my discussion in *The Civil Contract of Photography*.

46 The different prices photographs and paintings fetch is one flagrant indication of the construction of the inferiority of photography.

47 The discourse of art indeed became very dominant in the discussion of photography in a manner disproportionate to the limited and circumscribed inclusion of photography in the field of art practice.

48 For further discussion of the affinity of drama with the political domain of human action, see Arendt, *The Human Condition*, 187.

49 Ibid, 188.

50 On the image of atrocity in relation to human rights see Batchen et al., *Picturing Atrocity*.

51 Berger and Mohr, *Another Way of Telling*, 84.

52 Dwelling on their discovery does not mean that it had no precedents. I chose to start with their book and not, for example, with Walter Benjamin's concept of the "optical unconscious" because of their explicit claim about discovery.

53 Michal Heiman, *Michal Heiman Test No. 2: My Mother-In-Law—Test for Women*, exhibit at Le Quartier in Quimper, France, 1998.

54 Wendy Ewald, *Secret Games: Collaborative Works with Children 1969–1999*, Berlin: Scalo, 2000.

55 Susan Meiselas, *Kurdistan: In the Shadow of History*, Chicago: University of Chicago Press, 2008.

56 Berger and Mohr, *Another Way of Telling*, 87.

57 I treated the encounter between the space of the museum and artistic discourse in my book *TRAining for Art* .

58 Such practitioners include Catherine David and her ongoing project, *Contemporary Arab Representations*; Thomas Keenan and Carles Guerra in their *Antiphotojournalism* publication and exhibition at La Virreina Centre de l'Imatge in Barcelona, 2010; Galit Eilat in a series of exhibitions at the Israeli Center for Digital Art, Holon; or the ACADEMY project in collaboration with the Kunstverein in Hamburg.

59 On collective art see Blake Stimson and Gregory Sholette, eds., *Collectivism after Modernism: The Art of Social Imagination after 1945*, Minneapolis: University of Minnesota Press, 2007.

60 For discussions of the bourgeois public sphere, see Jürgen Habermas, *The Structural Transformation of the Public Sphere*, Cambridge, MA: MIT Press, 1991. For a critique of the identification of public spatial activity with the public sphere, see Arlette Farge, *Dire et mal dire*, Paris: Seuil, 1992.

61 Arendt, *Lectures on Kant's Political Philosophy*. This series of lectures, edited and with an interpretive essay by Ronald Beiner in 1992, was supposed, according to Beiner, to form the basis of the third and last part of Arendt's *Life of the Mind*, only two volumes of which were published during her lifetime.

62 Arendt distinguishes judgment from conscience, which is not judgment in the context of moral or practical issues but which issues a directive on what to do and not do.

63 It is not for nothing that Jerome Kohn grouped this article together with

others in an anthology he published under the title *Responsibility and Judgment*.

64 Arendt's account, penned over a year after completing the article, was rejected on the part of those who commissioned it because of the controversial stand Arendt articulates. See Hannah Arendt, "Reflections on Little Rock," in *Responsibility and Judgment*, ed. Jerome Kohn, New York: Schocken Books, 2003.

65 Ibid., 243–44.

66 In response to the criticism this article generated, Arendt revisited some of its claims. See particularly her correspondence with Ralph Ellison, and the "Response to Critics" (David Spitz and Melvin Tomin) that she subsequently published—once as a preface to the article and once as a supplement to it. For this correspondence see also Ross Posnock, "Ralph Ellison, Hannah Arendt, and the Meaning of Politics," in *The Cambridge Companion to Ralph Ellison*, ed. Ralph Posnock, Cambridge: Cambridge University Press, 2005.

67 Michal Ben-Naftali points to the originary act of imagining that must precede, in her view, the questions Arendt was able to pose: "the attempt to imagine myself as a girl." Michal Ben-Naftali, *The Visitation of Hannah Arendt*, Tel Aviv: Hakibbutz Hameuchad, 2005, 70.

68 It was only in 2003 with the publication of the volume *Responsibility and Judgment* that the article was published alongside the photograph that generated it, captioned with the name of the licensing agency, Bettman/Corbis, rather than the name of the photographer, possibly Will Counts. For the first time it became possible to tell what Arendt saw that elicited the article. It is notable that numerous photographs of the same event by Will Counts were available in books and anthologies as well as on the Internet, but this particular photograph was not included among them. See the book he wrote in connection with this event, *A Life Is More Than a Moment: The Desegregation of Little Rock's Central High*, Bloomington, IN: Indiana University Press, 2007.

69 Arendt, *Responsibility and Judgment*, 237.

70 In the summer of 2008, on the opening day of the school year, nine Arab children were prevented from entering a kindergarten in Ma'alot-Tarshiha, Israel. Their parents used various channels to defend the political equality of their children and were able to have them admitted to the kindergarten a day later.

71 Arendt, *Responsibility and Judgment*, 237.

72 Ibid., 240.

73 Ibid., 189.

74 In a conversation conducted in 1972, Mary McCarthy questioned Arendt directly about the distinction between the political and the social, and claimed that Arendt had neglected to take into consideration what humans might do in the public sphere were "all the economic questions, questions concerning the quality of life of a person [*bien-être*] or questions of busing and integration that concern the social sphere evacuated from the political scene." Arendt answered: "You are completely correct and I admit that I ask myself the same question." This conversation, conducted in French, was published under the title "Thought and Action" (Hannah Arendt, *Édifier un monde: Interventions 1971–1975*, Paris: Seuil, 2007).

75 Claude Lefort, *Essais sur le politique*, Paris: Seuil, 1986, 64.

76 Arendt, *Responsibility and Judgment*, 204.

77 Arendt, *Lectures on Kant's Political Philosophy*, 18.
78 See Jens Bartelson, *The Critique of the State*, Cambridge: Cambridge University Press, 2001.
79 Hannah Arendt, *The Promise of Politics*, New York: Schocken Books, 2005, 129. Arendt also sees the blurring of this boundary as catastrophic. During the colloquium whose participants included Mary McCarthy, Richard Bernstein asked her the following: "Can we agree on the negative conclusion of the thesis that crosses your oeuvre: if humans mix the social with the political, there will be catastrophic consequences for theory and for practice?" Arendt agreed: "I was indeed determined [to make this point]."
80 See Jacques Rancière, "Who Is the Subject of the Rights of Man?" *South Atlantic Quarterly*, vol. 103, no. 2/3, Spring/Summer 2004.
81 Arendt, *The Promise of Politics*, 95.
82 Arendt, *The Human Condition*, 9.
83 Bonnie Honing shows how democratic discourse conceives the stranger as a problem for the government, which is supposed to find ways to contain and accommodate strangers. My discussion above may be seen in line with her attempt to offer alternative models for bypassing what democracy poses as its problem. See Bonnie Honig, *Democracy and the Foreigner*, Princeton: Princeton University Press, 2001.
84 For further discussion of the failure of the governed to agree to take life as a basis of the civil contract, see Azoulay, "The Absent Philosopher-Prince."
85 Jacques Rancière, "Politics and Aesthetics: An Interview", *Angelaki*, vol. 8, no. 2, August 2003, 199.
86 Ibid., 198.
87 For the construction of the iconic image, see Robert Hariman and John Louis Lucaites, *No Caption Needed*, Chicago: University of Chicago Press, 2007.
88 See Vicki Goldberg, *The Power of Photography: How Photographs Changed Our Life*, New York: Abbeville Publishing Group, 1991, 139.
89 Thomas Keenan, "Mobilizing Shame," *South Atlantic Quarterly*, vol. 103, no. 2/3, Spring/Summer 2004, 436.
90 The notion of the différend relates to an irresoluble conflict given that no tribunal is constituted before which it might be arbitrated. See Jean-François Lyotard, *The Differend: Phrases in Dispute*, Minnesota: University of Minnesota Press, 1989.
91 An abbreviation of "*Noar Halutzi Lohem*" ("fighting pioneer youth"). It is an infantry brigade whose activities include the establishment of new agricultural settlements.
92 For "Act of State," see Ariella Azoulay, *Atto di Stato: Palestina–Israele, 1967–2007; Storia Fotografica dell'Occupazione*, Milano: Bruno Mondadori, 2008.
93 Between 1947 and 1948, 750,000 Palestinians were deported. The remaining 150,000 became citizens of the state of Israel. At the time, 600,000 Jews inhabited what had been mandatory Palestine. The expulsion of most of the Palestinian population rendered the Jewish minority into a majority.
94 Individual looting was differentiated from the organized state looting of land via the Jewish National Fund and of possessions via the Custodian of Absentee Property. See Tom Segev, *1949: The First Israelis*, New York: Free Press, 1986; and Ilan Pappé, *The Ethnic Cleansing of Palestine*, Oxford: Oneworld, 2006.
95 For a longer discussion of the Israeli political regime, see Ariella Azoulay and Adi Ophir, *This Regime Which Is Not One*, Palo Alto, CA: Stanford University Press, 2012.

96 From 1967, when a portion of these non-governed people began to be governed by the state of Israel as non-citizens, the major distinction put into play by the regime has been between citizens and non-citizens, whereas the remainder of the non-governed who reside in refugee camps on the West Bank and in Gaza are no longer even considered in the context of the body politic. For a longer discussion of the distinction between the governed and the non-governed, see my article, "The Governed Must Be Defended: Toward a Civil Political Agreement," *Sedek*, no. 4, 2009.

97 The name of the photographer is unknown. The photograph was given to Nahida Zahra, a second-generation refugee of Kufr Bir'im, and was scanned courtesy of Meron Farah, also a refugee from Kufr Bir'im. Hadas Snir located the photograph while working as my research assistant on the exhibition that I curated.

98 Many of the characteristics that I attribute to civil discourse can be attributed to "the political," as formulated in the work of Jacques Rancière or Adi Ophir, who think alongside and beyond Hannah Arendt (see Adi Ophir, "The Political," *Mafte'akh*, no. 2, Summer 2010 [in Hebrew]). But the thinking of the political in relation to governmental power, albeit by means of problematization, and the subordination of political discussion to the template of the judgment of taste, underscore the need to develop a form of discourse whose point of departure is the totality of citizens sharing a world together rather than power.

Chapter 3

1 This chapter is based on my exhibition *The Architecture of Destruction*, at the Zochrot Gallery in Tel Aviv, 2008. The exhibition presented photographs by Activestills, Joseph Algazy, Dorit Hershkovitz, Dafna Kaplan, Nir Kafri, Miki Kratsman, Ian Sternthal and Suha Zaid, alongside illustrative schemas by Meira Kowalsky. The exhibition was designed by Michael Gordon. My thanks go to Liron Mor, Mikhael Mankin, Itamar Mann, and Daniel Mann for their assistance in the research leading up to the exhibition. An earlier and shorter version of this chapter was published under the title "The (In)Human Spatial Condition," in *The Power of Inclusive Exclusion: Anatomy of Israeli Rule in the Occupied Palestinian Territories*, ed. Adi Ophir, Michal Givoni and Sari Hanafi, New York: Zone Books, 2009.

2 For the use of the term "architecture" in connection with destruction, see Eyal Weizman, *Hollow Land*, London: Verso Books, 2007; Rafi Segal and Eyal Weizman, eds., *A Civilian Occupation: The Politics of Israeli Architecture*, London: Verso, 2003; David Goldblatt, *South Africa: The Structure of Things Then*, New York: Monacelli, 1998.

3 See the website of the Israeli Committee Against House Demolitions. The Committee, jointly with Palestinian residents and international volunteers, acts to rebuild some of the demolished houses. On the history of house demolitions, see Badil, "A History of Destruction," May 18, 2004, at electronicintifada.net. This report explicitly states that the data does not include the demolition of housing units in the refugee camps, among them about 10,000 units demolished in the early 1970s.

4 I do not doubt the necessity of documenting acts of destruction and tallying them for specific needs, such as preparing for the eventual negotiation over

reparations. Such reckoning, though, is hardly sufficient on its own, and does not make superfluous the need to problematize the categories that serve it.

5 For further visual documentation of the beginning of the project of destruction, see Azoulay, *From Palestine to Israel.*

6 My exhibition *Untaken Photographs* showed the work of artists who have investigated the enterprise of destruction: Dor Guez, Aïm Deüelle Lüski, and Miki Kratsman's collaboration with Boaz Arad. In his most recent exhibitions, Guez explores the systematic nature of the destruction of the city of al-Lydd and its transformation into Lod (Dor Guez, *Al-Lydd*, Berlin: Distanz, 2010; and Dor Guez, *Georgiopolis*, Petach Tikva: Petach Tikva Museum of Art, 2009).

7 In recent years, Israeli and Palestinian scholars have begun to gather data about the scope of the demolition, but its full history as an enterprise of destruction has yet to be told. See Walid Khalidi, *All That Remains: The Palestinian Villages Occupied and Depopulated by Israel in 1948*, Washington, DC: Institute for Palestine Studies, 1992; and Eyal Weizman, *Hollow Land*, London: Verso Books, 2007. See also the databases of the Israeli Committee Against House Demolitions (icahd.org) and the continuous work by Zochrot and Eyal Weizman on house demolition in Gaza during the "Operation Cast Lead" attack on Gaza by Israel (Eyal Weizman, "Lawfare in Gaza: Legislative Attack," March 1, 2009, at opendemocracy.net).

8 The fact that no systematic study examines the scope and nature of these mixed relationships, and that trying to explore this is considered an unprecedented move in the historical research, is an effect of intentional measures to erase not only the memory of the Palestinian Nakba but also of the civil mixed society of Jews and Arabs. For further reading, see Zachary Lockman's book describing relations between Jews and Arabs working in Haifa in the period prior to their deterioration that began shortly after the Partition Plan was announced (Zachary Lockman, *Comrades and Enemies: Arab and Jewish Workers in Palestine, 1906–1948*, Berkeley: University of California Press, 1996). See also an unpublished lecture by Eitan Bronstein discussing statements and actions by Jews who explicitly opposed the obligatory division between Arabs and Jews imposed by the state's institutions, or who did so by not accepting their particular political ideology ("Local Jewish Resistance to the Palestinian Nakba," at nakbainhebrew.org [in Hebrew]). Dan Yahav, *Paths of Coexistence and the Joint Arab–Jewish Economic and Social Struggle, 1930–2008*, Tel Aviv: published privately, 2009; Nahum Karlinsky, "California Dreaming: Adapting the 'California Model' to the Jewish Citrus Industry in Palestine, 1917–1939," *Israel Studies*, vol. 5, no. 1, Spring 2000. See also photographic references to the issue in Mustafa Kabha and Guy Raz, eds., *Memory of a Place: The Photographic History of Wadi 'Ara, 1903–2008*, Umm el-Fahem: Umm el-Fahem Art Gallery, 2008 (in Hebrew and Arabic); Rona Sela, *Photography in Palestine in the 1930s and 1940s*, Tel Aviv: Hakibbutz Hameuchad, 2001 (in Hebrew); and recently, Boaz Lev Tov, "Cultural Relations between Jews and Arabs in Palestine during the Late Ottoman Period," *Zmanim: A Historical Quarterly*, no. 110, Spring 2010 (in Hebrew).

9 For the complicity of civilians in the Occupation through commercial companies, see Eyal Weizman, *Hollow Land*, as well as whoprofits.org, which presents a database of companies that profit from the Occupation.

10 An exemplary expression of this is the official position of Israeli political and military leadership, beginning in the late 1940s, striving to reduce the injury of civilians while focusing the damage to their homes. Thus, for instance, in the assault on Gaza in December 2008, Israel demolished 15,000 houses (homes to 100,000 inhabitants) and killed "only" 1,300 persons.

11 Much criticism has been directed at Arendt's distinction between the private and the public domains. It has focused mostly on two matters: her identification of the public with the political, and her designation of the home as non-political. Within the broader context of Arendt's thought, these criticisms appear to be inaccurate. Arendt indeed identifies political action with the public sphere and designates the home as a space outside the political; but contrary to the criticism she received, I claim she articulates the relation between the two domains, making the distinction itself unstable and necessary only as an empty form on which I shall elaborate shortly, enabling one to keep the two domains separate. She thus turns the question of boundaries between the public and the private into a political one, in other words, a question that cannot be finally resolved and remains open to the permanent involvement of humans in its shaping, just as the very conceptualization Arendt herself provides actually does. The form of her participation is problematizing the divisions and interconnections between the two domains, as well as the historicization she seeks.

12 See Hannah Arendt, " 'The Rights of Man': What Are They?" *Modern Review*, vol. 3, no. 1, Summer 1949, 33.

13 See Hannah Arendt, *The Human Condition*, Chicago: University of Chicago Press, 1958.

14 See Weizman's discussion of the management of effluent between the settlements and Palestinian territories in *Hollow Land*.

15 See the manifesto that I penned during Israel's most recent devastation of Gaza, "We Are All Palestinians," on my website cargocollective.com/ariellaAzoulay.

16 For prominent examples of such research efforts, see the work of Sandi Hilal, Alessandro Petti and Eyal Weizman at www.decolonizing.ps; also Elisha Efrat, *Geography of Occupation: Judea, Samaria and the Gaza Strip*, Jerusalem: Carmel, 2002; and Fatina Abreek, *The Architecture of the Palestinian "Refugee Camps" in the West Bank: Dheisheh Refugee Camp as a Case Study, 1948–1967*, M.A. thesis, Haifa: Technion, 2010.

17 I will not treat apparatuses involving the theft, appropriation, confiscation or dispossession of land since my emphasis is on the built environment. For these topics see Yehezkel Lein, ed., *Land Grab: Israel's Settlement Policy in the West Bank*, Jerusalem: B'Tselem, 2002; and Oren Yiftachel, *Ethnocracy: Land and Identity Politics in Israel/Palestine*, Philadelphia: University of Pennsylvania Press, 2006.

18 Jeff Halper of the Israeli Committee Against House Demolitions compares the situation in the territory to the game of "Go," where the object is not to defeat your enemy but to prevent his opportunities for movement.

19 Organizations such as B'Tselem, Badil and Physicians for Human Rights have collected testimony from many individuals whose houses have been destroyed, who have suffered physical or emotional harm as a result of being detained at checkpoints, or who have had their lives embittered by the effects of the separation wall.

20 Quoted in Avihai Becker, "With Surgical Precision," *Haaretz*, December 26, 2002.x.

21 These acts are the Occupation's variation of the category of *faits du prince*.

22 Becker, "With Surgical Precision."

23 These two citations are taken from interviews with officers charged with liaison activities with aid organizations, taken from the film *Sharsheret Hamazon* ("The Food Chain"), 2003.

24 For further details concerning the event, see Gideon Levy, "Collateral Damage," *Haaretz*, October 12, 2006.

25 For the connection between blasting passages through walls and certain post-modern theories, see chapter 7 of Weizman, *Hollow Land*.

26 For further discussion of this claim see my afterword to the Hebrew translation of Baudrillard, "Say 'It's Real' and No One Will Laugh. Say 'It's a Simulacrum' and Everyone Will Crack Up," in Jean Baudrillard, *Simulacra and Simulations*, Tel Aviv: Hakibbutz Hameuchad, 2007 (in Hebrew).

27 For a visual description of processes of destruction and the re-accommodation of refugees in apartment buildings, see Azoulay, *Atto di Stato: Palestina-Israele, 1967–2007*.

28 The efforts to keep the entries in the Hebrew version of Wikipedia consistent with the Zionist narrative have recently become visible. On August 16, 2010, I received an email concerning the opening of a "Zionist Editing Course." It announced that "Israel's difficulties in explaining and justifying its position to the outside world has motivated the organization 'My Israel' (*Yisrael Sheli*), a patriotic organization that organized the demonstrations outside the Turkish Embassy after the Flotilla, to take on a new kind of intervention. Tomorrow a course in 'Zionist Editing' will begin directed at the Internet encyclopedia, Wikipedia, in an effort to create an army of Wikipedia editors who will assist Israeli publicity efforts. The participants have been selected from among the pupils of Dice Marketing." About eighty participants were expected to take part in the course. The letter was signed by Nimrod Dayak.

29 Quoted in Yehezkel Lein, ed., *Through No Fault of Their Own: Punitive House Demolitions during the al-Aqsa Intifada*, Jerusalem: B'Tselem, 2004. See also Moshe Reinfeld, "The IDF to the Supreme Court: Terror Organizations Admit that Expulsion Is a Deterrent," *Haaretz*, August 27, 2002 (in Hebrew).

30 On the distinction between eruptive violence and withheld violence, see chapter 3 in Ariella Azoulay and Adi Ophir, *This Regime Which Is Not One*, Palo Alto: Stanford University Press, 2012.

31 For the provisions relating to Route 443, see "Route 443—West Bank road for Israelis only," at btselem.org.

32 In Hebrew, the phrase that inspired this section heading, *petach tikva*, literally means "the opening of hope." It is the name of an early Zionist settlement, now a city, located north of Tel Aviv.

33 The organization Riwaq, headed by Dr. Suad al-Amiry and Dr. Nazmi Jub'eh, has initiated and coordinated unique projects for the preservation of Palestinian architecture.

Chapter 4

1 This chapter is based on a lecture I presented at the closing of the exhibition *Constituent Violence 1947–1950* (from which all the photos are drawn) at the Zochrot Gallery in May 2009. See also Ariella Azoulay, *From Palestine to Israel: A Photographic Record of Destruction and State Formation, 1947–1950*. Pluto Press, 2011.

2 See the jacket to the Hebrew translation of Muhammad al-As'ad's *Children of Dew* (Haifa: Pardes, 2005).

3 See Boris Karmi, *A State in the Cradle*, Tel Aviv: Machbarot Lesifrut, 1997 (in Hebrew).

4 Israel presents a fruitful laboratory for investigating this claim, but such regimes also occur elsewhere in the Western world.

5 See United Nations High Commissioner for Refugees, *Images of Exile, 1951–1991*, United Nations Publications, 1991.

6 In the context of the exhibition, I organized a series of meetings with researchers from various fields, along with Norma Musih, the curator of the Zochrot Gallery. The meetings were held each Wednesday between mid-March and the end of May 2009. The researchers were requested to comment on the photographs on display. Kratsman's comments are taken from the first session of this intervention.

7 What is true for Hannah Arendt regarding action, might also be applied to the event of photography: it is never possible to know how it will end. In the repertoire of attempts to intervene in the event in order to destroy it, more factors are relevant than the hiding of photographs or the photographer's effort to stay away from the event of photography. These include making the photograph inaccessible to the persons photographed, the use of nonexistent photographs for the purposes of blackmailing detainees, or the institutionalized distancing of spectators from the event of photography. Such efforts intervene in the actual event itself or in the way it will be made accessible to others, but none of them will be able to bury and forget it. No one can annul an event alone, just as no one can generate it alone—and this is true for the event of photography as well.

8 Aviv Lavie and Moshe Gorali, "'I Saw Fit to Remove Her from the World,'" *Haaretz*, October 29, 2003.

9 The exhibition was shown at Zochrot in March–June 2009 and published as Azoulay, *From Palestine to Israel: A Photographic Record of Destruction and State Formation, 1947–1950*.

10 See chapter 5 of Ariella Azoulay, *The Civil Contract of Photography*, New York: Zone Books, 2008.

11 In two other captions I remarked on the rape of Palestinian women as a tool of expulsion and a deterrent to the return of Palestinians, but did not specifically link the claim to what is visible in the photograph itself.

12 From report no. 82, to Baruch, from Schnurman, November 19, 1948 (IDF Archive file no. 1261/49/4).

13 Still, this did not keep him from relating to such cases as exceptional and calling the rapists "undisciplined soldiers." See Benny Morris, *The Birth of the Palestinian Refugee Problem Revisited*, Cambridge: Cambridge University Press, 2004, 220.

14 Several individual cases were indeed brought to trial, but the documents I did get to review show that the charge of rape is downplayed out of fear for the

reputation of state institutions. See for example the trial of the policemen in Abu Ghosh, which was held in a disciplinary court and which pointedly fails to indict the accused for rape (State Archive, 337/41-c).

15 David Ben-Gurion, *War Diary*, vol. 2, July 15, 1948, p. 589 (in Hebrew).

16 Ibid., August 22, 1949.

17 Lavie and Gorali, "'I Saw Fit to Remove Her from the World.'"

18 Both citations are from ibid.

19 Concerning the rape cases in al-Ramla and the embarrassing discussion of them by the government, see Segev, *1949: The First Israelis*, New York: Free Press, 1986, 72. One of the cabinet ministers is on record as saying, "It's been said that there were cases of rape in Ramlah. I can forgive rape, but I will not forgive other acts which seem to me much worse. When they enter a town and forcibly remove rings from the fingers and jewelry from someone's neck, that's a very grave matter."

20 Regarding the rape of a refugee who attempted to return into Israeli area and was raped in Abu Ghosh by four policemen, the minister of police wrote a harshly critical letter to the chief inspector of the police wherein he pointed out endless defects in the handling of this affair. Among other things, he writes, "The detainee was kept in custody by men and not under charge of a woman as required by law" (State Archive, 337/41-c, 11.1.51).

21 See especially the chapters on the body and the home in Fatma Kassem, *Palestinian Women: Narrative Histories and Gendered Memory*, London: Zed Books, 2011.

22 Benny Morris, interview by Ari Shavit, "Survival of the Fittest," *Haaretz*, January 9, 2004.

23 See essays by the first three in Ahmad Sa'di and Lila Abu-Lughod, eds., *Nakba: Palestine, 1948, and Claims of Memory*, New York: Columbia University Press, 2007.

24 Haganah Archive file no. HA 105/260.

25 See for example a series of reports by the International Red Cross on Akka or Haifa (IDF Archive, 105/260) describing the terror regime imposed by the Haganah in Akka.

26 See Yoav Gelber, *Independence Versus Nakba*, Or Yehuda: Dvir, 2004, note 39, from a report by Schnurman to Baruch of November 12, 1948, IDF Archive file no. 1261/49/4. This document too, which Gelber had used, is no longer accessible to the public.

27 Ibid.

28 See his concluding remarks in Morris, *The Birth of the Palestinian Refugee Problem Revisited*, 592.

29 This claim is also replicated in two excellent studies, both trailblazing in their discussion of rape: Pappé, *The Ethnic Cleansing of Palestine*, and Kassem, *Between Private and Collective Memory*. The latter is based on fascinating primary testimonies gathered from Palestinian women who had lived in al-Ramla and al-Lydd. Kassem uses these testimonies of rape in a pioneering context of the uniqueness of women's Nakba memory-work.

30 From the IDF Archive, file no. 1261/49/4, report no. 46—"Removing Civilians from Faluja," March 9, 1948.

31 From the IDF Archive, file. no. 1860/1959/71.

32 According to the same letter, when asked why she took the pen, she answered,

"Never mind, you're alright." Cited from the file titled "Trial of the Policemen from Abu Ghosh," State Archives, file no. 337/41-c.

33 Testimony about rape in Jaffa heard by Sha'aban from his neighbors, as well as testimony about the abduction of a mother and her two daughters from the Carmel Market, stripping and transporting them all over Tel Aviv (thanks to Abed Satel for the source of this testimony).

34 See an exhibition on paper I recently curated, *Potential History: Photographic Documents from Mandatory Palestine*, presented within *Nineteen forty-eight*, a project by Remco de Blaaij and Anna Colin at the European Cultural Congress in Wrocław, Poland, in 2011.

Epilogue

1 Photographers have begun photographing increasingly in recent years, whether independently, through the mediation of human rights organizations, or under the auspices of local and international commercial photographic agencies. Yet despite the more heterogeneous makeup of the photographers in the field, the Occupied Territories are always subject to restrictions with regard to photography. The ban on international and Israeli photographers entering Gaza during the massive assault in 2009, and the systematic delegitimizing of pictures produced by the local Palestinian photo agency are just two examples of this.

2 One may often find photographs that appear in the archives of human rights groups elsewhere, in newspapers, photographic agencies, or photographers' studios, as well as in official state archives.

3 On this tautological assertion, see Ariella Azoulay, "Photography without Borders," in *Handbook of Human Rights*, ed. Thomas Cushman, New York: Routledge, 2011.

4 See for example the numerous photographs stored in government archives from 1948 onward, in which deportees or prisoners were photographed at the moment of receiving drinking water from the hands of those who were deporting or arresting them. Several examples like these from different periods can be seen in the two archives I created.

5 On the political urgency to redefine the borders of the photograph, see Judith Butler, *Frames of War: When Is Life Grievable?*, London: Verso Books, 2009.

6 On the possibility to reconstruct this possibility from the French Revolution, see Azoulay, "Photography Without Borders."

7 There have yet to arise international human rights groups committed to rehabilitating the historic legacy of the human rights discourse that originated with the French Revolution.

BIBLIOGRAPHY

Abreek, Fatina, *The Architecture of the Palestinian "Refugee Camps" in the West Bank, Dheisheh Refugee Camp as a Case Study, 1948–1967*, M.A. thesis, Haifa: Technion, 2010.

Arendt, Hannah, "'The Rights of Man': What Are They?" *Modern Review*, vol. 3, no. 1, Summer 1949.

——, *The Human Condition*, Chicago: University of Chicago Press, 1958.

——, *Lectures on Kant's Political Philosophy*, Chicago: University of Chicago Press, 1982.

——, "Reflections on Little Rock," in *Responsibility and Judgment*, ed. Jerome Kohn, New York: Schocken Books, 2003.

——, *The Promise of Politics*, New York: Schocken Books, 2005.

——, *Édifier un monde: Interventions 1971–1975*, Paris: Seuil, 2007.

——, *Origins of Totalitarianism*, LaVergne, TN: Benediction Books, 2009.

al-As'ad, Muhammad, *Children of Dew*, Haifa: Pardes, 2005 (in Hebrew).

Azoulay, Ariella, *TRAining for Art*, Tel Aviv: Hakibbutz Hameuchad, 1999 (in Hebrew).

——, *How Does It Look to You?*, Tel Aviv: Babel, 2000 (in Hebrew).

——, "Ecclesia and Synagoga," paper presented at the conference "Footsteps, Folds and Cracks: Kinds of Continua in Israeli Literature," Bar-Ilan University, January 7–9, 2002.

——, *Once Upon a Time: Photography Following Walter Benjamin*, Ramat Gan: Bar-Ilan University Press, 2006 (in Hebrew).

——, "Say 'It's Real' and No One Will Laugh. Say 'It's a Simulacrum' and Everyone Will Crack Up," afterword to Jean Baudrillard, *Simulacra and Simulations*, Tel Aviv: Hakibbutz Hameuchad, 2007 (in Hebrew).

——, *The Civil Contract of Photography*, New York: Zone Books, 2008.

——, *Act of State: A Photographed History of the Occupation 1967–2007*, Tel Aviv: Etgar, 2008 (in Hebrew).

——, "The Absent Philosopher-Prince," *Radical Philosophy*, no. 158, November/December 2009.

——, "The Revolutionary Potential of the Ruin: On Dor Guez's Photographic Series of Lydd Ruins," in Dor Guez, *Georgiopolis*, Petach Tikva: Petach Tikva Museum of Art, 2009.

—— "The Governed Must Be Defended: Toward a Civil Political Agreement," *Sedek*, no. 4, 2009, 74–79.

———, "Homeland Hospitality," in *Dor Guez: Al-Lydd*, ed. Susanne Pfeiffer, Berlin: Distanz, 2010.

———, "The (In)Human Spatial Condition," in *The Power of Inclusive Exclusion: Anatomy of the Israeli Rule in the Occupied Palestinian Territories*, ed. Adi Ophir, Michal Givoni and Sari Hanafi, New York: Zone Books, 2009.

———, "The Execution Portrait," in *Picturing Atrocity: Photography in Crisis*, ed. Geoffrey Batchen, Mick Gidley, Nancy K. Miller and Jay Prosser, London: Reaktion Books, 2011.

———, "Photography without Borders," in *Handbook of Human Rights*, ed. Thomas Cushman, New York: Routledge, 2011.

———, "Outside the Political Philosophy Tradition, and Still inside Tradition: Two Traditions of Political Philosophy," *Constellations*, vol. 18, no. 1, March 2011, 91–105.

———, *From Palestine to Israel: A Photographic Record of Destruction and State Formation, 1947–1950*, London: Pluto, 2011 (English translation of *Constituent Violence 1947–1950*).

———, "When a Demolished Home Becomes a Public Square," *Imperial Debris: On Ruins and Ruination*, ed. Ann L. Stoler, Durham, NC: Duke University Press, 2011.

———, "Declaring the State of Israel: Declaring a State of War," *Critical Inquiry*, vol. 37, no. 2, Winter 2011, 265–285.

———, "Getting Rid of the Distinction between the Aesthetic and the Political," *Theory, Culture & Society*, vol. 27, no. 7/8, 2011.

Azoulay, Ariella and Adi Ophir, *This Regime Which Is Not One*, Palo Alto, CA: Stanford University Press, 2012.

Bartelson, Jens, *The Critique of the State*, Cambridge: Cambridge University Press, 2001.

Barthes, Roland, *Camera Lucida: Reflections on Photography*, trans. Richard Howard, New York: Vintage, 2000.

Baruch, Adam, "Photography Is the Biggest Con-Job of Them All: Creator of Realities, Director of Memory, Promoter of Manipulation," *Ha'ir*, April 25, 1997 (in Hebrew).

Batchen, Geoffrey, *Burning with Desire*, Cambridge, MA: MIT Press, 1999.

Batchen, Geoffrey, Mick Gidley, Nancy K. Miller and Jay Prosser, eds., *Picturing Atrocity: Photography in Crisis*. London: Reaktion Books, 2011.

Becker, Avihai, "With Surgical Precision," *Haaretz*, December 26, 2002.

Ben-Gurion, David, *War Diary*, vol. 2, ed. Gershon Rivlin, Elhanan Orren, 1983 (in Hebrew).

Ben-Naftali, Michal, *The Visitation of Hannah Arendt*, Tel Aviv: Hakibbutz Hameuchad, 2005 (in Hebrew).

Benjamin, Walter, "Little History of Photography," in *Selected Writings, Volume 2: 1927–1934*, Cambridge, MA: Harvard University Press, 1999.

———, *Selected Writings, Volume 4: 1938–1940*, Cambridge, MA: Harvard University Press, 2003.

Berger, John, and Jean Mohr, *Another Way of Telling*, New York: Pantheon, 1982.

Bernard, Denis, and André Gunthert, *L'instant rêvé: Albert Londe*, Nîmes: Jaqueline Chambon, 1993.

Boulouch, Nathalie, "Peindre avec le soleil? Les enjeux du problème de la photographie des couleurs," *Études photographiques*, no. 10, November 2001.

Buck-Morss, Susan, "Aesthetics and Anaesthetics: Walter Benjamin's Artwork Essay Reconsidered," *October*, vol. 62., Autumn, 1992, 3–41.

Butler, Judith, *Frames of War: When Is Life Grievable?*, London: Verso Books, 2009.

—— and Gayatri Chakravorty Spivak, *Who Sings the Nation-State?*, London: Seagull, 2007.

Counts, Will, *A Life Is More Than a Moment: The Desegregation of Little Rock's Central High*, Bloomington, IN: Indiana University Press, 2007.

Daston, Lorraine, and Peter Gallison, *Objectivity*, New York: Zone Books, 2007.

Deüelle Lüski, Aïm, "Fragments of Horizontal Thinking," *Plastika*, no 3, 1999 (in Hebrew).

Didi-Huberman, Georges, *Invention de l'hystérie: Charcot et l'iconographie photographique de la Salpêtrière*, Paris: Macula, 1995.

Dunn, Susan, *The Deaths of Louis XVI: Regicide and the French Political Imagination*, Princeton: Princeton University Press, 2008.

Duras, Marguerite, *Hiroshima Mon Amour*, New York: Grove, 1994.

Duve, Thierry de, *Au nom de l'art*, Paris: Minuit, 1989.

Eagleton, Terry, *The Ideology of the Aesthetic*, Oxford: Blackwell, 1991.

Efrat, Elisha, *Geography of Occupation: Judea, Samaria and the Gaza Strip*, Jerusalem: Carmel, 2002 (in Hebrew).

al-Enany, Rashid, *Arab Representations of the Occident*, New York: Routledge, 2007.

Enwezor, Okwui, *Archive Fever: Uses of the Document in Contemporary Art*, London: Steidl, 2009.

Evans, Jessica, and Stuart Hall, eds., *Visual Culture: The Reader*, London: Sage, 1999.

Ewald, Wendy, *Secret Games: Collaborative Works with Children, 1969–1999*, Berlin: Scalo, 2000.

Farge, Arlette, *Dire et mal dire*, Paris: Seuil, 1992.

Ferrato, Donna, *Living with the Enemy*, New York: Aperture, 1991.

French, Lindsay, "Exhibiting Terror," in *Truth Claims: Representation and Human Rights*, ed. Mark Philip Bradley and Patrice Petro, New Brunswick, NJ: Rutgers University Press, 2002.

Frizot, Michel, *A New History of Photography*, Köln: Könemann, 1998.

Goldberg, Vicki, *The Power of Photography: How Photographs Changed Our Life*, New York: Abbeville, 1991.

Goldblatt, David, *South Africa: The Structure of Things Then*, New York: Monacelli, 1998.

Groys, Boris, *Art Power*, Cambridge, MA: MIT Press, 2008.

Guez, Dor, *Al-Lydd*, Berlin: Distanz, 2010.

——, *Georgiopolis*, Petach Tikva: Petach Tikva Museum of Art, 2009.

Habermas, Jürgen, *The Structural Transformation of the Public Sphere*, Cambridge, MA: MIT Press, 1991.

Halper, Jeff, "The 94 Percent Solution: A Matrix of Control," *Middle East Report*, no. 216, Fall 2000.

Hariman, Robert, and John Louis Lucaites, *No Caption Needed*, Chicago: University of Chicago Press, 2007.

Haskell, Francis, "Art and the Language of Politics," *Journal of European Studies*, vol. 4, no. 3, 1974: 218.

Heiman, Michal, *Michal Heiman test no. 2: Ma belle-mère: Test pour femmes*, Quimper: Le Quartier, 1998.

Honig, Bonnie, *Democracy and the Foreigner*, Princeton: Princeton University Press, 2001.

Hoock, Holger, *The King's Artists: The Royal Academy of Arts and the Politics of British Culture 1760–1840*, Oxford: Oxford University Press, 2005.

Jameson, Fredric, *The Political Unconscious*, Ithaca, NY: Cornell University Press, 1982.

Kabha, Mustafa and Guy Raz, eds., *Memory of a Place: The Photographic History of Wadi 'Ara, 1903–2008*, Umm el-Fahem: Umm el-Fahem Art Gallery, 2008 (in Hebrew and Arabic).

Karlinsky, Nahum, "California Dreaming: Adapting the 'California Model' to the Jewish Citrus Industry in Palestine, 1917–1939," *Israel Studies*, vol. 5, no. 1, Spring 2000: 24–40.

Karmi, Boris, *A State in the Cradle*, Tel Aviv: Machbarot Lesifrut, 1997 (in Hebrew).

Kassem, Fatma, *Palestinian Women: Narrative Histories and Gendered Memory*, London: Zed Books, 2011.

Keenan, Thomas, "Mobilizing Shame," *South Atlantic Quarterly*, vol. 103, no. 2/3, Spring/Summer, 2004.

Khalidi, Walid, *All That Remains: The Palestinian Villages Occupied and Depopulated by Israel in 1948*, Washington, DC: Institute for Palestine Studies, 1992.

Kristeva, Julia, *Le génie féminin: Hannah Arendt*, Paris: Fayard, 1999.

Lavie, Aviv, and Moshe Gorali "'I Saw Fit to Remove Her from the World,'" *Haaretz*, October 29, 2003.

Lefort, Claude, *Essais sur le politique*, Paris: Seuil, 1986.

Lev Tov, Boaz, "Cultural Relations between Jews and Arabs in Palestine during the Late Ottoman Period," *Zmanim: A Historical Quarterly*, no. 110, Spring 2010 (in Hebrew).

Levy, Gideon, "Collateral Damage," *Haaretz*, October 12, 2006.

Lockman, Zachary, *Comrades and Enemies: Arab and Jewish Workers in Palestine, 1906–1948*. Berkeley: University of California Press, 1996.

Lyotard, Jean-François, *The Differend: Phrases in Dispute*, Minnesota: University of Minnesota Press, 1989.

Maimon, Vered, "Displaced 'Origins': William Henry Fox Talbot's *The Pencil of Nature*," *History of Photography*, vol. 32, no. 4, December 2008.

Malraux, André, *Le musée imaginaire*, Paris: Gallimard, 1996.

McKee, Yates and Meg McLagan, eds., *The Visual Cultures of Nongovernmental Politics*, New York: Zone Books, 2011.

Meiselas, Susan, *Kurdistan: In the Shadow of History*, Chicago: University of Chicago Press, 2008.

Mirzoeff, Nicholas, *An Introduction to Visual Culture*, London: Routledge, 2000.

Mitchell, W. J. T., "Holy Landscape: Israel, Palestine, and the American Wilderness," *Critical Inquiry*, vol. 26, no. 2, Winter 2000: 193–223.

Morris, Benny, *The Birth of the Palestinian Refugee Problem Revisited*, Cambridge: Cambridge University Press, 2004.

——, interview by Ari Shavit, "Survival of the Fittest," *Haaretz*, January 9, 2004.

Nancy, Jean-Luc, *The Inoperative Community*, Minnesota: University of Minnesota Press, 1991.

Ofrat, Gideon, *The Definition of Art*, Tel Aviv: Hakibbutz Hameuchad, 1976 (in Hebrew).

Ophir, Adi, "Political," *Mafte'akh*, no. 2, Summer 2010 (in Hebrew).

———, "State," *Mafte'akh*, no. 1e, Summer 2010.

Pappé, Ilan, *The Ethnic Cleansing of Palestine*, Oxford: Oneworld, 2006.

Phillips, Sandra S., Mark Haworth-Booth and Carol Squiers, *Police Pictures: The Photograph as Evidence*, San Francisco: Chronicle Books, 1997.

Pinson, Stephen, "Revers de fortune," in *Le daguerréotype français: Un objet photographique*, ed. Quentin Bajac and Dominique Planchon-de Font-Réaulx, Paris: Réunion des Musées Nationaux, 2003.

Posnock, Ross, "Ralph Ellison, Hannah Arendt, and the Meaning of Politics," *The Cambridge Companion to Ralph Ellison*, Cambridge: Cambridge University Press, 2005.

Rancière, Jacques, *The Emancipated Spectator*, London: Verso Books, 2009.

———, "Politics and Aesthetics: An Interview," *Angelaki,* vol. 8, no. 2, August 2003, 191–211.

———, "Who Is the Subject of the Rights of Man?," *South Atlantic Quarterly*, vol. 103, no. 2/3, Spring/Summer 2004.

Reinfeld, Moshe, "The IDF to the Supreme Court: Terror Organizations Admit That Expulsion Is a Deterrent" *Haaretz*, August 27, 2002 (in Hebrew).

Reinhardt, Mark, Holly Edwards and Erina Duganne, eds., *Beautiful Suffering: Photography and the Traffic in Pain*, Chicago: University of Chicago Press, 2007.

Ritchin, Fred, *After Photography*, New York: W. W. Norton, 2010.

Rogoff, Irit, *Terra Infirma*, London: Routledge, 2000.

Rosler, Martha, *Decoys and Disruptions: Selected Writings, 1975–2001*, Cambridge, MA: MIT Press, 2006.

Rouillé, André, *La photographie en France: Textes et controverses, une anthologie 1816–1871*, Paris: Macula, 1989.

Sa'di, Ahmad, and Lila Abu-Lughod, eds., *Nakba: Palestine, 1948, and Claims of Memory*, New York: Columbia University Press, 2007.

Schott, Robin May, *Cognition and Eros: A Critique of the Kantian Paradigm*, University Park, PA: Pennsylvania State University Press, 1993.

Schwartz, Vanessa and Jeannene Przyblyski, eds., *The Nineteenth-Century Visual Culture Reader*, New York: Routledge, 2004.

Segal, Rafi and Eyal Weizman, eds., *A Civilian Occupation: The Politics of Israeli Architecture*, London: Verso Books, 2003.

Segev, Tom, *1949: The First Israelis*, New York: Free Press, 1986.

Sela, Rona, *Photography in Palestine in the 1930s and 1940s*, Tel Aviv: Hakibbutz Hameuchad, 2001 (in Hebrew).

Sorek, Adi, review of *Act of State: A Photographed History of the Occupation 1967–2007*, by Ariella Azoulay, *Umbr(a): A Journal of the Unconscious*, 2009.

Talbot, William Henry Fox, *The Pencil of Nature*, London: Longman, Brown, Green and Longmans, 1977.

Trachtenberg, Alan, ed., *Classic Essays on Photography*, Stony Creek, CT: Leete's Island Books, 1989.

———, *Reading American Photographs*, New York: Noonday Press, 1989.

United Nations High Commissioner for Refugees, *Images of Exile 1951–1991*, United Nations Publications, 1991.

Vitruvius, *On Architecture*, volume 1, ed. Frank Granger, Cambridge, MA: Harvard University Press, 1931.

Walker, Jonathan, *The Branded Hand: Trial and Imprisonment of Jonathan Walker*, New York: Arno Press, 1969.

Walzer, Michael, *Regicide and Revolution: Speeches at the Trial of Louis XVI*, New York: Columbia University Press, 1993.

Weizman, Eyal, *Hollow Land*, London: Verso Books, 2007.

Yahav, Dan, *Paths of Coexistence and the Joint Arab–Jewish Economic and Social Struggle, 1930–2008*, Tel Aviv: published privately, 2009.

INDEX

Page references in italics refer to photographs.